CANAL
GUIDES

THE DIFFUSE MUSEUM:
PAINTING

VENICE

CANAL & STAMPERIA EDITRICE

VENICE

A GUIDE TO PAINTINGS IN ORIGINAL SETTINGS

TERISIO PIGNATTI

CANAL & STAMPERIA EDITRICE

Terisio Pignatti
VENICE
A GUIDE TO PAINTINGS
IN ORIGINAL SETTINGS

Editing and layout
Maddalena Redolfi

Translation
Gus Barker

Map graphics
Michela Scibilia

Photo research
Silvia Colussi

© 1995
CANAL & STAMPERIA EDITRICE srl
Venezia, Santa Croce 2180

All rights reserved.
No part of this book may be reproduced, stored in a retrieval system, or transmitted in any form or by any means, including electronic, mechanical, photocopying, microfilming, recording, or otherwise without written permission from the Publisher.

ISBN 88-86502-14-1

Photographs
Venice:
Archivio Canal & Stamperia
Archivio Osvaldo Böhm
Arciconfraternita Scuola grande
 di San Rocco
Cameraphoto Arte
Civici Musei Veneziani
Peggy Guggenheim Collection
Fondazione Giorgio Cini
Fondazione scientifica Querini
 Stampalia
Istituto provinciale per l'infanzia
 Santa Maria della Pietà
Museo dell'Istituto Ellenico
New York:
Piero Corsini Collection

INDEX

7 THE CHARACTER OF VENETIAN PAINTING

THE MUSEUMS
23 The Accademia Gallery
43 The Hellenic Institute
44 The Museo Correr
49 The Franchetti Gallery at the Ca' d'Oro
50 The Pinacoteca Querini Stampalia
52 Ca' Rezzonico - Museum of the Eighteenth Century
57 Ca' Pesaro - Modern Art Gallery
58 Guggenheim Museum

THE ITINERARIES
61 Sestiere of San Marco
79 Sestiere of Castello
97 Sestiere of Cannaregio
113 Sestiere of Santa Croce
121 Sestiere of San Polo
133 Sestiere of Dorsoduro
145 The Islands of the Lagoon

REFERENCE
153 Essential Bibliography
156 Site index
157 Index of names and works

The guide starts from the city's museums and takes us through the various sestieri, visiting all the churches and palazzi which still house masterpieces of Venetian painting. If more than one work is described within a single place, then the discussion follows a chronological order.

In the upper righthand corner of each page there is a number (or letter in the case of collection or museums) which facilitates reference to the map printed inside the cover.

The map also contains a list of museums, monuments, painters and works (the latter two in chronological order), with a corresponding number to identify where they are located.

On the other hand, the indexes at the back of the book give page references for easy access to the discussions of the place, work or artist in question.

THE CHARACTER OF VENETIAN PAINTING

That it is the palette of Venetian painters which makes them some of the most "painterly" of artists is, by now, a critical commonplace. Art criticism has long recognised that colour is the fundamental feature of the city's paintings, and the Venetian School is always considered in symbolic contrast to the Schools of Florence and Rome, which put so much more emphasis on draughtsmanship and the modelling of form. The origins of this colourist vocation in Venetian painting are to be found in the way the arts in these provinces of the Roman Empire developed – under the joint influence of Rome and Byzantium – during the early centuries of the Christian era. However, critics have frequently tried to find other environmental explanations for this stylistic feature – as if there had to be some connection between the characteristic atmosphere and breadth of handling to be found in Venetian painting and the particular milieu of the city and lagoon, with its soft, shifting shades of light and its play of reflections off swelling tides. I myself believe that there is no denying the role played by nature in the development of the Venetian style. In a certain sense, the environment comprising terraferma, beaches and sea could be taken as ideal subject-matter for a style that is now defined as "painterly" – for an art of "improvisation" which aims to render changing lights and seasons. Is it possible, therefore, that the very appearance of the city and its lagoon exercised a direct influence on the style of Venice's artists? Is that where we have to look for the origins of the unmistakable "character" of Venetian painting? There would seem to be no doubt that in Venice more than elsewhere painters felt impelled to deny the rational order of vision, to break up images into independent fields of colour in which texture and handling are used to create effects of great

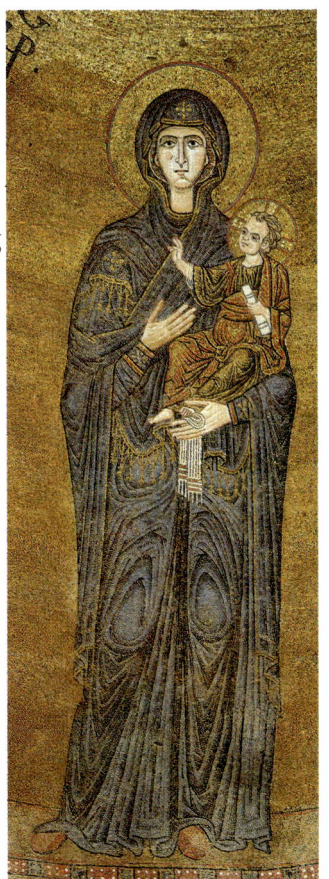

12th-Century Mosaicist, Madonna. *Torcello, Basilica of Santa Maria Assunta.*

immediacy. My aim here is investigate this stylistic tendency in the work of some of the most original artists who have worked in the city over the centuries. The unique, independent cultural language of Venice has developed over a thousand years, and naturally enough, any discussion of it has to take as its starting-point the mosaics of St Mark's, which are the highest expression of medieval art within the city. From there the discussion will move on to the Early Renaissance, with the Bellini family and Carpaccio, and then to the developments to be seen in the work of Giorgione and Titian. After looking at the work of such mid-sixteenth-century artists as Bassano, Tintoretto and Veronese, we will take a quick look at the painting of the Baroque period (paying particular attention to Maffei), and then move on to eighteenth-century rococo, with Tiepolo and the urban "realism" of Longhi, Canaletto and Francesco Guardi – whose work will mark the culmination of our investigation into the use of colour in Venetian painting.

So, let's go back to the mosaics, the earliest of which – in Santa Maria Assunta, the Cathedral of Torcello – date from before the year 1000 A.D. Almost immediately afterwards come the oldest mosaics to be found in St Mark's, which at the time was the chapel of the Doge's Palace and thus at the very centre of the city's political and religious life. Look, for example, at the large mosaic of the various episodes of *Christ's Prayer in the Garden of Olives*, dated by scholars around the beginning of the thirteenth century. Here, the dreamlike atmosphere of Byzantine mosaics (such as those to be seen in Ravenna) has not yet given way to the more vivacious Romanesque style which can be seen in the cupolas and the large archway mosaic depicting *Christ's Passion*, even if there is no doubt that the landscape of tender saplings around the praying

Christ strikes the eye as an unmistakable herald of the soft and painterly palette which will so characterize Venetian art. The mosaics in the portico of St Mark's date from the same period (beginning of the thirteenth century); especially those in which we can see a new attention to narrative. The stories include the *Creation of the World*, *Noah's Flood* and other episodes from the Old Testament. And what could be more effective than the "fragmented" style used in the scenes recounting the story of Noah's Ark, in which there is a touching rendering of the light from the vessel's windows as glimpsed through driving rain, and of a rainbow seen shimmering against a blue sky? And where else in Western Art could we find anything as evocative as the glimmer of bright colours in the *Pairs of Birds* flying away from the Ark? These mosaics also contain a stylistic and technical innovation: for the blue-green wave of the flood, the unknown mosaicist did not prepare a detailed drawing but rather painted in a rough sketch on the wet plaster and then set about patiently arranging his marble and glass tesserae. In short, in the St Mark's mosaics there is already evidence of that typically Venetian style in which the creative power of colour is not restrained within the limits set by a drawn model. This transition from outline to colour is the most sensational innovation of Early Renaissance painting – in which Giovanni Bellini (c. 1430-1516) played such

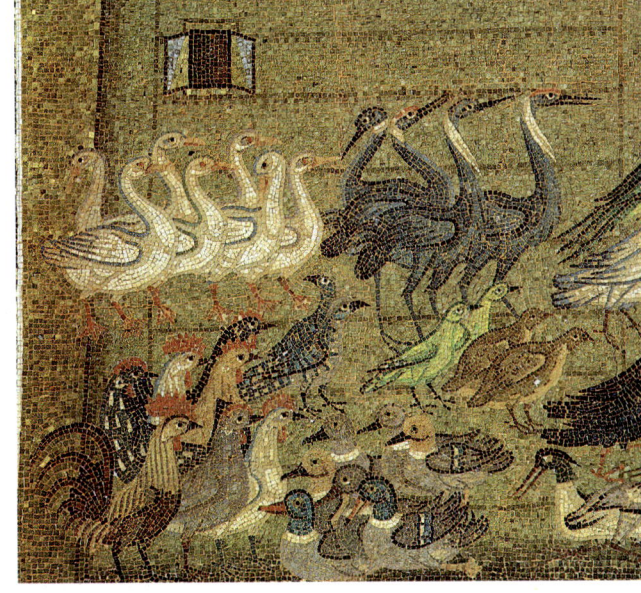

13th-Century Mosaicist,
Noha's Flood *(detail).*
Venice, St. Mark's Basilica.

THE CHARACTER OF VENETIAN PAINTING

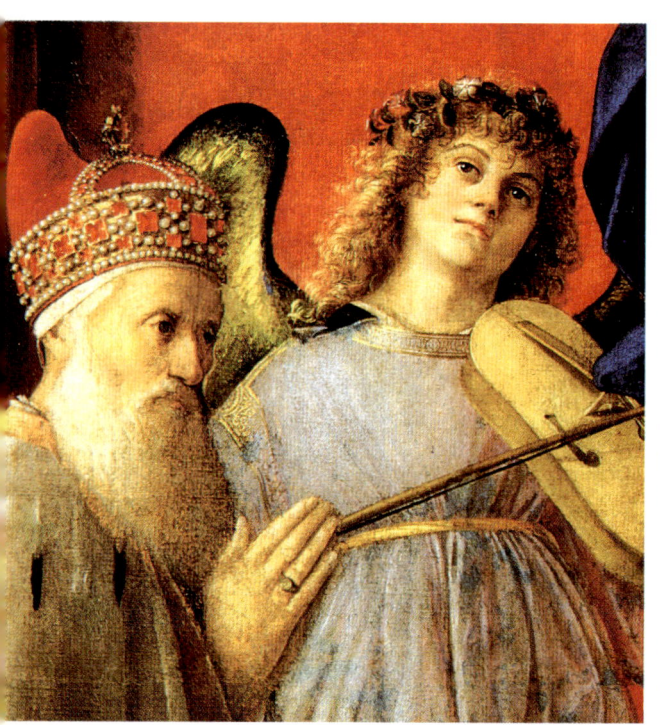

Giovanni Bellini,
Votive Picture of Doge
Agostino Barbarigo *(detail).*
Murano, San Pietro Martire.

a leading role. In the *Madonnas* of his early maturity – dating from just after the middle of the fifteenth century – he was already showing a very delicate eye for colour. Later, towards the end of the century, Bellini would develop an even more "substantial" feel for colour – as can be seen in the *Angel Musician* in the *Votive Picture of Doge Agostino Barbarigo* altarpiece in Murano (1488), where the paint seems to be clotted on the canvas.

The narrative cycles of late fifteenth century – such as those painted by Gentile Bellini (1429-1507) and Vittore Carpaccio (c. 1465-1526 ?) – supply further proof of the close attention to colour in Venetian Renaissance art. Even if the magnificent canvases that decorated the *Saloni* of the Doge's Palace have been lost, the extant works in the *Scuole* of the religious confraternities are sufficient proof of the point: one need only look at Gentile Bellini's *Miracles of the True Cross* and Carpaccio's *Legend of Saint Ursula* (both now in the Accademia Gallery), or at the paintings still hanging in the Scuola Dalmata for which they were originally painted. Narrative force is particularly clear in Carpaccio's works, which are reminiscent of the popular religious processions of his day. The characteristically intense colour is often applied with dense impressionistic strokes, which bring out the changing shades of the whites, reds and blues.

In all of his works there is a clear correspondence between inital drawings and the final painting; and whatever the differences between these two media, it is clear that outline is always subordinate to the "creative" power of colour. For example, in the preparatory sketch for *The Dream of St. Ursula* (now in the Uffizi), we can already see the artist preparing for the lighting effects he will use in the finished work, in which the silent space of the sleeping saint's room is defined by tumbling motes in a cascade of light. The whole setting is embued with feeling, the delicate balance of which is rendered by diluted and dense strokes of paint – all of which contribute to the work's freshness of colour. There is no doubt that Carpaccio was a central figure among those fifteenth-century painters who established the rules for the "creative" use of paint; and this is especially clear in those narrative works in which he renders his subject matter with objective credibility. Take, for example, the *Arrival of the Ambassadors* in the Saint Ursula cycle, in which the use of colour goes beyond anything to be found even in the works of great Venetian painters such as Giovanni Bellini or Giorgione. Nor should one forget Carpaccio's *Miracle of the Reliquary of the True Cross* (part of the *Miracles of the True Cross* cycle), in which the eye lingers upon the luminescent touches that serve to create the unforgettable details of the Moorish gondolier or

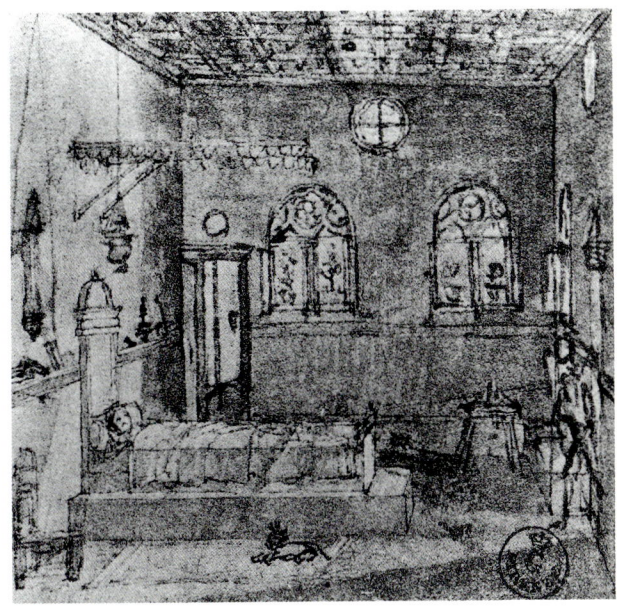

Vittore Carpaccio, The Dream of St. Ursula *(preparatory sketch). Florence, Uffizi.*

Vittore Carpaccio, The Study of St. Augustine *(detail). Venice, Scuola di San Giorgio degli Schiavoni.*

THE CHARACTER OF VENETIAN PAINTING

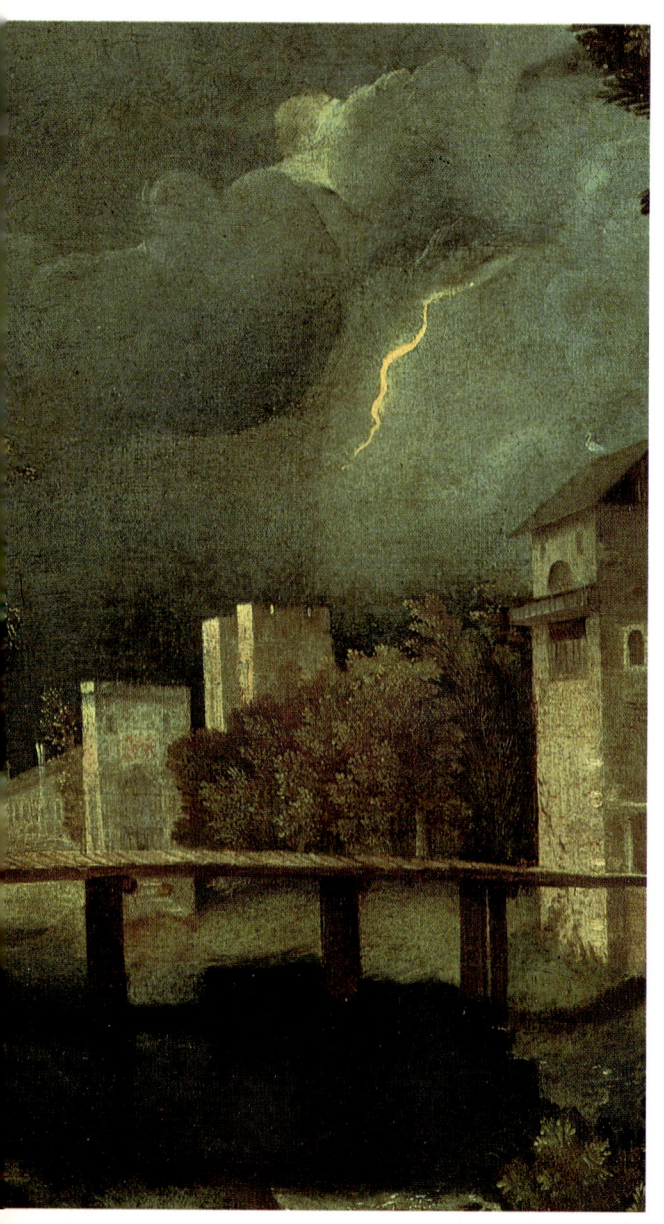

Giorgione, La Tempesta (detail).
Venice, Accademia Gallery.

the white dog on the prow of the boat. The same dog turns up again crouching on the floor in *St. Augustine's Study* in the Scuola Dalmata. The painted figures here are created without resort to preliminary cartoons; the chromatic qualities of white lead and silver greys are used directly, with a fresh and playful agility, to give body to the image, curl by curl, highlight by highlight. A fully-fledged "impressionistic" technique that was centuries ahead of its time, Carpaccio's extraordinary achievement would continue to exercise a powerful influence over generations of Venetian painters from the High Renaissance onwards. At this point one cannot help wondering if Carpaccio's contemporaries were fully aware of the implications of a technique that inaugurated the era of what we know as the "Venetian" style of painting. However, when we look at the work of artists such as Titian and Giorgione (1476-1510) – who belonged to the first generation of sixteenth-century painters – it would

appear that there were those who got the message loud and clear. Carpaccio's influence is clear in the lively little figures in the background of Giorgione's *Adoration of the Shepherds* in Washington, or again in the dashing brushstrokes the same artist uses in his two panels of *Moses* and *Solomon* (now in the Uffizi). Even clearer proof is to be found in the inventive freedom Giorgione shows in the pretend drawings and medallions he included in his *Frieze of the Arts* (Castelfranco). The interrupted and dotted lines used in creating these figures (a saint, two satyrs, a female nude and various heads of philosophers) recall the style of Carpaccio's pen and brush drawings, which were so clearly taken as a model. No one, therefore, would deny that – particularly in his later works – Giorgione showed himself to be fully aware of the creative role of paint itself. X-rays may reveal clear emphatic preliminary drawings – the result of the influence of Bellini (and an unavoidable consequence of the need for chiaroscuro)- but when one looks at the actual surface of the picture one sees paint coming into its own in a modulated melody of colour. One only needs to think of the quivering surfaces of water and the lowering skies of the *Tempesta* (a masterpiece of the painter's later years), or of the thinly applied paint used by the artist in his *Three Philosophers* (Vienna) and the play of shadow used to highlight the bearded face of the figure traditionally identified as Aristotle. Brushstrokes seem to rise from the depths of the painting to annul clear outlines and thence evaporate in the mellow mystery of the paint's surface, which is rendered tremulous by the light which falls across it. It is clear that Giorgione achieves his greatest results thanks to delicate play on shades of colour, a technique which gives his works their diffuse tonality. This was to be the unmistakable hallmark

Titian, Miracle of Severed Foot *(detail).*
Padua, Scuola del Santo.

THE CHARACTER OF VENETIAN PAINTING

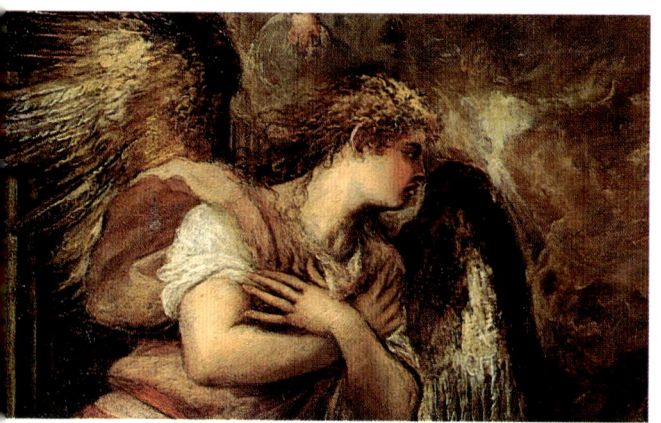

Titian, The *Annunciation (detail).*
Venice, San Salvador.

Titian, Couple embracing.
Cambridge, Fitzwilliam Museum.

of an artist who, in many ways, was already mysteriously close to Leonardo da Vinci (who made a brief visit to Venice in the year 1500). Vasari was a critic of profound insight when it came to understanding the style of individual painters, and he quite rightly saw that the naturalism of Giorgione was a key influence on the young Titian (c. 1490-1576), who would soon establish himself as the greatest Venetian painter of his day. With a natural bent towards realism, Titian had unbounded admiration for Dürer, whom he met during his 1505-1507 Venice visit and immediately took as a model to be followed. To the style of Giorgione, therefore, the young Venetian artist added dashing, dazzling modelling, which seems to underline a deep, instinctive inner feeling in his art. One need only compare the lightning-torn sky of Giorgione's *Tempesta* with Titian's early works of 1510 – from the *Concerto campestre* in the Louvre to the frescoes painted for the Scuola del Santo in Padua – for one to see the development and perfection of an artistic language that speaks to immediate emotional effect (a language that would serve as a model

for centuries of Venetian landscape painting). From this point onwards Titian would increasingly tend to abandon preliminary background drawings in favour of direct use of the paintbrush. And this was true not only when he was painting landscapes (which might seem best suited to such a technique), but even when he was painting portraits. Think, for example, of the magical plasticity of detail in the Louvre's *Young Man with a Glove*, or of the flaming reds and frozen whites used to portray the *Pesaro family* in the Frari altarpiece (both paintings which date from the 1520s). One can only try to imagine what such examples must have meant to the young Velazquez when he visited Venice over one hundred years later. In the works painted after 1550 Titian's "direct" use of paint became even more pronounced; drawn chiaroscuro was abandoned as an imposition which limited the freedom of paint – and thus the way was open for the Baroque. In the church of San Salvador hangs the startling *Annunciation*, which is a perfect example of the artist's magical breadth of handling: the brush seems to have only glanced across the canvas, leaving a mere shadow of gilded brown which throws off a ferment of dazzling flashes of colour. The same thing happens in Titian's drawings: the line is broken by brusque flashes, achieving a result similar to that created in the painted works, in which shining oils are mixed together with dull earth colours. Such charcoal works as the studies for the *Battle of Cadore* (Munich and Oxford) or the *Embracing Couple* (Cambridge, c. 1570) are drawings from the technical point of view alone; the style in which they are executed achieves all the pictorial effects that are most characteristic of the Venetian use of paint. Even the contrast of black and white seems to give rise to colour: the darker pigments are suggested by vehement lines of black,

Jacopo Tintoretto, Female Hermit in Meditation *(detail). Venice, Scuola grande di San Rocco.*

THE CHARACTER OF VENETIAN PAINTING 15

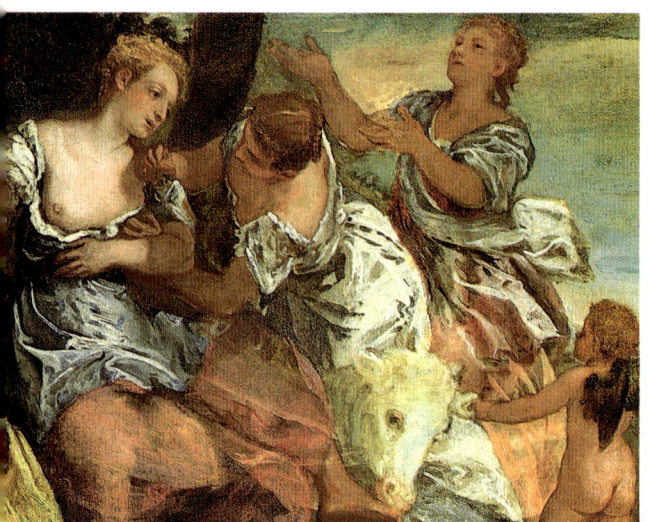

Paolo Veronese, The Rape of Europe *(detail of sketch). New York, Corsini Collection.*

and a highlight of white chalk is used to render vibrant atmospheric contrasts.

Towards the middle of the century the crisis of Mannerism made itself felt in Titian's artistic language and further confirmed his move away from geometrical, balanced compositions. Reality as represented became more tremulous and unstable; lighting became more dramatic, with light being scattered in a vortex of directions. The breadth of handling in the fragmented and abrupt style of the late Titian could be compared to that in the tormented style of the late Rembrandt.

The later generation of sixteenth-century Venetian painters – such as Bassano, Tintoretto and Veronese – took Titian's artistic language as their starting-point. This is particularly clear in the work of Jacopo Bassano (c. 1510-1592), especially when one moves from the pastel drawings – such as those in the Louvre or the *Head* in the Albertina – to the smudged paint of the late (1585) *Susanna,* now in Nîmes. It is his Venetian eye for paint and colour which saves Jacopo Tintoretto (1519-1594) from Mannerist excess, which suggests the phosphorescent touches in the distant background of the *Baptism of Christ,* or the enflamed night sky over the supernatural landscape of *Two Female Hermits* (Scuola Grande di San Rocco). Even in the most intimistic of Tintoretto's backgrounds one can always note the same Venetian feeling for colour and paint, and that is why his artistic language was so readily adopted by the Baroque artist Francesco

Maffei.

And finally, there is the independent – almost imperturbable – Paolo Veronese (1528-1588), who adapted his artistic language to the law of colour and thus overcame a tendency to Mannerist abstraction. This is clearest in the details of his most ambitious paintings, those scenes of magnificent Feasts which are crowded with figures. When these figures are in the foreground – as is the case with an Apostle in the Louvre *Marriage Feast of Cana*, or the dazzling figure in the Corsini sketch of the *Rape of Europa* (New York, c. 1570), one is inevitably caught up in the light-hearted festivity of colour, in the light reflecting off the scenography of a "set" in which each architectural feature seems to have achieved totally untainted purity. Of course, the case of Veronese is more complex, given his early years in Verona and Mantua (where he absorbed the influence of Michelangelo as filtered through the work and figure of Giulio Romano), the time he spent in Parma (where he was influenced by the elegance of Correggio and Parmigianino) and the interest in the modelling of volumes that he acquired from the architect Sanmicheli. In fact, his representation of the human figure and of architectural space would seem to place him outside the mainstream of Venetian painting. However, as time went by, the local tradition – and the influence of Titian in particular – made themselves felt; and the palette of the later Veronese is characterised by a sort of highly-charged expressionism. The resultant

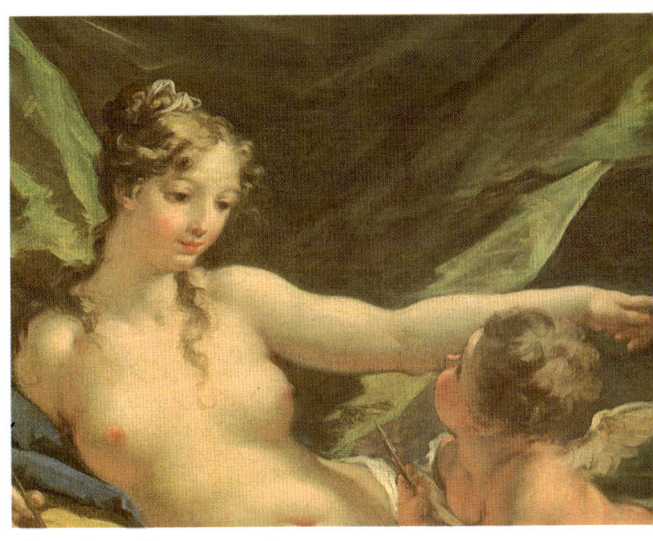

Giovanni Antonio Pellegrini,
Venus *(detail).*
New York, Corsini Collection.

Giambattista Tiepolo, Rebecca at the Well (detail). New York, Corsini Collection.

Giambattista Tiepolo, Abraham and the Angels (detail). Udine, Patriarcato.

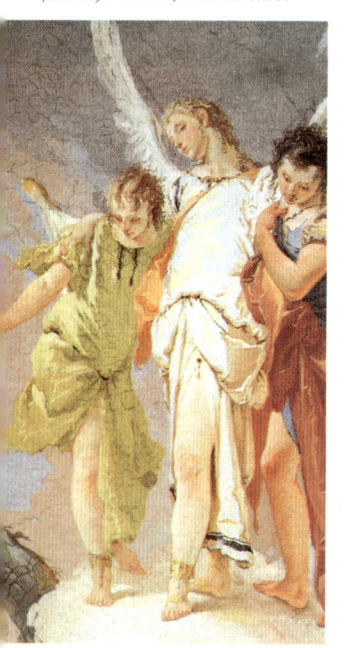

style is unmistakable: against cold, silvered tones, the artist applies dense strokes of paint which sparkle like precious stones (to use an expression dear to critics who were close to the artist). In the works painted for the church of San Sebastiano – which, in fact, form a veritable monument to his genius – or in the numerous crowded Feasts (which became something of a speciality), the artist displays a Venetian eye for paint and colour as he joyously distributes floods of light around the canvas. And it was the colours of these secular feasts which made Veronese such an attractive painter to the rococo artists of the eighteenth century, whose main interest was the rendering of elegance and *joie de vivre*. The consequent Veronese "revival" made its mark on artists such as Sebastiano Ricci, Pellegrini, Tiepolo, and Antonio Guardi – that is, on the masters of great European decorative painting, whose work is nevertheless in line with the great colourist tradition of Venice (consider, for example, the visual sensuality in Pellegrini's *Venus*, c. 1720). Foremost amongst these artists was Giambattista Tiepolo (1696-1770), who strikes one as a direct descendant of the Cinquecento, that great age of Venetian colourists. Anyone who studies his sketches – which are of incomparable inventiveness and chromatic freshness – cannot doubt his place in the Venetian tradition. Tiepolo's brush condenses and thins out the paint as it is applied to the canvas, in a sort of "improvisation" which suggests that every moment has to be invented and reinvented.

Rebecca at the Well (c. 1720) is dressed in shimmering clothes that stand out against the heavy clouds flitting across the background. The beauty of the *Three Angels* in the Archiepiscopal Palace in Udine is rendered even more fascinating by the sensual quiver of the brushstrokes around the hems of garments lifted by a mischievous breeze. Nor should one forget the fine collections of drawings in Venice (Museo Correr), Trieste, London (Victoria and Albert) and New York (Metropolitan); their shimmering brilliance is such that one might almost believe they were drawn on sheets of precious metal.

The only artist who can be compared with Tiepolo is Antonio Guardi (1699-1760), that last master of decorative painting whom modern criticism has restored to his rightful place as the most refined of the late rococo artists in Venice. Only Tiepolo and Guardi can be considered as offering anything like a serious challenge to the supremacy of the French "rocaille" of Watteau, Boucher and Fragonard. Standing before Guardi's masterpiece – the organ frontal in the Venetian church of Angelo Raffaele (c. 1750) – the eye wanders enthralled as it makes out all the dazzling and refined games of a style which renders all that was most joyful and light-hearted in the elegant eighteenth century. Once again, colour and paint play a central role – so much so that Guardi has been seen as a precursor of that breadth of handling to be found in Impressionism.

Gian Antonio Guardi, Marriage of Tobias (detail). Venice, Angelo Raffaele.

THE CHARACTER OF VENETIAN PAINTING

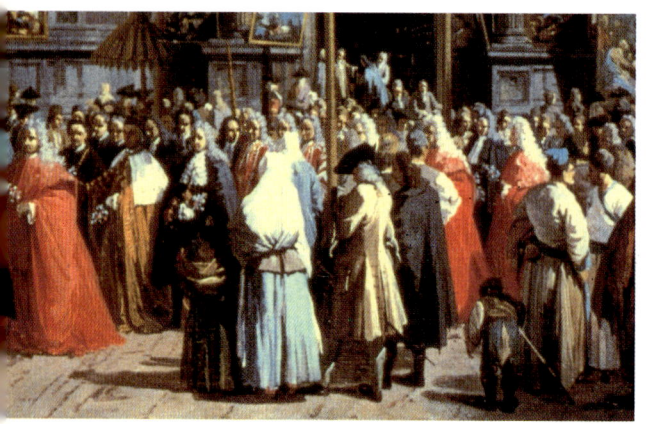

Canaletto, Feastday of San Rocco *(detail).* London, National Gallery.

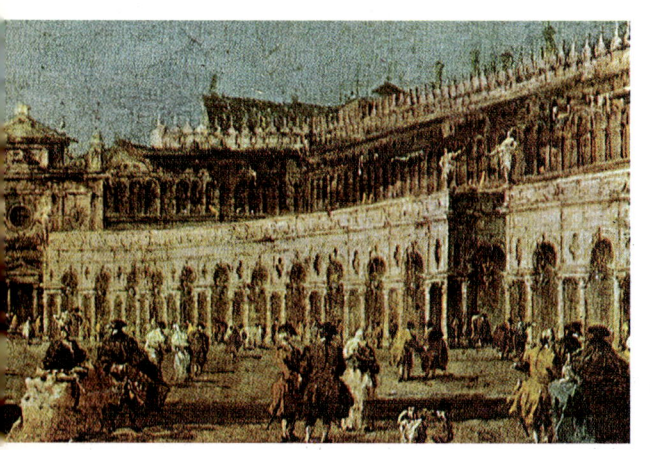

Francesco Guardi, Ascension Day Stalls in St. Mark's *(detail).* Vienna, Kunsthistorisches Museum.

The European fame of Rosalba Carriera rests on the same attention to colour. Her portraits in coloured crayon are of such lightness and delicacy of shading that one almost feels that the least breath of air could destroy their evocative frivolity. The Venetian tradition of colour was maintained with honour and success even by some of the "painters of reality" who appeared in the mid- and late eighteenth century. Pietro Longhi (1701-1785), for example, created tiny interiors which have the glow of miniatures and made skilled use of sharp counterpoint between charcoal and crayon highlights in his delicate life drawings. Similarly, in his daring but convincing perspective views of the city, Canaletto (1697-1768) seems to be able to make the colours of the popular festival of *San Rocco* (London, National Gallery) vibrate with life; the lively dashes and dabs of paint seem to recreate the massive crowd swaying right in front of us. And finally, the last poet of Venetian paint and colour: Francesco Guardi (1712-1793). Adapting the free use of paint he learnt from his brother and teacher, Antonio, Francesco produced the vibrant *City Views* in which, one after another, we can see the lights being dimmed before the world stage on which Venice had played a leading role.

THE MUSEUMS

For those with a genuine interest in the subject, but no specialist training as art historians, the best approach to Venetian painting is a visit to the city's main museums, followed up by visits to the works which are still to be found in situ, *in Venice's various churches, palazzi and Scuole.*

So, the best starting point for this first chapter is, naturally enough, Venice's main museum, the Accademia. The collection here ranges over five centuries of Venetian painting: with fourteenth-century works varying between Byzantine-style paintings and the Gothic works of Paolo Veneziano, fifteenth-century painting represented by the Early Renaissance works of the Bellini family and Carpaccio, and the sixteenth-century works present ranging from the powerful paintings of Giorgione and Titian to the later Mannerism of Bassano, Tintoretto and Veronese. The theatrical seventeenth century is represented by the works of foreign artists visiting the city and by the Baroque works of Maffei; whilst the eighteenth-century collection ranges from the great rococo decorators such as Ricci, Pellegrini, Tiepolo and Antonio Guardi, to the more realist works of Longhi, Canaletto and Francesco Guardi.

After the Accademia, a visit to the other museums is in order. The Museo Correr (with its fine collection of early Bellini, Tura and Carpaccio), the Pinacoteca Querini and Ca' Rezzonico (with delightful examples of eighteenth-century artists such as Tiepolo, Longhi and Guardi), have all maintained the atmosphere of the private collections from which they were formed. Sometimes one painting alone is enough to make a visit to the museum an unforgettable occasion (this is the case, for example, with Mantegna's St. Sebastian *in the Ca' d'Oro collection). Equally memorable collections are also to be seen at the Greek Orthodox Museum (with its fine gold-based Byzantine icons, which anticipate the work of El Greco), at the Ca'*

Pesaro gallery (with its collection of modern masters from Guglielmo Ciardi to the present day), and finally, the Guggenheim Museum (whose collection of contemporary artists contains the work of many Venetians).

So the Museum section in this short Guide to Painting has a strictly didactic role; without pretending to be exhaustive, its aim is to bring out the poetry of the paintings to be seen. The intention is to give the reader some sort of systematic basis for understanding the particular quality of the Venetian artist's eye for paint and colour. Thereafter, in the last part of the guide, we will move on to the individual works which are still to be seen in the places for which they were originally painted.

THE ACCADEMIA GALLERY

Paolo Veneziano (active 1310-1362)
The Coronation of the Virgin

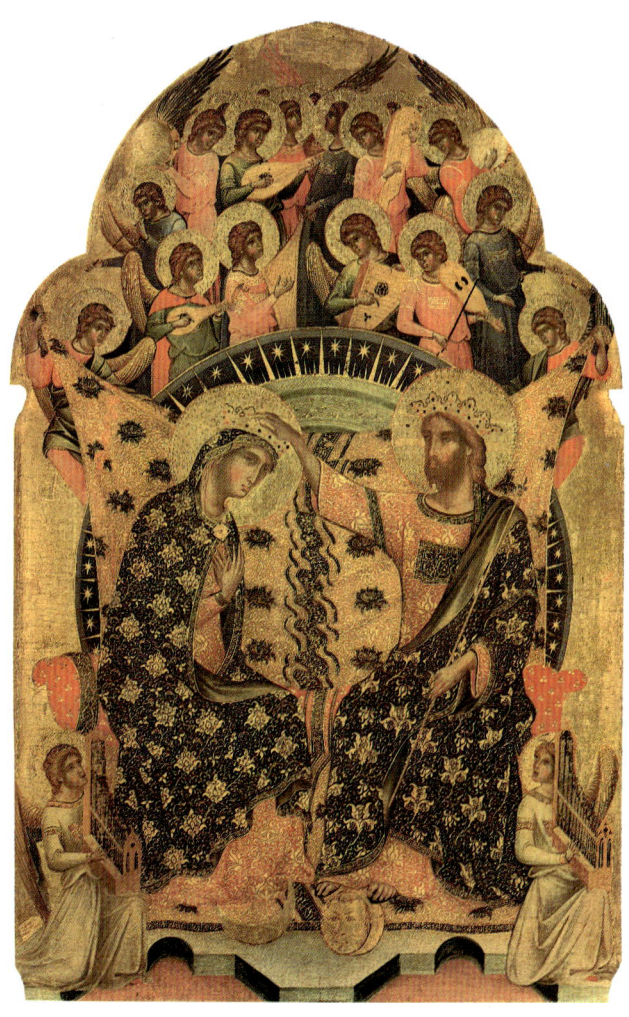

Paolo Veneziano is the first great master of Venetian painting for whom we have a name. This polyptych from the church of St. Chiara is his masterpiece. The first thing that strikes one about the work is its complexity, which means that it must date from the very last years of the artist's career, when he was already being assisted by his sons Luca and Giovanni (c. 1358). In fact, within the imposing original frame, the large central panel showing the *Coronation of the Virgin* is flanked by some twenty smaller panels (the work, it is safe to assume, of more than one hand). The eight lower panels illustrate scenes from *The Life of Christ*, whilst the upper six upper panels show scenes from the *Life of St. Francis and St. Claire*, with the *Four Evangelists* on either side. The fascination of this work is partly due to the fact that it so clearly reveals the two tendencies in Paolo's art: byzantine in the side panels, and so clearly Gothic in the large central panel. The fine decoration of the flowing robes of Christ and the Virgin is admirable and reminds one of the rich gold brocades which adorned Venetian garments of the "International Gothic" period. But the eye is even more fascinated by the delicate colours used in portraying the angelic musicians; painted against a gilded sky, these figures seem to form a marvellous basket of flowers glazed with morning dew. A clear example of that mature eye for paint and colour which will soon be the hallmark of Venetian art.

THE ACCADEMIA GALLERY

Giovanni Bellini (c. 1430-1516)
The Camerlenghi Madonna

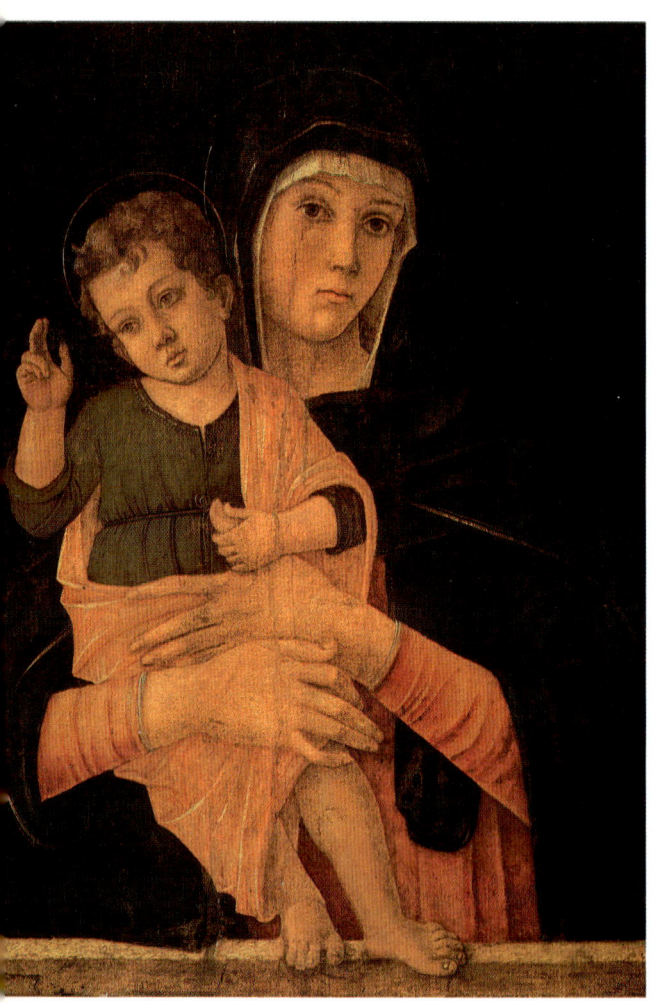

Of all the Bellini Madonnas hanging here, it is only the *Camerlenghi Madonna* (named after the Rialto palazzo housing the financial courts, where it originally hung) which reflects the "primitive" style of the two earlier Madonnas alongside it, which were painted by Jacopo Bellini, the founder of the greatest family dynasty of painters in Early Renaissance Venice.

The artist uses an incisive line to create large islands of colour, in which the chiaroscuro is still reminiscent of Mantegna, who was Giovanni Bellini's maestro in Padua.

This dates the masterpiece in the artist's early 50s; but within the form of the painting – so clearly determined by the proto-Renaissance influences which were making themselves felt in the area (particularly in Padua, where Mantegna, Filippo Lippi and Donatello were active) – one catches a glimpse of the artist's intimate, almost moody, humanity. At the same time, the staring eyes of the Virgin are a clear echo of the continuing fascination exercised by Byzantine icons.

THE ACCADEMIA GALLERY

Gentile Bellini (1429-1507)
Procession of the Reliquary of the True Cross in Piazza San Marco

This large canvas – a superb example of the narrative style favoured by "history" painters in late-fifteenth-century Venice – is one of the most impressive pictures in the Gallery. The Venice of 1496 is recreated before our very eyes in this representation of one of the religious processions that were so typical of the time. This episode in the chronicle of the *Reliquary of the True Cross* is one of a cycle of paintings hanging in the same room (two others by Gentile Bellini, two by Mansueti, one each by Bastiani and Diana and finally, the best of all, one by Carpaccio). The legend of the miracles performed by the True Cross, which had been discovered in Palestine by St. Helen, was well-known in Venice (partly due to the recent publication of Jacopo da Varagine's *Golden Legend*). At the time, Gentile Bellini was Master Artist and *Impresario* of the Scuola di San Giovanni Evangelista, and this painting gave him an ideal opportunity to attempt a narrative work using the theatrical techniques that were adopted in the "sacred spectacles" that were so much a part of popular religious life. The painter enriches his narrative by adding the episode of the miraculous healing of the son of Jacopo de Solis (portrayed in red, kneeling near the centre of the procession); to the left, the three figures in the red of the Confraternity of San Giovanni Evangelista are portraits of Jacopo Bellini and his sons Gentile and Giovanni.

The painting is particularly interesting because of what it shows of St. Mark's Square. To the left one can see the Procuratie Vecchie (built for Doge Ziani in 1178), to the right the Orseolo Hospice for pilgrims (alongside the twelfth-century campanile), and on the facade of St. Mark' itself one can identify five of the great thirteenth-century mosaics in the portal vaults.

On the upper level one can see the four mosaic lunettes representing scenes from the life of Christ. The proto-Renaissance features of these lunettes have led to their being attributed to the influence of early-fifteenth-century Tuscan art, brought to Venice by Paolo Uccello and Andrea del Castagno (but there is no decisive proof for such an attribution).

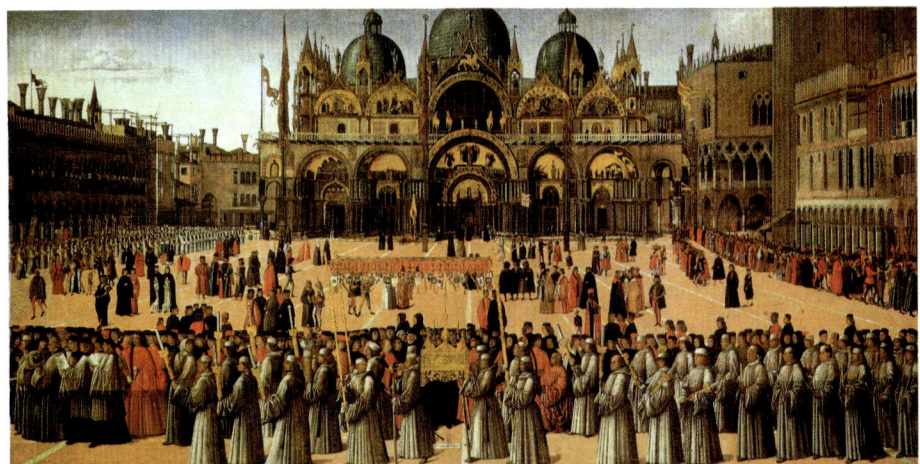

A

THE ACCADEMIA GALLERY

Vittore Carpaccio (c. 1465-1526 ?)
The Dream of St. Ursula

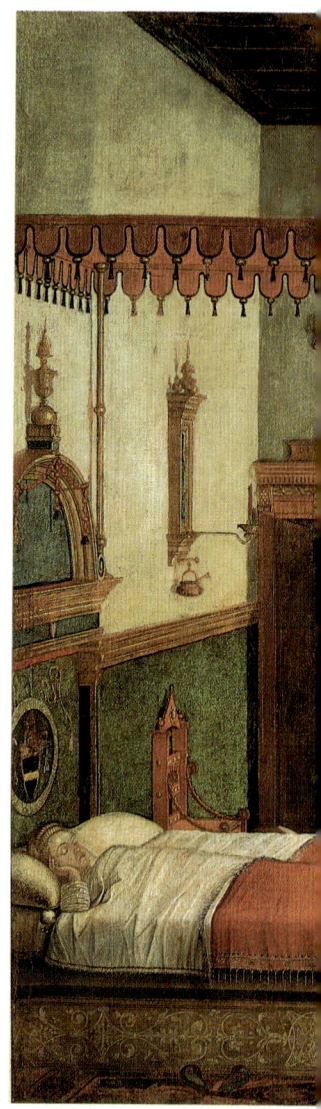

Printed in Venice in 1475, Jacopo da Varagine's *Golden Legend* was to provide many iconographical suggestions for the painters of the period, and there seems to be no doubt that the Bellinis – who at the time were working in the Doge's Palace and various Venetian Scuole – had a copy of the book to hand. Vittore Carpaccio was another artist who was to make free use of Varagine's hagiographies when, between 1490 and 1500, he painted his nine-canvas early masterpiece for the Scuoletta di Sant'Orsola (which recent discoveries have revealed to have been located in the monks' cemetery on the south side of the apse of the church of San Giovanni e Paolo). The story Carpaccio chose for the cycle of paintings commissioned by the Loredan family was the moving and poetic legend of a Catholic princess from Brittany, whose hand is asked for in marriage by the English prince Etherius. Ursula tells the prince's ambassadors that if he wants to marry her, the prince will first have to convert to Catholicism and accompany her to Rome to meet the Pope, who will marry them. During the pilgrimage an angel appears to Ursula in a dream and tells her of her imminent martyrdom, which in fact occurs during the return journey (at Cologne, which is under siege by the Huns). All the pilgrims are killed and Ursula ascends to heaven to take her place amongst the saints.

This story had already been the subject of famous frescoes by Tomaso da Modena in Treviso and by Memling in Bruges, and when looking at Carpaccio's cycle I have often wondered which of the paintings should be taken as representing the best of his art. I have chosen *The Dream of St. Ursula* because the narrative style seems so close to the religious feeling of the period. At the same time, the perfect perspective of the composition contributes to creating an atmosphere that is typical of Carpaccio's style – that "magical" suspence between the artist's spiritual identification with his subject and his inexorably realist eye for the rendering of detail (which serves to make this supernatural event totally credible).

The light in the painting is unforgettable, with the luminescent colour veiled

THE ACCADEMIA GALLERY

by motes of gold which seem to settle so calmly on all objects in the painting: on the bedside table and its prayerbooks, on the soft bed, and on the windowsill decorated with myrtle and carnations (symbols of faith and chastity). All this is depicted in the silent and serene light of dawn. One can almost hear the light breathing of the saint as the seemingly weightless blue angel advances towards her on a ray of light, admitted to the room by a door which seems to have opened by magic.

A

THE ACCADEMIA GALLERY

Giorgione (1476-1510)
La Tempesta

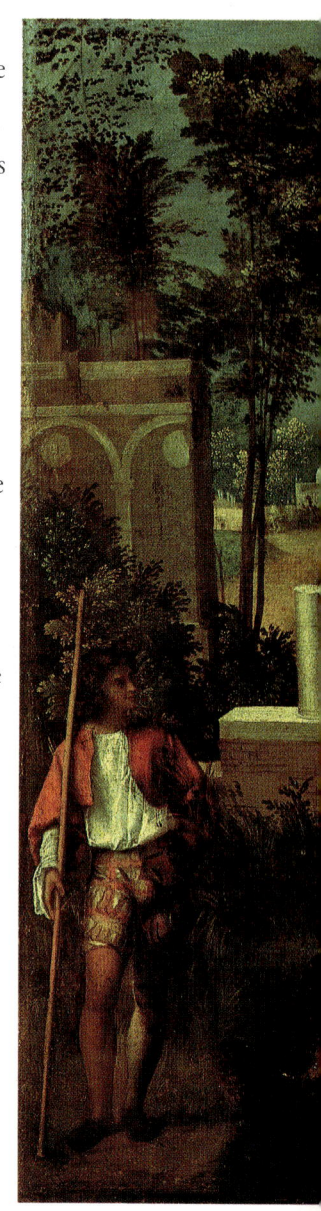

Described by Giorgione's friend Marcantonio Michiel as representing "a gypsy and a soldier", this small painting was hanging in the house of Gabriele Vendramin, a rich Venetian merchant, in 1530. It is undoubtedly the best example of the type of easel painting which was introduced into sixteenth-century Venice by Giorgione da Castelfranco. One of the most innovative – and mysterious – of High Renaissance artists, Giorgione has been surrounded by legend since his premature death in the plague of 1510. The legendary image that has come down to us has had a deep effect on both the interpretation of the scant biographical material available and on the chronological attribution of the works produced in his short ten-year career. However, despite the brevity of his active life, Giorgione was such a genius that he was able to impose a new style – one which his contemporary Giorgio Vasari described as "without drawing" – and thus lay the basis for the Venetian manner of painting, in which colour and paint were paramount. The very theme of *La Tempesta* (as the work has been commonly known since the nineteenth century) seems designed to force the curiosity of the observer towards an area of mystery (which the incessant efforts of critics have made no easier to penetrate). What exactly was Giorgione intending to represent when he painted this evocative image of a nude breast-feeding an infant whilst seated on the bank of a stream, on the other side of which another nude starts to enter the water (only to be painted over with this figure of a "soldier", who seems more like a pastoral shepherd dressed in the finery of one of those *Compagnie* for young gentlemen which were so common in Early Renaissance Venice)? Was it perhaps the finding of Parides, or the baby Moses saved by Pharaoh's daughter? Certainly the claim that this is a portrait of the "painter's family" can be discounted, because biographers make no mention of the artist having either a wife or a child. It seems most likely that the true reading of *La Tempesta* can only be an esoteric one. I myself continue to believe that the key to the work is Francesco Colonna's poem *The Dream of Polyphilus*, published by Aldo Manuzio in 1499, which

THE ACCADEMIA GALLERY

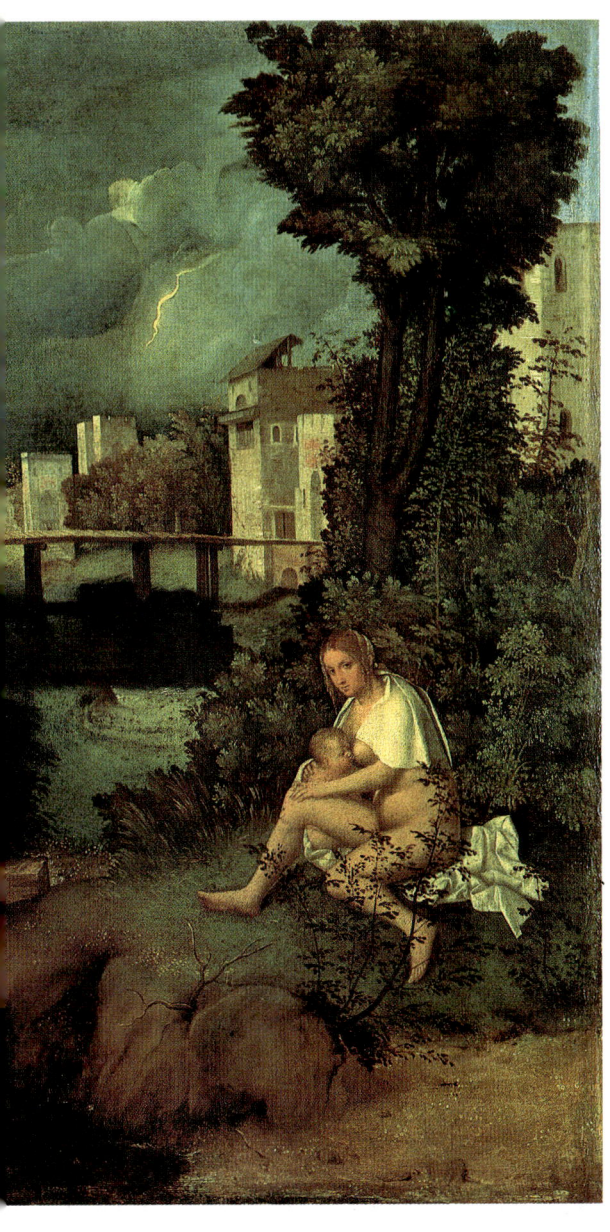

contains a description of Venus feeding Love whilst the poet-shepherd Polyphilus looks on and the sky becomes heavy with storm clouds through which burst forks of lighning. The poem also mentions the two broken columns of a building in ruins, the turreted city walls and the domed temple which can be seen in the distance. Whatever the correct reading – and there have been those who have argued there is no "reading" at all, that this is the first modern landscape painting – *La Tempesta* remains one of the most famous images in the entire history of painting. The air of mystery in the picture is used to emphasize the fascination of the colours – from the soft greens of the grass (touched with warm gold by the leaves of the birches and ilexes bending in the wind), to the pale glow of the nude against the white of the cloak (itself contrasted with the green of the laurel-tree) and the silvery light of the towers and city walls which seem to glow beneath the thunder and lightning. A dramatic and visionary scene, in poetic contrast with the apparent indifference of the figures occupying it.

THE ACCADEMIA GALLERY

Titian (1490-1576)
The Presentation of the Virgin in the Temple

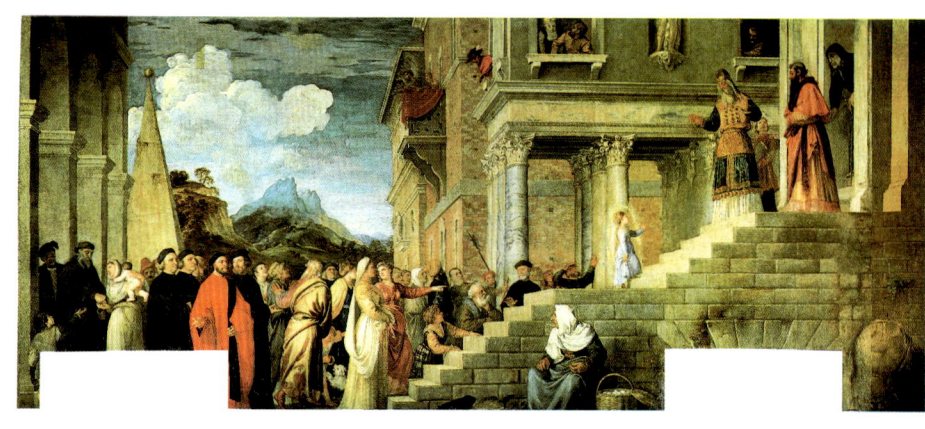

Painted for the *Albergo* (Hospice) of the Scuola della Carità, this fascinating and moving picture still hangs in its original site. It is likely that Titian painted the work in 1539, making ample use of details in the work of contemporary architects who were so deeply influenced by Roman Antiquity.

The work's rigorous perspective gives it a substantial theatricality, whilst the stunning richness of colour in the scene crowded with sumptuous and imposing figures – together with the narrative realism of the rendering – seem to make us part of the event depicted. The theme of the Virgin's affirmation of religious faith was a reference to the very function of the Scuola della Carità, which once a year – in this very room – gathered together a number of poor (but virtuous) girls to secure them the dowry that would enable them to marry. One should also point out that the period in which the widowed Titian produced this joyous feast of colour was the same as that in which he was seeing his daughter Lavinia grow into a young woman. There is something unforgettable about the slight figure of the fair-haired Mary in her deep-blue gown, suffused as she is by a supernatural light. At the bottom of the steps leading up to the temple Titian gives vent to his recognised skill as a portraitist and produces a polyphonic chorus of witnesses, composed of beautiful women and of imposing councillors dressed in the ceremonial robes of the Scuola.

THE ACCADEMIA GALLERY

Titian (1490-1576)
Pietà

In 1576 a terrible plague broke out in Venice and rapidly decimated the population. Those who could fled to the mainland, those who couldn't trusted – without much hope – to the safety of quarantine areas or of medical potions. Titian was one of those who stayed – perhaps because his courageous and intolerant character inevitably pushed him to defy the disease, or because his advanced age prevented him from leaving his comfortble house in San Canciano (where he lived with his son Orazio, his grandson Francesco and the other few assistants who worked in his studio). As was natural enough, thoughts of death began to obsess the artist and he started work on the plans for a large tomb for himself in the church of Santa Maria Gloriosa dei Frari – which already contained some of his masterpieces and where he would be received with the same honours as those bestowed on the doges and condottieri who were already buried there.
As was often the case with Titian, the artist's eye for the grand scale led him to exceed the scale of real life – and this can be seen in the painting he intended to hang above the altar which

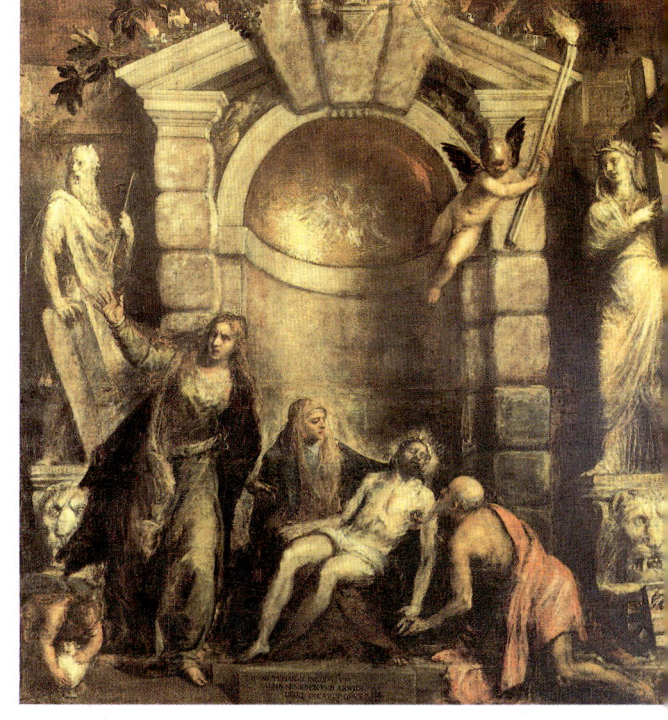

THE MUSEUMS 31

he planned should be built above his tomb. The inspiration is clearly Michelangelesque. In front of a niche of massive blocks of stone, the Virgin holds the body of the dead Christ. Nicodemus kneels in prayer, whilst on the left a wild and tragic Mary Magdalene runs straight towards us; her cry of horror and desperation filling the silence of the carved stones and echoing off the immobile statues of Moses and the Hellespontic Sybil. Sinister gleams are caught in the paint – metallic greys, dull reflections off the golden mosaic in the central niche, thick greasy smoke from the torch held by the funerary angel (which was probably completed by Titian's pupil Palma il Giovane, who signs the long Latin inscription on the lower step). Unfortunately this imposing creation was destined to remain unfinished. His family scattered, his favourite son Orazio killed by the plague, Titian was soon to die at the age of eighty-six (not the one hundred and three claimed by the parish register – on the basis of a legend that Titian himself had never discouraged). He just had time to sketch in the votive tablet on the bottom right (showing himself and Orazio supplicating the intercession of the Virgin) and, perhaps, add the shading and iron-grey out of which are modelled the two lion heads on either side of the painting. The fragmentary representation of their gapping jaws, fierce snarl and flashing eyes, adds to the sense of imminent tragedy. Over the head on the right there is the slightest sketch of the shadow of a raised hand – a desperate gesture of defence against the incumbent nothingness of the after-life. This was how Venice's greatest artist bid his farewell to life on 27 August 1576.

THE ACCADEMIA GALLERY

Lorenzo Lotto (c. 1480-1556)
Portrait of a Melancholic Young Man

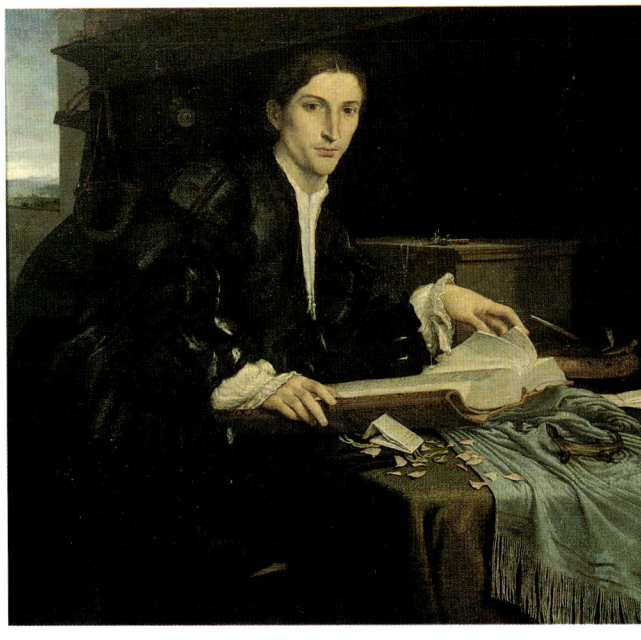

Around ten years older, Lorenzo Lotto was at times seen as being the "alternative" to Titian; though he never sought out direct comparison, as did the more aggressive Pordenone. His age meant that Lotto was beginning his career just after the encounter in Venice of Bellini, Antonello da Messina and Albrecht Dürer. Open as he was to the most varied experiences, Lotto used this convergence of influences to good effect. Later, as a result of a long period in Rome alongside Raphael and Michelangelo, Lotto would be drawn towards Mannerism, which better suited his elegant draughtsmanship and unusual palette. Lotto's period in the Marches and in the Bergamo area then brought him into contact with patrons whose high expectations were the result of their familiarity with the work of the Lombard and Rome schools. Though Lotto never enjoyed *un succès fou* – his modesty itself was against him – he was well-appreciated, particularly in the provinces (where his work compared so well to the less-advanced work of artists such as Crivelli and Vivarini).
The Accademia portrait, now universally known as "A Melancholy Young Man", dates from between the end of the 1520s and the beginning of the 1530s; the marine background suggests it could have been painted during one of his periods in the Marches. The melancholy atmosphere is heightened by the details, all of which would seem to indicate a solitary existence: the hunting and musical equipment, the massive accounts book, the letter and crumpled petals, which perhaps indicate some past love.
An acute psychologist of a very sensitve nature, Lotto has been called the most "modern" of sixteenth-century Venetian painters. Emphasis has been placed on the way his pictures would seem to illustrate a humble and retiring persona, jealous of his privacy. As he retreated further and further into himself, Lotto's work became more and more intensely religious.
He died between 1556 and 1557 in the Monastery of the Santa Casa di Loreto, where he had lived for years, painting his last tormented pictures.

THE MUSEUMS 33

THE ACCADEMIA GALLERY

Jacopo Tintoretto (1519-1594)
Miracle of St. Mark freeing the Slave

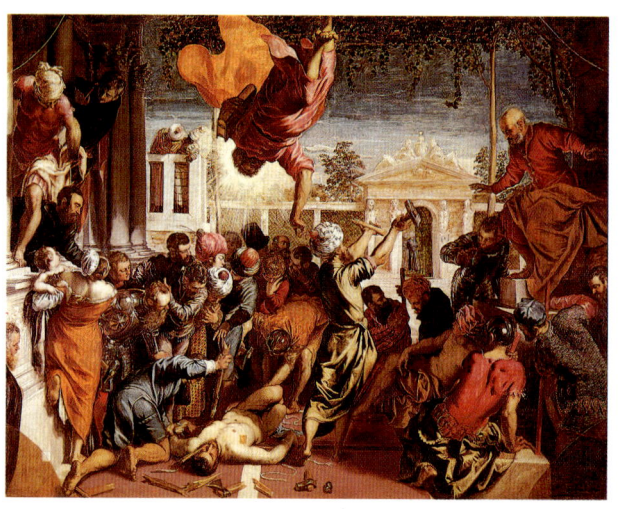

In April 1548 Pietro Aretino, one of the most famous and feared writers of his day, wrote a letter to Jacopo Tintoretto which was destined to become famous. After extensive praise, the noted critic concluded with the observation that "blessed would be your name if you reduced the speed with which you have done into patience in doing". A comment which appears even more justified today than it could possibly have done to anyone at the time. In fact the letter should be read in the context of the lively debate over the relative merits of the more rational figurative tradition of Rome and Florence and the figurative tradition of Venice, which to some seemed to be built upon improvisation and recklessness. In a word, the choice was between the "fine draughtsmanship" of Michelangelo and Raphael and the "colour" of Titian. It was in that selfsame year of 1548 that Tintoretto completed a painting which would seem to deserve all of Aretino's criticisms – the *Miracle of St. Mark freeing the Slave*, which was destined for the large central hall of the Scuola di San Marco. The story concerns the slave of a local landowner in Provence, who left his owner's land to go on a pilgrimage to venerate the relics in St. Mark's. Recaptured, he was condemned to be tortured; but the saint himself intervened to save him from death. The crowd flees in terror, the slave's shackles break open and the torturers' hammers and nails fall apart in their hands. Giorgio Vasari, another contemporary witness, perhaps gives us a better idea of the public reaction to the painting at the time when he describes Tintoretto "as the most terrible mind that ever dedicated itself to painting". But whilst there may be some truth in the rumour he reports, that the very officials of the Scuola who had commissioned the painting were left dumbfounded by such vehement images, the work no longer has the same effect on us today. This is the real Tintoretto, at the height of his youthful vigour and daring inventiveness. And, as if to confirm his creative genius, the painter includes a number of portraits in the picture: on the left is the noble, bearded profile of Marco Episcopi, Grand Guardian of the Scuola and the artist's future father-in-law, whilst the black-robed figure shown against the columns of the palace is a self-portrait (almost a suggestion that the artist had been an actual eye-witness of the scene as painted). Completed before he was thirty years of age, this work is an open declaration of the main characteristics of Tintoretto's art: realistic, devout and imbued with popular feeling.

THE ACCADEMIA GALLERY

Paolo Veronese (1528-1588)
The Mystic Marriage of St. Catherine

The original site of this work was the church of Santa Caterina in Cannaregio – a very humble setting for one of Veronese's most sumptuous works, a polyphony of gold and silver silks and brocades beneath an arch of heavenly voices accompanied by two lutes. As if in deliberate contrast to the setting, Veronese used the whole range of his palette to create an unforgettable feast of colour, which the imaginative critic and poet Marco Boschini would describe in one of his most beautiful pieces (1660): "One could say that the Painter/ to achieve these effects/ Had mixed gold, pearls and rubies/ and emeralds and sapphires beyond fineness/ and pure and perfect diamonds". These lines seem to capture the poetics behind the greatest of Veronese's works: those painted in the 1570s when, after completing the paintings in the church of San Sebastiano, the artist would work exclusively on the decoration of the Doge's Palace, which had been damaged by fire in 1574 and 1577. Just like the Venetian *Virtues* painted in the Sala del Collegio, the work seems to draw on the magnificence of aristocratic life in the city: the saint's gown seems exactly like that of a Venetian noblewoman, who is tentatively approaching a ceremony of which she does not fully understand the significance. As always, there is a sort of aristocratic detachment in the way Veronese follows through the ideas inspired by light and colour. "I paint figures", he was to say to the judges of the Inquisition who, in this very period, called him before them to justify the religious coldness and decorative excess in his work. Here, once again, we can see this master of the sumptuous palette betting everything on the, inevitable, triumph of colour.

THE MUSEUMS

THE ACCADEMIA GALLERY

Jacopo Bassano (c. 1510-1592)
St. Jerome the Hermit

The glorious triumvirate of Venetian painting of the second half of the sixteenth century consists of Tintoretto, Veronese and Bassano, with the latter the champion of a naturalistic poetics which draws humble inspiration from the world of concrete objects. True to his peasant origins, Bassano had little in common with the pomp of this Golden Age and seems to have chosen his models from among humble farming folk. Painted around 1565, his *St. Jerome* seems, in fact, to be a robust woodsman caught taking a rest after a hard day's work. Around him there are a few objects – a crucifix, a skull, an hourglass and some books – chosen to indicate a saintly hermitage. None of these objects, however, seems out of place; it is their very simplicity which makes them credible. Bassano was most at ease when depicting scenes of popular life – all of which are described with ingenuous faith; yet these selfsame works are in a style which reveals the artist to be capable of the most complex and refined chromatic effects.

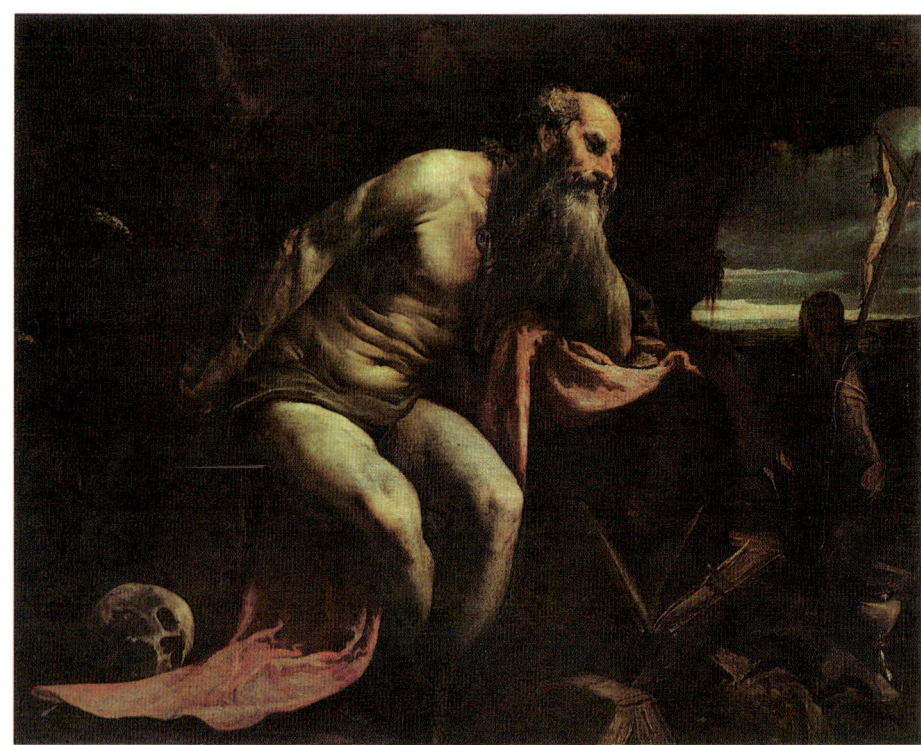

THE ACCADEMIA GALLERY

Francesco Maffei (c. 1605-1660)
Mythological Scene

Given the variety of the interconnected currents in seventeenth-century Venetian art it is difficult to identify one artist as the master who was followed by all other painters. The painting of the early part of the century was characterized by a sort of Caravaggesque realism (imported into the city by non-Venetian artists such as Saraceni); thereafter other non-Venetian artists made a name for themselves within the city: Domenico Fetti (from Rome), Bernardo Strozzi (from Genoa) and the German Johann Liss (who had been a pupil of Rubens). All of them helped to reawaken the Venetian eye for colour, which seems to have become dulled in a transitional period characterized by the academic works of Palma il Giovane and Padovanino. Only towards the middle of the century does one find a return to what had been best in the painting of the sixteenth-century Golden Age – a return that is particularly clear in Maffei's Manneristic works. Eclectic but independent, a Mannerist but no slave to abstract formalism, he was a prolific artist whose imaginative, painterly style reveals an eye for what was the best in the compositions of the sixteenth-century masters. The scene perhaps represents Mars and Pallas Athena and dates from the painter's maturity (towards the middle of the century). There are definite echoes of Tintoretto's dynamic use of light, but one can also see the influence of the new interest in colour revived by the "foreign" artists in the city: the sparkling strokes that are reminiscent of Strozzi's style are used together with an *impasto* which recalls Titian's late works. A virtuoso of the palette, Maffei's dazzling inventiveness and vivacious use of colour make him the forerunner of the most Baroque of seventeenth-century Venetian art.

THE MUSEUMS

THE ACCADEMIA GALLERY

Gian Battista Piazzetta (1683-1754)
The Fortune-Teller

A genuinely European artistic language, Rococo emerged between the end of the seventeenth and beginning of the eighteenth century. In Paris, artists of the calibre of Watteau, Boucher and Chardin were at work, whilst Venetian artists such as Ricci, Pellegrini, and Rosalba Carriera preferred to travel abroad, taking their works to England, France and Germany. Rococo art culminated in the early decades of the eighteenth century, and is well represented in Venice – in such collections as Ca' Rezzonico and the Pinacoteca Querini. But meanwhile, the Accademia offers us a chance to look at the work of the realist painters from the same period. Active up to the middle of the century, Gian Battista Piazzetta was an extraordinary painter and draughtsman, a veritable master for the entire generation. Whilst "tenebrous" painters such as Zanchi and Mazzoni favoured a gloomy and dramatic palette with sharp contrasts of light, Piazzetta followed the example of artists such as Celesti, Sebastiano Ricci and Pellegrini in opting for *chiarismo*. A painter of great technical virtuosity and versatility, he tended to work on historical-religious subjects; the dignified pictorial language he created in these works was to provide the basic vocabulary for subsequent generations of painters in the Venetian Accademia. Particularly worthy of note are Piazzetta's moralistic works, which seem to be peopled with characters from the society of his day. Painted in 1740, the *Idyll on the Seashore* (Cologne), the *Pastoral Scene* (Chicago) and the Venice *Fortune-Teller* are all striking for both the aggressive realism of their theme, and for their noonday lighting, which renders the stunning wealth of the palette even more immediate and expressive. One of Piazzetta's achievements was the foundation of a veritable school of painting which would produce a number of artists of worth (including Giambattista Tiepolo, who studied under Piazzetta when he was a young man).

THE MUSEUMS

THE ACCADEMIA GALLERY

Pietro Longhi (1701-1785)
The Dancing Lesson

Pietro Longhi occupies a very special place amongst the "realist" painters of the second half of the eighteenth century. His work marks the introduction into Venetian art of the "conversation piece" painting – a European genre which was being popularized in France by Watteau and in England by Hogarth. It is now clear that it was his links with the Paris school of painting – and, in particular, his studies of engravings of Watteau's work – that first led to Longhi's interest in such a genre; though the success Crespi was having in Bologna with similar "conversation pieces" was another important stimulus. As the extant drawings in the Museo Correr show, Longhi worked from life when creating his compositions – which are rendered all the more precious and precise by his delicate, meticulous application of paint. *The Dancing Lesson* is an early masterpiece dating from 1741, and is one of the first of Longhi's "conversation pieces". His Venetian interiors not only document architectural and domestic details, they also give us an account of the life once lived within the palazzi of Venice. The record left by his paintings becomes even more important when one thinks that he was in fact portraying a world which, with the defeat of the Republic of St. Mark in 1797, was soon destined to disappear for ever. As an artist Longhi distinguishes himself by his attentive handling of colour and a touch that has all the charming grace of the eighteenth century and the technical delicacy of a miniaturist.

THE MUSEUMS

Bernardo Bellotto (1720-1780)
The Scuola di San Marco at San Giovanni e Paolo

The works of the *Vedutisti* are amongst some of the most attractive of eigteenth-century Venetian paintings. And there is no doubt that these "views" of the city's buildings, squares and canals had a special appeal for those numerous foreign visitors who were passionately interested not only in the arts but also in the particular environment of Venice itself. The *vedute* had long been a part of Venetian art – one need only think of the way the city appears in the works of the narrative painters of the Quattrocento, such as Bellini and Carpaccio. Several of their historic works reproduce a particular corner of Venice. Another important stimulus to the *vedutisti* was Jacopo de Barbari's magnificent engraving of a bird's-eye view of Venice; published in 1500, this *Prospettiva di Venezia* was certainly more beautiful than any before or since. These, therefore, were the roots for a seventeenth-eighteenth-century school of *vedutisti*. Whilst the first examples of such city views are to be found in the work of Northern artists like Heintz and Van Wittel, the theme was soon taken up by local artists such as Carlevaris, Marieschi, Visentini and other minor painters. It was in the first decade of the eighteenth century that the Canal family – father Bernardo and son Antonio (better known as Canaletto) – began producing their views of the city. In the early stages of their career both had had close links with the theatre and had painted scenery for the city's opera houses; however, in 1719, Canaletto "excommunicated the theatre" (to use the words of the biographer Zanetti) and dedicated himself to *vedute* alone – producing works for which he would soon be renowned throughout Europe. This success may well have been one of the reasons why Canaletto decided to set up a studio (so that he could meet the demand from his ever-growing clientele). The first assistant he appointed to work alongside him was his nephew Bernardo Bellotto, who remained in his studio for at least four years (from 1740 to 1744). The ground rules for this "partnership" must have been very strict, with Bellotto having to totally assimilate Canaletto's style and technique: a contemporary, Orlandi, wrote in his *Abecedario* (reprinted by Guarienti in 1744) that "not even connoisseurs can

THE ACCADEMIA GALLERY

distinguish between one of his [Bellotto's] paintings and one of his uncle's." The business partnership was destined to come to an end sooner or later, and finally it did so in 1744, when Canaletto and Bellotto broke with each other – most probably because the talented young man refused to tolerate being a mere substitute for his more famous uncle. What followed for the young artist was an almost endless period of wandering – first to the Melzi estate in Vaprio d'Adda, then to Turin and Verona, and finally to Dresden, Vienna, Munich and Warsaw (where Bellotto lived until he died). There is no doubt that this Wandering Artist constantly honed his style in a search for total realism (rendered through the use of cold colours and silvery shading). In fact, there is really little problem in identifying the works produced during his four-year partnership with his uncle, for Bellotto had already developed an unmistakable personal style. The Accademia *Scuola di San Marco at San Giovanni e Paolo* is one of those pictures: a sharp image reflected in the slightly-rippled water of the canal. The reflections between the sky and the earth are rendered with meticulous care and the "patches of colour" are enlivened with the merest touch of paint, applied with the very point of the brush to achieve an effect of surprising realism. Where Canaletto aimed for interesting light effects – often adapting the cityscape to that purpose with all the skill and imagination of a scenographer – Bellotto was already an artist who aimed to represent reality as it was, as faithful to the facts as any *Encyclopédiste*.

Francesco Guardi (1712-1793)
The Fire at San Marcuola

Canaletto and Bellotto both belonged to the more realist school of *Vedutisti* – and in producing their pictures often had resort to the "camera obscura" (a machine which projected a small version of an image onto a sheet of paper). But in the same period there were other *vedutisti* whose style was very different and who preferred a more "impressionistic" approach – suggesting rather than representing the view before them. This group included the striking colourist Michele Marieschi and the even more "impressionistic" Francesco Guardi. He was raised and trained within a family of rococo artists. The head of the family, Domenico, was a religious painter of modest talent, as appears from the few paintings of saints which have recently been attributed to him.

The eldest son, Antonio, was an artist of unmistakable genius. Born in Vienna but almost immediately brought to Venice (at the beginning of the eighteenth century), Antonio followed in the footsteps of Ricci and Pellegrini and soon became a master of elegant international rococo (though he never achieved the fame he deserved). He took over as head of the studio when his father died and was then the first teacher of his younger brother Francesco (and perhaps of a third brother, Nicolò, whose work as an artist is yet to be identified). The few paintings of human figures which date from the period of Francesco's apprenticeship are not very felicitous works. Soon, the younger brother switched his attention to the work of the *Vedutisti* and took the greatest exponents of the genre as his masters until, eventually, he had established himself as a worthy successor to them. Contemporary sources casually refer to him as "a good student of Canaletto". However, even a first glance at such works as this *The Fire at San Marcuola* is enough to reveal the substantial differences between Guardi and Canaletto. The latter may have allowed himself extensive poetic licence, but he remained a painter who represented the real world in the spirit of Enlightenment Rationalism, whilst Guardi is much more a painter of the imagination and of individual sensibility. His works seem to anticipate Romanticism, or even Impressionism. This painting was inspired by a real event – the fire in the oil warehouses near San Marcuola on 28 December 1789 – but even here Guardi's renders the subject with great breadth of handling, creating a composition which is built around vibrant lines and atmospheric perspective. The work is a good example of the merits of Guardi's style, which brings together short hand, allusive brushstrokes and the most fanciful palette ever to be used by a Venetian painter.

THE HELLENIC INSTITUTE MUSEUM

Michele Damaskinos (active in Venice 1574-79)
Icon of St. Anastasius

Let's now continue our tour by visiting the city museums which have smaller or less important collections than the Accademia.
Again we will proceed in chronological order, which will help us to piece together the various aspects of the history of Venetian art.
Echoes of Byzantium can often be felt in Venetian painting.
So it should come as no surprise that we are starting in the oriental atmosphere of the Icon Museum, housed in the former Scuola di San Nicolò, near the Greek Orthodox church of San Giorgio. Strictly limited to the technique of tempera on wood, the work of Byzantine masters reveals an almost unchanging tradition and is characterised by certain key features: a gold background (a symbol of infinite space) and a scorched dryness of colour.
The late-sixteenth-century Michele Damaskinos was one of the last important artists of the Byzantine school, and here we will look at his tormented, hieratic icon of *St. Anastasius*.
Damaskinos is, incidentally, credited with having encouraged a young Crete artist who was in Venice at the time – Domenico Theotocopuli, who would absorb all he could from Tintoretto's work and then move on to Spain in 1575 (where he would be better-known as El Greco).
So Damaskinos represents a link between the archaic school of Byzantium and the most modern of Venetian Mannerist painting.

THE MUSEO CORRER

Cosmè Tura (c. 1430-1495)
Pietà

The Museo Correr is unusual amongst Venetian museums because its collection often extends beyond the traditional guidelines. This is a result of the particular tastes of the original founder of the collection, who had a marked interest in the art of Northern Europe or in painting that was in some way similar to it (outside the Renaissance traditions of Rome and Florence). Teodoro Correr was a Venetian nobleman who put his collection together in the dark years of the end of the Venetian Republic. The break up of many private Venetian households did, however, enable him to gather together works which ranged from the traditional conversation pieces of Pietro Longhi, through the paintings and drawings of *vedutisti* such as Francesco Guardi to German, Dutch and Flemish works by artists of the calibre of Derek Bouts, Hugo Van der Goes, and the schools of Bosch and Brueghel. Unusually for his time, the collector was also interested in those Venetian painters who might be considered as "primitives", who had a harsh, realistic and, at times, tormented style which had nothing classical about it.

Thus the Correr collection includes early Bellinis (including a *Pietà*, which bears a false inscription attributing it to Dürer) and Carpaccios (whose *Portrait of A Man in the Red Beret* has all the stylistic incisiveness of a Flemish artist or even of Antonello da Messina – whose tragic *Pietà* is also part of the collection). Amongst this group of works showing Correr's marked predilection for North European Art I would include this *Pietà* by Cosmè Tura, the Ferrarese master who simultaneously came under the influence of Venetian artists such as Bellini and Flemish artists such as Rogier van der Weyden.

Tura offers us his own interpretation of the suffering, tense mask of tragedy in Weyden's work; his paintings are of such sharp marble coldness that he has clearly found a way into the tormented world of the "northerners".
Thus we find ourselves in front of this disturbing image of the dead Christ – which is made all the more disturbing by the tragic contrast set up between the image of death and the portrayal of the quietly-mourning Virgin, who holds and caresses her son

ns if she believes she could breathe life back into him. Here, however, there is almost no trace of the stiff folds of the garments which are so typical of German or Flemish *Pietà* (the "Vesperbilder", which were also to be found in Venice); the line has been softened and the artist's palette seems to have been chosen from amongst a mosaic of semi-precious stones of adamantine sheen.

In all the solitude of the masterpiece, this panel reveals a very rare moment in Venetian painting. Without over-emphasis, it seems to enhance the art of the city with the tears of a unique artistic language, the tragic silence of which haunts one.

THE MUSEO CORRER

Giovanni Bellini (c. 1430-1516)
Pietà

The most important room in the Museo Correr – housed in the Procuratie Nuove in St. Mark's Square – contains at least four early masterpieces by Giovanni Bellini, all dating from between 1445 and 1455.
Unknown to critics up until a few decades ago, the *Pietà* is one of these works and is particularly important because it dates from the beginning of Giovanni's career when, after having worked along with his brother Gentile under their father Jacopo, he moved to Padua, where he was exposed to the influence of the very latest in Tuscan Renaissance art. In fact, the landscape in the *Pietà* is noticeably archaeological – a result of the influence of Mantegna, Bellini's brother-in-law – whilst the angels bearing up the dead Christ remind one of the bronze angels that Donatello produced for the Altare Del Santo in Padua around 1455. However, along with this obvious evidence of early influences we can also see traces of that use of colour which was to become the hallmark of Bellini's work. Look, for example, at the delicate way in which the artist uses thin layers of paint to create the atmospheric effects in both the distant landscape and the harmonious group formed by the dead Christ and angels.
This specific characteristic of Bellini's artistic language will soon mark the arrival of the Renassiance in Venetian painting.

THE MUSEO CORRER

Vittore Carpaccio (c. 1465-1526 ?)
Portrait of the Man in the Red Beret

One of the most remarkable paintings in the collection, this wonderful portrait long served as the very symbol of Museo Correr. No one who looks for any length of time into those piercing steely blue eyes will ever forget them. The only works that can stand comparison with this portrait are those by the very greatest Flemish painters (such as Jan Van Eyck's *Arnolfini Wedding* in London) or the inexorably realist works of Antonello da Messina (for example, the *Pasqualigo Portrait* in London). It seems clear to me that Carpaccio took these very artists as his model here; it is also equally clear that, in spite of recently reiterated doubts, the portrait cannot be attributed to any minor artist.

Certainly attribution is no easy matter, especially when one takes into account evidence provided by the linguistic features of the painting – which include an aerial perspective background (in the style of Piero della Francesca), a gently wooded landscape (somewhere between the style of Cima and Bellini) and a realism which merges into abstractionism (such as one might find in the work of Muranese

THE MUSEUMS

artists at the time of Alvise Vivarini)...
However, all these features can also be found in Carpaccio's style. What I believe to be beyond doubt is that the one place in Italy where such a union of influences could be found was Ferrara – and recent studies have lent support to the thesis that in his youth Carpaccio worked in that city (between the years 1485 and 1490) and would therefore have been exposed to the work of the Ferrarese school (which included such artists as Tura, Cossa and de' Roberti). At the same time he might also have come into contact with the other artists we know to have been in the city: Piero della Francesca and the Flemish Rogier Van der Weyden. This theory of a Ferrara period in Carpaccio's career is borne out by evidence contained in the two *Tondi* depicting tornaments which are usually attributed to him (London National Gallery).
I would identify these works as portraying the tornaments held in occasion of the wedding of Ercole d'Este and Anna Sforza in 1487 (which fits perfectly with the time when the Venetian painter may have been in Ferrara).

So we are just a few years before the *Saint Ursula* cycle (1490-1500), and no one could deny that the most pertinent resemblances to the Correr portrait are to be found in the young gentlemen who appear in that cycle (particularly in the three pictures involving the Ambassadors).
So, after so much critical effort, is the mystery of the *Man in the Red Beret* still unsolved?
I would say not. But whatever the truth, one can never forget those sharp eyes which seem to pierce to the very heart of things.
The same realism as found in them can also be seen in the dark green damask collar of the blue jacket, in the natural way the red cloak falls on the shoulder, in the two unfastened mother-of-pearl buttons which one feels one could reach out and touch.
This man in the red beret is a perfect symbol of Venice's solidly-established merchant classes, who had created a political and financial empire that was a power throughout the world.

THE FRANCHETTI GALLERY AT THE CA' D'ORO

Andrea Mantegna (1431-1506)
St. Sebastian

The subject of St. Sebastian seems to have had some mysterious fascination for Mantegna, who worked upon it several times. His Accademia version emphasises the youthfulness of the Saint, whilst his Louvre version is a monumental archaeological fragment made up of a series of studies of rediscovered Roman sculpture, and the version now in Vienna is a more measured and intimate rendering of the scene. However, the most powerful treatment of the martyrdom is to be found in this Ca' d'Oro *St. Sebastian* – a work which the refined connoisseur Baron Giorgio Franchetti. The style is certainly that of the late Mantegna (towards the end of his period in Mantua), around 1490-1500 (if it is true, that is, that the artist intended this *St. Sebastian* for his generous young patron, Cardinal Ludovico Gonzaga). In fact, the spiritual treatment of the subject matter could also be taken as bearing out a "religious" commission. The tortured line of the drapery accentuates the idea of Christian suffering in the name of Faith, whilst the purple-greys used by the artist emphasise human agony and death.

THE MUSEUMS

THE PINACOTECA QUERINI STAMPALIA

Pietro Longhi (1701-1785)
The Sagredo Family

As our tour of Venetian museums draws to a close we will find ourselves looking mainly at the works that illustrate the last great period of Venetian painting, the eighteenth century. Some of the public collections in the city are dedicated almost exclusively to this period, whilst the personal taste of Count Giovanni Querini, the founder of the Querini Stampalia collection, is well-represented by social portraits, conversation pieces and rich furnishings. In fact, the Querini Gallery is particularly noteworthy for its numerous collection of works by Pietro Longhi, that pleasant-mannered chronicler of everyday life who produced family portraits, picture series on specific subjects (servants, peasants, charlatans, etc.) and narrative conversation pieces (dealing with subjects as varied as the Sacraments of the Church and Hunting). It was undoubtedly the aristocracy who provided Longhi with most of his commissions, and *The Sagredo Family* is perhaps the artist's masterpiece. Painted in around 1750, it shows the two branches of the family under the power of the matriarch Cecilia, here portrayed with her two daughters Marina Pisani and Caterina Barbarigo and their children. However, Longhi's realism is not without its irony and the studied pose of the figures seems to reveal a deliberate attempt to take refuge from the increasing difficulties of the real world in the smiling mood of Goldonian comedy. But the quality of Longhi's art deserves more than a distracted first glance. The fineness of his almost miniaturist style makes his art much closer to the pastels of Rosalba Carriera than to the out-of-date, pompously baroque portraits still being turned out by the likes of Nogari, Nazzari, Pasquetti and Uberti. Longhi never lost sight of reality, which "he depicted with his own eyes", as Gaspare Gozzi put it in 1761. This approach was clearly in keeping with the Rationalism which inspired the Enlightenment; and at a European level, the spirit in Longhi's work can be compared to the *ésprit de finesse* to be found in contemporary French and English masters.

THE PINACOTECA QUERINI STAMPALIA

Giambattista Tiepolo (1696-1770)
Portrait of the Procuratore Dolfin

Apart from the many self-portraits which he included amongst the minor figures of his large-scale paintings, Tiepolo rarely showed much interest in portraiture; his imagination was much more attracted by mythology or historical subjects. So those few portraits we have stand out amongst the innumerable Rinaldos, Didos, Roman condottieri and Germanic bishop-princes. Pride of place amongst these works I would definitely award to this portrait of the bombastic *Procuratore Dolfin*, painted between 1750 and 1755. Given that the work comes from Ca' Dolfin in San Pantaleon – for which the young Tiepolo had painted a series of Roman generals – critics have tended to identify the sitter as Daniele Dolfin IV (1656-1723), a noted captain in the Venetian navy. The cruel energy in that gloved hand, and that sinisterly spectral white wig, are perfectly in keeping with the prestige of such a position, given that reserve captains were only called out in times of the gravest emergencies. The daring perspective used by the artist, and the theatrically billowing draperies, all take on an expressionistic significance. Allusive use is also made of the sculpture in the portal behind the figure, with a grotesque contrast being suggested between the old man carved on the keystone of the arch and the harshly-determined face of the Procuratore with the jutting jaw. The style of the portrait hestitates between magic and hallucination, and reminds one of those scenes of witchcraft to be found amongst the *Capricci* etchings Tiepolo produced around the mid-1740s (in which the artist gives free rein to his imagination and thus reveals his skill in biting social satire). Perhaps one wouldn't be far wrong in seeing something satirical in this portrait of the Procuratore, who seems to flaunt the importance of his position in the face of his fellow Venetian nobles.

CA' REZZONICO - MUSEUM OF THE EIGHTEENTH CENTURY

Rosalba Carriera (1675-1752)
Faustina Bordoni

The Ca' Rezzonico collection includes not only paintings but also original furniture and decorations from the eighteenth century.
The works I have chosen from amongst the numerous masterpieces on display here may not be amongst the most striking but will, I think, be of great interest to anyone visiting the museum for the first time.
Moving past the radiant Tiepolo fresco allegory of the Savorgnan-Rezzonico wedding, one comes into a room hung with Rosalba Carriera's pastel portraits – and almost immediately one seems to hear the buzz of conversation between elegant ladies and mannered gentlemen in a Venetian salon.
Amongst these various works one that stands out is the imposing portrait of Faustina Bordoni (c.1693-1797), a leading contralto of her day who, in the 1730s, would move to the Dresden court, where she would marry the courtier von Hasse.
Rosalba Carriera often shaded and softened her velvety pastels with delicate touches of the fingertips. One would be at a loss to find any flaws in her meticulous technique, in which expressions and profiles are so often eloquent testimony to her sitter's character.
Her skill as a portraitist is such that she raises pastels from the anonymity of boudoir art or snuffbox decoration to the very heights of poetry.
The culmination of her career came in 1720, when she was invited to Paris to portray the royal family. Admired and courted by many of the ruling families of Europe, Rosalba Carriera used an almost realist artistic language which made her talents respected by all.
There can be no doubt that she was a significant influence on the great French pastel artists Quentin de la Tour and Chardin.

CA' REZZONICO - MUSEUM OF THE EIGHTEENTH CENTURY

Pietro Longhi (1701-1785)
The Moor and the Letter

Various rooms in Ca' Rezzonico are set aside to house the largest single collection in the world of works by Pietro Longhi. All in all, some fifty works, which offer a complete panorama of the work of an artist who was apparently most concerned with minute detail but was in fact a painter of unparalleled finesse. Whilst the eye wanders over these works – which are all of more or less the same small size – one cannot help thinking of those elegant Venetian mezzanines in which well-informed ladies like Caterina Dolfin Tron and Giustina Renier Michiel held salons where the talk would often be of France and things French – the very nation in which the ground was being prepared for a democratic revolution that would change the face of Europe. Longhi's work is always centred around the world of the Venetian nobility, provided him with the greatest number of commissions. This depiction of a moorish slave delivering a secret letter to the lady of the household is far too realistic to be a mere joke; the workroom, in which the lady is surrounded by her maids, is depicted in far too intimistic a way. And, perhaps, the Zuccarelli painting recognizable on the wall of the room is too clear an allusion – a sensual vision of Arcadia, which evidently echoes a moment of pleasure enjoyed by the unknown writer of the letter which, at this very moment, is being delivered with a pompous – and slightly ironic – gesture. His works sometimes suggest that Longhi was a bit of a Frondeur – especially when he charges his paintings with repressed eroticism (visits paid by important personages, little *tete-à-tete* suppers with English lords, procuresses offering saucy girls). It is even said that the Inquisition was keeping its eye on him. However, even without giving credence to these unsubstantiated rumours, there is no doubt that Longhi belonged to that intellectual bourgeoisie which was becoming increasingly critical of the *veneta nobiltà*.

THE MUSEUMS

CA' REZZONICO - MUSEUM OF THE EIGHTEENTH CENTURY

Francesco Guardi (1712-1793)
The Parlour of the Nuns of San Zaccaria

The Ca' Rezzonico collection offers the visitor the perfect occasion to understand the early development of Francesco Guardi, the greatest of all Venetian *vedutisti*. Before dedicating himself to that genre, the artist had tried others.

The decade 1730-40 was spent working in his brother's studio, and tradition naturally enough required him to deal with religious or historical-mythological subjects. His handling of these themes reveals a certain Northern grimness, in which a harsh palette goes together with fractured, rather wooden draughtsmanship (the lines of which recall the popular sculpture of Guardi's native area, the Val di Sole in Trentino).

In a Venice infatuated by Rococo elegance, such works were not likely to have enjoyed much success, and Guardi consequently turned to the conversation piece genre – in which the standard to follow was set by the subtle, and much more "modern" artistic language of Longhi's works.

The two Ca' Rezzonico paintings – *The Foyer of Ca' Giustinian* and the *Parlour of the Nuns of San Zaccaria* – are perfect examples of the attempts Guardi made during the 1740s to assimilate Longhi's style. This is clear not only in the choice of subject-matter (obvious "conversation pieces"), but also in the inclusion of certain of the leit-motivs of Longhi's work: the ladies in *andrienne*, masked gentlemen in *bauta*, and the restrained and respectful good manners that would have been expected of a painter at the service of the Venetian nobility. When dealing with the notoriously libertine atmosphere which prevailed in the parlour of the nuns of San Zaccaria, the artist does not allow himself to go too far and prefers to limit himself to the depiction of the infantile games centred around a puppet theatre and of novices preparing doughnuts.

Twentieth-century critics have had a fine old time in attributing and re-attributing these paintings to each of the Guardi brothers in turn.

Quite rightly, in my opinion, the works are now generally attributed to Francesco – even if dated very early (between 1747 and 1750). The dating aims to account for a certain "fraying" in the brushstrokes – something which Francesco derived from his brother Antonio. Of course this only adds to the importance of the works, by revealing their intertwined origins. However lively and fresh the technique shown in these works, Francesco quickly realised that conversation pieces were not for him. Soon he would start painting his views of Venice – following in (and then striding beyond) the footsteps of Canaletto.

CA' REZZONICO - MUSEUM OF THE EIGHTEENTH CENTURY

Canaletto (1698-1768)
Rio dei Mendicanti at San Giovanni e Paolo

The public collections in Venice contain very few examples of Canaletto's work because contemporary collectors – and English collectors in particular – snapped up any available works by this painter who seemed to be able to seize the essence of Venice, to capture the fleeting shift of light on the lagoon, the atmosphere of the magnificent processions of boats along palazzi-lined canals, the quiet of campi recreated through vivid patches of colour, and the deep mirror of a sky that seemed to bend low over the water until sea and sky merged in light parallel ripples.

The growth of Canaletto's fame was rapid and irresistible – even if some potential customers (such as the sly Count of Tessin, a minister of the King of Sweden) refused to pay the artist's high prices. Almost immediately after Canaletto abandoned his father's trade of scenery-painting, the commissions came flooding in, and the works were dispatched to sumptuous chateaux, schloss and castles throughout Europe.

Of the four works bought in Venice by Prince Josef Wenzel of Lichtenstein, two – the *Rio dei Mendicanti at San Giovanni e Paolo* and the *View of the Grand Canal at Rialto* – have recently been added to the Ca' Rezzonico collection. Painted when Canaletto was about twenty-five years old, they already show him an expert in the use of the camera obscura, a instrument then enjoying great vogue amongst dilettanti and professional *vedutisti*. The optical precision of the lens naturally leads to a certain coldness in the final image – something which would become more noticeable in Canaletto's later works. However, in these early paintings, Canaletto's buildings have an expressive truth about them, bathed as they are in the muted light of sunset (as if the entire scene were depicted in the clarity which follows a storm). Whilst faithful to the truth of what is before his eyes, Canaletto already demonstrates his command of synthesis, which will enable him to capture the most subtle variations in colour as they occur at different times of day. The living image of Venice which he creates is unmistakable, and his contemporaries were quick to see its superiority over the work of such *vedutisti* as Carlevaris. In the words of the dealer who negotiated on behalf of the Lucca collector Stefano Conti in 1726, "one could see the sun shine" within Canaletto's paintings.

Giandomenico Tiepolo (1727-1804)
The Stroll

After having decorated numerous wonderful villas with mythological allegories intended to satisfy the nouveaux-riches' desire for self-aggrandizement, Giambattista Tiepolo decided to think about himself for a while. Didn't the Tiepolo family themselves deserve a residence on the mainland, somewhere in which they could escape from the summer heat? Thus in 1753 he bought the attractive little villa which still stands at Zianigo near Mestre and shortly afterwards began to decorate it. All the lucrative commissions which came his way limited his work on the villa to the altar in the chapel and to the design (but not execution) of the ceiling fresco of *The Triumph of the Arts* in the portico. All the other frescoes on the ground and first floors were entrusted to Giandomenico, who was already establishing himself as his father's chief assistant. Between 1758 and the end of the century he worked to complete a cycle of works whose bourgeois ispiration was well in keeping with the times. At the beginning of this century all the fresco decoration in the villa was ripped from the walls; and after many vicissitiudes was finally bought by the Venice City Council and the Italian State for the new Museum of the Eighteenth Century to be set up at Ca' Rezzonico, where Giandomenico's most important cycle of paintings can now be seen within a very charming reconstruction of the entire villa. The three frescoes in the salon are all datable 1791 and depict the country life led by Venetian nobles: there is a village fair complete with a magic lantern show (the device was known as the *Mondo Novo* because it projected views of continents beyond the seas), a couple dancing a grotesque minuet and a strolling trio (wife, husband and attendant gentleman – the latter a typical figure in eighteenth-century society). This group is followed by a servant carrying one of those lapdogs which are too highly bred to dirty their paws in a field. Perhaps Giandomenico had appreciated the ironic scene in Parini's poem *The Day*, in which a "virgin puppy" is the object of these selfsame attentions. The frescoes in the *Sala dei Pulcinella* (1793-97) reveal a similar mix of the ironic and the grotesque – almost as if Giandomenico was holding up the declining ruling classes to ridicule. In fact, it is now the cityfolk who are turning somersaults to entertain the *commedia dell'arte* characters and Pulcinellas are now seen going on trips to the hills with copious picnics, or else depicted having a good time larking about on the swings which had been one of the most popular sources of "proper" entertainment for those who were *comme il faut*. The Zianigo frescoes are in fact the masterpiece of Giandomenico's caustic wit. Both the frescoes and the grisailles achieve their descriptive effect through an incisive graphic line which emphasises the moral of the tale. It is as if the artist, in adding to the frescoes day by day, came to regard them as a sort of autobiography.

CA' PESARO - MODERN ART GALLERY

Guglielmo Ciardi (1842-1917)
Lagoon

With the end of the Republic, Venetian painting went into sharp decline – mainly due to the absence of patrons. For those few valid painters still at work the secret was an attachment to the tradition established by centuries of Venetian colourists.

However, very different aesthetic revolutions were on the horizon, and the centres of modern art were elsewhere, in the major capitals of Europe.

As one can see from the exhaustive collection in Ca' Pesaro, early nineteenth-century Venetian painters took refuge in tradition, copying the models left by sixteenth-century artists (and by Titian and Veronese in particular). But in opposition to these pointless velleities for past glories which characterize the academic works of Matteini and Molmenti, one can also find a genuine type of realism in the portraits of Grigoletti and Favretto, in the historical paintings of Hayez and Zona and in the landscapes of Guglielmo Ciardi. Ca' Pesaro contains what is perhaps Ciardi's masterpiece – *Lagoon*, a view of the Giudecca Canal which the artist painted for the Florentine Prince Demidoff around 1868. Even though Ciardi had nothing in common with the Tuscan *Macchiaioli* – the only valid artistic movement in Italy at the time – his work still found favour with the greatest Florentine critic of the day, Cecioni.

Certainly *Lagoon* shows Ciardi's sensitivity to the shifting phenomena of light. We are here in a stunning world of mother-of-pearl, in which there are melancholic echoes of the atmosphere to be found in the works of the great eighteenth-century *vedutisti* Canaletto and Guardi.

GUGGENHEIM MUSEUM

Giuseppe Santomaso (1907-1990)
Secret Life

Created in 1980 around the collection of the late Peggy Guggenheim, this museum is a major attraction in Venice for those with a passion for contemporary art. The light-filled rooms of the incomplete Palazzo Venier dei Leoni on the Grand Canal contain works that are representative of European and American avant-gardes throughout this century.

The Venetian artists present are again unmistakable because of the way they remain true to the tradition of colour in Venetian art. Those on display include Tancredi, with his spheres of light, Vedova and Santomaso, with their abstract expressionism, and many others. Comparison with the Giants of world painting present in the collection – from Picasso to Max Ernst, from Pollock to Magritte – once again reveals the special quality of the Venetian school. Even if the ground is trembling under their feet, Venetian artists face the complexity of the various avant-gardes and demonstrate that the vibrant palette of Venetian art still has a valid message to communicate.

THE ITINERARIES

After our brief introductory section on the role of colour in Venetian painting and a selection of works from the city's main museums, we come to the "heart" of this guidebook – a series of itineraries that are intended to bring the curious visitor into direct contact with a selection of the paintings to be seen around Venice.

These itineraries will follow the natural division of Venice into six sestieri *[sixths] and individual islands, though even this logical arrangement will still involve us in some wandering through the maze of alleys and small* campi *that are an integral part of Venice's very special urban fabric.*

The main aim of this section is to focus attention on the "hidden masterpieces" which still hang in the churches, palaces or Scuole for which they were originally commissioned. In a certain sense, these works consitute a key part of that "diffuse museum" which is of increasing interest to the modern visitor to the city. In fact, such paintings in situ *are of special interest to anyone who wants to have a more direct and genuine experience of Venetian history. Seen in their original context, these less famous – but equally significant – works give each and every visitor the satisfying experience of making a "personal" discovery.*

SESTIERE OF SAN MARCO

1. ST. MARK'S BASILICA
2. ST. MARK'S LIBRARY
3. DOGE'S PALACE
4. SANTA MARIA DEL GIGLIO
5. SAN GIORGIO MAGGIORE
6. SAN ZULIAN
7. SAN SALVADOR
8. SAN BENETO

ST. MARK'S BASILICA

Byzantine artist (12th century)
Madonna and Child

Our visit to this sestiere begins in St. Mark's Square itself, from which we pass into the golden silence of the Basilica. The *Madonna and Child* on the altar on the left has, for centuries, been the most famous painting in all Venetian art. This Madonna Nicopeia (that is, Bringer of Victory) was in fact brought to Venice from Constantinople, the capital of the Byzantine empire, after the sack of the city by the Crusaders at the beginning of the thirteenth century. Placed in the Basilica in 1234, it has never been moved since. Over the centuries it was repainted and touched up many times, but a radical cleaning in 1968 removed many of the additions and revealed the glittering, enamel-like colours of the original. As a result of the restoration, experts were able to date the work with some certainty as early twelfth-century Byzantine. This primitive image exudes all the mysterious fascination of the Byzantine Orient yet is, at the same time, intensely human; the staring eyes of the Madonna have something like a miraculous power.

ST. MARK'S BASILICA

Venetian mosaicist (12th century)
The Creation of the Heavens and the Stars

The earliest mosaics in St. Mark's date from the time of Doge Sebastiano Ziani (c. 1170) and most of them were completed over a fifty-year period. The Basilica as we know it was completed in 1094, and for the decoration of the interior the Venetians immediately decided upon mosaics rather than frescoes, which would have been less resistant to the humid climate of the lagoon. The decision was also influenced by the example of Constantinople, where all the great Justinian churches – Santa Sophia, the Twelve Apostles, etc. – were decorated with mosaics. We know all this from the writings of old Venetian chroniclers, who mention that right from the very beginning the Doge told his architects to follow Byzantine models, so as to make St. Mark's "the most beautiful church known to the world". Various schools of artists seemed to have worked on the structure: the twelfth-century mosaics on the southern side of the basilica (such as the *Life of Christ* and the *Transport of St. Mark's Body to Venice*) are clearly inspired by Byzantine models, whilst the early-thirteenth-century mosaics on the vault of one of the arches and South wall (the *Passion* and the *Christ's Prayer in the Garden*) are closer to the Romanesque art of Central Europe. Finally come the later thirteenth-century cycles in the Atrium (*Genesis, Noah's Ark* and scenes from the Old Testament), which are the product of a nascent Venetian school. Of the atrium mosaics, those in the first cupola – depicting the creation of the world – are particularly noteworthy. The great originality of the work is clear even in its very format – with the scenes unfolding within the dome like illustrations in an unfurled illuminated scroll. In *The Creation of the Heavens and the Stars*, the master mosaicist is clearly fascinated by the abstract possibilities of this star-dotted dark-blue sky encompassing the sun and the moon. The figures of God and the angels are strange and unreal: they look like the deacons of the Early Christian church. The longer one looks into this sphere of the world, the more the realistic draughtsmanship seems to dissolve in the luminous splendor which evokes the atmosphere of the original miracle of creation.

ST. MARK'S BASILICA

Venetian Mosaicist (c. 1345)
The Dance of Salome

After the works of the thirteenth century, the second great period of mosaic art in the Basilica comes in the mid-fourteenth century, which was also the time when the painter Paolo Veneziano was active. The first Venetian painter to be known to us by name, Paolo is often claimed to have worked on the Baptistery mosaics which include the striking lunette of *The Dance of Salome*. The scene is presented in a effective narrative composition which centres on a magnificent banquet presided over by King Herod and his wife Herodias, the mortal enemy of St. John the Baptist. This is the climax of the story, the point at which the perfidious queen has finally obtained the condemnation of the prophet, and we are shown the light-footed entrance of the cruel princess Salome, holding the head of the martyr on a dish. Figures had never before been represented with such intense dynamism, nor had figurative art ever achieved such realism – a realism of movement and of costume (note the magnificent gown of gold-damasked velvet with ermine-lined sleeves). The expressive force of the elegant dancer is emphasized by a marked sensuality of form; the draughtsmanship shows a surprising feel for volume which is absolutely unique among the works of 1345. One is even tempted to think that the suggestions made by the Doge who commissioned the work, Andrea Dandolo – a friend of Petrarch and himself a poet – are part of the reason for the exceptional originality of this mosaic. The extraordinary realism in the representation of Salome is a clear indication that the work was influenced by the elegant forms of Venetian International Gothic.

1 ST. MARK'S BASILICA

Paolo Veneziano (active c. 1310-1362)

The Miracle of the Rocks

In the Museo Marciano one can see not only the famous gilded horses of St. Mark's but also the so-called *Pala feriale* (worka-day altarpiece) which was used to protect the famous *Pala d'oro* altarpiece. The complex composition of the panel is divided into a lower section which recounts the life of St. Mark, and an upper section which contains individual panels depicting Christ and various saints. The most striking panel is that which shows St. Mark appearing to the sailors who are returning to Venice with his body (which they have have just smuggled out of Alexandria). Driven towards the rocks by a storm, their ship can only be saved by a miracle – which duly occurs as the rocks open to let the ship pass through. A gold inscription at the base of the painting records that the work was painted by Master Paolo and his sons Luca and Giovanni in the year 1345. One has no difficulty in believing that Paolo was able to produce such a work by 1345. Between the deep green of the storm-tossed sea and the golden sky with its sinister gleams of lightning, the red rocks open up like the claws of some ferocious sea monster.

ST. MARK'S BASILICA

Zanino di Pietro (active between the 14th and 15th centuries)
The Passion of Christ (tapestries)

By the end of his career, Paolo Veneziano's art was clearly inclining towards the Gothic style as exemplified in the works of the artists of North Europe and of the Italian regions of Emilia and Lombardy. This was the time in which the bases for so-called International Gothic were being laid in the Rhine area (and in the urbane court of Prague in particular). Between the end of the fourteenth century and the beginning of the fifteenth various artists who were linked with this new style – for example, Lorenzo Veneziano, Niccolò di Pietro, Gentile da Fabriano and Pisanello – were at work in Venice. Zanino di Pietro, who worked mainly in the region of the Marches, is one of the least well-known of these transitional masters; yet it was he who created what is perhaps the greatest masterpiece to be seen in the Museo Marciano: the magnificent tapestries representing twelve scenes from *The Passion of Christ*. The expressive line and sharp colours of these works have led critics to argue that the unknown artist who prepared the cartoons for these works must have had some contacts with the International Gothic culture of Northern Europe and, above all, with the court of Bohemia. The few works attributed to Zanino di Pietro – for example *The Crucifixion* in Rieti – reveal a style which is very close to that of these scenes of *The Passion*. What is certain is that the works were commissioned for the Basilica (where they were hung in the Sacristy every Holy Week). The symbol of St. Mark's that is incorporated within the design of the foliage-decked borders would seem to confirm that Zanino moved to Venice itself to produce these works. But whatever the answer to these doubts, there is no question that what we have here is a very special work fortunately preserved in its original site.

ST. MARK'S BASILICA

Giambattista Tiepolo (1696-1770)
Nativity

The only eighteenth-century painting now hanging in St. Mark's comes from the nearby vicarial church of San Zulian. It is one of Tiepolo's most successful religious paintings: *The Nativity.* The only concession to pagan myth here is the figure of the angel alongside the Virgin – which in the composition as a whole is much more credible than the conventional cherub tumbling about on a silvery-blue cloud. Tiepolo achieved a similarly successful compromise with conventional religious iconography in the *Education of the Child Mary* (painted for the church of Madonna della Fava in 1732), in which there is a group of the same beautiful angels surrounding the child Virgin. Completed aound the same time, the St Mark's *Nativity* is not so much a spiritual work as one in which there is a fascinating play upon the contradiction between religious feelings and sensuality. The polished colours have all the precious quality of Cozzi porcelain and seem to caress the images with all the virtuoso subtlety of a Vivaldi *adagio*.

ST. MARK'S LIBRARY

Paolo Veronese (1528-1588)
Music

Designed by Jacopo Sansovino in 1537, the imposing Salone d'Onore (Hall of Honour) in the St. Mark's Library (now the Biblioteca Marciana) is well worth a careful visit: unusually, the decorative scheme for the hall was entrusted to seven different artists, most of whom were in the early years of their career and all of whom exemplify the aesthetic sophistication that was the driving force behind Mannerism. Alongside the works of Demio, Porta, Franco, Licinio, Zelotti and Schiavone, there are the three tondi of *Music*, *Song* and *Honour* by Paolo Veronese, some of his finest early works.

Within the complex decoration of the Hall the eye of the visitor naturally strays towards the Veronese tondi, which seem to gather to them all the light which falls through the large windows. The dazzling feast of light and colour is accompanied by the full vibrant voice of the singer on the left, who is accompanied by the subtle melody of the lute and the viola da gamba in the centre.

Painted in 1556-57, these works date from when the artist's fame was already well-established, thanks to his decoration of the Chambers of the Council of Ten in the Doge's Palace and of the ceiling in the church of San Sebastiano (all this before the artist was even thirty years old). It is said that for his work in the Library the young man was awarded a special gold chain – a sign of the "office" the artist would hold for the rest of his career.

In these works Veronese's aesthetic Credo is already clear: to the classicism of Rome (the source of all Mannerism), the painter brings a festive sense of light and colour together with his elegant virtuosity as a draughtsman (acquired from his early exposure to the influence of Parmigianino – another great model for Mannerist artists in the Veneto). Baroque critics spoke of this style as a compound of precious stones and jewels.

DOGE'S PALACE

Paolo Veronese (1528-1588)
The Rape of Europa

Our itinerary now takes us into the Doge's Palace, the prestigious seat of Venetian government.
Here, in a setting of glittering gold and stucco interspersed with brilliantly-coloured paintings, it is easy to see that decoration was intended to serve a political purpose. The artists working here never missed the occasion to celebrate the myth of Venice. Even the damage the building suffered as a result of fire simply became yet another opportunity for adding new decorations which glorified the state. From amongst all this embarrassment of riches we have chosen works by Veronese, Tintoretto and Bassano, though visitors will obviously want to pick out other things for themselves.

Veronese produced numerous important works for the re-decoration of the rooms of the palace after the fires of 1574 and 1577. In the *Collegio* he painted the votive painting to celebrate the Venetian victory in the Battle of Lepanto as well as the ceiling-panel *Allegories*, whilst in the *Sala del Maggior Consiglio* hangs his painting of *The Triumph of Venice*. However, his most fascinating work in the palace is not part of these picture cycle commissions: now hanging in the *Sala dell'Anticollegio*, the *Rape of Europa* was, in fact, donated to the city of Venice in 1723 by Jacopo Contarini.

Even a casual glance is enough to identify this as one of the greatest masterpieces of the Golden Age of Venetian painting. The theme is one that Veronese worked on in several different paintings (and is one that occurs in innumerable seventeenth- and eighteenth-century versions).

Europa is here depicted as a blonde-haired girl whose pinkish flesh is scantily-clad; the handmaidens that attend upon her look more festive than tragic and are, in their turn, protected by flying cherubs. The dense wood behind serves as a gold-green background in contrast to the deep-blue skies and the azur water, whilst in the foreground the girl chosen by Jove is about to be carried off to Olympus. There is nothing dramatic about this divine abduction, which in fact becomes an occasion for the artist to use some of the freeest and most creative brushstrokes to be found in the musical handling of colour that was typical of Venetian painting.

Jacopo Tintoretto (1519-1594)
Paradise

This immense painting of *Paradise* (measuring 7 by 22 metres) is undoubtedly one of those works of art that literally take one's breath away.

It was completed in the last years of his life (probably around 1592) by the artist Jacopo Tintoretto, working together with his son Domenico and other assistants from his numerous studio.

However, the story of this enormous work, which hangs directly behind the Doge's chair in the *Sala del Maggior Consiglio* (the main Council chamber), is a very complicated affair and covers a period of over thirty years.

It seems that by 1563 the Venetian Council was already making moves to have Guariento's fresco of *The Coronation of the Virgin* (which was probably also known as *Paradise*) replaced by a more recent work.

Dating from 1368, the work was already in need of replacement when the two fires of the 1570s made the situation even more urgent.

The Venetian Council was, at first, very uncertain when it came to awarding the commission for the new *Paradise*. It seems that the commission first went to Federico Zuccari, who produced two sketches in pen (one in the Louvre, the other in the Metropolitan), but nothing in paint.

With his usual enterprise, it appears that at this point Tintoretto got in on the act: his sketch in oils (now in the Louvre) shows a heaven of concentric balconies crowded with saints and martyrs singing hallelujahs to Christ and the Virgin in the centre. The composition was certainly a fine solution for the site – and was taken as a model by numerous later artists – but it still did not get put into effect. In the meantime, in fact, the Council had decided they should hold a competition before awarding the final commission.

Presumably called sometime between 1578 and 1582, this competition resulted in a victory for the "team" of Francesco Bassano and Paolo Veronese (their proposed sketches can now be seen in St. Petersburg and Lille). However, even this decision did not put an end to the question because, whilst waiting for the final go-ahead,

Veronese died in 1588. Only then did work on the Paradise project start up again, with the calling of a second open competition. Amongst those taking part was Palma il Giovane (his sketch, and various studies for the composition, can now be seen in the Ambrosiana); but the outright winner was Tintoretto, who presented a large-scale oil sketch of his composition (1.52 × 4.90 m, now in the Thyssen Collection, Madrid).

Finally work could begin, and as it progressed it remained remarkably faithful to the Madrid painting.

The initial work on the massive canvas and its massive crowds of hundreds of figures began in Tintoretto's studio at Scuola della Misericordia, hampered though it was by the infirmities due to the artist's advanced age. A large part of the final work was due to the collaboration of Jacopo's various assistants, headed by his son Domenico. Proof of this is to be found in the various sketches and copies produced by Domenico, either as studies or pro-memoria, which are now in various collections (including the Prado and the Cassa di Risparmio, Venice).

Infirm and afflicted with gout, which made it difficult for him to get up on the scaffolding, Jacopo probably saved his energies for the central figures of Christ and the Virgin.

By 1592, when he started working on what would be his last works (for the church of San Giorgio Maggiore), the *Paradise* had finally been completed.

Divided into various sections, the work was then transported to the Doge's Palace, re-sewn together and adapted to the wall on which it would hang. Ridolfi tells us that Jacopo Tintoretto could finally feel satisfied with his work, and that he wrily remarked he was "now sure of having Paradise in this life at least, whilst hoping that, through divine mercy, he would continue to possess it in the next life as well."

SANTA MARIA DEL GIGLIO

Jacopo Tintoretto (1519-1594)
The Four Evangelists

Having moved away from St. Mark's Square, we will continue our visit to this sestiere by going to one of the most sumptuous churches of the city centre – Santa Maria del Giglio (also known as Santa Maria Zobenigo, after the old Venetian family which used to live nearby). Rebuilt by Sardi in 1679, the present church still contains the works commissioned for its predecessor, including Tintoretto's *The Four Evangelists*. These two pictures are unusual for Jacopo, who is best known for crowded compositions depicting feasts or miracles within theatrical architectural settings or well-laid-out gardens. However, the artist did sometimes fix his contemplative gaze upon a single image (especially in the early years of his career). With the buzz of the crowd absent, these works bring out the profound spirituality of the painter. The two organ-door panels in Santa Maria del Giglio are unparalleled proof of Tintoretto's ability to condense his inspiration within a composition involving only a few figures. Commissioned by the Procuratore Giulio Contarini between 1552-57, the two show St. Mark and John and St. Luke and Matthew. Riding their clouds with all the ease of acrobats on a trapeze, the Evangelists stand out against a gold-brown sky which heightens their dramatic expressiveness. These early work shows Jacopo revelling in inventive contrasts, which are clearly inspired by the example of Roman Mannerism. The four figures are characterized not only by their usual iconographical attributes of Lion, Eagle, Book and Angel but also by the miraculous atmosphere created from the clash of colour and light which highlights their deep humanity. Jacopo was, in fact, a sincere believer in the authentic value of the Gospels as recounted by these four resolute witnesses to Christ's teachings.

CHURCH OF SAN GIORGIO MAGGIORE

Jacopo Tintoretto (1519-1594)
The Last Supper

The church of San Giorgio Maggiore, on the island opposite St. Mark's, was the last place Tintoretto worked. In the very last days of his life, the artist returned to a theme he had depicted many times – *The Last Supper*. And yet, right up to the end, his "terrible brain" continued to come up with inventive surprises that make this work rich in figurative poetry.

The miracle of the painting relies mainly on the totally artificial lighting of the scene which, as in other versions of the same subject, shows those present arranged diagonally across the painting (with Christ and Judas on opposite sides of the table). There are only two sources of light in the entire composition: Christ's halo and the large oil lamp hanging from the ceiling on the left. There are therefore two skilfully contrasted directions to the light, and one cannot but be amazed and transfixed by the almost "magical" way the oily fumes turn into angelic forms as they unfurl over the the heads of the surprised and spellbound apostles. Around these central characters, various servants move within the shadows of the picture to bring food and wine to the table. When looking at this painting one is reminded of what we are told by Tintoretto's biographers – that these particular effects were achieved though preliminary studies involving small wooden figures, a toy theatre and torches. A miraculous technique that anticipates some of the more fantastic inventions of the baroque. Given their large cast, Tintoretto's *Last Suppers* break with the usual iconographical norms (which limit the scene to Christ and the Apostles); however, Tintoretto was not an artist to shy away from innovation, and handles his various characters with the consummate skill of a theatre director.

CHURCH OF SAN ZULIAN

Paolo Veronese (1528-1588)
Pietà and Saints

Attached to the parish of St. Mark's, this small church of San Zulian was rebuilt after the 1553-55 fire by Sansovino and Vittoria, the two greatest sculptor-architects working in Venice during the mid-Renaissance period. The patron for the restoration work was the famous physician and philosopher Tommaso Rangone, whose statue by Sansovino sits above the main portal. The numerous paintings inside include striking works by Palma il Giovane and Zanchi, but the work that interests us here is the *Pietà with St. Mark, Rocco and Jerome*, completed by Paolo Veronese in 1582. This was one of the artist's first monumental treatments of the *Pietà*, and he would return to it several times over the course of the last years of his life. One gets the impression that St. Jerome is another portrait of Tommaso Rangone. As a true portraitist, Veronese uses a full-frontal close-up to emphasize the importance of this austere figure – thus adding a note of contemporary interest to a work which is of the very highest quality.

CHURCH OF SAN SALVADOR

Titian (1490-1576)
The Annunciation

At the end of the Mercerie – the street which runs between St. Mark's and Rialto – we come to the church of San Salvador, whose monumental façade dominates the small square in which stands the Scuola di San Teodoro. Built by Spavento and Tullio Lombardo between 1506 and c. 1550, the church contains a number of important sixteenth-century paintings. The greatest masterpiece in the church is Titian's *Annunciation*. The picture, in Titian's late "impasto" manner, is hung in a such a way that it seems to be a capital on the right wall; the artist chose this location because it enhanced the "magical" play of light and shade within a composition built up of broad, free brushstrokes. The altarpiece was a legacy commission in the will of the merchant Antonio Cornovì (1559), but was most probably finished some time after the merchant's death in 1562. We know from Palma il Giovane that in the later part of his career, Titian had taken to making the finishing touches to his paintings with his fingertips rather than with brushes, and the edge of the painting here seems to bear such fingerprints in paint. The *Annunciation* was signed "Titianus faciebat", which was subsequently modified into "Titianus fecit fecit" – as if to emphasize the value of the painting; but the alteration may have been made at a later period. The bottom part of the painting is the most atmospheric, with a view of Venice seen through what seem to be the fumes of a fire. This view of Venice is a leitmotif in many of Titian's great works, a sort of act of recognition paid to the city that had taken him in when a young man and given him the chance to achieve lasting fame.

CHURCH OF SAN BENETO

Sebastiano Mazzoni (c. 1621-1678)
St. Benedict presenting the parish priest to the Virgin

San Beneto (which is the Venetian dialect version of San Benedetto) faces timidly onto an attractive little square dominated by the Palazzo degli Orfei, an imposing Gothic structure in red brick. The church is worth a visit for anyone interested in the history of Venetian painting in the second half of the seventeenth century as it contains one work by Strozzi and two by Sebastiano Mazzoni, an undeservedly neglected painter who arrived here from Florence when a young man of less than thirty years old (the San Beneto altarpieces date from that time, 1648-49). The exposure to such mid-seventeenth-century masters as Maffei had a decisive effect on Mazzoni's work – as can be seen from what I consider to be his masterpiece, *St. Benedict presenting the parish priest to the Virgin in the presence of Faith, Hope, Charity and St. John the Baptist.* The fantastic inventiveness of compositions built up with snatches of light and shadow – in which the sudden grimness of the colours creates the impression of a painter "possessed" – made Mazzoni a very diffcult artist for his contemporaries; it is only today that his expressionistic forms can be fully appreciated. Mazzoni's rare works were often small easel paintings for collectors; though he nevertheless played an important role in the development of the so-called *maniera tenebrosa* of Loth, Langetti and Zanchi, one of the most characteristically Venetian forms of Baroque painting.

SESTIERE OF CASTELLO

9 SAN ZACCARIA
10 SAN GIOVANNI IN BRAGORA
11 SCUOLA DI SAN GIORGIO DEGLI SCHIAVONI
12 PIETÀ
13 SAN FRANCESCO DELLA VIGNA
14 SAN GIUSEPPE
15 SAN LAZZARO DEI MENDICANTI
16 SANTI GIOVANNI E PAOLO
17 SANTA MARIA DEI DERELITTI (OSPEDALETTO)
18 SANTA MARIA FORMOSA
19 SAN LIO
20 SANTA MARIA DELLA CONSOLAZIONE (LA FAVA)

CHURCH OF SAN ZACCARIA

Antonio Vivarini (c. 1420-1484)
Madonna of the Rosary

Our tour of the Castello Sestiere begins at the church of San Zaccaria, which used to stand within the "brolo" (garden) of the monastery attached to the Basilica of St. Mark's. The original Gothic structure was left incomplete and the present facade is the work of the greatest of High-Renaissance Venetian architects, Mauro Codussi (late fifteenth-century). The three Vivarini polyptychs from the San Tarasio Chapel were part of the decoration of the original church, and can be taken as a perfect example of late-Gothic altarpieces. Dated 1443, the *Madonna of the Rosary* is an imposing work with a massive wooden frame of carved niches, turrets and pinnacles, which is decorated not only with Vivarini's paintings of *Saints*, but also with panels by Giovanni d'Alemagna and a *Madonna* by Stefano da Sant'Agnese – which makes it the sort of composite work that was typical of the transitional period between Late Gothic and Early Renaissance. Against the "thorough bass" of gold leaf, the *Saints* in San Zaccaria stand out like so many beautiful flowers in a celestial garden. With the balanced forms of Renaissance art just ready to appear, the sumptuous Venetian eye for colour was the main inspiration for the inexhaustible decorative fancy of Late Gothic painters such as Vivarini and d'Alemagna.

CHURCH OF SAN ZACCARIA

Andrea del Castagno (c. 1421-1457)
The Church Fathers: St. Mark

Still within the Gothic chapel of San Tarasio one only has to raise one's eyes from the delicate charm of Vivarini's polyptychs to Andrea del Castagno's 1442 frescos of *The Church Fathers* in the apse for one to feel oneself transported to a totally different world. At the selfsame moment that Late Gothic art was producing its last masterpieces in Venice, here are the first traces of the arrival of the Tuscan Renaissance. The artist himself was not yet twenty years old, but his work must have struck the Venetians as an inevitable sign of things to come. The aggressive force of Andrea del Castagno (who had been Masaccio's first pupil) is remarkably clear in the enraptured faces of such figures as this St. Mark. It is not hard to imagine the effect these works must have had on younger Venetians – one of whom, Giovanni Bellini, would soon introduce the city to the work of various other Renaissance masters such as Donatello and Mantegna.

CHURCH OF SAN ZACCARIA

Giovanni Bellini (c. 1430-1516)
Madonna and Saints

From the charm of Late Gothic and the first traces of New Florentine art within San Zaccaria, we now leap forwards more than half-a-century, to the Bellini altarpiece of *Madonna and Saints* (first altar on the left). Signed and dated 1505, this – the artist's late masterpiece – is a fully Renaissance painting. Giorgione was already twenty-eight years old and his Castelfranco altarpiece had already announced its revolutionary message for the younger generation of artists comprising Titian, Lorenzo Lotto, Palma and Paris Bordone. There's something almost miraculous about the fact that among such a youthful company we should also find Bellini, who was then in his seventies; but there can be no doubt that the old painter fully appreciated the innovative content of Giorgione's style of painting (which Giorgio Vasari would defined as "painting without drawing" – that is, based on the direct application of paint to canvas). The soft brushstrokes used in creating the figure of this enthroned Madonna are animated by a cascade of chromatic effects, whilst the sunlight has a new transparency which gives body to the hieratical figures of Saints Peter, Jerome, Catherine and Lucia. The oils are applied in almost transparent washes, so that the air seems to be vibrant. One gets that impression that directly behind the altar an enormous window has been thrown open to let in this flood of light and colour.

CHURCH OF SAN GIOVANNI IN BRAGORA

Cima da Conegliano (c. 1459-1517)
The Baptism of Christ

A short walk along the *calli* behind San Zaccaria brings us to the square in which stands the Gothic church of San Giovanni in Bragora. The moment one enters the building one seems to be inundated by the flood of light that falls from the high altar, above which hangs a large painting in which a deep blue sky is reflected in the calm waters of a stream where St. John the Baptist, accompanied by three angels in red, blue and yellow, is baptising Christ. This is the masterpiece of Cima da Conegliano, an artist who was jointly influenced by Giovanni Bellini and Antonello da Messina. The painting dates from 1492-95, according to the contract and payments registered by the parish priest Antonio Rizzo, who was also responsible for the completion of the original marble frame. Cima's stay in Venice dates precisely from the period he was working on this altarpiece, a work which was so popular with his contemporaries that Bellini took up many of its key ideas and used them a few years later in his *Baptism* for the church of Santa Corona in Vicenza. However, the earlier work remains unmistakable and has all the features that are typical of Cima's style: deeply-felt sensitivity to a natural world which is shown bathed in limpid air, jewel-like colour that seems to hold the figures within an unbroken world of silence, and a gentle ingenuousness which is redeemed by the clear religious message of the painting.

Vittore Carpaccio (c. 1465-1526 ?)
The Study of St. Augustine

Vittore Carpaccio tended to work mainly for Scuole di Devozione (religious confraternities), on commissions which gave him the opportunity to indulge in his natural vocation for a simple and apparently ingenuous narrative art (which, in many ways, reminds one of the those *sacre rappresentazioni* that were the most widespread forms of popular theatre of the time). Originally without the present marble facade, the small Scuola degli Schiavoni now houses eight canvases recounting the lives of the Scuola's three patron saints: Augustine, Jerome and Tryphon.

A further development of the narrative language used in the *Saint Ursula* cycle (of 1490-1500), these works mark the very high point of the artist's career. The moment one enters the ground-floor hall containing the paintings one is struck silent in admiration and then entranced by the atmospheric power of the images. Most poetic of all seems to be *The Study of St. Augustine*, which depicts a scene recounted in the *Golden Legend*: alone in his study, the Bishop of Hippo hears the voice of his friend St. Jerome (then absent in Antioch) announcing that he has died. The room is flooded with a sudden light as, at the moment of the miracle, St. Augustine interrupts his writing. Every movement comes to a halt, and time and space are treated in a way that is typical of Carpaccio's compositions.

The vanishing point of the entire perspective has been shifted from geometric centre to the right of the painting, so that it coincides with the saint's pen – held in his raised hand like some sort of baton. Thus our attention is immediately fixed on that point, highlighted by the mote-filled bands of light which fall across the floor. Even the saint's fluffy white dog is silent and still. Carpaccio never again achieved such expressive force in his narrative art, never created an effect as magical as that produced here: living figures and inanimate objects are all part of an orchestration of light and colour which leaves us dumbstruck, caught up within the atmosphere of the miracle depicted.

CHURCH OF THE PIETÀ

Giambattista Tiepolo (1696-1770)
The Coronation of the Virgin

Situated on the light-filled Riva degli Schiavoni, the church was designed by Massari (with building work beginning in 1745) and then became the chapel of the Conservatory for Orphaned and Abandoned Girls at which Antonio Vivaldi had been Concert Master from 1703 to 1740. In 1745 – shortly after his return from Würzburg, where he had painted the frescoes in the Bishop's Residence – Tiepolo was appointed to fresco the large ceiling. Naturally enough the theme had to have something to do with Music and thus *Coronation of the Virgin* is duly accompanied by two heavenly orchestras and choir – with the angels playing the same instruments as those used by Vivaldi's musicians. With its dazzling colours dominated by blues and whites, this is perhaps the most beautiful Tiepolo fresco in Venice.
The Virgin's ascension into Heaven has a spiralling motion which gives the impression of having been inspired by a Vivaldi crescendo, in which motifs joyfully answer and echo other.

CHURCH OF SAN FRANCESCO DELLA VIGNA

Antonio da Negroponte (active 1463-1469)
Madonna and Child

Standing in a quiet *campo* that preserves all the original character of the old sestiere of Castello, the church of San Francesco della Vigna was designed by Sansovino and Palladio and contains numerous masterpieces. The one work that can be attributed with certainty to Friar Antonio Falier da Negroponte, this *Madonna and Child* is undoubtedly an unusual painting (even the technique is novel, with paper glued to the base of the Madonna's throne in what is otherwise a normal panel painting). Painted in the 1470s – perhaps for the Morosini altar in the right transept – the altarpiece would have been rather a solitary thing amidst all the Venetian paintings produced by the artists who had followed Giovanni Bellini's lead into the Renaissance. For his part, the mysterious friar – who may have been a member of the Falier family – chose to look backwards and filled his painting with Late Gothic decoration (the rose-covered chair-back, the brocade garment, the flowered lawn, etc). Nevertheless, the architectural features of the Virgin's throne seem to reveal a desire to vaunt up-to-the-minute knowledge: the bas-reliefs are clearly inspired by classical antiquity and by ideas taken from the Padua school (and especially from Mantegna's work in that city). Overall, the painting's charm comes from its medieval ingenuousness and from its almost miniaturistic sense of colour. The artist seems to have drawn his inspiration from a nostalgic re-evocation of the most opulent Gothic.

CHURCH OF SAN FRANCESCO DELLA VIGNA

Paolo Veronese (1528-1588)
Madonna and Saints (Giustinian Altarpiece)

On the left side of the nave in San Francesco della Vigna there stands one of those numerous family chapels that were traditionally built and maintained by the patrician families of Venice. Documents and a plaque inform us that this chapel was completed in 1551 for the brothers Lorenzo and Antonio Giustinian. The date on the wall plaque may well be applicable to this altarpiece by Paolo Veronese, which would make it the earliest of his masterpieces to be seen in Venice. This commission from the Giustinian family would have been a great help in establishing the reputation of the almost unknown Veronese. But the artist also had something else in his favour – his extraordinary gifts as a painter, and a style which in many ways ran contrary to that of Titian (who at the time had no rivals in Venice). However, the young Veronese was cunning enough to take a Titian composition as his model for this painting: the unusual diagonal composition of the *Giustinian Altarpiece* clearly being derived from Titian's *Pesaro Altarpiece* in the church of Santa Maria Gloriosa dei Frari. It was a choice that opened a lot of doors to the young artist. Nevertheless his work did contain a number of new features: first of all there was his excellent draughtsmanship (inspired by the great Mannerists, such as Parmigianino) and then the way he actually applied his paint (achieving the cool tones of the picture through clear, contrasting brushwork – a technique that was a long way from the "impasto" favoured by Titian and most of the Venetian painters of the day). St. Catherine's elegant profile, the luminescent brushstrokes of the Madonna, and the engaging smiles of the Saints are as appealing today as they must have been to Veronese's contemporaries. Only two years later the young artist would be appointed to work on a very major commission: the decoration of the Chambers of the Ten in the Doge's Palace. It was the beginning of a triumphant career which would see Veronese become the greatest "state painter" in Venice and the favourite of patrician connoisseurs such as the Soranzo and Barbaro; with the result that his work is to be found decorating religious buildings, Venetian palazzi and sumptuous country villas.

CHURCH OF SAN GIUSEPPE

Paolo Veronese (1528-1588)
The Adoration of the Shepherds

Not far from the Church of San Francesco della Vigna, among the narrow streets where the sailors and workers of the Serenissima's Arsenale used to live, stands the small church of San Giuseppe. Inside is another patrician family chapel: the Grimani Chapel, which is decorated with this Veronese *Adoration of the Shepherds* – datable around 1582-83, thanks to an autograph letter complete with drawing (now in Berlin). There is also evidence that the work was commissioned by Marino and Almorò, sons of the rich Procurator and Senator Gerolamo Grimani (Marino himself later became Doge); this commission is confirmed by the fact that the figure in priestly robes on the left of the painting is a portait of Gerolamo Grimani. Whilst the *Giustinian Altarpiece* in San Francesco dates from Veronese's youth, this painting is one of his very last works. The colour seems to be dampened by a certain melancholy, and the usual decorative tones are muted by the poignant play of light within the composition. The work marks one of the high points of Veronese's career and is characterized by genuine religious feeling.

CHURCH OF SAN LAZZARO DEI MENDICANTI

Paolo Veronese (1528-1588)
Crucifixion

I have already referred to the religious feeling in the severe *Grimani altarpiece* in San Giuseppe – a work in which the artist gives the impression that he is trying to forget the festive colours of his years of glory. We are left with a similar impression by the *Crucifixion* in San Lazzaro dei Mendicanti (the work originally came from the Incurabili on the Zattere, where it was seen by Sansovino in 1582). Influenced by the new rules for artists issued by the Council of Trent in 1563 and also, perhaps, by Jacopo Bassano's taste for realism, Veronese painted a number of these crepuscular works during the last decade of his life (moving a long way away from his usual decorative style).

However, whilst the tears of Mary and St. John are clear, there is also a flash of the old Venetian sense of colour in the garland of blue-pink cherubs swooping under the arms of the Cross.

This delicate and melancholy motif reminds us of the works in which Veronese had achieved glory as an incomparable colourist.

CHURCH OF SAN GIOVANNI E PAOLO

Gerolamo Mocetto (1454-1531)
Window of Warrior Saints

This tour of Venetian painting could not omit the one surviving example of the large painted glass windows that were a speciality of Murano glassmakers in the period between Late Gothic and Early Renaissance. Nothing serves better than this one stupendous work to express the triumphal spirit of this Basilica of San Zanipolo (the popular Venetian version of "San Giovanni e Paolo"), which was a veritable Pantheon for the Greats of the Venetian nobility. Certainly there were years of work here for those master glass-artists, who were perhaps headed by Bartolomeo Vivarini (to whom documents records payments made in 1510-1515). In 1515 the diarist Sanudo recorded that the large window was being completed with four *Warrior Saints* in the lower section, and one of these – *St. Theodore* – bears the signature of Gerolamo Mocetto.

Here again, the artist would have prepared a model from which the glass masters worked, using all the resources of colour to produce a finished window through which light filters to great pictorial effect.

Lorenzo Lotto (1485-1556)
The Charity of Saint Antonino

The conventional image of a wealthy and magnificent city – such as that painted by all those who champion the "myth" of sixteenth-century Venice – did not, unfortunately, correspond to the facts. In Venice too there was poverty – which was all the more harsh for being surrounded by such wealth. One only has to recall the severe laws against begging and the efforts made by the city government to encourage the foundation of hospices and charitable institutions to realise just how widespread poverty must have been within the city. Many of these hospices were in the Castello area and included the Ospedaletto, situated a few metres from the church of San Giovanni e Paolo, which received continual applications for handouts and accommodation. One of the members of the Ospedaletto confraternity was the painter Lorenzo Lotto, who had returned to Venice in 1526 after long periods spent in Lombardy and the Marches. And it was this great portrait-artist who painted the large altarpiece commissioned to commemorate the generosity of one benefactor of the poor – the Bishop of Florence, Pierozzi (who was canonized in 1529). Completed in 1542, the work shows the saint judging requests for charity and handing out alms. Seated on the steps of the saint's throne, two priests receive requests and distribute money with a very moving intensity of expression. At the bottom of the painting are the huddled poor: a multicoloured group of prisoners to a harsh fate, whose lot is alleviated by the generosity of the saint.

Giambattista Tiepolo (1696-1770)
Abraham and Isaac

At the beginning of the picturesque Calle di Barbaria delle Tole (carpentry shops) stands the hospice and church of the Ospedaletto. Behind Longhena's facade (1674) is an interior decorated with paintings of the Twelve Apostles and other biblical figures, each placed between two of the columns. According to contemporary sources some of these figures were painted by Tiepolo, when he was around nineteen years old. However, a document drawn up by the *proto* Domenico Rossi gives 1724 as the year in which the *Abraham and Isaac* – the finest of these Tiepolo works – was hung here. All of which has created great confusion as to the other paintings in the series. I still incline to date the *Abraham and Isaac* as the work of a young artist, one in which Tiepolo's genius was still heavily influenced by the style of Piazzetta, his first real teacher. Look, for example at how the surfaces are lit by flashes of light which render them more plastic, at the sharp, incisive lines and the dramatically expressive half-profiles in this biblical scene of the father about to sacrifice his son before being stopped by divine intervention. The burnt colours seem to have been touched by an unreal flame, and are made all the more intense by the red-brown tones of the Armenian bole used to achieve this *tenebroso* effect. Many of these characteristics look forward to Tiepolo's works of the mid-1720s – from the first ceiling paintings in the Church of the Scalzi to the frescoes in Palazzo Sandi. It is there that we will soon see the full flowering of those extraordinary innovations that will be part of Tiepolo's art, and of which these brilliant youthful works give us a mere foretaste. In the Hospice of the Ospedaletto one should not omit to visit the charming *Music Room*, with its Guarana frescoes (1776); in the eighteenth century the concerts given by the girls of the Hospice were rightly famous.

CHURCH OF SANTA MARIA FORMOSA

Jacopo Palma il Vecchio (1480 ? - 1528)
Santa Barbara Polyptych

The church of Santa Maria Formosa (1492) is Codussi's masterpiece, and the measured plasticity of its architecture is much more impressive than the few paintings conserved within the church. However, a guide such as this cannot overlook Palma il Vecchio's large *Santa Barbara Polyptych* on the altar of the Scuola dei Bombardieri (painted between 1523-24), which contains the figures of five saints (Barbara, Sebastian, Antony of Padua, John the Baptist and Vincenzo Ferrer) and, above them, a Pietà.

By now under Titian's overpowering "protection", Palma il Vecchio was an artist whose works were endowed with imposing "body" – and this can be seen in the majestic figure of the central saint who, like a portait sitter, is bedecked in a crimson gown that shows off her opulent blond hair. There can be no doubt that the original gilded wood frame would have brought out the dazzling colour of the work much better that the present marble frame, which dates from the early eighteenth-century.

CHURCH OF SAN LIO

Titian (1490-1576)
St. James

The San Lio area is a bustling district near Rialto, and the Cappellai Altar in the original sixteenth-century church here was decorated with a work by Titian. Recent restoration has returned this *St. James* to its rightful place as one of the finest works produced by the artist in the 1560s. In an atmosphere of suffused colour, against a smoky background that seems to suggest a distant fire, the powerful figure of the pilgrim saint moves towards the edge of the picture, amidst white and carmine-streaked light. The lighting here is close to that in the famous San Salvador *Annunciation*, a masterpiece of the same period. The modesty of the theme – which requires only one figure – is, therefore, deceptive. Even here, Titian makes a very creative use of his medium. His broad brushstokes seem to model the figure as if it were sculpted out of paint, creating a work that is vibrant with drama.

CHURCH OF SANTA MARIA DELLA CONSOLAZIONE (LA FAVA)

Giambattista Tiepolo (1696-1770)
The Education of the Virgin

Recovered after a recent theft, the magnificent Tiepolo *The Education of the Virgin* (1732-33) has now been returned to its rightful place in the small elegant church of Madonna della Fava, which was designed by the Baroque architect Pietro Gaspari and completed by the Rococo architect Giorgio Massari (the name of the church comes from that of a local family). The work is unusually tender for Tiepolo, with the Child Mary working away at a large book while angels and cherubs look on in wonder from clouds above.

Tiepolo adopts near pastel shades of blue and silver to depict the little girl – in marked contrast to the solidly-painted figures of Anna and Joachim, who seem to form a shady niche about their daughter. Certainly it is uncommon to find something of Rosalba Carriera in Tiepolo's work, but perhaps the fact that this was the time when he himself was experiencing the joys of a growing family explains the tenderness in the work. The Fava painting offers us an unusual view of Giambattista as an artist who could feel and communicate poignancy.

SESTIERE OF CANNAREGIO

21 SAN GIOVANNI CRISOSTOMO
22 SANTI APOSTOLI
23 SANTA MARIA DEI GESUITI
24 ORATORIO DEI CROCIFERI
25 MADONNA DELL'ORTO
26 SANT'ALVISE
27 SAN MARCUOLA
28 SAN MARZIALE
29 PALAZZO LABIA

Giovanni Bellini (c. 1430-1516)
St. Jerome and two Saints

The merchant Giorgio Diletti died in 1494, leaving money for the construction of a St Jerome Chapel in Codussi's harmonious single-nave church; on the right of the nave, the chapel would later house the altarpiece of *Saints Jerome, Christopher and Augustine*, signed and dated by Giovanni Bellini in 1513. This is one of the very last paintings by this seemingly inexhaustible artist, who was still at work three years after the death of Giorgione (in the period when Titian was already producing his early works). There are plenty of works which demonstrate Bellini's remarkable desire to keep up to date, and here it is clear that the painting was influenced by the pyramidal composition of Giorgione's Castelfranco altarpiece: the central figure is raised above the other two, in an arrangement which seems to echo the three panels of a triptych. And further proof of the modernity of this work comes from the paint itself – applied in a way that is remarkably similar to the technique of Giorgione and Titian. The old technique of tempera has by now been totally replaced by the technique of oil impasto. So, in a work that shows the towering influence of the two giants of sixteenth-century Venetian painting, where should one look for what is unique to Bellini? I think the answer lies in the very humanity of the figures – in the massive St. Christopher who turns round, like any caring father, to make sure that the child riding on his shoulders is sitting safely or in the austere and cordial St. Jerome, who seems to be closing his book in order to be able to take a more active part in the conversation with the Christ Child.

CHURCH OF SANTI APOSTOLI

Francesco Maffei (c. 1605-1660)
The Guardian Angel

Vittoria's fine church of Santi Apostoli stands at the beginning of Strada Nuova and contains one of the rare Venetian examples of the art of Francesco Maffei, who tended to work mainly in the Vicenza area. The very evolution of Maffei's style, however – from youthful Mannerism to exuberant whimsical Baroque – is sure proof that he spent some time in Venice.

The influence of Tintoretto and and Titian – as well as that of non-Venetian masters such as Liss, Fetti and Strozzi – can be seen in many of his works, including this *Guardian Angel with Tobias*, whose exuberance of colour and movement are indicative of the very features which make Maffei the greatest master of mid-seventeenth-century Venetian painting. Maffei's small altarpiece stands in the Bragadin Chapel, where it replaced a *St. Ludovico* by Domenico Tintoretto.

It was donated to the Scuola dell'Angelo by an unknown benefactress, whose portrait can be seen in the lefthand corner of the painting.

Was it perhaps an ex-voto offering?

Titian (1490-1576)
The Martyrdom of St. Lawrence

The present church of the Gesuiti was designed by Domenico Rossi and built on the site of the church of the Crociferi after the re-admission of the Jesuits to the city of Venice in 1657. Recognising the extraordinary beauty of Titian's large altarpiece the Jesuits hung the painting in a very prominent position within the church. St. Lawrence was accused of having distributed the gold of a pagan temple to the poor and then condemned to be burnt to death in Rome; this representation of his tragic end was commissioned by the merchant Lorenzo Massolo in 1548 to stand in the old church of the Crociferi. For a long time the painting stood unfinished, and was still incomplete when the donor died in 1557. However, Garcia Hernandez, the Procurator of the Spanish king Philip II, mentions the painting hanging in the church in 1564, so it seems likely that the work was completed around 1560. This scene is a perfect expression of all the desperation felt by Titian the old man. The only sources of light are the burning coals under the grid on which the saint is being martyred, the chill moon breaking through storm clouds, and the smoky torches which cast a tragic gleam on the background temple with its pagan statue of Virtue. The heads of the soldiers and executioners are a good example of the technique to be found in Titian's very last works: the brushstrokes are built up on one another in patches of colour that are lit by sudden gleams. The traditional outline of forms has totally disappeared and the scene before our eyes is rendered as some sort of painful vision.

CHURCH OF SANTA MARIA DEI GESUITI

Jacopo Tintoretto (1519-1594)
The Assumption of the Virgin

Our tour could not omit this work, which bears witness to a particular facet of Tintoretto's personality – that instinctive need he had to prove himself against any contemporary who might be seen as a challenge. In his *Maraviglie*, published in 1648, the well-informed Carlo Ridolfi writes: "In the main chapel of the Church of the Order of Crociferi he did the painting with the Ascension of Our Lady into Heaven, and all that which the Fathers had agreed with Paolo Veronese that he shoud do in that painting. Tintoretto had heard of that agreement and promised the Fathers that he would do the painting in the same syle as Paolo, so that no one would have believed it was by himself, and thus he got the commission. Nor did he promise in vain: he produced such a mixture of the bold and the muted that it was clear he really could paint in any style that happened to suit him." Undoubtedly this is a very interesting episode – because it reveals both the aggressive nature of this painter – who tried to "snatch up everything" – and his professed ability "to paint in any style that happened to suit him".

Vasari, who knew him personally, did not call Tintoretto "a terrifying mind" for nothing. This *Assumption*, painted around 1555 for the high altar of the Church of the Crociferi (which was subsequently transformed into the church of the Gesuiti), comes at an important point in Venetian painting and in the development of Tintoretto's own art. Obviously Titian had no real rivals, but this was the time when the generation of the *maniera nuova* were gaining a foothold. These artists – all around twenty-five to thirty years old – included such figures as Jacopo Bassano, Tintoretto himself and, above all, Paolo Veronese, who had arrived in Venice only a short time before but had immediately established a reputation for himself with such important works as the *Giustinian Altarpiece* in the church of San Francesco della Vigna (c. 1551) and the wonderful paintings in the Chambers of the Council of Ten in the Doge's Palace (1553-55). There seems to be little doubt that Tintoretto had immediately seen that Veronese would be his most dangerous rival, and thus his determination to get the Crociferi

commission – even if it had already gone to the "outsider". And, as Ridolfi points out, the final work offers such a mixture of "the bold and the muted" that the sumptuous colours and refined draughtsmanship of the painting prevented anyone from thinking they had lost out. Today we are still charmed and fascinated by the exceptional skill Tintoretto shows in his use of light and colour effects, with the whole composition thrusting upwards and the Virgin herself held halfway between the dazzling clarity of the sky and the angelic choir of colour. The faithful gathered around the altar of carved marble create a dynamic effect that is characteristic of Tintoretto – and of him alone. It's worth recalling the description of the artist given by the critic and poet Marco Boschini in his 1660 *Navegar pitoresco*: "A Mannerist who leaves everyone amazed." Whether the episode recounted by Ridolfi be true or false, it certainly emphasises a key aspect of Tintoretto's character – that desire to "take on" his contemporaries and push himself to the limit of his abilities. History does not tell us what Veronese thought of the whole affair.

THE ORATORY OF THE CROCIFERI

Jacopo Palma il Giovane (1544-1628)
The Mass of Pasquale Cicogna

Up to the time of the 1514 fire the Order of the Crociferi had a church, monastery and hospital in this square. The small Oratory was part of the hospital and still contains the finest series of paintings ever produced by Palma il Giovane, an artist who could adapt himself to meet the needs of any commission. Trained in Rome under the Mannerists, he then moved to Venice when he could be said to have been one of those most active in "carrying on" the art of Titian and Tintoretto. A natural storyteller and an incisive portrait artist, Palma worked between 1586-87 on these Oratory paintings, which narrate the story of the Doges Zen and Cicogna, who played an important part in various important episodes in the history of the Order of the Crociferi.

This picture, showing the Senator Pasquale Cicogna receiving the announcement of his forthcoming election as Doge whilst he is attending Mass, is a particularly emotional work. The faces of the various simple folk gathered around the senator are amongst the greatest works of realism in late sixteenth-century Venetian painting.

Giambattista Cima da Conegliano (c. 1459-1517)
St. John the Baptist and Saints

Cima was commissioned to paint this altarpiece of St. John the Baptist with Saints Peter, Paul, Mark and Jerome for the solitary church of Madonna dell'Orto during his first visit to Venice in 1493-95; the coat-of-arms of the donor, Saraceno del Zio, are included within the picture. As usual in Cima's work, the background contains references to the history of the work and shows the castle of Conegliano on the summit of a hill along with a representation of the Basilica del Santo in Padua (a probable allusion to the donor). Once again the secret of the work's expressiveness lies in the crystalline atmosphere of the brilliant blue sky, a realistic rendering of the transparent air of the Veneto hills, which Cima creates with skilfully applied washes. Cima's world is a classical one, in which the rustic serenity of the figures seems to recall a lost Golden Age (a world similar to that to be found in Virgil's *Georgics*). One does not have to look far to find an echo of that renewed interest in classical literature which was so much a part of the Venetian cultural life of the time (the period when the printer Aldo Manuzio was active).

CHURCH OF MADONNA DELL'ORTO

Jacopo Tintoretto (1519-1594)
The Presentation of the Virgin in the Temple

If one wants to understand Tintoretto's early works then one has to visit the presbytery of Madonna dell'Orto, which was the artist's parish church. Dating from the early 1550s, the works here are among the most monumental compositions he ever produced and include *The Adoration of the Golden Calf* and *The Last Judgement* – massive arrangements of figures in fluidly twisting poses that are typical of Mannerism. But perhaps the most inspired Tintoretto work in this church is the *Presentation of the Virgin in the Temple* (1552-53), in the St. Mark's Chapel in the right aisle. Originally the two outer doors of the church organ, the panels have now been joined into a single picture centred around the daring perspective view of the semi-circular staircase, up which the undaunted Child Mary makes her way towards the priests awaiting her.

Whilst looking at this work one should perhaps recall Titian's 1539 treatment of the same subject in the Scuola della Carità (now in the Accademia Gallery). Tintoretto too opts for the isolation of the central figure of the Virgin, even going so far as to depict her against the immense space of a sky of shifting colours. However, the treatment of the crowd in the two pictures is very different: whilst Titian aimed for a realistic portrait of faces and costumes, the figures which crowd the foreground and the steps on the left of Tintoretto's painting are clearly inspired by Roman Mannerism (particularly those sculptural Michelangelesque figures massed at the foot of the steps). This development in Tintoretto's artistic language has led some critics to suppose he actually went to Rome at some point. Whether he did or not, it is clear from this work that, whenever he could, Tintoretto made full use of that "mighty brain" critics were already beginning to credit him with.

CHURCH OF SANT'ALVISE

Lazzaro Bastiani (c. 1475-1512)
The Poverty of Job

Tradition has it that the fourteenth-century church of Sant'Alvise was built as the result of a dream by its patron, Antonia Venier. Perhaps this is why an air of mysticism did hang over this church – one of the most remote in Venice – which stands at the far end of Cannaregio.

The church now houses a *predella* of nine panels depicting the lives of the saints (originally from the church of Santa Maria delle Vergini at the Arsenale, which no longer exists). Perhaps due to its ingenuous simplicity, which makes it so similar to the work of the Italian "primitives", the work enjoyed a certain vogue from the mid-nineteenth century to the early years of the present century (it was even considered by some to be one of the earliest works of Vittore Carpaccio).

The modern attribution to Lazzaro Bastiani would, however, seem to be much more convincing. The simple narrative approach – along with the rather rigid Mantegnesque line – are both typical of Bastiani's better-known works such as the *Reception of the Reliquaries of the True Cross* (in the Accademia). The rather harsh line and the dull colours of this work would seem to put Bastiani amongst those backward-looking artists of the late fourteenth century who had failed to keep pace with the chromatic innovations of a master such as Giovanni Bellini. The puppet-like gestures of the figures are another archaicism in the work, and seem to be inspired by the work of medieval miniaturists.

Giambattista Tiepolo (1696-1770)
Christ on Calvary

Sant'Alvise also contains a masterpiece of Tiepolo's religious art – the three paintings depicting *The Passion of Christ* (c. 1740). The Tiepolos of this period are very much "costume" works – so much so that the artist gives the impression of having sought out his subjects on the stage of the opera house.

The compositions certainly seem to show the influence of theatrical scenography – something which it would have been difficult to avoid in a Venice full of opera houses.

These were the influences amongst which Tiepolo was preparing himself for the great decorative commissions of the 1740-50s (Carmini, Scalzi, Palazzo Labia, Würzburg and the Pietà). Obviously Tiepolo also made ample use of the great sixteenth-century paintings which he had at his disposal, even if it is clear that he "re-read" them in a rococo key. However, there can be no doubt that the Sant'Alvise *Christ on Calvary* was inspired by the grandeur of Tintoretto and by his dynamic use of illumination.

Other influences can also be traced: the very choice of the biblical figures seems determined by the Rembrandt engravings which Tiepolo would have known thanks to the collection owned by his friend Anton Maria Zanetti.

However Tiepolo's real world remains the rhetorical and rather fatuous world of Rococo. Even if his patrons' main request was the exaltation of family myths – which tended to result in a rather melodramatic presentation of his figures – Tiepolo still remained true to his festive palette, his colours a swirl of elegance and playfulness that is quintessentially eighteenth-century.

CHURCH OF SAN MARCUOLA

Jacopo Tintoretto (1519-1594)
The Last Supper

Commonly known as San Marcuola, the church of Saints Hermagoras and Fortunatus was remodelled in 1736 by Massari. This elegant Rococo building still houses the works painted for the original church, including this wonderful *Last Supper* by Tintoretto.
One of his very first treatments of the subject, it was long one of the artist's own favourites.
Still under thirty, the young artist here used a frontal composition derived from Medieval art. What is new in the work is the breadth of handling of the paint, with sudden flashes of light which imbue the figures of Christ and the twelves Apostles with a sort of stormy energy. At the sides of the picture stand the figures of Faith and Charity.
Painted in 1547 for the Scuola del Santissimo Sacramento, the work dates from the period when Tintoretto was beginning to establish himself as an artist who offered a more lively, "popular" alternative to the sumptuous chromaticism of Titian, whose supremacy in Venetian painting had been unchallenged for years. There are certain noteworthy stylistic parallels between this work and that of the Cretan painters who were then working in Venice (Crete was at the time a Venetian possession) and whose art expressed the same ingenuous feeling which can be seen in Tintoretto's work. It was from this very background that the unmistakable artistic genius of Domenico Theotocopuli (otherwise known as El Greco) would emerge a few decades later.

CHURCH OF SAN MARZIALE

Sebastiano Ricci (1659-1743)
The Miraculous Arrival of the Statue of the Madonna

Popular legend would have it that the angels carved a statue of the Madonna and brought it to the newly-remodelled church of San Marziale (where work had begun in 1693). The episode is depicted in this canvas by Sebastiano Ricci; painted in 1705, it is a surprisingly early trace of the Rococo style in Venice. The refreshing dynamism of this playful swirl of Angelic wings – with its frayed surfaces of paint aglitter with sudden gleams – would be a model for decades of painters. A few years later Ricci would set off on travels that would take him the length and breadth of Europe, where he would produce numerous masterpieces in the Rococo style he undoubtedly anticipated here. The fruits of his work would be gathered in the second decade of the century by the youthful genius of Giambattista Tiepolo. Given their location within this obscure church, the ceiling paintings have never received the attention they deserve. However, one should not forget that Venetian painting of the early years of the eighteenth century played an unforgettable role in the development of European Rococo.

PALAZZO LABIA

Giambattista Tiepolo (1696-1770)
The Banquet of Cleopatra

In his famous travel diaries, the Frenchman De Brosses records having met Donna Maria Labia, one of the most famous of Venetian noblewomen, in 1739. At that very time, Donna Maria was working along with her son Paolo Antonio on the finishing touches to their extension work on the family palazzo at San Geremia, and was already thinking of the addition of a magnificent ballroom. De Brosses was most impressed by the intelligence, gentility and well-preserved beauty of a woman who was famous in the popular imagination as a figure of fabulous wealth; her collection of jewels, for example, was legendary. Given the woman she was, it was almost predictable that she should appoint Tiepolo to decorate her ballroom the moment it was completed. Nor should we be surprised that the mistress of the house chose as a theme for these frescoes the story of Cleopatra, Queen of Egypt – a woman known for her fabulous wealth – and the tragic end of her love affair with the Roman general Mark Antony.
Tiepolo most probably began work on the ballroom in 1746 (and to do so delayed his departure for Würzburg, where he

had been called to decorate the Residence of the Bishop). All in all, the decorative scheme consists of a ceiling fresco of *The Triumph of Apollo* and of the two major scenes of *The Meeting of Antony and Cleopatra* and *The Banquet of Cleopatra*. It is in this latter, which now strikes us as the most extraordinary of the whole room, that one cannot help but notice parallels with the mistress of the house. Just as Donna Maria delighted in flaunting her jewels and wealth, so Cleopatra enjoys betting Antony that she will be able to hold a banquet that will cost her no less than one hundred thousand sesterces – a bet which she then wins by simply dissolving one legendary pearl, worth exactly that sum, in a glass of vinegar.

Tiepolo spent a long time on this composition, even availing himself of the suggestions of his erudite friend Francesco Algarotti (for whom he had already painted another *Banquet*, now in Melbourne).

The moment depicted is precisely that when Cleopatra dissolves the pearl. Seated opposite each other, the two lovers seem to brave each other with lofty gestures: dressed in armour, Antony has even forgotten to take off his helmet as he fixes a languid gaze on his beloved Cleopatra, who is magnificent in her gown of dazzling silk. The whole event has a sense of theatre about it – but the actors are so compelling that they make the incredible scene perfectly believable.

The two main characters are caught up in a festive atmosphere, whilst the small orchestra seems intended to establish a link between the days of Ancient Egypt and those of eighteenth-century Venice. Thus Tiepolo's painting seems to perform an important miracle for a Venice that was struggling to revive its heyday while it was slowly sinking into illusions and oblivion.

SESTIERE OF SANTA CROCE

30 SANTA MARIA MATERDOMINI
31 SAN CASSIANO
32 SAN STAE
33 SAN NICOLA DA TOLENTINO

CHURCH OF SANTA MARIA MATERDOMINI

Vincenzo Catena (c. 1480-1531)
The Angels save St. Christine

Santa Maria Materdomini is a Renaissance church in a cosy little square set amongst the maze of *calli* that run through the sestiere of Santa Croce. Inside there are two rare works by followers of Bellini: Bissolo's *Transfiguration* and Catena's *St. Christine*. We are particularly interested in the latter, which like so many Venetian works depicts a story told in the *Golden Legend*. Convicted of distributing her father's wealth to the poor, Christine was condemned to be thrown into the Lake of Bolsena with a millstone round her neck. However the angels saved her and carried her back to dry land.
Catena represents this simple story in a very "primitive" style; the little choir of winged angels around the saint make the dramatic scene into a tender one, whilst Christ looks on from within an "almond" of light.
The naturalness of the narrative cannot but charm us and we are soon caught up in the ingenuous atmosphere of the scene.

CHURCH OF SAN CASSIANO

Jacopo Tintoretto (1519-1594)
Crucifixion

In 1568 Tintoretto decorated the presbytery of the church of San Cassiano near Rialto with two large paintings: *The Descent into Limbo* and *The Crucifixion*. The latter is an unusual composition which reveals the extraordinary range of Tintoretto's artistic imagination.

The three crosses mark out the diagonal perspective of the painting from right to left, with the result that the moment he walks in the door of the presbytery, the visitor feels he is actually present within the tragic scene depicted.

The dynamic rhythm of the scene can also be seen in the very bodies of those crucified, who are turned to face the spectator full-on and seem to swell up to occupy the entire painting; whilst the background is measured out by the lances of the soldiers standing around Calvary.

The blues and greys of the sky indicate that the moment of Christ's death is near, and are in vivid contrast to the vivid pinks of the cloak thrown on the ground to be divided.

It almost seems as if a light shines forth from these details themselves to seize upon the emotions of the spectator like a cry of desperation and death.

CHURCH OF SAN STAE

Gian Battista Piazzetta (1682-1754)
The Capture of St. James

Situated on a key site overlooking the Grand Canal, the church of San Stae underwent numerous modifications at the beginning of the eighteenth century, with the result that it now has much of the elegance of early Rococo. In 1709 Domenico Rossi re-did the church's facade and adorned it with statues by some of the most famous sculptors of the day (Torretto, Tarsia, Baratta, Cabianca, Groppelli and Corradini). New paintings were added to the interior – and in particular to the presbytery, which was decorated with the Twelve Apostles left to the church by Andrea Stazio. Each of the twelve paintings had been commissioned from a different artist (Ricci, Pittoni, Pellegrini, Piazzetta and Tiepolo, to name a but few) and so the whole series constitutes a unique panorama of Venetian painting around 1722. Piazzetta's *St. James* dragged off to martyrdom is a marvellous summary of the artist's style: perfect anatomical draughtsmanship which emphasizes volume, gleaming twilight colours which enhance the moulding of form and a profoundly touching vigour of expression.

THE ITINERARIES: SANTA CROCE

Giambattista Tiepolo (1696-1770)
Martyrdom of St. Bartholomew

Hanging opposite the Piazzetta *St James* in the San Stae Presbytery, Tiepolo's picture must have been completed around the same time (c. 1722); in fact, the two paintings are in some ways mirror images of each other. There is an overwhelming cruelty in this depiction of the *Martyrdom of St. Bartholomew*, who after a period of missionary work in India had moved to Armenia, where he was skinned alive.

In this early work we can already see the differences between Tiepolo's artistic language and that of his first masters (Piazzetta and Ricci) – not only in the draughtsmanship but also in the very special quality of the colours used. Look, for example, at the red and green brushstrokes used to construct the executioner's beret, which is echoed lower down by the green-hooded figure of the young man drawing back in horror. That figure incidentally is an obvious self-portrait – a further sign of Tiepolo's peremptory entrance onto the scene.

CHURCH OF SAN NICOLA DA TOLENTINO

Bernardo Strozzi (1581-1644)
St. Lawrence giving Alms

If one is to see Bernardo Strozzi in his true Venetian setting, one has to search him out in the grandiose church of the Tolentini, which was built after designs by Scamozzi. Here his work can be seen alongside that of other early-seventeenth-century artists such as Padovanino and Johann Liss. The early part of Strozzi's life was spent in Genoa, a recalcitrant monk subject to persecution by his fellow Capuchins. As a painter, his style developed under the Caravaggesque influence imported into Genoa from Rome by a number of artists; later he would come under the influence of Rubens and Van Dyck during the period of their short stays in Liguria, and the high-quality draughtsmanship and sharp colours he took from them would henceforth become his own hallmark. He arrived in Venice around 1630 and soon made an important contribution to the renewal of the Venetian colourist tradition which took place during the early decades of the century (due largely to the influence of foreign artists).
The *St. Lawrence giving Alms* in the church of the Tolentini is one of the few Strozzi paintings in Venice that is still hanging in its original site. The acute angle of the perspective adds to the realism of the representation, whilst the dashing, animated brushstrokes are clearly inspired by Dutch art. Thanks to Strozzi, Venetian painting overcame the academic isolationism that had been engendered by those who had followed on from the great masters of the sixteenth-century, and thus Venetian painters once more re-established contact with the painterly world of European art.

SESTIERE OF SAN POLO

34 SANTA MARIA DEI FRARI
35 SCUOLA GRANDE DI SAN ROCCO
36 SAN POLO

Giovanni Bellini (c. 1430-1516)
Madonna and Saints

The imposing Gothic basilica of Santa Maria dei Frari contains some of the most important paintings of the Venetian Renaissance (by artists such as Bellini and Titian). We will begin our visit in the sacristy, which contains a marvellous *Madonna and Saints* by Bellini. In spite of his advanced age, the artist produced some of his most noteworthy works in the year 1488: various wonderful *Madonnas*, the *Votive Picture of Doge Agostino Barbarigo* in the church of San Pietro Martire in Murano and this, the most moving of all that year's paintings, the *Madonna and Saints* (Nicholas, Peter, Paul and Benedict), commissioned to hang over the altar of the sacristy (where it still hangs in the original gilded wood frame made by Jacopo da Faenza). It is worth spending some time on this picture if one wants to find one's way around the space so brilliantly created by the artist. First impressions are dominated by the scintillating gold mosaic niche which contains the seated Madonna and Child. Two delightful angel musicians play on flute and lute and their music swells up within the golden motes of light. To both sides, corridor-like perspective opens out onto a narrow band of landscape. Thus the various parts of the composition fit together to form a pictorial whole which serves to focus the devout intensity of the various figures. The atmospheric handling of the paint adds to the mystic aura which surrounds the figures and captivates the spectator. Bellini's saints seem to project an aura of religious devotion and moral strength, creating an atmosphere which clearly returned to the mind of Albrecht Dürer when he was working on his *Four Apostles* in Nuremberg (works that appear to openly admit their debt to Bellini).

Titian (1490-1576)
The Assumption of the Virgin

The aisle perspective of the church of Santa Maria dei Frari is dominated by Titian's *Assumption of the Virgin* over the high altar, which is undoubtedly the most famous painting of the Venetian Renaissance. Numerous contemporary sources mention the work, a foretaste of the unconditional admiration the painting has enjoyed ever since. An inscription in the marble frame records that the work was commissioned in 1516 by Friar Germano, Superior of the Franciscan Monastery. Titian must have started work on the project with unusual urgency because the finished altarpiece was installed on 20 May 1518, in an elaborate public ceremony. The bafflement caused by the iconographical innovations in the work – such as the shapely Madonna and the gesticulating Apostles – soon gave way to enthusiastic praise. In his 1548 *Dialogo*, the critic Paolo Pino put it well when he said: "...And if Titian and Michelangelo were one person; that is, if the draughtsmanship of Michelangelo went together with the colour of Titian, one could call that person the god of painting." In fact, the modelling of the painted figures in Titian's altarpiece does have a monumental quality about it. And the numerous innovations here add even greater realism to the charisma that can already be seen in other similar works of the same period (for example, Bellini's 1513 *Appearance of the Virgin* in the church of San Pietro Martire). This joyous range of colours, which seem to glow with an inner fire, is, however, something totally new. As Ludovico Dolce, another contemporary critic, put it in 1544: with the *Assumption of the Virgin*, Venice finally had "her own Raphael and Michelangelo". The figure of the Virgin herself is particularly felicitous: a wonderful young woman of fascinating, yet noble, sensuality, who embodies all the empassioned admiration for beauty that is a relevant characteristic of Titian's art.

Titian (1490-1576)
The Pesaro Altarpiece

The sensation caused by the *Assumption* had not yet died down when the church of Santa Maria dei Frari got the chance to add another Titian masterpiece to its collection: the *Pesaro altarpiece* commissioned in 1519 by Bishop Jacopo Pesaro, former admiral of the Venetian fleet in the victorious sea-battle of Santa Maura (1502). The altar chosen was that of the Immacolata (where an important service was held for Venetian admirals every year on 30 April); so the painting enabled the Pesaro family – one of those from which Venice's doges were elected – to unite celebration of that religious function, of the naval victory of Santa Maura and of themselves (their collective portraits in the painting form a sort of ex-voto). In fact, bottom left is Bishop Jacopo Pesaro himself, with a soldier in armour who is leading a Turkish prisoner; to the right is Senator Francesco Pesaro with two other brothers (perhaps Antonio and Giovanni), whilst behind are Antonio's young sons (Leonardo and Nicolò). Above them stands St. Peter and the family patron saints of Francis and Antony, who look on benevolently; whilst the centre of the picture is occupied by a sumptuous image of the Madonna and Child, enthroned between two columns which represent the Gates of Heaven. Given his European reputation, Titian was by this time a very busy man and the Pesaro family had to wait years for their altarpiece, which was finally installed with great solemnity on 30 april 1526. The picture marks another important step forward by the great Venetian colourists. The dazzling reds of the flag and the robes of the saints, the full-bodied transparency in the handling of the furs adorning the donors, and the clear sunlight which floods the rich colours of the whole – all of these show that the *Pesaro Altarpiece* has nothing to envy any of the other great paintings of its time.

Giorgione (1476-1510)
Christ carrying the Cross

This famous holy image of *Christ carrying the Cross* was already hanging on a column in the presbytery of the Church of San Rocco by 1508, and remained there for centuries; recently it has been moved to the better-protected Scuola alongside. The attribution of the work is a matter of controversy, given that the oldest known attributions – including Vasari (1550) – give the paintings as Giorgione's, but Vasari later contradicts himself (in 1568) and mentions the work as by Titian. Modern criticism has since identified a very late period in Giorgione's art, when the artist was making a conscious attempt to assimilate Titian's artistic language. This could explain those Titianesque features in *Christ carrying the Cross*; however one could attribute the work to Titian himself if one gives excessive importance to the pronounced realism of the depiction of the executioners. There are, nevertheless, many reasons for keeping to the original Giorgione attribution. Firstly there is the fact that in 1508 Titian was still only an apprentice of genius in comparison to Giorgione; he would not have had the depth of insight or technical mastery to produce such a mature work. Secondly, there is the *Christ* in the Gardner Museum (Boston), which is undoubtedly a Giorgione and clearly served as a model for this *Christ carrying the Cross*. Finally, the slightly opaque colours and the gentle handling seem to be typical of such late Giorgione works as the San Diego *Terris portrait* (signed and dated 1510) and the *Col Tempo* in the Accademia. Whatever the truth, no questions of attribution can take away from the melancholy and mysterious fascination of the figures in this painting – a fascination that is characteristic of all Giorgione's late work (particularly his portraits).

Jacopo Tintoretto (1519-1594)
Crucifixion

The Scuola Grande di San Rocco could be described as a veritable monument to Tintoretto's art, and the adventurous story behind the paintings here is largely the result of the bizarre character of the artist himself. Immediately after the completion of Scarpagnino's building (1549), the Confraternity of St. Roch began planning the decoration of the interior. However the meeting to judge the various schemes submitted by Venetian artists of the day (including Federico Zuccari, Giuseppe Salviati, Paolo Veronese and Jacopo Tintoretto) was only held on 31 may 1564. The competition design had to be an oval painting of *The Triumph of San Rocco*. However, whilst the others submitted drawings and sketches, Tintoretto – with the help of the custodian of the building – arranged for the judging panel to find a finished picture already installed within the oval space of the ceiling panel. Thus, in spite of the grumbling of a few members of the confraternity who were hostile to Tintoretto, the artist got the commission (he even promised to paint the rest of the ceiling at no extra cost – as long as he was commissioned to do the entire decorative scheme for the Scuola). Perhaps it is because of this daring behaviour, or perhaps it is because of the passion that one senses behind this eagerness, but it does seem to be that this room still contains the most significant paintings of a scheme that would eventually extend throughout the Scuola and finally comprise 38 paintings (all by Tintoretto's own hand). Occupying the end wall of the Sala dell'Albergo (above the seats occupied by the Confraternity Council), the massive *Crucifixion* is undoubtedly a work of great theatrical effectiveness. Completed in 1565 and measuring approximately 5 by 12 metres, the composition is laid out like a theater. Centre-stage forward is the pyramid of mourners surrounding the Virgin, whilst the Roman officers who look on act as stage curtains on either side of the scene. Upstage, left and right, we can see two caravans of camels and horses approaching. But the lynchpin of the whole composition is Christ's Cross, fixed at the junction of the diagonals. Fascinated by so much drama, we are caught up in the unfurling of the narrative and our imagination is seized as if by some supernatural event.

SCUOLA GRANDE DI SAN ROCCO

Jacopo Tintoretto (1519-1594)
Christ before Pontius Pilate

This is another of the paintings in the *Albergo* which immediately seizes upon our emotions. The imposing figure of Christ is deliberately out of proportion to the rest of the scene, emphasising the drama of the event. His pure white garment serves to distinguish him from Pilate, who is portrayed sideways within a sort of shadowy niche. Christ is the virtuous man dragged before Injustice, and Pilate seems to be trying to hide behind the pillars of his own palace (a perfect symbol of cowardice and treachery).

In the background, from amongst the rabble crowded around the Roman Governor comes the rowdy cry: "Whom do you want saved – Jesus or Barabbas?" (a self-confessed murderer about to be executed). "Barabbas" answers the savage crowd. And Tintoretto – who is perhaps symbolised by the court chancellor who squats on the steps writing out the sentence – seems to be making an accusatory gesture directed against all of us, involving the whole of humanity in this scene of tragic suffering.

Jacopo Tintoretto (1519-1594)
Christ in the Garden of Gethsemane

After the *Sala dell'Albergo* Tintoretto moved on to the Upper Hall, where he decorated first the ceiling with *Scenes from the Old Testament* (1572-75) and then the walls with *Scenes from the life of Christ* (1578-81).

An insatiable innovator in both style and technique, the artist here adapted his extraordinary narrative skills to the unsophisticated sentiments of the faithful. As a result, he seems to have made a technical discovery which enabled him to manage the temporal sequence of his story more effectively.

In fact, this dynamic narrative uses a rapid – almost cinematic – succession of images.

How does the painter achieve such a fluidity of narrative? He takes each of the episodes and holds them, emphasizing the key moments in each.

In *Christ in the Garden of Gethsemane*, for example, we see first the scene of Christ and the angel with the chalice – a symbol of Christ's ineluctable fate – first offered and rejected, then accepted with resignation.

However, other events are simultaneously unfolding within the same picture: Judas is leading the soldiers to arrest Christ and Peter has awoken from his sleep to look in the direction of the approaching footsteps. A moment later and Judas and the soldiers will be upon them and Christ will be captured.

One might think that Tintoretto was expecting too much of his unsophisticated audience, but that is not the case. The images follow on from each other with such speed that the dramatic narrative is made even more telling. What one sees here could be described as Tintoretto giving a hand to the Wheel of Destiny.

SCUOLA GRANDE DI SAN ROCCO

Jacopo Tintoretto (1519-1594)
Female Hermit in Meditation

Tintoretto came back to the Scuola in 1582-87 to work on the decoration of the Lower Hall.
Dating from the last decade of the artist's life (when his health was failing), these works reveal a certain tiredness in both execution (often the work of assistants) and palette (the colours are darker and more tormented).
The two works that hang alongside the San Rocco altar – traditionally identified as Mary Magdalene and Mary of Egypt meditating in the desert – are typical of this late style. The latter work is particularly striking, with its female hermit meditating alongside a babbling stream, the source of which is in the distant hills seen against a nocturnal sky heavy with an approaching summer storm.
Flashes of lightning and far-off growls of thunder, heavy rain clouds and a wind that rustles through palms whose fronds burn like so many fireworks – these are all so many disguises for the uncontrollable anguish of an aged artist who knows that death is approaching.

CHURCH OF SAN POLO

Giandomenico Tiepolo (1727-1804)
Jesus stripped of his Garments

Whilst the name of Giambattista Tiepolo is associated with a triumph of light and colour, the name of his son Giandomenico is linked with the grotesque and the melancholic – expressive means favoured by a more introverted personality. However, Giandomenico rarely worked as other than his father's assistant – so those few occasions when he is "his own man" should be treasured as authentic statements of his real artistic personality.

One such case is the *Via Crucis* in the small Oratory of the Crucifixion in the church of San Polo (1747-48), commissioned when Giandomenico was just over twenty years old (probably as a result of Alvise Cornaro's patronage of the artist).

The work reveals an unexpected artistic spirit: figures are drawn with an unusual realism which verges on caricature; the muted, melancholic colours have a pallid, chalky glow. This *Christ stripped of his Garments* is a perfect example of Giandomenico's temperament and leaves one feeling somewhat bewildered. What is the significance of those gesticulating figures seen from behind – in the middle of a crowd which seems to be protesting against its own lack of freedom?

And why is that young woman on the right (in modern dress) staring disconsolately towards us, as if she wants to communicate some feeling, some secret message to us? Years later Giandomenico continued to be under the regime of his father, but we get further glimpses of his true spirit in the *foresteria* (guest-quarters) of Villa Valmarana or, even better, in the small rooms of Tiepolo's own villa at Zianigo (the work which is now in Ca' Rezzonico). Giandomenico's personal style seems to reach beyond his own time, beyond the Venice that was apparently trapped in an interminable Carnival.

SESTIERE OF DORSODURO

37 SANTA MARIA DELLA SALUTE
38 SANTA MARIA DEL ROSARIO (GESUATI)
39 SAN TROVASO
40 SANTA MARIA DEL CARMELO
41 SCUOLA DEI CARMINI
42 SAN SEBASTIANO
43 SAN PANTALON
44 ANGELO RAFFAELE
45 REDENTORE

CHURCH OF SANTA MARIA DELLA SALUTE

Titian (1490-1576)
Pentecost

Begun in 1631 as an ex-voto for Venice's redemption from a terrible pestilence, the most striking thing about the church of Santa Maria della Salute is undoubtedly its architecture. Baldassare Longhena's winning design for the church is calculated for full spectacular effect; conceived as a "crown", the building not only renders homage to the Madonna herself but also serves as a perfect setting for the popular celebrations held to mark the end of the plague. Given the profusion of monumental pilasters, columns, capitals and cornices – as well as the theatrical figures by the sculptor Josse Le Court (an essential part of Longhena's design) – it is inevitable that paintings should take a backseat within the church. However, quite apart from the paintings that have been brought here from other (subsequently destroyed) churches, each of the Salute's six altars is decorated with paintings which merit careful study. Titian's *Pentecost* (originally from the church of the Holy Spirit, which no longer exists) is of particular importance. Thanks to a courtcase over its late delivery, it can be dated with precision as completed in 1559 (a few years after Titian's return from Rome) – and there can be no doubt that the monumental composition owes something to the work of Michelangelo (particularly those statuesque Apostles gathered around the Madonna under the flashing Holy Spirit). Once again the most evocative feature of the painting is the range of colours used, which are highlighted by the explosions of light within the ceiling of the chapel inside which the miracle occurs. It almost seems as if those who commissioned the work had encouraged Titian to vie with Veronese's palette and Tintoretto's dramatic use of light – in short, to take on, on their own terms, the artists who had become his two greatest rivals.

CHURCH OF SANTA MARIA DEL ROSARIO (GESUATI)

Giambattista Tiepolo (1696-1770)
The Virgin appears to three Domenican Saints

Completed in 1736 and subsequently decorated with elegant rococo statues and bas-reliefs by Gian Maria Morlaiter, this Massari church on the Zattere waterfront looks like something in a theatrical backcloth. In Venice the church is commonly known as *I Gesuati*, after the religious Order who are responsible for it, and it was in fact those Fathers who commissioned Tiepolo to decorate the ceiling of the building with frescoes recounting the *Institution of the Rosary* (1737-39). The work is clearly one of the very first examples of the "Veronese" style which Tiepolo favoured in the 1730s. In clear morning light the Virgin hands the Rosary to a St. Domenico who is kneeling on splendidly scenographic steps. The sky is illuminated by groups of angels slowly beating their mother-of-pearl wings in a translucent blue light. It was only in 1748 that Tiepolo would complete the second half of the commission – the altarpiece which shows the *Three Female Saints of the Domenican Order*, one of the most ornate and freely-handled of his religious paintings. St. Catherine of Siena holds the crucified Christ, St. Rose of Lima bears the Christ Child in her arms and St. Agnes is kneeling – all three of them arranged around the superbly beautiful Virgin, depicted against the light on a throne of clouds. Placed near the door of the church – which gives onto the Zattere – the painting seems to draw into itself all the bleached light which enters the building from outside.

THE ITINERARIES: DORSODURO

CHURCH OF SAN TROVASO

Michele Giambono (active 1420-1462)

San Crisogono

In this quiet part of Dorsoduro, near an old *squero* (gondola-yard) that is still in operation, stands the church of San Trovaso (the name being a dialect abbreviation of Saints Gervasio e Protasio). The most interesting painting here is that of *San Crisogono*, who was apparently a warrior saint from the time of the Crusades. The medieval charm of this magnificent work depends largely on the decorative rendering of the armour, with the entire composition enclosed by a streaming damasked banner painted against the gold background.

A very unprolific painter, Giambono was one of those artists who worked in the Doge's Palace under Jacopo Bellini, which makes this – one of his very few works – all the more interesting. The International Gothic taste revealed here (c. 1445), is precisely the same as that to be found in so many of the sumptuous buildings which would make Venice a city unique in Europe.

CHURCH OF SANTA MARIA DEL CARMELO

Lorenzo Lotto (c. 1480-1558)
St. Nicholas in Glory

Upon his return from Bergamo in 1526, Lotto tried to regain his rightful place amongst the leading Venetian painters of the day. However, the increasing success of Titian obliged him to play second fiddle more and more frequently. Dolce (1557) even went so far as to cite this 1529 *St. Nicholas* altarpiece in the Carmini as a "notable example of wretched colouring". Nowadays, however, we are more fair to the painting, particularly with regard to its landscape – a stunning vision of a port under a stormy sky which seems to extinguish all colours under a pall of grey. Meanwhile the saints and angels gathered around the rather conventional figure of St. Nicholas seem totally oblivious to what is happening behind them. Was their indifference part of the reason for the unfavourable critical reaction to the work in the sixteenth century?

SCUOLA DEI CARMINI

Giambattista Tiepolo (1696-1770)
The Madonna appearing to Blessed Simon Stock

At the southern end of bustling Campo Santa Margherita is the facade of the Scuola di Santa Maria del Carmelo (popularly known as the Scuola dei Carmini). Even though there is no documentary proof to support the claim, the original designs for this building are attributed to Baldassare Longhena. In the mid-eighteenth century it was decided to decorate the interior with a series of large-scale canvases, and the commission for the ceiling of the Council Hall went to Tiepolo; the dates given on the various pictures, which represent *The Christian Virtues*, show that the artist started work in 1743. Six years later he completed the main central panel, which shows the *Madonna* descending to give the scapular (a symbol of penitence) to Blessed Simon Stock.

The Carmini paintings are a jubilant triumph hailed by a choir of angelic voices. The sensual beauty of the Virtues and of the Madonna herself are openly inspired by Veronese's work in the Doge's Palace. This is therefore one of the most explicit expressions of triumphalism in Tiepolo's work, and seems to mark a return to the Golden Age of Venetian painting. Certainly, one has some difficulty in identifying genuine religious feeling in these works; but then this was the time of the most carefree Rococo – a style in which Tiepolo engaged wholeheartedly, uniting it with a classically-inspired palette in works that would make him the undisputed master of the European artists of his day.

Paolo Veronese (1528-1588)
The Triumph of Mordecai

The opening of Veronese's career in Venice was marked by the *Giustinian Altarpiece* – painted in 1551, when he was barely twenty years old – after which he soon went on to the decorations of the Chambers of the Council of Ten in the Doge's Palace (works that would triumphantly establish his reputation in the city). Two years later Prior Bernardo Torlioni commissioned the artist to paint what is now considered his masterpiece – the decoration for the monastery church of San Sebastiano. When he had finished work in the sacristy in 1555, Veronese moved on to the ceiling of the nave of this luminous church, where his three large paintings of *The Story of Queen Esther* were installed in 1556. Thereafter would follow the frescoes in the aisles and choir, and the paintings for the two organ doors, the high altar (1561) and the presbytery (the large *Martyr* canvases of 1565-70). Amongst such wonderful works one is almost spoilt for choice; but perhaps the paintings that decorate the ceiling of the nave are among Veronese's most felicitous works. The counterpoint achieved between the two rearing horses of the opposing generals in *The Triumph of Mordecai* is one of the highpoints in Veronese's use of emphatic colour. The black horse of the defeated Haman rears up amongst Mordecai's victorious soldiers whilst above him unfurls the crimson banner of King Ahasuerus, adding a vivid decorative touch to the picture. The composition pushes the figures to the very edge of the foreground, creating the impression of a headlong rush halted just before the figures tumble out of the painting. The vertiginous foreshortening creates a world of giants, thus adding to the dramatic tension of the scene. An unparalleled draughtsman and an instinctive colourist, Veronese seems to use his brush to dash off figures in a blaze of light. A veritable rainbow of colours shines against a limitless clear sky.

CHURCH OF SAN PANTALON

Paolo Veronese (1528-1588)
The Conversion and Miracle of San Pantalon

Paolo Veronese's career unfortunately came to an abrupt end in his sixtieth year, and the palette of his last years reveals a change towards more crepuscular, shadowy colours.

The paintings are often interior scenes without an open expanse of sky, or else nocturnal scenes with artificial lighting.

There are also numerous scenes of death – such as those of the *Pietà*, with the body of Christ held up by angels.

However, even in this period of meditation and melancholy, Veronese's work could still achieve the standard of his former masterpieces.

A typical painting from this late period is the *Miracle of San Pantalon*, which hangs in a rather dark side chapel in the south aisle of the church. The setting is the door of a hovel, with a priest (Bartolomeo Borghi), the saint himself (who was a doctor) and a boy who is dying from a snakebite. San Pantalon raises his eyes to heaven and his prayer is heard: the boy will live. The poignant expressions on the faces are illuminated from beneath by a tremulous, almost lunar, light. San Pantalon's gown is a vibrant concentration of dark red gleams, which attract the attention to the saint's tear-veiled eyes.

The work seems to have been commissioned in 1587, the year before Veronese's death, and is a true example of his late style.

CHURCH OF ANGELO RAFFAELE

Gian Antonio Guardi (1699-1760)
The Marriage of Tobias

A graceful eighteenth-century church facing onto a canal, Angelo Raffaele contains an organ whose frontal is decorated with a delightful series of panels recounting the story of Tobias.

On behalf of his blind father, the young man undertakes a perilous journey to the East. Guided by an angel he will overcome a number of difficulties, then he catches a miraculous fish (the liver of which will restore his father's sight), marries the beautiful Sara (after casting out the demons that possess her) and finally watches his guardian angel rise up towards heaven. Gian Antonio Guardi – brother of the celebrated *vedutista* Francesco – is now universally recognised as the author of these works.

The documents in the church archives are ambiguous but seem to suggest that the paintings can be dated around 1750, that is, amongst the late works Gian Antonio produced.

This was the period when his work achieved a sort of aethereal lightness, with his thin washes of colour enlivened by a certain breadth of handling which gives an impressionistic effect.

This is clear in the scene of the *Marriage of Tobias*: the swirl of colours raised by the angel's wings are as ineffable as the gleams cast by a precious stone.

No painter was a greater master of the musicality of rococo – a style which was at its very zenith in this period.

CHURCH OF REDENTORE

Carlo Saraceni (1579-1620)
The Ecstasy of St. Francis

We are still on the Giudecca (part of the Dorsoduro Sestiere), but have now moved on to Palladio's imposing Church of the Redentore, which looks out over the wide Giudecca canal. Given the preponderance of Palladio's architectural genius here, it is difficult to think of the building as a container for paintings; however, it is well worth paying a visit to the sacristy to see Saraceni's *The Ecstasy of St. Francis*, one of the first works of Caravaggesque realism in Venetian art. Appointed to work on the Doge's Palace in 1619, Saraceni unfortunately fell victim to the plague a year later. The *St. Francis* is, therefore, one of his last works (and in his will the artist left it to the Capuchin friars). The angel appears to the saint in a miserable monastic cell – the humble objects of which are organised as a Caravaggesque "still life". Even Saraceni's skill as a colourist cannot hide the substantial influence of his Roman training in the early 1600s. However, when the eye wanders over the soft folds of the garments and the shading of those flesh-and-blood faces it cannot help but note the unmistakable touch of a Venetian colourist.

THE ISLANDS OF THE LAGOON

46 MALAMOCCO, SANTA MARIA ASSUNTA
47 MURANO, SAN DONATO
48 MURANO, SAN PIETRO MARTIRE
49 BURANO, SAN MARTINO
50 TORCELLO, SANTA MARIA ASSUNTA

Gerolamo Forabosco (1604-1679)
The Miracle of Malamocco

A visit to the fifteenth-century parish church of Malamocco on the Venice Lido (the old capital of the Venetian Republic) offers one a chance to see the work of one of the greatest of seventeenth-century Venetian painters, Gerolamo Forabosco. His fame rests mainly on his portraits, in which the sumptuous palette of Padovanino goes together with the sparkling handling that was characteristic of Strozzi. Forabosco worked mainly in Venice and Padua, and in the period 1664-1670 he produced this *Miracle of Malamocco* – a votive picture offered in thanksgiving for the safe recovery of a gondola full of women and children caught in a sudden storm on the lagoon. The artist has chosen to depict the moment when, after their perils at sea, the passengers are reunited with their families. The sky is black with storm clouds, the waters of the lagoon are whipped into a fury, but the attractive spouses calmly alight from the gondola as if going to a party. The artist also adds the comic touch of the disconsolate boatman watching his straw hat being carried away on the wind.

Paolo Veneziano (active 1310-1362)
San Donato Altarpiece

In the evocative setting of the basilica of San Donato on Murano one can admire one of the oldest paintings in Venice. Dated 1310, it has been tentatively attributed to Paolo Veneziano, an artist who can be credited with having started one of the first "artist's studios" in the city.
The panel shows two donors: the Podestà Donato Memmo and his wife.
The incisive line and vivid colours of the figures set them in sharp contrast to the rather flat figure of the saint in pontifical robes (clearly inspired by the two-dimensional style of the Byzantine tradition, this figure looks like something out of a bas-relief). The two donors, on the other hand, are painted in a more advanced style, reminiscent of the naturalistic realism which emerged in early-fourteenth-century Padua, Lombardy and Emilia. The new Gothic style is clearly announced here.

Giovanni Bellini (c. 1430-1516)
Votive picture of Doge Agostino Barbarigo

Passing down the picturesque Fondamenta dei Vetrai one comes to the old cathedral of San Pietro Martire, one of the most imposing churches on Murano. Inside, the *Votive picture of Doge Agostino Barbarigo* seems to gather to itself whatever light there may be in the sombre nave. Dated 1488, Bellini's paintings shows Doge Agostino Barbarigo being presented to the Virgin by St. Mark and St. Agustine. However this was not the location originally intended for the work; recent studies have shown that Agostino Barbarigo commissioned the work to hang in the *Sala dello Scudo* in the Doge's Palace, to celebrate his succession to his brother Marco in 1486.

Well aware of the importance of this commission, Bellini set to work to produce what would turn out to be a masterpiece of both portraiture and landscape painting. Recent restoration has revealed the *finesse* of colour in the almost miniaturist handling of the doge's sumptuous robes and St. Augustine's cope. The Madonna is one of the most majestic and humane figures that Bellini ever painted, whilst the draughtsmanship in the handling of the golden-haired angel is of particularly delicate quality. Another reason for this work's interest is that it was undoubtedly admired by Albrecht Dürer during his 1505-1507 stay in Venice. The German artist used the same pyramidal composition for his *Madonna of the Rosary*, which used to hang in the Church of San Bartolomeo (the parish church of the Fondaco dei Tedeschi) but is now in Prague. Thus this Bellini altarpiece marks a link between the Venetian colourist and the German realist – a conjunction which will begin to bear fruit in the early work of Giorgione and Titian.

BURANO: CHURCH OF SAN MARTINO

Giambattista Tiepolo (1696-1770)
Crucifixion

The Church of San Martino, which dominates the centre of Burano, contains one of the first large-scale religious works commissioned from the young Tiepolo (1722-25). The figure in the oval frame on the left is a portrait of the donor, a local pharmacist, whilst the figure at the base of the Wicked Thief's cross is a self-portrait, showing the young Tiepolo staring in horror towards the dead Christ. The pictorial inventiveness that would become a hallmark of Tiepolo's art is here exerted to place this Gospel tragedy within the real world. The colours are striking because of the emphatic lighting from below – a scenographical effect which reveals the true temperament of the young artist who would soon break away from the models set by Piazzetta and Bencovich.

TORCELLO: BASILICA OF SANTA MARIA ASSUNTA

Venetian mosaicist (12th century)
The Last Judgement

In splendid isolation at the heart of the Venetian lagoon, the Basilica of Torcello contains one of the oldest mosaics in Venice: the majestic *Last Judgement*. Almost certainly this work was fully completed by the time the mosaicists set to work on St. Mark's in 1156. The most intact original sections are those depicting Minosse's realm of Hell, with the *Seven Deadly Sins* of Pride, Lust, Greed, Anger, Envy, Avarice and Sloth. There are many unforgettable details here: the tremendous energy of the angels as they drive the Proud into hellfire, the smoky burst of flame that envelops the Lustful, the chill bodies of the Greedy depicted engulfed by darkness, the sinister pallor which throws into relief the writhering serpents emerging from the eyes in the skull faces of the Envious... There's no doubt that the master of such expressive intensity had moved a long way beyond the bejewelled charm of Byzantium.

ESSENTIAL BIBLIOGRAPHY

General Reference Works

Venetian History: S. Romanin, *Storia documentata di Venezia*, Venezia 1853-61; A. Zorzi, *La Repubblica del Leone*, Milano 1969; W. Dorigo, *Venezia, le origini*, Milano 1983; S. Bettini, *Venezia*, Milano 1978.
Venetian Doges: *I dogi* (ed: G. Benzoni), Milano 1982.
Figurative Arts: T. Pignatti, *Venezia, mille anni d'arte*, Venezia 1989.
Guides: T. Pignatti, *Venice*, London 1974; G. Bellavitis and G.D. Romanelli, *Venezia*, Roma-Bari 1985; *Venezia*, Touring Club Italiano, Milano 1985.
Museum Catalogues: G. Nepi Scirè and F. Valcanover, *Le Gallerie dell'Accademia*, Milano 1985; G. Romanelli and F. Pedrocco, *Ca' Rezzonico*, Milano 1986; G. Romanelli, *Il Museo Correr*, Milano 1994.
Restoration Information: *Quaderni della Soprintendenza ai Beni artistici e culturali di Venezia* (series).

The Thirteenth Century

Mosaics: O. Demus, *The Mosaics of San Marco in Venice*, Chicago-London 1984; R. Polacco, *La Basilica d'oro*, Milano 1990.

The Fourteenth Century

Doge's Palace: U. Franzoi, W. Wolters and T. Pignatti, *Il palazzo ducale in Venezia*, Treviso 1989.
Gothic Painting: R. Pallucchini, *La pittura veneziana del Trecento*, Venezia-Roma 1964; M. Muraro, *Paolo Veneziano*, Milano 1969.

The Early Fifteenth Century

In General: L. Grossato, *Da Giotto a Mantegna*, Milano 1984; L. Magagnato, *Da Altichiero a Pisanello*, Venezia 1958; B. Degenhart and U. Schmitt, *Jacopo Bellini: l'album di disegni del Louvre*, Milano 1984; R. Lightbown, *Mantegna*, Milano 1986; G. Fiocco and T. Pignatti, *La cappella Ovetari nella chiesa degli Eremitani*, Milano 1978; L. Puppi, *La grande vetrata della basilica dei Santi Giovanni e Paolo*, Venezia 1985.

The Early Renaissance in Venice

T. Pignatti, *Giovanni Bellini*, Milano 1969; R. Goffen, *Bellini*, Milano 1990; J. Meyer zur Capellen, *Gentile Bellini*, Stuttgart 1986; J. Steer, *Alvise Vivarini*, Cambridge 1982; L. Menegazzi, *Cima da Conegliano*, Treviso 1981; P. Humfrey, *Cima da*

153

Conegliano, Cambridge 1983; T. Pignatti, *Carpaccio*, Géneve 1958; J. Lauts, *Carpaccio*, London 1962; V. Sgarbi, *Carpaccio*, Milano 1994; *Le Scuole di Venezia*, Milano 1982; P. Fortini Brown, *La pittura narrativa a Venezia nel tempo di Carpaccio*, Venezia 1988.

The Early Sixteenth Century

G. Mazzariol and T. Pignatti, *La pianta prospettica di Jacopo de' Barbari del 1500*, Venezia 1963; J. Schulz, "Jacopo de' Barbari View of Venice", *The Art Bulletin* (1978), pp. 425-474; N. Huse and W. Wolters, *Venezia, l'arte del Rinascimento*, Venezia 1989. *The Genius of Venice*, London 1983; T. Pignatti, *Giorgione*, Milano 1978; M. Lucco, *Sebastiano del Piombo*, Milano 1980; C. Furlan, *Il Pordenone*, Milano 1988; T. Pignatti, *Lorenzo Lotto*, Milano 1953; P. Zampetti, *Lotto*, Bologna 1983; P. Rylands, *Palma il Vecchio*, Milano 1989.
Relations with German Painting: T. Pignatti, "The Relationship between German and Venetian Painting", in J. Hale, *Renaissance Venice*, London 1973, pp. 244-273.

The Age of Titian

R. Pallucchini, *Tiziano*, Firenze 1969; H.E. Wethey, *The Painting of Titian*, London 1969-75; M.A. Chiari Moretto Wiel, *Tiziano. Corpus dei disegni*, Milano 1989; *Tiziano*, Venezia 1990.

The Late Sixteenth Century

R. Pallucchini et al., *Da Tiziano a El Greco. Per la storia del Manierismo a Venezia (1540-1590)*, Milano 1981; B. Brown and P. Marini, *Jacopo Bassano*, Bologna 1992; R. Pallucchini and P. Rossi, *Tintoretto*, Milano 1982; P. Rossi and G. Nepi Scirè, *Tintoretto. Ritratti*, Venezia 1994; T. Pignatti, *Paolo Veronese*, Milano 1976; T. Pignatti and F. Pedrocco, *Veronese*, Firenze 1991; T. Pignatti and F. Pedrocco, *Veronese*, Milano 1995, R. Rearick, *The Art of Paolo Veronese*, Washington 1988; S. Mason Rinaldi, *Jacopo Palma il Giovane*, Milano 1984.

The Seventeenth Century in Venice

R. Pallucchini, *La pittura veneziana del Seicento*, Milano 1981; P. Rossi, *Francesco Maffei*, Milano 1991.

The Early Eighteenth Century

In General: R. Pallucchini, *La pittura veneziana del Settecento*, Venezia-Roma 1960; *The Glory of Venice: Art in the XVIIIth*

Century, New Haven - London 1994; T. Pignatti, *Il Rococò*, Milano 1968.
Rococo Painters: L. Rizzi, *Sebastiano Ricci*, Milano 1989; A. Bettagno, *Disegni e dipinti di G.A. Pellegrini*, Venezia 1959; B. Sani, *Rosalba Carriera*, Torino 1988; A. Scarpa Sonino, *Jacopo Amigoni*, Soncino 1994; P. Zampetti, *I Guardi*, Venezia 1965; A. Morassi, *I Guardi*, Milano 1973-75; F. Pedrocco and F. Montecuccoli degli Erri, *Antonio Guardi*, Milano 1992; T. Pignatti, *I Guardi. I disegni*, Firenze 1967.

The Mid Eighteenth Century in Venice

A.P. Zugni Tauro, *Gaspare Diziani*, Venezia 1971; F. Zava, G.B. Pittoni, Venezia 1979; A. Mariuz, *G.B. Piazzetta*, Milano 1982; M. Magrini, *F. Fontebasso*, Vicenza 1988.

The Great Decorative Artists

A. Morassi, *A Complete Catalogue of Giambattista Tiepolo*, London 1952; A. Pallucchini, *L'opera completa di G.B. Tiepolo*, Milano 1968; M. Levey, *Gian Battista Tiepolo*, New Haven-London 1986; T. Pignatti, *Tiepolo. Disegni*, Firenze 1974; M. Gemin and F. Pedrocco, *Giambattista Tiepolo. I dipinti*, Venezia 1993.

The Painters of the World of Eighteenth-Century Venice

A. Rizzi, *Luca Carlevarijs*, Venezia 1967; A. Scarpa Sonino, *Marco Ricci*, Milano 1991; M. Manzelli, *Michele Marieschi*, Venezia 1991; W.G. Constable and J. Links, *Gian Antonio Canal*, Oxford 1989; A. Corboz, *Canaletto*, Milano 1985; T. Pignatti, *Canaletto. Disegni*, Firenze 1972; T. Pignatti, "Gli inizi del Bellotto", *Arte Veneta* (1966), pp. 218-229; S. Kozakiewicz, *Bernardo Bellotto*, Milano 1972; A. Mariuz, *Giandomenico Tiepolo*, Milano 1971; F. Pedrocco, *Giandomenico Tiepolo. Disegni*, Milano 1990; T. Pignatti, *Pietro Longhi*, Milano 1990; A. Mariuz, G. Pavanello and G. Romanelli, *Pietro Longhi*, Milano 1993. P. Zampetti, *I Guardi*, Venezia 1965; T. Pignatti, *Francesco Guardi*, Brescia 1971; A. Morassi, *I Guardi*, Milano 1973-75; T. Pignatti, *I Guardi. I disegni*, Firenze 1967; A. Bettagno, *I Guardi*, Milano 1993; Idem, *I Guardi. Quadri turcheschi*, Milano 1993.

SITE INDEX

Burano, Church of San
 Martino 150

Cambridge, Fitzwilliam
 Museum 14

Florence, Uffizi 11

Malamocco (Lido), Church of
 Santa Maria Assunta 147

London, National Gallery 20

Murano
 Church of San Donato 148
 Church of San Pietro Martire
 10, 149

New York, Corsini Collection
 16, 17, 18

Padua, Scuola del Santo 13

Torcello, Basilica
 of Santa Maria Assunta
 7, 151

Udine, Patriarcato 18

VENICE

Churches
 Angelo Raffaele 19, 142
 St. Mark's Basilica
 9, 63-68
 Madonna dell'Orto 105, 106
 Pietà 86
 Redentore 143
 San Beneto 77
 San Cassiano 116
 San Francesco della Vigna
 87, 88
 San Giorgio Maggiore 74
 San Giovanni Crisostomo 99
 San Giovanni in Bragora 84
 San Giuseppe 89
 San Lazzaro dei Mendicanti
 90

San Lio 95
San Marcuola 109
San Marziale 110
San Nicola da Tolentino 119
San Pantalon 141
San Polo 131
San Salvador 14, 76
San Sebastiano 140
San Stae 117, 118
San Trovaso 137
San Zaccaria 81-83
San Zulian 75
Sant'Alvise 107, 108
Santa Maria dei Derelitti
 (Ospedaletto) 93
Santa Maria dei Frari
 123-125
Santa Maria dei Gesuiti
 101-103
Santa Maria del Carmelo 138
Santa Maria del Giglio 73
Santa Maria del Rosario
 (Gesuati) 136
Santa Maria della
 Consolazione (La Fava) 96
Santa Maria della Salute 135
Santa Maria Formosa 94
Santa Maria Materdomini
 115
Santi Apostoli 100
Santi Giovanni e Paolo 91,
 92

St. Mark's Library 69

Museums
Accademia Gallery 12, 23-42
Ca' Pesaro - Modern Art
 Gallery 57
Ca' Rezzonico - Museum of
 the Eighteenth Century
 52-56
Franchetti Gallery at the Ca'
 d'Oro 49
Hellenic Institute 43
Guggenheim Museum 58
Museo Correr 44-48
Pinacoteca Querini Stampalia
 50-51

Doge's Palace 70-72

Oratorio dei Crociferi 104

Palazzo Labia 111, 112

Scuola dei Carmini 139
Scuola di San Giorgio
 degli Schiavoni 11, 85
Scuola grande di San Rocco
 15, 126-130

Vienna, Kunsthistorisches
 Museum 20

INDEX OF NAMES AND WORKS

Andrea del Castagno, *The Church Fathers: St. Mark* 82
Antonio da Negroponte, *Madonna and Child* 87
Bassano Jacopo, *St. Jerome the Hermit* 36
Bastiani Lazzaro, *The Poverty of Job* 107
Bellini Gentile, *Procession of the Reliquary of the True Cross in Piazza San Marco* 25
Bellini Giovanni
 Madonna and Saints 83, 123
 Pietà 46
 St. Jerome and two Saints 99
 The Camerlenghi Madonna 24
 Votive Picture of Doge Agostino Barbarigo 10, 149
Bellotto Bernardo, *The Scuola di San Marco at San Giovanni e Paolo* 40-41
Byzantine artist, *Madonna and Child* 63
Canaletto
 Feastday of San Rocco 20
 Rio dei Mendicanti at San Giovanni e Paolo 55
Carpaccio Vittore
 Portrait of the Man in the Red Beret 47-48
 The Study of St. Augustine 11, 85
 The Dream of St. Ursula 26-27
 The Dream of St. Ursula (preparatory sketch) 11
Carriera Rosalba, *Faustina Bordoni* 52
Catena Vincenzo, *The Angels save St. Christine* 115
Ciardi Guglielmo, *Lagoon* 57
Cima da Conegliano
 St. John the Baptist and Saints 105

The Baptism of Christ 84
Damaskinos Michele, *Icon of St. Anastasio* 43
Forabosco Gerolamo, *The Miracle of Malamocco* 147
Giambono Michele, *San Crisogono* 137
Giorgione
 Christ carrying the Cross 126
 La Tempesta 12, 28-29
Guardi Francesco
 Day Stalls in St. Mark's 20
 The Parlour of the Nuns of San Zaccaria 54
 The Fire at San Marcuola 42
Guardi Gian Antonio
 Marriage of Tobias 19, 142
Longhi Pietro
 The Moor and the Letter 53
 The Dancing Lesson 39
 The Sagredo Family 50
Lotto Lorenzo
 Portrait of a Melancholic Young Man 33
 St. Nicholas in Glory 138
 The Charity of St. Antonino 92
Maffei Francesco
 Mythological Scene 37
 The Guardian Angel 100
Mantegna Andrea, *St. Sebastian* 49
Mazzoni Sebastiano, *St. Benedict presenting the Parish Priest to the Virgin* 77
Mocetto Gerolamo, *Window of Warrior Saints* 91
Palma il Giovane Jacopo, *The Mass of Pasquale Cicogna* 104
Palma il Vecchio Jacopo, *Santa Barbara Polyptych* 94
Paolo Veneziano

San Donato Altarpiece 148
The Miracle of the Rocks 66
The Coronation of the Virgin 23
Pellegrini Giovanni Antonio, *Venus* 17
Piazzetta Gian Battista *The Capture of St. James* 117
The Fortune-Teller 38
Ricci Sebastiano, *The Miracolous Arrival of the Statue of the Madonna* 110
Santomaso Giuseppe, *Secret Life* 58
Saraceni Carlo, *The Ecstasy of St. Francis* 143
Strozzi Bernardo, *St. Lawrence giving Alms* 119
Tiepolo Giambattista
 Abraham and Isaac 93
 Abraham and the Angels 18
 Christ on Calvary 108
 Crucifixion 150
 Nativity 68
 Portrait of the Procuratore Dolfin 51
 Rebecca at the Well 18
 The Banquet of Cleopatra 111-112
 The Coronation of the Virgin 86
 The Education of the Virgin 96
 The Madonna appearing to Blessed Simon Stock 139
 The Martyrdom of St. Bartholomew 118
 Three Female Saints of the Domenican Order 136
Tiepolo Giandomenico
 Jesus stripped of his Garments 131
 The Stroll 56
Tintoretto Jacopo
 Christ before Pontius Pilate 128

157

Christ in the Garden of
 Gethsemane 129
Crucifixion 116, 127
Female Hermit in Meditation
 16, 130
Miracle of St. Mark freeing the
 Slave 34
Paradise 71-72
The Assumption of the Virgin
 102-103
The Four Evangelists 73
The Last Supper 74, 109
The Presentation of the Virgin
 in the Temple 106
Tiziano
Couple embracing 14
Miracle of Severed Foot 13
Pentecost 135
Pietà 31-32
St. James 95

The Annunciation 14, 76
The Assumption of the Virgin
 124
The Martyrdom of St.
 Lawrence 101
The Pesaro Altarpiece 125
The Presentation of the Virgin
 in the Temple 30
Tura Cosmè, Pietà 44-45

Venetian Mosaicist
Madonna 7
Noha's Flood 9
The Creation of the Heaven
 and the Stars 64
The Dance of Salome 65
The Last Judgement 151
Veronese Paolo
Crucifixion 90
Madonna and Saints

(Giustinian Altarpiece) 88
Music 69
Pietà and Saints 75
The Adoration of the
 Shepherds (Pala Grimani)
 89
The Conversion and Miracle of
 San Pantalon 141
The Mystic Marriage of St.
 Catherine 35
The Rape of Europe 70
The Rape of Europe (detail of
 sketch) 16
The Triumph of Mordecai
 140
Vivarini Antonio,
 Madonna of the Rosary 81

Zanino di Pietro, The Passion
 of Christ (tapestries) 67

Film preparation by Foligraf, Venezia-Mestre
Printed in Italy by
La Grafica & Stampa editrice s.r.l., Vicenza

THE JOURNALS OF
DR. THOMAS COKE

KINGSWOOD BOOKS
Randy L. Maddox, Director
Seattle Pacific University

EDITORIAL ADVISORY BOARD

Justo L. González
Hispanic Theological Initiative, Emory University

W. Stephen Gunter
Candler School of Theology, Emory University

Richard P. Heitzenrater
The Divinity School, Duke University

Robin W. Lovin
Perkins School of Theology, Southern Methodist University

Rebekah L. Miles
Perkins School of Theology, Southern Methodist University

Mary Elizabeth Mullino Moore
Candler School of Theology, Emory University

Jean Miller Schmidt
Iliff School of Theology

Harriet Jane Olson, *ex officio*
Abingdon Press

Neil M. Alexander, *ex officio*
Abingdon Press

THE JOURNALS OF DR. THOMAS COKE

EDITED BY
JOHN A. VICKERS

KINGSWOOD BOOKS
An Imprint of Abingdon Press
Nashville, Tennessee

THE JOURNALS OF DR. THOMAS COKE

Copyright © 2005 by Abingdon Press

All rights reserved.
No part of this work may be reproduced or transmitted in any form or by any means, electronic or mechanical, including photocopying and recording, or by any information storage or retrieval system, except as may be expressly permitted by the 1976 Copyright Act or in writing from the publisher. Requests for permission can be addressed to Abingdon Press, P.O. Box 801, 201 Eighth Avenue South, Nashville, TN 37202-0801, or e-mailed to permissions@abingdonpress.com.

This book is printed on acid-free paper.

Library of Congress Cataloging-in-Publication Data

The journals of Dr. Thomas Coke / edited by John A. Vickers.
 v. cm.
 Includes bibliographical references and index.
 Contents: 1784–85 : an extract of the late Rev. Dr. Thomas Coke's first journal to North America—1786–87 : extracts of the journals of the late Rev. Dr. Thomas Coke's second visit to North America and first to the West Indies—1788–89 : extract of the journals of the late Rev. Dr. Thomas Coke's third visit to North America and second to the West Indies—[etc.]
 ISBN 0-687-05421-4 (pbk : alk. paper)
 1. Coke, Thomas, 1747–1814—Diaries. 2. Evangelists—Biography. 3. Methodists—Biography. 4. United States—Description and travel—Early works to 1800. 5. West Indies—Description and travel—Early works to 1800. 6. Southern states—Description and travel—Early works to 1800. I. Vickers, John A. (John Ashley)
BV3705.C583A3 2005
287'.6'092--dc22
[B]

2005013811

All scripture quotations are from the King James or Authorized Version of the Bible.

05 06 07 08 09 10 11 12 13 14—10 9 8 7 6 5 4 3 2 1

MANUFACTURED IN THE UNITED STATES OF AMERICA

*For Hilary, Stephen, and Michael,
who grew up with Thomas Coke*

Contents

Acknowledgments . 1

Introduction . 3

Coke's Title Page, Dedication, and Preface to
 Collected Editions . 19

1784–85: An Extract of the late Rev. Dr. Thomas
 Coke's First Journal to North America 23

1786–87: Extracts of the Journals of the late Rev.
 Dr. Thomas Coke's Second Visit to North America
 and First to the West Indies . 67

1788–89: Extract of the Journals of the late Rev.
 Dr. Thomas Coke's Third Visit to North America
 and Second to the West Indies . 91

1790–91: Extracts of the Journals of the late Rev.
 Dr. Thomas Coke's Third Visit to the West Indies 131

1791: Extracts of the Journals of the late Rev. Dr.
 Thomas Coke's Fourth Visit to North-America 153

1792–93: Extracts of the Journals of the late Rev.
 Dr. Thomas Coke's Fifth Visit to North America
 and the West Indies . 169

1796–97: Extracts of the Journals of the late Rev.
Dr. Thomas Coke's Sixth Visit to North-America and
on his return of a Tour through a part of Ireland 203

1797: Letter to John Pawson, Describing His Voyage
to America . 245

1813–14: Extracts of the Journals of the late Rev.
Dr. Thomas Coke's Nearly Finished Voyage to Asia with
the Messrs. Ault, Lynch, Erskine, Harvard, Squance,
and Clough . 253

Appendix . 263

Bibliography . 281

Index . 283

Acknowledgments

Much information in the following pages has been gleaned from the footnotes in *The Journal and Letters of Francis Asbury* edited by Elmer T. Clark (1958). I also gladly acknowledge the help of staff of Lambeth Palace Library, of the new *Oxford Dictionary of National Biography*, and of the Barbados Department of Archives. Mrs. Sue Gascoigne and her colleagues at the Methodist Publishing House, Peterborough, made the transcription of the *Journal* text with their usual efficiency.

My work on Thomas Coke over more than forty years has brought me many friends and many debts of gratitude. In particular, in preparing Coke's journals for publication I am indebted to the following individuals: Heather Hall of the Zoological Association of London, Sam Hammond of the Duke University Library, Dr. Richard P. Heitzenrater, Rev. Dr. Albert W. Mosley, Dr. Paul Peucker of the Unitätsarchiv at Herrnhut, Rev. Robin P. Roddie, and Dr. Charles Yrigoyen and his colleagues at the United Methodist Archives in Madison, New Jersey. I am especially indebted to the meticulous editing of Randy Maddox, which has improved the volume at a number of points.

Finally, the late Dr. Frederick E. Maser underwrote the cost of transcribing Coke's text. His warmhearted encouragement and practical support for the project will be recognised as characteristic by all who knew him and miss his friendship.

John A. Vickers

INTRODUCTION

The name of Thomas Coke occurs with remarkable frequency and in a wide variety of contexts in the records of early Methodism, and specifically in the decades before and after the death of John Wesley in 1791. It was a period of climactic developments for the British connexion, and Coke was never far from the centre of it. But his influence and active involvement were by no means confined to the British Isles. During the same period he played a significant role in the launch of the first overseas missions and in the coming of age of American Methodism in the wake of the Revolutionary War.

Coke's early background could not have been more different from that of the rank and file of Wesley's itinerant preachers with whom he was to associate in later years.[1] An English-speaking Welshman, the son of a prosperous apothecary, he was born in 1747 in Brecon, a market town and provincial centre in mid-Wales on the busy post-road from London to Carmarthen. He had no siblings to claim a share of his parents' affection and admiration, a fact that may well be one key to his character later in life. He was educated at the local grammar school and went from there as a gentleman-commoner to Jesus College, Oxford, in 1764. The Oxford into whose life he was flung at the age of sixteen was the one that Edward Gibbon, ten years earlier, had found offered few incentives to academic endeavour but every opportunity for both scepticism and licentiousness. It was some years since, having

1. For fuller biographical details see my *Thomas Coke, Apostle of Methodism* (London: Epworth / Nashville: Abingdon Press, 1969).

resigned his fellowship in 1751, John Wesley had ceased to visit the city. Among Coke's university associates were some who would later play a major part in public life, including future statesmen like Lord North.

The influence of Deism during his undergraduate years was counterbalanced by his reading of Thomas Sherlock's *The Trial of the Witnesses of Jesus* (1729), which argued the orthodox case for miracles, life after death, and the authority of Scripture. Having obtained his BA in 1768 and his MA two years later, he was ordained deacon by the Bishop of Oxford in 1770 and priest in 1772. Meanwhile, returning to his native Brecon, he lost no time in entering, like his father, into public affairs. In September 1769, though barely twenty-one, he became a member of the Common Council and just a year later was elected bailiff (i.e., mayor). There is evidence that, at this juncture, he expected preferment in the church, perhaps through Lord North, but this did not materialise. It was well within his means to purchase a living (as was common in the church of his day). But by 14 July 1771 he had set foot on the lowest rung of the ecclesiastical ladder by taking up residence as curate to Rev. Robert Twyford in the Somerset village of South Petherton.

A handful of manuscript sermons survive from the five years he spent at South Petherton, but few other primary sources throw any light on this period of his life. During these years he added to his academic titles a doctorate in civil law.[2] But a more important development was his increasingly evangelical leanings, partly under the influence of the writings of John Fletcher of Madeley and of John Wesley himself. This, together with a reading of Joseph Alleine's *Alarm to the Unconverted*, began to affect his preaching and his pastoral work, with the result that the opprobrious term 'Methodist' began to be bandied about. Then came his first meeting with John Wesley, on the evening of 13 August 1776. Hearing from his evangelical friend Rev. James Brown of Clevedon and Kingston St. Mary that Wesley was to preach at Taunton, Coke rode over from South Petherton expressly to meet him. The most detailed account of this encounter is that of Henry Moore, who claimed to have it from Coke himself:

2. Coke's doctorate has sometimes been described (by Coke himself as well as by others) as an L.L.D.—a degree that did not exist at Oxford since, unlike Cambridge, it had no power to grant degrees in canon law.

In the morning, Mr. Wesley having walked into the garden [of the Kingston parsonage], he joined him there, and made known his situation and enlarged desires. Mr. Wesley, with marked sobriety, gave him an account of the way in which he and his brother proceeded at Oxford, and advised the Doctor to go on in the same path, doing all the good he could, visiting from house to house, omitting no part of his clerical duty; and counselled him to avoid every reasonable ground of offence. The Doctor was exceedingly surprised, and, indeed, mortified. 'I thought,' said he, when he related the account to me, 'he would have said, *Come with me, and I will give you employment according to all that is in your heart.*'[3]

Wesley summed up their first meeting in words that are scarcely less prophetic for having been penned several years later: 'A union then began which I trust shall never end.'

More immediately, Coke did return, with whatever reservations, to his parish duties with a fresh evangelical enthusiasm guaranteed to antagonize the more worldly among the parishioners. Twyford's death and the arrival of a new vicar less accommodating than his predecessor added to his problems. The final showdown came the following spring. Not for the last time in his life, Coke failed to win over his opponents and he found himself drummed out of town. Wesley recorded in his *Journal* under the date 19 August 1777: 'Dr. Coke, . . . being dismissed from his curacy, has bid adieu to his honourable name, and determined to cast in his lot with us.'

Coke was almost certainly present at the Annual Conference of Wesley's preachers that year, though his name does not appear in the Minutes. At any rate, he was soon busily employed as the willing and able assistant whom the ageing Wesley had so long sought in vain. Five years later, in a letter to Mrs. Fletcher (whose husband had firmly declined to leave his parish and join forces with Wesley), the latter could look back and acknowledge the support he had received from the young Welshman: 'It seems to have been the will of God for many years that I should have none to share *my proper labour*. My brother never did [which was a totally unfair judgment on Charles Wesley!]. Thomas Walsh began to do it; so

3. Henry Moore, *Life of the Rev. John Wesley*, 2 vols. (London: Kershaw, 1824–25), 1:309-10.

did John Jones. But one died and one fainted. Dr. Coke promises fair; at present I have none like-minded.'[4]

On the other hand, there were some among the Methodists, especially the older itinerants, who regarded the newcomer as an upstart, resented the degree of confidence Wesley placed in him, and doubted the depth of his spiritual experience. Charles Wesley in particular clearly felt ousted from his privileged position and suspected Coke of self-interest. Coke's ebullient nature and impulsiveness certainly exposed him to criticism. Nevertheless he was to prove himself invaluable to Wesley in a period of growing unrest and uncertainty in the Methodist connexion. He was entrusted during the next few years with a number of difficult administrative tasks, not least of which was the settlement of disputes that arose at places like Birstall and Dewsbury in Yorkshire; and in this his legal knowledge was of considerable use. These were much more than local issues. The struggle between local trustees and the Conference for control of the preaching-houses and the right to appoint preachers involved the survival of Methodism as a connexion. The adoption of a 'model deed' for all preaching-houses was a crucial step. The dispute culminated in 1784 in Wesley's Deed of Declaration, defining the legal Conference and its authority. Coke played a leading part in these somewhat unedifying affairs, and for his pains found himself accused of being a troublemaker—rather than a problem-solver. Undoubtedly, his temperament was not the ideal one for a diplomat; but at the same time he was acting as the representative and spokesman of one who was himself a natural autocrat. Nor did it help Coke's standing among the itinerant preachers that he had been too ready to accuse some of them of Arianism and other heresies, almost as soon as he joined the connexion.

The years between 1777 and 1784, therefore, were busy ones in which Coke travelled on Wesley's behalf, not only through England and Scotland but also to Ireland, where he presided for the first of many times over the Conference of the Irish preachers. By 1784 the stage was set for the major undertakings of his career. That year was a climactic one for Methodism in its development from a group of societies within the Church of England into an

4. Letter to Mrs. Mary Fletcher (12 July 1782), in *The Letters of the Rev. John Wesley A.M.*, edited by John Telford (London: Epworth, 1931), 7:128.

independent movement. It marked a similarly radical change of direction for Coke. In comparison with the major activities that were to occupy his later years on both sides of the Atlantic, his life up to this point appears almost leisurely. It is at this turning point that his published journals begin.

* * *

Insofar as Coke is now remembered, it is not as Wesley's right-hand man (and potential successor), but for two other aspects of his ministry, both of which date from that crucial year of 1784. In British Methodism he is the acknowledged founder of its overseas missions. In American Methodism it is his involvement, alongside Francis Asbury, in establishing the Methodist Episcopal Church that stands out. Light is thrown on both of these roles by the journals reprinted here.

Coke's reputation as founder of British Methodist overseas missions is fully justified by the facts. Towards the end of 1783, with no encouragement or support from Wesley, he issued his first missionary appeal, *A Plan of the Society for the Establishment of Missions among the Heathens* (eight years before William Carey's more famous *Enquiry*). The appeal was not confined to members of the Methodist societies, but was addressed to 'all the real lovers of mankind'. Though it elicited some subscriptions, it seems otherwise to have sunk without trace. But Coke was not one to be deterred by failure. Two years later, this time with Wesley's blessing, he published an *Address to the Pious and Benevolent* in which he surveyed two potential mission fields in the British Isles and two abroad—the West Indies and British North America. The Caribbean was already the scene of early Moravian missions and would become, under Coke's supervision, the first overseas mission field authorized (though with little financial support) by the British Methodist Conference. The 1786 Conference appointed two preachers to work in Newfoundland and a third, William Warrener, to go to Antigua, where the shipwright John Baxter had already gathered a Methodist society. In the event, Atlantic storms took over and brought Coke and all three of his companions to the Caribbean, where they landed early on Christmas morning at St. John's, Antigua.

Coke's journals describe in some detail his four visits to the Caribbean between 1786 and 1793. These represent the earliest phase in the mission from which the present Methodist Church of the Caribbean and the Americas derives. By the time Coke paid his last visit in 1793, West Indian Methodism had grown from the single society of nearly 2,000, which he found on landing in Antigua, to a membership of 6,570, with twelve missionaries working in ten of the islands. By the time of his death in 1814, there were twelve circuits throughout the Caribbean, with a total membership of 17,000, and this had been achieved in the face of determined opposition in some quarters, sometimes amounting to hostile legislation or active persecution. Though he never returned in person after 1793, Coke's continuing commitment to the work and its financial support (by fund-raising and by his personal giving) never wavered. The shortcomings in his administration of the mission funds have to be judged against the background of reluctance on the part of the British Conference to take effective responsibility. Abortive attempts to put the missions on a more stable footing came to very little. A Committee of Finance appointed in 1798 seems never to have met. The following year Coke was formally designated the Conference's agent for the missions, and an annual collection was authorized throughout the connexion. But when a new missionary committee was set up in 1804, its main function was that of curbing expenditure rather than furthering the work, and Coke found himself frustrated by voluminous correspondence. Only in 1813, on the eve of his departure for Asia, were the first effective measures taken to relieve him of the burden of responsibility, and then not by the Conference but as a series of local initiatives beginning in Leeds and spreading to other Districts. Not until 1818, when Coke had been dead for four years, was the Wesleyan Methodist Missionary Society set up at connexional level.

* * *

If one were writing in contentious mode, it is Coke rather than Asbury who might claim to be 'the first American Methodist bishop.' Whatever significance might be given to the title applied first to Coke and was passed on by him to Asbury on the author-

ity of John Wesley. But the point will seem of no consequence to anyone who understands the 'apostolic succession' in spiritual rather than historical terms.

The Revolutionary War had left the former American colonies free from British rule, but at the same time had weakened, if not quite severed, the ties that linked American Anglicans with the parent church back in England. Few of the former colonial clergy remained at their posts, and this affected Methodists too, since Wesley insisted that they should still look to the Anglican Church for the sacraments. Moreover, of the itinerant Methodist preachers sent over by the British connexion from 1769 on, only Asbury survived the war years. The American preachers who met at Fluvanna, Virginia, at the height of the war had determined to take on themselves the right to ordain one another so that the Methodist societies could receive the Lord's Supper from their hands. While Asbury persuaded them to abandon this innovation, the need to provide some alternative solution remained unsatisfied until Wesley's intervention in 1784.

Wesley's ordinations of that year, and Coke's involvement in the decision to take so drastic a step, are among the most problematical issues in that period of early Methodism; but this is not the occasion to rehearse the evidence again. In any case, the verdict reached is likely to be determined by the presuppositions with which one approaches the evidence, as much as by the evidence itself. The evidence remains ambiguous and inconclusive, not least in determining what part, if any, Coke's influence played in Wesley's decision to act as he did. The main facts are as follows: After some months of indecision and pondering, at the beginning of September 1784, without consulting or informing the Conference and in particular without involving his brother Charles (whose disapproval he knew would be implacable), Wesley ordained two of the lay preachers, Richard Whatcoat and Thomas Vasey, for the work in America, thereby empowering them, as he believed, to administer the sacraments. Wesley took this action on the conviction, derived from his earlier reading of Lord Peter King and Edward Stillingfleet, that it conformed to the nature of the ministry in the early church. So far he was being logical, if highly irregular. But at the same time, by the imposition of hands and by prayer, he 'laid hands' on Thomas Coke as

'superintendent' of the Methodist work in America. The question has been repeatedly asked, What power or authority did he consider he was conferring by this action on someone who was, like himself, already an Anglican priest? The answer probably is *none*—except in the sense that he believed it would give Coke a status and influence among the American Methodists that he would otherwise lack. This is in line with what Coke himself had written in a letter to Wesley a few weeks earlier:

> The more maturely I consider the subject, the more expedient it seems to me that the power of ordaining others should be received by me from you, by the imposition of your hands. . . . I may want all the influence in America which you can throw into my scale. . . . [A]n authority *formally* received from you will be fully admitted by the people, and my exercising the office of ordination without that formal authority may be disputed, if there be any opposition on any other account.[5]

Wesley could be logical enough when it suited his purpose, but in his leadership of the Methodist movement he was above all a pragmatist. If the Bishop of London, in whose jurisdiction the British colonies lay, was hampered by legal or political considerations from ordaining clergy for these rebellious territories, then he, John Wesley, would provide for their spiritual needs, and he proceeded to do so.

Arriving in New York on 3 November 1784, Coke rode south via Philadelphia and met Asbury ('a plain, robust man') for the first time at Barratt's Chapel in Delaware. The main topic of their discussions was Wesley's plans for a Methodist church independent of the Church of England, which had been so weakened by the war. A few weeks later they met again in Baltimore, this time with a majority of the itinerant preachers, in what became known as the 'Christmas Conference'. Asbury was ordained successively as deacon, priest, and 'Superintendent' (the term 'bishop' being adopted, to Wesley's dismay and strong disapproval, only in 1788) and other ordinations followed as part of the establishment of the Methodist Episcopal Church.

The newly independent states strung out along the eastern

5. Moore, *Life of Wesley*, 2:530-31.

seaboard were still discovering their identity and framing a constitution. Both before and after the Christmas Conference, Asbury saw to it that Coke experienced at first hand the largely virgin terrain in which the American itinerants worked—described by Joseph Pilmore in 1772 on his first venture southwards from Philadelphia as 'waste places of the wilderness'.[6] Coke's first impressions of American life make for interesting reading. Over the next twenty years he was to make nine visits in all and to witness a growing sense of nationhood and of national confidence. It is worth noting that eighteen voyages across the Atlantic in the small sailing vessels of the day were in themselves no small feat. Though he spent altogether rather less than three years on American soil, his influence on American Methodism during this formative period of its existence was out of all proportion to the time involved and indeed may be judged second only to that of Asbury himself. He travelled extensively between New England and Georgia. He was on horseback for many hours at a stretch as he traversed the wide forests, swamps, and flooded rivers of that thinly settled territory, sleeping at night three in a bed or on the floor of a solitary log cabin, with the wolves prowling outside the fences. He presided at many of the General and Annual Conferences, and had a hand in editing several editions of the *Book of Discipline*. Though he failed in 1791 in his bid to repair the breach between Methodism and the Episcopalian Church (which by then had its own bishops), his influence on several important issues (such as Asbury's scheme for the government of the church by a permanent Council) was decisive. On his first visit he bore a heroic, though premature, witness against slavery. Together with his fellow-bishop he was twice received by George Washington, and on his final visit in 1804 was honoured with an invitation to preach before Congress—a tribute worthy of one who, though retaining his British citizenship, had yet succeeded to a considerable degree in identifying himself with the American people and their aspirations.

The relationship between Coke and Asbury during these years is a fascinating study in itself.[7] In almost every respect, apart from

6. For his southern journey, see *The Journal of Joseph Pilmore*, edited by Frederick E. Maser and Howard T. Maag (Philadelphia: Historical Society of the Philadelphia Annual Conference of The United Methodist Church, 1969), 147-205.

7. See John A. Vickers, "Coke and Asbury: A Comparison of Bishops," *Methodist History* 11, no. 1 (October 1972): 42-51.

their devotion to Christ, the two men were contrasted personalities: often conflicting, though sometimes complementary. By 1784 Asbury had already been in America for thirteen years and, by courageous perseverance in the face of daunting odds, had emerged from the troubled war years as the natural leader of the American Methodists so that he no longer needed the backing of Wesley's authority. Coke, on the other hand, was an unknown and untried newcomer, two years younger than Asbury and many years his junior in the itinerancy. He was neat, even elegant in dress and studiously courteous in bearing (so long as his volatile temperament was not brought into play!); his conversation was informed and witty, a characteristic that must sometimes have aroused suspicion and even hostility in Methodist circles. The fact that this newcomer was furnished with authority from Mr. Wesley might have served to underline the discrepancy between the two men, had Coke been tactless in the way he exercised it. It says much for his handling of the situation that the mutual respect and the warm friendship immediately struck up between them survived, through many vicissitudes, to the end of their lives.

With the War of Independence still fresh in everyone's mind, relations between Methodists on either side of the Atlantic were affected by strong political cross-currents. Coke was venturing into what was still, in a sense, enemy territory. His position was somewhat equivocal. His first encounter with the American people transformed his attitude towards the Revolution so that when he returned home, his sympathy with the American cause got him into some trouble. In the course of his ordination sermon at Baltimore he had said: 'Blessed be God, and praised be his holy name, that the memorable Revolution has struck off these intolerable fetters and broken the antichristian union which subsisted between Church and State. And had there been no other advantage arising from that glorious epoch, this itself, I believe, would have made ample compensation for all the calamities of the War.'[8] Though they were typical of his impulsive temperament, these

8. Thomas Coke, *The Substance of a Sermon preached at Baltimore, in the State of Maryland, before the General Conference of the Methodist Episcopal Church, on the 27th of December, 1785* [corrected to 1784 in subsequent editions], *at the Ordination of the Reverend Francis Asbury, to the Office of a Superintendent* (Baltimore: Goddard & Langworthy, 1785), opening paragraph. Compare the edition published later that same year in London by J. Paramore.

were strong words coming from one who was still a British citizen. It is hardly surprising that he modified them considerably when publishing the sermon in England later in 1785, including deletion of the second sentence altogether. In 1789 he was again in hot water when the British Conference criticized him for his part in the loyal address presented by the American Methodists to President Washington. He did his utmost to be 'all things to all men', but with a foot in both camps it was virtually impossible for him to do the right thing.

Coke's divided loyalties, both political and ecclesiastical, were a matter of great concern to Asbury, who had unequivocally thrown in his lot with the Americans. The fact that Coke retained his British citizenship and that he continued to divide his time between England and America meant that he could never be entirely acceptable to the Americans. Asbury had a shrewd enough grasp of the situation to be aware of this; and Coke, in turn, became increasingly aware of Asbury's determination to clip his episcopal wings. Whenever he was in the States, he was treated with a degree of respect, as a figure-head and a useful link between the British and American connexions. But, as the years passed, Asbury saw to it that he was given little opportunity for the effective exercise of his superintendency. Political factors apart, Asbury felt towards American Methodism as paternally possessive (and protective) as Coke did towards the West Indian missions. It was impossible for Asbury to relinquish lightly an authority that he had won the hard way, and that he exercised in so personal a way, to someone who was, by comparison, a bird of passage and a stranger in their midst.

After Wesley's death in 1791 Coke was more than ever involved in the affairs of the orphaned British connexion and consequently was more than ever absent from the American scene. At the General Conference of 1796, however, he offered to settle there for life and devote himself entirely to his American brethren. Asbury was ill, and there was an urgent need to strengthen the episcopacy. Coke's offer was accepted—though not without misgivings in some quarters—and he returned home to settle his affairs in Europe. The British Conference, however, reacted to the news by hastily and belatedly electing him to the presidency and begging their American brethren to release him from his obligations. With

British Methodism still convulsed by the Kilhamite agitation, they felt their need of him as never before. Consequently, for the next few years Coke endured a kind of shuttlecock existence, bearing official letters back and forth across the Atlantic. He was released from this only by his sudden and unexpected marriage in 1805. The delicate health of his beloved Penelope virtually settled the matter, and he was eventually discharged from his American obligations, though his name was retained on their Minutes.

After 1804, therefore, Coke did not leave the British Isles until he set out on his final voyage in 1814 to launch a mission in Asia. Such a venture was no rash, hastily conceived scheme, but one he had been cherishing and planning for many years. Once again we are led back to the year 1784 when, amidst all his other commitments, he had begun a correspondence with Charles Grant, an employee of the East India Company and a devout Christian. Coke consulted him for on-the-spot information about the possibility of a Methodist mission to India. Grant responded eagerly, yet realistically, but Coke's dream was destined to be shelved because of his ever-increasing commitments elsewhere. All he could do for the time being was to assure Grant that the proposed mission to Bengal would receive attention 'as soon as the present extraordinary calls from America are answered'.

Although those calls took far longer to answer than Coke had envisaged, the vision of an Asian mission lived on: he had heard the call of the East and in the end was to respond to its persistent summons. The British Conference of 1811 authorized him to make preparations for a mission to Ceylon. While he was busy with these he lost his second wife, just a year after their marriage, and in the midst of his grief he seemed to hear a voice saying repeatedly, 'Don't grieve; go to Asia.' Thus when he emerged from the valley of the shadow, it was to declare that he was now dead to all else but Asia and was determined, despite the pleadings of his friends, to accompany the missionaries in person.

The renewal of the East India Company's charter in 1813 created a fresh opportunity for Christian missions to be established in India. After months of preparation, the missionaries sailed from Portsmouth at the end of the year as part of a large convoy. Having endured many storm-tossed weeks, during which several ships were lost, the convoy rounded the Cape of Good Hope into the

Indian Ocean. But Coke was not to see the land to which he had dedicated his declining powers. The prolonged passage, coupled with the intensity with which he applied himself to his studies in preparation for their arrival in India, told on his health. On the morning of 3 May 1814 he was found stretched on the floor of his cabin. He was buried at sea the same day. There could have been no more fitting end to a life so filled with restless activity and endless journeying than that he should lie, not in the Priory Church at Brecon as he desired, but in an unmarked grave beneath the waters of the Indian Ocean.

* * *

The writing of autobiographical 'journals' was quite a common feature of the early Evangelical Revival, though not necessarily with the intention of publication.[9] During his first voyage to Georgia in 1738, Whitefield wrote an account of the voyage in the form of a letter to friends back at home, who published it in his absence and without his knowledge. This was followed by six further instalments that Whitefield himself published and that covered his activities up to March 1741. Meanwhile, following *his* return from Georgia, John Wesley also published what was to be the first of twenty-one 'Extracts' from his journal during the next half-century. The first two of these extracts were primarily designed as a defence against the criticisms of his ministry in Georgia and a justification of his split from the Moravians. Later extracts were a series of progress reports on the developing Methodist movement that, in the absence of modern media and means of transport, served to strengthen the bonds between the societies throughout the country. His brother Charles also kept a journal, but it was not published until the mid-nineteenth century, and then only in fragmentary form.

Coke thus had sufficient precedents for keeping, and publishing, his journals. But there is no evidence that he kept either a journal or a diary before September 1784, when he left for America. After that date he seems to have done so only while he was out of

[9]. For a survey of journal-writing as a genre, see W. R. Ward's Introduction to John Wesley's manuscript and published journals in *The Works of John Wesley* (Nashville: Abingdon Press, 1984–), 18:1-62, 105-19.

the British Isles, with the exception of the time he spent in Ireland on his way back from his sixth visit to America in 1797. His motives for writing remain conjectural.[10] They may have included literary aspirations (more so than is evident in the earlier Methodist journals mentioned above) and the predilection for travellers' tales characteristic of all venturers into unfamiliar territory. One result of this is that Coke's journals make interesting reading for their own sake. The journals of Wesley and Asbury tend to be more prosaic records of their journeys and preaching, with only occasional side glances at the landscape through which they travelled or the wider culture and contemporary events. Coke's narrative, on the other hand, gives quite detailed impressions of the eastern American seaboard at a time when it was still largely virgin territory and of the exotic tropical islands of the Caribbean.

Another difference between Coke's journal and that of Wesley may be noted. The latter was written up at intervals, sometimes several years after the events described and drawing on the diaries Wesley kept meticulously throughout his adult life. From stylistic evidence, especially in his account of the first American visit, it is clear that Coke wrote his journal more or less from day to day, though that does not, of course, preclude his revising it for later publication. Comparison of the manuscript and printed versions of the 1784–1785 *Journal* provide some indication of how much—or how little—editing he did.

Accounts have survived of the first six of Coke's nine visits to America and of his four Caribbean tours. All of these were published in separate instalments in his lifetime. The account of the first visit was initially published without his knowledge or consent in Philadelphia in 1789. It was then included with a number of omissions and variations in Coke's own collected edition of 1790. A second collected edition appeared in 1793. After his death a further collected edition was published in London and Dublin in

10. It seems clear that in the case of his first American tour, Coke did not write with a view to publication; otherwise he would not have written as candidly as he did, for example, about his host and benefactor Henry Dorsey Gough (see under the date 17 December 1784), or expressed as openly his approval of the still recent repudiation of British rule. Later journals, especially those describing his West Indian tours, were a different matter. In some cases, as with Whitefield, they originated as letters to Wesley, reporting the progress of his mission.

1816, with an introductory biography by Joseph Sutcliffe. It is the text of this 1816 edition that is reproduced here, without the biography, but with two additions. The first is an account of his seventh voyage to America late in 1797, in the form of a letter to John Pawson, printed in the *Methodist Magazine* for 1814. (No firsthand account of the rest of this visit has survived.) The second is a supplement to Coke's account of the first weeks of his voyage to Asia in 1814, sent back as a letter to the Missionary Committee and ending abruptly on 21 February. This letter was included in the 1816 edition of his *Journals*, but without any details of the remainder of the voyage. Reports written by his companions after his sudden death are included here to supplement and complete Coke's account of his final journey.

The 1816 text is presented unchanged so far as spelling, punctuation, and the use of italics are concerned, apart from the silent correction of one or two obvious typos. The footnotes are of three kinds, combined into a single sequence: (1) Footnotes that originally appeared in the 1816 edition; (2) variant readings, mainly from the Philadelphia edition of the *Arminian Magazine* in 1789; and (3) my own editorial notes on the text. The latter mainly identify persons and locations and elucidate references that are no longer self-explanatory.

<div align="right">John A. Vickers</div>

[original title page]

Extracts of the Journals of the late Rev. Dr. Thomas Coke's Several Visits to America, the West Indies, &c &c, &c.

[original dedication]

To the
Rev Mr Wesley.[1]

Honoured and very dear Sir,

Permit me to lay at your feet the first Publication of any magnitude that I have ventured to offer to the public Eye. In you I have for thirteen years found a Father and a Friend, and feel a peculiar happiness on every opportunity afforded me of expressing my obligations to you.

I know you hate flattery, and therefore I must avoid all panegyric. To say but little of you, would derogate from your due; and to do you justice, would offend you. I must therefore only subscribe myself, with very great respect,

Dear Sir,
Your dutiful, affectionate, and
Most obliged Son,
THOMAS COKE

1. The dedication and preface appeared first in the 1790 edition of Coke's *Journals* and were retained in the later collected editions of 1793 and 1816.

[original preface]

THE PREFACE

The very favourable reception my little Journals have met with, demonstrated by the rapid sale of the former editions, induces me to publish the whole of them collectively; and to add thereto an extract of the Journal of my first visit to America, which was never printed before.[2] Two things only can I venture to mention in their recommendation, They have been written with artless simplicity, and with truth. If the account which I have given, of the infant work of God among the poor Negroes in the West Indies, and of the more established work on the Continent of America, administer not only pleasure but profit to the Readers, the highest ambition of the Writer will be gratified, and to God be all the glory.

City-Road, London,
Jan. 25, 1790

2. Except in the 1789 volume of the Philadelphia edition of the *Arminian Magazine*, of which Coke either was unaware or chose to ignore.

1784–85

An Extract of the late Rev. Dr. Thomas Coke's First Journal to North America

Introduction

In 1784 the Methodists in America were living in the aftermath of the War of Independence. The fighting had ended in 1781 with the surrender of the British forces at Yorktown, but the peace treaty was not signed until 3 September 1783. The Constitution of what became the United States and the election of Washington as the first President were still several years in the future.

The war had left the Methodist societies bereft of the pastoral and spiritual care provided by John Wesley from the ranks of British itinerants. Only Francis Asbury survived to give the leadership desperately needed by both members and preachers in this uncertain new world. This situation was exacerbated by the fact that most of the colonial clergy, to whom, as in England, the Methodists had hitherto looked for the sacraments, had left the country. Pressure for the Methodist itinerants to administer the Lord's Supper among the societies surfaced at the Fluvanna Conference, Virginia, in 1779, and only the influence of Asbury, supported by the northern preachers, prevented a widespread revolt against Wesley's authority in this matter.

With the former colonies now independent of British rule, there were legal and constitutional hindrances in the way of providing for the post-war needs of the American people. The Anglican Church in America was still

under the jurisdiction of the Bishop of London. As early as 1781 Wesley had appealed to the Bishop to take action, but without effect. Samuel Seabury arrived in England in July 1783, seeking consecration, but it was not till November 1784 that he achieved his purpose, and then only by resorting to non-juring bishops in Scotland. Meanwhile, in the interest of his American followers, Wesley had taken matters into his own hands. At the beginning of September 1784 he ordained two of the British itinerants, Richard Whatcoat and Thomas Vasey, and also 'set apart as Superintendent' his clerical assistant Thomas Coke. This was consecration in all but name, and before long (though in the face of Wesley's strong disapproval) the American Methodists adopted the more scriptural term 'bishop.'

Coke and his companions embarked at Pill, to the west of Bristol, on 18 September 1784 and landed in New York in November on what was to prove for him the first of nine visits to the United States. He found a nation still in its infancy, its public life still in the process of formation, much of the countryside still virgin forest, and its population outside the few major towns widely scattered in isolated farmsteads and settlements. Asbury saw to it that Coke learned at first hand the widespread and hazardous nature of the work of the American itinerants, and his journal gives us vivid glimpses of a nation on the threshold of its history. Major events during this first visit, such as the first meeting of Coke and Asbury at Barratt's Chapel and the formative 'Christmas Conference' in Baltimore, are separately described in the journals of Coke and Asbury, as well as sometimes by other participants.

With typical impulsiveness, Coke threw himself into the task of witnessing against slavery, only to have to recognise that it was premature for the Methodist Church to launch a major campaign against this intrinsic feature of colonial life. The post-colonial mood was infectious, and his political sympathy for the American cause found its way into the text of his journal as it appeared in Philadelphia in 1789. Some of the expressions he used were seen as sufficiently injudicious to be quietly excised from the British edition that followed in 1790.

The journal of this first American tour was not published in England for several years. Its first printed appearance (apparently without Coke's approval) was in four instalments in the Philadelphia edition of the Arminian Magazine *in 1789.*[1] *A manuscript version has survived as the main item in a small brown notebook belonging to Francis Thursby (or Thoresby), a missionary ordained by Coke in 1793 for work in*

1. Pp. 237-44, 286-97, 339-46, 391-98.

Jamaica.[2] *There are only minor variations between these two versions, but they differ at a number of points from the text as it was first published by Coke himself in 1790, with the title page, dedicatory letter, and preface above. This 1790 version was included in the collected editions of 1793 and 1816 and is therefore the one reprinted here. It includes certain passages not found in the other versions, such as the long paragraph on 8 November 1784 describing the visit from Dr. Magaw and Dr. White of Philadelphia and the account of Coke's public testimony against slavery on 23 April 1785. On the other hand, it quietly omits some of the expressions Coke had originally used, e.g., several favourable references to American Presbyterians and Baptists, and the reference under 2 December 1784 to Mr. Airey as 'a friend to the Revolution.' Clearly, Coke realised, in retrospect, that these were likely to prove offensive in England.*

In presenting here the text of the 1816 edition, variations found in the other versions are given in the notes.

September 18, 1784

At ten in the morning we sailed from *King-Road* for *New York*.[3] A breeze soon sprung up, which carried us with the help of the tides, about a hundred leagues from *Bristol* by Monday morning. — St. *Austin's* Meditations[4] were this very day made no small blessing to my soul.

2. The notebook is now in the Methodist Missionary Society's archives in London. Besides the journal transcript, it contains copies of Coke's letter of commendation to the Methodist society in Kingston, Jamaica, his ordination certificate for Thursby, and an extract of his letter to William Thompson, dated 21 April 1794, regarding the Conference decision to abandon ordination by the imposition of hands; also a copy of a letter to Coke from 'the heathens of London and Westminster' taken from the *London Chronicle*, 1783. All appear to be in Thursby's own hand. The notebook's survival may have something to do with the fact that Thursby never left for Jamaica and proved unsatisfactory in British circuits, withdrawing from the ministry after only two years.

3. MS: 'There was hardly a breeze of wind stirring but the tide was in our favour. My Brethren and myself retired to prayers in the Cabin. Almost immediately a breeze sprung up....'

A plaque now marks the spot at Pill, five miles west of Bristol and close to the mouth of the river Avon, from which Coke and his companions embarked. King Road is in the Severn estuary close by. The exact date of their embarkation is uncertain, but the painting *Offer Them Christ* by Kenneth Wyatt is misleading in one vital detail. There is no evidence, apart from historical romanticizing, that Wesley was there to see them leave. On the contrary, his *Journal* (and, even more significantly, his diary) for this period makes no mention whatever of what would have been a memorable event, and indeed precludes the possibility of his being at Pill. Up till 13 September he was busy in Bristol and Kingswood, and from the 14th on he was preaching among the societies in northern Somerset.

4. Augustine of Hippo; probably his 'Confessions,' which are partly autobiographical, partly devotional.

Sunday 19. — This day we intended to give two sermons to the company, but all was sickness: we were disabled from doing any thing but casting our care upon God.

Wednesday 22. — I passed a night of trial. The storm was high: the sea frequently washed the deck. My thirst was excessive, and all the sailors were at work upon deck, except a few that were gone to rest: sleep had forsaken me, but my trust was truly in the Lord.

Thursday 23. — This and the three former days we lost several leagues, being now nearer *Bristol* considerably than on Monday morning. The storms were high and frequent, and the ship obliged to tack backwards and forwards every four hours between the coasts of England and France. It appeared doubtful some time, whether we should not be obliged to take refuge in the port of *Brest*. — For the five last days, my brethren and myself tasted no flesh, nor hardly any kind of meat or drink that would stay upon our stomachs.

Friday 24. — This morning I was hungry, and breakfasted on water gruel.[5] I now begin to recover my strength, and employ myself in reading the Life of *Francis Xavier*.[6] O for a soul like his! But, glory to God, there is nothing impossible with him. I seem to want the wings of an eagle, and the voice of a trumpet, that I may proclaim the gospel through the East and the West, and the North and the South.

The wind has veered[7] from North-West to South-West, and our ship sails from three to five miles an hour towards America.

I enjoy one peculiar blessing—a place of retirement, a little secret corner in the ship; which I shall hereafter call my study. It is so small that I have hardly room to roll about, and there is a window in it which opens to the sea, and makes it the most delightful place under the deck. Here, God willing, I shall spend the greatest part of my time.

Saturday 25. — We have now sailed one hundred and fifty leagues towards America. My brethren and myself are tolerable recovered. May we improve this time of rest to the profit of our souls and the preparation of them for the work of God. A sailor

5. MS: 'This morning I began to be hungry and thought [it] prudent through the weakness of my body although it was Friday to breakfast on water gruel without bread.'

6. Dominic Bouhours, *The Life of St. Francis Xavier, of the Society of Jesus, apostle of the Indies, and of Japan,* translated by John Dryden (London: Jacob Tonson, 1688).

7. MS: 'Now the Lord was pleased to hear our prayers and the wind veered. . . .'

dangerously ill, affords us an opportunity of visiting the crew in the steerage, and preaching to them through him the Lord Jesus Christ.

The Captain of our ship, I believe, never swears; nor does he suffer any of his men, as far as he can prevent it, to game or get drunk. And though the men are, I find, like the rest of their brethren, profane to the last degree, yet when we are on deck, there is seldom an oath heard.

Sunday 26. — This day we performed divine service both morning and afternoon, and the sailors, except those on immediate duty, attended. A French ship passed us with her colours hoisted, and of course expecting the same compliment from ours, whilst I was enforcing the history and example of the trembling jailor converted by Paul and Silas; which much interrupted us. The little congregation appeared, indeed, to give close attention to brother *Whatcoat*[8] in the afternoon, while he explained to them, the wages of sin, and the gift of God. But, alas! I am ready to despair of our doing them any essential good.[9]

Tuesday 28. — For the two last days the winds were contrary, and we hardly gained a league; but they are again favourable, and we are come two hundred and fifty leagues from *Bristol*. The sailors now attend us daily at morning-prayer. For these few days past I have been reading the life of *David Brainerd*.[10] O that I may follow him as he followed Christ.[11] His humility, his self-denial, his perseverance, and his flaming zeal for God, were exemplary indeed.

This morning a whale played round the ship for an hour and a half: it was a noble sight! And after him an innumerable company of porpoises. How manifold are thy works, O God!

Friday, Oct. 1. — I devoted the morning to fasting[12] and prayer,

8. Richard Whatcoat (1736–1806) had been in the itinerancy since 1769. Wesley had ordained him and Vasey for America during the recent Conference in Bristol. He spent the rest of his life in America, although the O'Kelly schism almost persuaded him to return home in 1790. After an initial refusal by the American preachers to appoint him a bishop in accordance with Wesley's wishes, he was eventually elected bishop in 1800.

9. MS adds: 'O for faith!'

10. David Brainerd (1718–47), pioneer missionary among the indigenous people of northeastern America. Wesley was influenced by his ministry and published an *Extract* of his life (Bristol: Pine, 1768).

11. MS adds: 'though in some things I believe, he ran to great extremes. But. . . .'

12. At Oxford and in Georgia the Wesley brothers had observed the 'statutory' fast-days of Wednesday and Friday. John Wesley encouraged his preachers to fast on Fridays, but the practice gradually died out.

and found some degree of refreshments, and a sacred longing after more fervency and activity in the service of my God.

Saturday 2. — Hitherto the wind had not blown from any one of the sixteen eastern points of the compass; but now a brisk gale from the East carries us directly to our point. We are about three hundred and fifty leagues from *Bristol*, but probably have not sailed in all fewer than seven hundred.

I am entering on the works of Virgil. Indeed I can say in a much better sense than the poet,

> Deus nobis hæc otia fecit,
> Namque erit ille mihi semper Deus.[13]

Sunday 3. — Brother *Vasey*[14] this morning described to the sailors the tremendous transactions of the day of judgment; and in the afternoon I endeavoured to make them sensible of the necessity of being born again. They gave apparent attention, and that is all I can say. We also distributed among them, the Word to a Sailor.

Monday 4. — I have finished the life of *David Brainerd*. The most surprizing circumstance in the whole, I think, is this, That the great work which (by the blessing of God) he wrought among the Indians, was all done through the medium of an interpreter. We are come about four hundred leagues.

Tuesday 5. — I have just finished the Confessional:[15] and believe the author does not speak without reason in his observations concerning National Churches, that the *kingdom of Christ is not of this world:* that in proportion to the degrees of union which subsist between the Church and State, religion is liable to be secularized and made the tool of sinister and ambitious men.

Wednesday 6. — I devoted this morning to fasting and prayer. It was a good time. O that I never may lose any thing I gain in the divine life.

13. Virgil, *Eclogues*, 1. Coke added a footnote in the 1790 *Extracts*: 'Which may be thus translated: "God has provided for us these sweet hours of retirement: and he shall be my God for ever."'

14. Thomas Vasey (1746–1826) became an itinerant in 1776 and was ordained by Wesley for America in 1784. While in America he obtained Anglican orders from Bishop William White. Returning to England in 1789, he rejoined the Methodists and from 1811 to 1826 served as Reader at Wesley's Chapel, where he was acceptable to those trustees who disapproved of the ministrations of the unordained itinerant preachers.

15. Francis Blackburne, *The Confessional* (London: S. Bladon, 1766).

Thursday 7. — In the morning we had a perfect calm, and the Captain spread all his sails; the consequence of which was, that a sudden squall attacking us at dinner time, our main-mast was very near being snapt in two. The mate has been just informing me, that during the squall, and the amazing bustle in which they were, not a single oath was heard among the sailors. So far hath God wrought! We are about five hundred leagues on our voyage.

Friday 8. — I devoted the morning to fasting and prayer, and reading the scriptures, and found it a truly profitable time.

Sunday 10 — Brothers *Whatcoat* and *Vasey* preached to the sailors, and I expounded in the evening: but, alas! I do not perceive that we reach their hearts, though they now attend morning and evening on the week days.

Friday 15. — I set apart this morning for fasting and prayer, as I did also last Wednesday, and found it a refreshing season for my soul. For many days we had contrary winds till yesterday; but within these two days we have made a considerable progress.

Sunday 17. — Two dolphins visited our ship, and immediately the sailors brought out their spear and lines. I knew not whether I should oppose them or not on account of the day: but as the difficulty I should have to convince them of the sin would be very great, and as they now consent to have public worship three times on the Lord's day, I forbore for this time, hoping to bring them in gradually. They killed one of them with the spear, and we are to dine upon it to-morrow. It is more like a salmon, than any other fish I know. We have sailed about seven hundred leagues.

Monday 18. — I have waded through Bishop *Hoadley's* Treatises on Conformity and Episcopacy; five hundred and sixty-six pages, octavo.[16] He is a powerful reasoner, but is I believe wrong in his premises. However he is very candid. In one place he allows the truth of St. *Jerom[e]'s* account of the Presbyters of *Alexandria,* who, as *Jerom[e]* informs us, elected their own Bishops for two hundred years, from the time of St. *Mark*, to the time of *Dionysius*. In another place he makes this grand concession, viz. 'I think not an uninterrupted line of succession of regularly ordained Bishops necessary.' page 489. In several other places he grants

16. I.e., Benjamin Hoadly, *The Reasonableness of Conformity to the Church of England, in two parts* (London: James Knapton, 1712). Hoadly was Bishop of Winchester from 1734, a Latitudinarian, a political and theological controversialist, and an advocate of toleration.

that there may be cases of necessity, which may justify a Presbyterian ordination. But he really seems to prove one thing, that it was the universal practice of the Church from the latter end of the lives of the Apostles to the time of the Reformation, to invest the power of Ordination in a superior Church Officer to the Presbyters, whom the Church soon after the death of the Apostles called Bishop by way of eminence.[17]

Thursday 21. — I finished the Pastorals of *Virgil*, which notwithstanding their many exceptionable passages, by a kind of magic power, conveyed me to fields and groves and purling brooks, and painted before my eyes all the feigned beauties of *Arcadia;* and would have almost persuaded me that it is possible to be happy without God. However, they served now and then to unbend the powers of the mind.

Friday 22. — This day being set apart for fasting and prayer, as also Wednesday last, I finished St. *Austin's* Meditations. Certainly he was a good and great man, however false zeal might sometimes have led him astray.[18] We were now visited by a sparrow, which informed us we were not a great way from land. It probably came from *Newfoundland*.

My brethren and I spent two hours or thereabouts in reading together in the evenings. The Captain and his son, and the mate, sometimes listen with great attention.

The Lord has I trust now given us one soul among the sailors; that of *Richard Hare*. His mother lived in *Stepney*, near *London*, and was a member of our Society. I believe he is in a measure awakened, blessed be God, by our ministry.

Saturday 23. — Infidels have objected to that passage in the Psalms, *The Sun shall not burn thee by day, neither the Moon by night*[19] but *Virgil* has taken a much greater licence where he says,

> Ne tenues pluviæ, rapidive potentia Solis
> Acrior, aut Boreæ penetrabile frigus *adurat*.[20]

17. MS adds: 'but who had no distinct name given him in the New Testament.'
18. MS adds: 'or his Manichean principles drawn him into errors after his conversion.'
19. Psalm 121:6.
20. Virgil, *Georgics*, i.89; Coke's 1790 *Extracts* added the translation as a footnote: 'May the thin rain, or the stronger power of the rapid Sun, or the penetrating cold of the North East wind, never burn you.'

Sunday 24. — I never in my life saw so beautiful a sky as this morning a little before sun-rise—so delightful a mixture of colours, and so fine a fret-work. I do not wonder that the poor Heathens worship the sun. During our afternoon service, and whilst I preached my farewell sermon, the people listened with great attention; and now, I think, I am free from their blood. This afternoon we spoke a brig bound for *London*.

Sunday 31. — Contrary to our expectation we are still at sea, and brother *Whatcoat* and *Vasey* preached. I have entered again on my Greek Testament. What a precious thing is the word of God!

Wednesday, Nov. 3. — We are safely arrived at *New York*, praised be God, after a very agreeable voyage. We inquired for the Methodist preaching-house,[21] and a gentleman, who, as I afterwards found, had not sort of connection with us, led us to our friend *Sands*[22] with whom we make our abode in a most comfortable manner. I have opened Mr. *Wesley's* plan to brother *Dickens*,[23] the travelling Preacher stationed at this place, and he highly approves of it, says that all the Preachers most earnestly long for such a regulation,[24] and that Mr. *Asbury* he is sure will agree to it. He presses me earnestly to make it public, because as he most justly argues, Mr. *Wesley* has determined the point,[25] and therefore it is not to be investigated, but complied with. By the reports of some who lately came from *Europe*, or by some means or other, the whole country has been, as it were, expecting, and Mr. *Asbury* looking out for me for some time. This evening I preached on the kingdom of God within, to a serious, little congregation, the notice being very short.

Thursday 4. — In the morning[26] I preached on, *As the hart*

21. John Street, built in 1768 with the encouragement and support of Capt. Thomas Webb. It was rebuilt in 1817 and again in 1841.

22. Probably Stephen Sands, a trustee of John Street Church. Cf. *The Journal and Letters of Francis Asbury*, ed. Elmer T. Clark, 3 vols. (London: Epworth / Nashville: Abingdon Press, 1958), 1:117.

23. John Dickins (1747–98) was born in London and educated at Eton. He had emigrated to America by 1774. He became a Methodist itinerant in 1777 and was one of the 'Fluvanna brethren' who in 1779 decided to take matters into their own hands and administer the Lord's Supper. He withdrew in 1780, when his voice failed. Re-entering in 1783, he was stationed at John Street chapel, New York. It was he who at the Christmas Conference proposed the name 'Methodist Episcopal Church.' In 1789 he became the first Book Steward, based in Philadelphia. He died in a yellow fever epidemic.

24. MS: 'reformation.'

25. MS adds: 'though Mr. Asbury is most respectfully to be consulted in respect to every part of the execution of it.' *Arminian Magazine* then omits the rest of the sentence.

26. MS: 'This morning (at six o'clock in compliance with the desire of some of our friends). . . .'

panteth after the water-brooks, so panteth my soul after thee, O God:[27] and had very near as many, I think, as on the evening before.

Friday 5. — I enforced on the people in the morning, the example of the *Rechabites:*[28] last night, the necessity of being sealed with the Holy Spirit of Promise. In the afternoon I set off for *Philadelphia*.

Saturday 6. — I arrived at *Philadelphia*, and was received most kindly by brother *Baker*,[29] merchant, in *Market-street*.

Sunday 7. — I preached in the morning and afternoon in St. *Paul's* Church at the desire of Dr. *Magaw*,[30] and in the evening to a large congregation in our own Chapel[31] on the necessity of the witness of the Spirit.[32]

Monday 8. — Dr. *Magaw* and Dr. *White*,[33] two of the clergymen of this city made me a visit: Dr. *White* offered me his church on the Sunday following. The honourable Mr. *Reid* undertook to introduce me to the governor of this State: we waited on him according to appointment, but business of State in Council detained him: however I had the honour of spending three hours with his lady and Mr. *Reid* (who is her first cousin). She is a Quaker, a woman who, I doubt not, loves God. I soon felt liberty to talk with her in the freest manner concerning the deep things of God. On Wednesday the 9th, we waited on his Excellency again at the appointed time, and drank coffee, and spent a couple of hours with him. He is a man of excellent sense, and the utmost

27. Psalm 42:1.
28. See Jeremiah 35.
29. Possibly Jacob Baker, a wholesale dry-goods merchant who had joined the Methodists in 1773, though a footnote in Asbury's *Journal* (1:445) gives his address as 62 Front Street.
30. Samuel Magaw (1735–1812) had been rector of Christ Church, Dover, DE, since 1767 and was now at St. Paul's, Philadelphia. He gave the Delaware Methodists their first meeting-house (Asbury, *Journal*, 1:299n).
31. St. George's, built by a German Reformed congregation, but bought from them and furnished by the Methodists in 1769. Now a National Methodist Shrine.
32. MS adds: 'After preaching I opened to the Society our new plan of Church Government, and I have reason to believe that they all rejoice at it' (*Arminian Magazine:* 'in it').
33. Dr. William White (1748–1836), rector of Christ Church, Philadelphia. He was consecrated bishop of Pennsylvania in 1787, played a significant role in establishing the Protestant Episcopal Church in 1789, and was Presiding Bishop from 1796. The moderate stance and tolerance he manifested in the post-war era—e.g., in his *Case of the Episcopal Churches in the United States* (1782)—made him open to overtures from Coke, but he met with coolness on the part of the American Methodists and Wesley himself, with whom he sought an interview in 1787. It appears that at the time of their first meeting, in 1784, Coke did not take White into his confidence regarding the plans for a Methodist Episcopal Church and was obliged to apologise for this when a fresh rapprochement was attempted in 1791.

politeness, and is looked upon by many as the first literary character in *America*. He told me, that he had the pleasure of spending some time with Mr. *Wesley* in the year 1755, at Mr. *Blackwell's*[34] at *Lewisham*, near *London*, and spoke of him with the highest respect. He has read some of Mr. *Fletcher's* Polemical Writings,[35] and admires them mostly highly. I brought a volume of Mr. *Wesley's* Magazines to his lady, with which she was much pleased, for Mr. *Reid* had praised them to her, and she had expressed a desire of reading them.

Friday 12. — I preached at the *Cross-Roads*[36] in the State of *Delaware*, to a pleasing, attentive congregation.[37] Brother *Whatcoat* had almost as many to hear him in the morning as I had in the evening. On our journey to this place, we were most sumptuously entertained at an Inn gratis. The landlady[38] has certainly some love for the people of God; but, alas! she neglects her own vineyard!

Saturday 13. — I was most kindly received by Mr. *Basset*,[39] one of the Executive-Council for the State of *Delaware*. The place where he lives, is called *Dover*. He is not in society, but is building us a large chapel.[40] Here I met with an excellent young man, *Freeborn Garretson*.[41] He seems to be all meekness and love, and yet all

34. Ebenezer Blackwell, London banker, whose Lewisham home was one of John Wesley's refuges over many years and who gave generous financial support to the Methodists.
35. No doubt primarily a reference to John Fletcher's *Checks to Antinomianism*.
36. I.e., Duck Creek Cross Roads, now Smyrna; see under the date 15 February 1785.
37. MS: '. . . to a simple hearted people. But there is no morning preaching.'
38. Mrs. Mary Withey (d. 1810), widow of James Withey, an English officer (see under the date 15 February 1785). She kept the Columbia Hotel, Chester, described as 'the best Inn on the continent,' where Washington is said to have stayed frequently.
39. Richard Bassett, governor of Delaware, a good friend to the Methodists. Two houses in Dover are known to have been owned by him: one on the south-west corner of The Green and Bank Lane, and the other on the north-west corner of State and Water Streets. Richard Whatcoat died at his home in 1806.
40. Wesley Chapel on South State Street (Asbury, *Journal*, 1:468n). The present building dates from 1850; cf. George Jones, *The Methodist Tourist Guidebook through the 50 States* (Nashville: Tidings, 1966), 40.
41. MS: 'It was this young man (though but just come out into the work) who joined himself to Mr. Asbury during dreadful disputes concerning the ordinances and bore down all before him.'
Freeborn Garrettson (1752–1827), a native of Maryland, was brought up a devout Anglican. Introduced to Methodism through Robert Strawbridge, he became an itinerant in 1776. During the war he suffered persecution as a conscientious objector. Following the Christmas Conference he served for three years in Nova Scotia. But the American Conference of 1787, in defiance of Wesley's wishes, declined to ordain him as superintendent of the work there. Even after his marriage in 1793 he remained in the itinerancy, a prominent and much respected figure in the Methodist Episcopal Church. There are lives by Nathan Bangs (1829) and E. S. Tipple (1910).

activity. He makes me quite ashamed, for he invariably rises at four in the morning, and not only he, but several others of the preachers: and now blushing I brought back my alarm to four o'clock.

Sunday 14. — Brother *Whatcoat* had a very good congregation in the Court-house[42] at six in the morning. About ten o'clock we arrived at *Barret's-Chapel*,[43] so called from the name of our friend that built it, and who went to heaven a few days ago. In this chapel, in the midst of a forest, I had a noble congregation, to which I endeavoured to set forth our blessed Redeemer, as our wisdom, righteousness, sanctification, and redemption. After the sermon, a plain, robust man came up to me in the pulpit, and kissed me: I thought it could be no other than Mr. *Asbury*, and I was not deceived.[44] I administered the sacrament after preaching,[45] to, I think, five or six hundred communicants, and afterwards we held a love-feast. It was the best season I ever knew, except one in *Charlemont*, in *Ireland*. After dining in company with eleven of our preachers at our sister *Barret's*, about a mile from the chapel,[46] Mr. *Asbury* and I had a private conversation concerning the future management of our affairs in *America*.[47] He informed me that he had received some intimations of my arrival on the Continent; and as he thought it probable I might meet him that day, and might have something of importance to communicate to him from Mr. *Wesley*, he had therefore collected a considerable number of the

42. The old court-house stood on the southern part of the site now occupied by the old statehouse.

43. Barratt's Chapel, one mile south of Frederica, DE, named after Philip Barratt, donor of the site and a friend and supporter of Asbury. Now a National Methodist Shrine.

44. Asbury described this first meeting and its immediate aftermath: '*Sunday,* 14. I came to Barratt's Chapel: here, to my great joy, I met these dear men of God, Dr. Coke and Richard Whatcoat, we were greatly comforted together. . . . Having had no opportunity of conversing with them before public worship, I was greatly surprised to see brother Whatcoat assist by taking the cup in the administration of the sacrament. I was shocked when first informed of the intention of these my brethren in coming to this country: it may be of God. My answer then was, if the preachers unanimously choose me, I shall not act in the capacity I have hitherto done by Mr. Wesley's appointment. The design of organizing the Methodists into an Independent Episcopal Church was opened to the preachers present, and it was agreed to call a general conference, to meet at Baltimore the ensuing Christmas; as also that brother Garrettson go off to Virginia to give notice thereof to our brethren in the south' (Asbury, *Journal,* 1:471–72).

45. MS: 'with the aid of brother Whatcoat.'

46. The Barratts' home survives as a private house, one mile east of the chapel on the south side of Route 372.

47. MS omits the reference to their 'private conversation' and reads: 'I privately opened our plan to Mr. Asbury. He expressed considerable doubt concerning it, which I rather applaud than otherwise.'

preachers to form a council; and, if they were of opinion that it would be expedient immediately to call a Conference, it should be done. They were accordingly sent for, and after debate, were unanimously of that opinion. We therefore sent off Freeborn Garretson, like an arrow, from North to South, directing him to send messengers to the right and left, and to gather all the preachers together at Baltimore on Christmas-Eve. Mr *Asbury* has also drawn up for me a route of about eight hundred or a thousand miles in the mean time.[48] He has given me his black (*Harry* by name,)[49] and borrowed an excellent horse for me. I exceedingly reverence Mr. *Asbury;* he has[50] so much wisdom and consideration, so much meekness and love; and under all this, though hardly to be perceived, so much command and authority.[51] He and I have agreed to use our joint endeavours to establish a School or College on the plan of *Kingswood*-School.[52] I baptized here about thirty or forty infants and seven adults. We had indeed a precious time at the baptism of the adults.[53]

White's Chapel, Kent's County, State of Delaware, Tuesday 16. — I am now at the house of our brother White, who is a Justice of the Court of Common Pleas, and General Steward of the Circuit.[54] I preached to a moderate congregation, and baptized many children.

48. This journey took Coke by a zigzag route through Delaware, Maryland, and Virginia, almost to the southern end of the Delmarva Peninsula. See William H. Williams, *The Garden of American Methodism: The Delmarva Peninsula 1769–1820* (Wilmington, DE: Scholarly Resources, 1984), 68-72.

49. Harry Hosier, a black from North Carolina, was an illiterate but eloquent preacher who attracted whites as well as his fellow blacks. He accompanied Asbury and other preachers on their journeys and in 1790 visited England with Freeborn Garrettson, but later fell from grace and became addicted to drink.

50. MS: 'so much simplicity, like a little child, so much. . . .'

51. MS adds: 'that he is exactly qualified for a primitive Bishop.'

52. MS adds: 'One of our American preachers Brother Tunnell has been this year at St. Christopher's in the West Indies, for his health, and the people liked him so well, that they offered him £150 per Ann, a horse, a room and a slave, if he would stay among them; but he refused.'

53. MS adds: 'I am now convinced that the preachers cannot preach early in the mornings except in the Towns, which are very thinly scattered. Nay, they can seldom preach in the evenings. The middle of the day, even upon the weekdays, is their general time of preaching throughout the whole continent, except in the large towns.

'My whole plan, except one day, leads me to preach in the middle of the day, and then only in general.'

54. Judge Thomas White (1730–95). His home near Whitleysburg, in south-west Kent County, DE, on the Maryland state line west of Frederica, had been Asbury's refuge for eighteen months during the Revolutionary War.

Brown's Chapel,[55] Sussex County, Thursday 18. — I enforced the necessity of the power of godliness, to a tolerable congregation, in the midst of a forest.[56]

Quantico-Chapel,[57] Somerset County, State of Maryland, Saturday and Sunday 20 and 21. — Near this chapel I was kindly entertained by one Mrs. *Walters*, a widow-lady of considerable fortune, but not in Society. The chapel is most beautifully situated in a forest, and the congregations were very large both Saturday and Sunday. On the Lord's Day the chapel could not contain the people.

Annamessex-Chapel,[58] Somerset, Monday 22. — I preached to a tolerable congregation in a forest. It is quite romantic to see such numbers of horses fastened to the trees. Being engaged in the most solemn exercises of religion for three or four hours every day, and that in the middle of the day, I hardly know the day of the week: every one appearing to me like the Lord's-Day.

Tuesday 23. — I preached at a chapel called Lower Chapel,[59] to the first inattentive congregation I have met with in America. There is indeed a little society here, which seemed to be all attention, whilst I pointed out the necessity of being redeemed from all iniquity. In the afternoon I preached at the house of Dr. *Robinson,* a physician, and one of our local Preachers: here they were very attentive.

Accomack-County, State of Virginia, Wednesday 24. — I preached at Captain *Downing's* at noon, and Captain *Burton's*[60] in the afternoon: both of them Justices of the Peace. In this part of the country we have no preaching-houses, the work being of very

55. In Sussex County, DE, south-west of Bridgeville. Asbury refers to the building of this chapel in his *Journal* for 12 October 1779. It was named after White Brown of Delaware, a nephew of Judge White who later became Governor of Ohio, and was the predecessor of the present Bethel Church, Andrewsville, on the same site.

56. MS adds as a separate paragraph: 'Moore's Chapel, Sussex, Frid. 19th. I preached also to a tolerable congregation in the midst of a forest.'

57. West of Salisbury on Route 347, in Somerset County, MD. Methodism was introduced here by Garrettson in the summer of 1778, in response to an invitation from Mr. and Mrs. Ryder. Asbury visited the town later that year. The first chapel was on a corner of the present primary school site and was burned down in 1820.

58. Now known as 'Old St. Peter's.' North-east of Chrisfield on the old Chrisfield-Marion Road near the municipal airport. The society was founded in 1782; the first chapel, built in 1784, was rebuilt in 1850.

59. Probably Curtis Chapel (now known as 'John Wesley UMC') on Curtis Chapel Road, three miles east of Westover.

60. For Capt. William Downing and Capt. Burton, see Asbury, *Journal*, 1:469, etc. Both lived in Accomack County in the part of Virginia on the eastern shore of Chesapeake Bay. N.B.: Coke also mentions a *Colonel* Burton two days later.

short standing, from one year to four; but they talked of building, and I encouraged them.

Thursday 25. — We rode to Col. *Paramore's*:[61] his brother is a Member of the Assembly. Here I had a small congregation. The clergy in general in these parts, never stir out to church, even on a Sunday, if it rains.[62]

Northampton-County, Friday 26. — I rode to Col. *Burton's*, and preached in his house: and on Saturday returned back to Col. *Paramore's*, preaching at Mr. *Garretson's*[63] in my way, and at the Colonel's in the afternoon.

Sunday 28. — I read prayers and preached at Accomack in the Court-house, and in the afternoon returned to, and preached at Captain *Burton's*, with a great deal of power, blessed by God!

Monday 29. — I preached at one *John Purnell's*.[64] I have now had the pleasure of hearing *Harry* preach several times. I sometimes give notice immediately after preaching, that in a little time *Harry* will preach to the blacks; but the whites always stay to hear him. Sometimes I publish him to preach at candle-light, as the negroes can better attend at that time. I really believe he is one of the best preachers in the world, there is such an amazing power attends his preaching, though he cannot read; and he is one of the humblest creatures I ever saw.

Tuesday 30. — At noon I preached in the Court-house, at a place called Snow-hill,[65] to a small congregation, most of whom, I suppose, were almost as dead as stones; and in the evening to a little lively congregation, at the house of one *Law*.[66]

Wednesday, Dec. 1. — I preached at a chapel of our's in a forest, called *Lane-chapel*.[67] Here I had a large, lively congregation, baptized a great many children, and administered the sacrament to a great many communicants. For a week past I have been in a barren

61. Col. William Paramore had a plantation of 911 acres in Accomack County, VA. He emancipated his ten slaves (Asbury, *Journal*, 1:552).

62. MS adds: 'The people I am told expected me to be one of those lazy fellows.'

63. Jonathan Garrettson of Accomack County, VA, who provided a site for one of the early chapels.

64. John Purnell (or Purnall) lived near Pokomoke City, Worcester County, MD (Asbury, *Journal*, 2:194).

65. Snow Hill, Worcester County, MD.

66. Probably the William Law mentioned by Asbury (*Journal*, 1:318, etc.).

67. Or Line Chapel, twelve miles west of Selbyville, DE (Williams, *Garden of American Methodism*, 71).

country for the gospel, but am now, blessed be God, got again into the heart of Methodism.

Thursday 2. — I rode through heavy rains and through the forests about thirty miles to Mr. *Airey's*,[68] in Dorset county in the State of Maryland; a most excellent man, and our most valuable friend.[69] There is not one in this county, perhaps, more respected by all ranks of people than he; and he has the highest esteem for our dear father Mr. *Wesley*. Indeed he has entered into the deep things of God. In this place I had a very lively congregation. As I had also at Colonel *Vickers's*, on Saturday 4, — where I administered the sacrament.

Cambridge, Sunday 5. — In this town, which has been remarkable above any other on the Continent for persecution, there arose a great dispute whether I should preach in the church or not. The ladies in general were for it, but the gentlemen against it, and the gentlemen prevailed. Accordingly the church door was locked, though they have had no service in it, I think, for several years; and it has frequently been left open, I am informed, for cows, and dogs, and pigs. However, I read prayers and preached at the door of a cottage, to one of the largest congregations I have had in America. We have no regular preaching here, but I trust shall soon have a good Society notwithstanding all the opposition.[70]

Dr. Allen's, Monday 6. — I preached at noon at a place called *Bolingbroke*.[71] Our chapel is situated in a forest. Perhaps I have in this little tour baptized more children and adults than I should in

68. Henry Airey, whose plantation was south-east of Cambridge in Dorchester County, MD.

69. MS has a fuller version of this account of Mr. Airey: '. . . valuable friend. He has a high esteem for our dear father, Mr. Wesley; and is a leader of a class of about thirty members. He was the grand supporter of the preachers in this country during the late contest. When two of them were imprisoned, because they would not take the oaths, he went to Annapolis and got discharges for them from the Governor and council. He would have opened a correspondence with Mr. Wesley before this but he thinks it would be intruding on his valuable moments, and therefore does not do it. He is a most hearty friend of the new plan. Indeed he has entered into the deep things of God. This man would no more have committed wilful rebellion than murder: and yet he was a friend to the revolution. He had no more idea than many others, that the English government, whenever distress came upon them like an armed man, had any right to throw their burdens on this country.'

70. Garrettson had been imprisoned here in the Dorchester County jail, and other preachers suffered violent treatment. But by 1780 a Methodist circuit had been established. Cf. Williams, *Garden of American Methodism*, 36-38.

71. Seven miles north of the Cambridge ferry over the Choptank River. Dr. Moses D. Allen was the leader of a society in the vicinity of Trappe, MD, from which Bolingbroke Chapel was named (Asbury, *Journal*, 1:334).

my whole life, if stationed in an English parish. I had this morning a great escape in crossing a broad ferry. After setting off, Harry persuaded me to return back, and leave our horses behind us, to be sent after me the next day, on account of the violence of the wind. I have hardly a doubt but we should have been drowned if we had not taken that step. We were in great danger as it was; and if my heart did not deceive me, I calmly and sincerely prayed that God would take me to himself, if the peculiar work in which I was engaged, was not for his glory.

Dr. *Allen*[72] is a physician of great eminence in these parts, and a most precious man, of excellent sense, and of the greatest simplicity.[73] One of the ferrymen of that dangerous ferry, (who I suppose owns the boat) is half a Methodist, and therefore supplied us with two horses to *Bolingbroke*. which is about seven miles from the ferry; and one Captain *Frazier*[74] carried me in his carriage from *Bolingbroke* to Dr. *Allen's*. This Captain and his wife have been lately awakened: but said he to me, we have neither of us yet found the blessing. He is a man of large fortune.[75]

Wednesday 8. — I preached to a lively congregation at Tuckaho-Chapel[76] in a forest. These are, I think, the best singers I have met with in America. In the afternoon I went to Colonel *Hopper's*.[77] This gentleman is a man of excellent sense: he is a member of our Society, and in simplicity a little child. He was six years sheriff of a neighbouring county (Caroline) and three years its Representative in the assembly. He has been lately removed into Queen-Ann's county, and therefore has not been chosen for this year: there being a law of this State, that no person shall be a Representative for any county, but that in which he resides and has resided for twelve months. In my way to this place, I dined with Colonel *Downs*,[78]

72. Allen became a trustee of Cokesbury College. On the last of several visits to him, in April 1802, Asbury found him 'rapidly declining' (*Journal*, 2:334).

73. MS adds: 'I suppose we have a dozen Physicians in our Society on the continent.'

74. Capt. William Frazier, a wealthy convert to Methodism, lived near Preston, Caroline County, MD, on the Delmarva Peninsula. There is a memorial to him in the graveyard at Bethesda Methodist Church (Asbury, *Journal*, 1:554n).

75. MS adds as a separate paragraph: 'Tuesd. 7. I preached today in a large church at a place called Bayside. The congregation was very large.'

76. Tuckahoe (or Ebenezer) Chapel, near Hillsboro, Caroline County, MD, originated from Garrettson's preaching to the militia in 1776 and was associated with Squire Henry Downs.

77. Col. William Hopper of Hall's Cross Roads, Queen Anne's County, MD, at whose home the Methodist society met until a chapel was built in 1794 (Asbury, *Journal*, 2:52n).

78. Squire Henry Downs lived near Tuckahoe Chapel. He was converted by Thomas Chew while the latter was in custody at his home.

one of the present Representatives for Caroline-county, a dear brother of ours, who has lately built us a Synagogue. Some time ago, during the war, when he was sheriff for Caroline county, and unawakened, one of our Preachers was apprehended in his county, because he would not take the oaths of allegiance; and Mr. *Downs* told the Preacher, he was obliged to imprison him, but that he would turn his own house into his prison; and both the colonel and his lady were awakened by their prisoner. Not far from brother *Hopper's*, is one Colonel *Emery*, whose wife is in our Society. He professes faith, but will not join us. When Mrs. *Emery* received one day at preaching a sense of pardon, and related at home the blessing she had received, Mr. *Emery* who was a candid inquirer after truth, and placed the greatest confidence in his wife, was awakened by the relation, and used to continue on his knees at prayer, till they bled; and never rested till he was clearly justified. I think he will not keep from us long. There is also in this neighbourhood one Mr. *Kent*, a member of our Society, who was for some years a Representative for Caroline-county, but withdrew this year on account of a multiplicity of private business. There is not, perhaps, in the whole assembly a person more respected than he. They offered to chuse him Speaker, but he refused.

Kent-Island, Thursday 9. — Here I was obliged to preach out of doors. The very man who published me in the church, and who is one of the Vestry, and one of the principal men in the Island, shut the doors of the church against me. Many people, I believe, who had no regard for the Methodists, were filled with indignation. But the natural and spiritual Sun, blessed be God, shone upon many of us.

Friday 10. — I preached in Colonel *Hopper's* house; but the house would not hold the people; and many, who could not come within hearing, went away. This afternoon I went to visit one Mr. *Chairs*,[79] about two years ago a famous foxhunter, now a leader of a Class, and one of the most zealous men in the country. It is remarkable that his foxhounds, though he took equal care of them, left him one after another in about two months after he gave over hunting.[80]

79. Probably John Chairs, near Centreville, Queen Anne's County, MD, a trustee of the chapel there (Asbury, *Journal*, 2:193).

80. MS adds as a separate paragraph: 'Churchhill. Satur. 11. Here I preached in spite of the bigots, the vestry giving me an invitation.'

New-Town,[81] Sunday 12. — I preached to three large congregations. The preaching-house would not hold, I think, above half the people in the afternoon: so after reading prayers in the chapel, I preached at the door.[82]

Near the *Cheasapeak*, Monday 13. — At noon I preached, baptized and administered the sacrament in Kent-chapel;[83] and at three preached in Worton-chapel,[84] to a large congregation.

Tuesday 14. — We crossed the Bay, and at the other side were met by Mr. *Dallam*,[85] in his chariot, to whose house I went.[86] He is brother-in-law to the Governor of the State, and a member of our Society. We have a preaching-house near, where I preached in the evening to a few, there having been little notice given. Mr. *Asbury* met me on this side of the Bay: between us we have got about one thousand pounds sterling subscribed for the college.

Gunpowder-Chapel,[87] Wednesday 15. — I preached to a small congregation; but most of them I believe were genuine Christians.[88] We had indeed a refreshing shower at the sacrament. I spent the remainder of the day at our kind brother *Walter's*,[89] well known to brother *Rankin*.

Thursday 16. — We returned to brother *Dallam's* where I preached, and administered the Lord's Supper to an attentive people.

Friday 17. — We set off for our valuable friend's Mr *G*.[90] His new mansion-house, which he has lately built, is the most elegant in

81. Now Chestertown, the county seat of Kent County (Asbury, *Journal*, 1:526).
82. MS adds: 'The clergyman had but few I believe to hear in the church.'
83. Kent Chapel, also known as Hynson's Chapel, after Carvill Hynson of Rock Hall, five miles south of Chestertown. This was the focal point of early Methodism on the Eastern Shore (Asbury, *Journal*, 1:526).
84. A log building, north of Chestertown, Kent County, built in 1780 and named after a nearby village. Robert Strawbridge had preached the first Methodist sermon in this vicinity in the house of John Randall in 1769 (Asbury, *Journal*, 1:526).
85. Richard Dallam, one of the chief supporters of the proposed college at Abingdon (Asbury, *Journal*, 1:473).
86. MS adds: 'I have prevailed upon him to give in land 250£ in currency towards the college (for that is to be its name).'
87. Built in 1773 on the site of the later Edgewood Arsenal, near Abingdon. Cf. Asbury, *Journal*, 1:609; and G. P. Baker, *Those Incredible Methodists* (Baltimore: Commission on Archives and History, Baltimore Conference, 1972), 25.
88. MS adds: 'I found myself uncommonly enlarged upon the doctrine of Christian Perfection.'
89. Richard Walters, mentioned in Asbury, *Journal*, 1:379.
90. MS: 'Gough'; i.e., Henry (Harry) Dorsey Gough of Perry Hall, twelve miles north-east of Baltimore, described by William Black as 'the most spacious and elegant building I have seen in America.'

this State.[91] But, alas, it has robbed him I am afraid of a considerable part of his religion. His lady is a precious woman: of fine sense. His daughter, about twelve years old, is of excellent parts, but not awakened. He intends to go to England next spring, to buy furniture for his house, which, I fear, will only still lower him in grace. On these accounts he will only give thirty guineas towards the college, and give five guineas for tracts for the poor. Here I have a noble room to myself, where Mr. *Asbury* and I may, in the course of the week, mature every thing for the Conference.

Baltimore, Sunday, Jan. 2, 1785. — On Christmas-Eve we opened our Conference, which has continued ten days.[92] I admire the American Preachers. We had near sixty of them present. The whole number is eighty-one. They are indeed a body of devoted, disinterested men, but most of them young. The spirit in which they conducted themselves in chusing the Elders, was most pleasing. I believe they acted without being at all influenced either by friendship, resentment, or prejudice, both in chusing and rejecting.[93] The Lord was peculiarly present, whilst I was preaching my two Pastoral Sermons.[94] God was indeed pleased to honour me before the people. At six every morning, one of the Preachers gave the people a sermon: the weather was exceedingly cold, and therefore we[95] thought it best to indulge

91. MS: 'one of the most elegant in the thirteen States.'

92. Coke does not mention the two most significant events of this 'Christmas Conference,' held at the Lovely Lane chapel, E. Redwood Street: (1) It was agreed to form a separate Methodist denomination and to call it the Methodist Episcopal Church; and (2) Coke, assisted by the Reverend Philip Otterbein, ordained Asbury successively as deacon, elder, and (after his fellow preachers had given their approval) superintendent (a title soon changed to bishop). Twelve other preachers were ordained as elders; these included Freeborn Garrettson and James O. Cromwell for Nova Scotia, for whose expenses a collection was taken at one of the mid-day preaching services.

93. MS adds: 'One elder was elected for Antigua, Jeremiah Lambert, two for Nova Scotia, Freeborn Garretson and James Cromwell, and ten for the States, John Tunnell, John Haggerty, James O'Kelly, Le Roy Cole, William Gill, Nelson Reed, Henry Willis, Reubin Ellis, Richard Ivey, and Beverley Allen. They also elected three deacons, John Dickins, Caleb Boyer, and Ignatius Pigman. Brothers Tunnell, Willis and Allen of the elected elders were not present at the Conference, nor brother Boyer of the deacons.'

94. Both sermons, on 'the Godhead of Christ' and on 'the character of a Christian Bishop,' were published the following year.

95. MS: 'brother Asbury.'

them by preaching one hour later than usual; and our morning congregations held out to the last.[96]

One of the week-days at noon, I made a collection towards assisting our brethren who are going to *Nova-Scotia*:[97] and our friends generously contributed fifty pounds currency, (thirty pounds sterling.)

Monday 3. — I left *Baltimore*, and came to our good friend Mr. *Gough's*, but had the coldest ride I ever rode.

Tuesday 4. — I went with several of my friends to the side of the *Cheasapeak-Bay*, but found it so frozen that we could not pass. Here a hospitable planter took in and kindly entertained four of us.

Wednesday 5. — I returned to *Abingdon*. Brother *Dallam* had buried his father-in-law that very day, and his house was full of carnal relations; so I set up at good brother *Toy's*,[98] the silversmith: however, I preached a funeral sermon in Mr. *Dallam's* house, and was heard with great attention. I now gave orders that the materials should be procured for the erecting of the college.

Thursday 6. — I crossed the *Susquehanna*-River, with my horse, on the ice; and lay at one of our friends, whose name is *Thompson*, a truly good man.

Friday 7. — We came to one *Burton's*, a local Preacher, formerly a Quaker; he is a precious old man, and most fervently loves God.

Philadelphia, Saturday 8–19. — In this city I find myself perfectly at home. One thing worthy of notice happened here—One of our sisters who belonged to the *Dutch* Church, was particularly prejudiced against our Liturgy, but whilst I was reading it, she received one of the greatest manifestations of God's love she had

96. MS adds: 'At noon I preached; except on the Sundays and other ordination-days when the service began at ten o'clock, it generally lasted on those occasions four hours: and the chapel was full every time. At six in the evening, a travelling preacher preached in the Town chapel, another in the Point chapel, (a chapel about half a mile out of Town) and another in the Dutch church, which the pious Mr. Otterbein gave us the use of in the evenings during the Conference. (Brother Asbury has so high an opinion of Mr. Otterbein that we admitted him, at brother Asbury's desire, to lay his hands on brother Asbury with us, on his being ordained Bishop.) By this means the congregations were divided, otherwise we should not have had half room enough for the people, who attended in the evening. Our friends at Baltimore were so kind as to put up a large stove and to back several of the seats, that we might hold our conference comfortably. Before I left the Town, I met our principle [sic] friends who promised me to put up a gallery in our Town church (for so we call our preaching-houses now) immediately.'

97. MS adds: 'and Antigua.' The preacher appointed for Antigua was Jeremiah Lambert, but he died before he could take up his appointment there.

98. Probably Joseph Toy, who had been the first class leader at Burlington, NJ, in 1771, organized a class at Trenton in 1771, and is found in Philadelphia in 1773.

ever enjoyed in her life, and went away as much prejudiced in favour of it, as she was before against it.[99]

New-York, January 22–Feb. 6.[100] — Here I published at the desire of the Conference, my Sermon on the Godhead of Christ.[101] Our friends in *Philadelphia* and *New-York* gave me sixty pounds currency for the Missionaries, so that upon the whole I have not been obliged to advance above three or four pounds on their account.

Monday 7. — I left *New-York:* and on Tuesday 8, reached *Trent-Town*[102] (State of Jersey).[103] Here I had but a small congregation, and about twenty hearers in the morning.

Wednesday 9. — I went to *Burlington*.[104] The Vestry opened to me the church, and some of the first men in the State came to hear me: Mr. S.— R.—[105] formerly one of our Travelling Preachers, and a very zealous man, but now a prophesier of smooth things, has been appointed a reader and preacher in this church by the Convention of the clergy of the church of *England*. He expects to be ordained as soon as they have a Bishop.

Mount-Holly,[106] Thursday 10. — Here is another preacher

99. MS adds: 'Thursd. 20th. Princeton, State of Jersey. I have had the pleasure of Mr. Jones's company from Philadelphia to New York, where the Congress is going to sit. He introduced me this evening to Dr. Smith a Presbyterian minister, son in law to Dr. Witherspoon, a very candid, sensible and pious man. We lie tonight at his house.'

100. In the MS this paragraph begins: 'We expected that this Society would have made the greatest opposition to our plan, but on the contrary they have been the most forward to promote it. They have already put up a reading Desk, and railed in a Communion table, also purchased a burial ground. I have united some Bands here. The assistant has promised me to continue the morning preaching faithfully. I have now given over all thought of going to the West Indies: but have taken a ship for Brother Lambert our Elder: he is an excellent young man and will I trust be a great blessing to that country.' Jeremiah Lambert died of consumption before he could take up his work in Antigua.

101. MS adds: 'Perhaps it was the most expedient measure [*Arminian Magazine:* 'in some measure expedient'] as some of our enemies began to whisper that we were enemies to the doctrine of the Trinity, because we left out the Athanasian and Nicene Creeds in our liturgy. The general Minutes I published at Philadelphia. I took shipping for brother Garretson to go to Halifax in Nova Scotia, and left some money for brother Cromwell, who is [*Arminian Magazine:* 'soon'] to follow him.'

102. *Arminian Magazine:* 'Trenton.' Capt. Thomas Webb had preached there in 1766, and Joseph Toy organized the first class in 1771 (Asbury, *Journal,* 1:31, 36).

103. MS adds: 'In my way I dined with my kind hospitable friend Dr. Smith, he would have opened his meeting-house to me if I could have stayed.'

104. Formerly the county seat, where Asbury and others frequently preached in the courthouse. Captain Webb had formed a society there in December 1770, with Joseph Toy as its leader.

105. Samuel Roe (1756–91) had been an itinerant since 1779 and later obtained Episcopalian orders. Cf. N. W. Rightmayer, *The Episcopal Church in Delaware* (1947).

106. Formerly Bridgetown, NJ, Burlington County. George Shadford and Thomas Rankin had preached in the Presbyterian Church in 1774, but no Methodist society was formed until 1805 (Asbury, *Journal,* 1:185).

appointed by the Convention, who was also formerly one of our Travelling-preachers, (*Mr. Sprague,*)[107] a genuine christian.

New-Mills,[108] Friday 11. — My congregation in this chapel, was not large, but very serious. Surely this place will have much to answer for.[109]

Philadelphia, February 12–14. — They are now going in reality to repair our chapel here; the scaffolding is already put up. I have united above a hundred, I think, in band, and they seem to be in good earnest about it, determined to meet. There is certainly a considerable revival in this city.

Wilmington, State of *Delaware,* Tuesday 15. — At noon I preached in *Chester-Town,*[110] in the Court-house, and dined with Mrs. *Withey,*[111] (the kind landlady mentioned above, as having entertained me gratis). She has subscribed five pounds for the college. In the evening I had a large congregation at *Wilmington,* and also at five in the morning: the work revives in this place. From hence I went to *Duck-Creek,*[112] to Dover (Mr. *Bassett's;*) to brother *White's,* the Justice; to *Tuckaho,* (brother *Downs's;*) to Colonel *Hopper's;* to *Sadler's-cross-roads;* to *New-Town;* then over the *Cheasapeak-Bay* to *Abingdon,* (poor Mr. *Dallam's* wife lies dangerously ill, and his fondness for her is such, that he by no means seems prepared for the shock of her death;) from thence to Mr. *Gough's;* and then to *Baltimore.*[113]

Baltimore, February 26, to March 6. — The work of God does indeed prosper in this town. The preaching-house will not contain even my weekday's congregations; and at five in the morning the chapel is about half full. I think I have prevailed on our friends in this place to build a new church.[114] They have already subscribed

107. Samuel Spraggs, formerly a Methodist preacher, was ordained in the Protestant Episcopal Church after the war (Asbury, *Journal,* 1:188).
108. Now Pemberton, NJ. Captain Webb preached there in 1770, and a Methodist preaching-house was built in 1775.
109. MS adds: 'Such faithful preaching these fifteen years.'
110. Not Chestertown, MD, but Chester, PA, which originated as a Swedish settlement. Methodism is said to have been introduced by Captain Webb ca.1769 (Asbury, *Journal,* 1:26).
111. See 12 November 1784.
112. Duck Creek Cross Roads; see note 36 above.
113. MS adds: 'Brother Gough has laid aside his intention of going to England for which I am not sorry.'
114. Lovely Lane chapel, where the Christmas Conference had met, was built in 1774 and was replaced by the Light Street Church in 1786.

about five hundred pounds sterling.[115] I have now formed the believers into bands.

Elcreek,[116] Monday, March 7. — I preached in the church to a tolerable congregation, and in the evening at the house of Mr. *D—*,[117] a chief man in this neighbourhood, good-natured, but of no religion. His cousin (Colonel *D—*) fears God. The church of *England* people in *America*, have a vile custom of walking out and in during divine service. I have now no engagements upon my hands for between two and three hundred miles, so I must post on as fast as I can.

Blaidensburg,[118] Tuesday, March 8. — This day I lost my way in the woods, and after riding ten miles out of my road, found out a hospitable tavern-keeper, who entertained me and my horse *gratis*.[119]

Wednesday, March 9. — In my ride this morning to *Alexandria*, (Virginia) through the woods, I have had one of the most romantic scenes that ever I beheld. Yesterday there was a very heavy fall of snow, and hail, and sleet. The fall of sleet was so great, that the trees seemed to be trees of ice. So beautiful a sight of the kind I never saw before.[120]

And now I am going to open a solemn scene indeed! May God deeply impress it on my heart. We had this day a very sudden thaw. I had two runs of water (as they are called) to cross between *Alexandria* and *Colchester,* which swell exceedingly on any thaw or fall of rain; but being earnestly desirous to get into the work, I determined to proceed on my journey. My servant, whom I had permitted to make a visit to his wife on the other side of the *Cheasapeak*-Bay, had deceived me, by staying with her beyond his time: and the southern preachers knew not where I was, imagining

115. MS adds: 'Here I printed [*Arminian Magazine:* 'have printed'] according to the desire of the conference the substance of a Sermon which I preached at the ordination of brother Asbury to the office of a Bishop. It consists of two parts, 1st A vindication of our conduct. 2ndly The characteristics of a Christian Bishop. There is nothing in the world, I think, about which I find more reluctance, than the becoming an Author, but they force me into it.'

116. MS: 'Elkridge.' Probably Elkridge, south-west of Baltimore.

117. MS: 'Dorsey.'

118. Bladensburg, south of Hyattsville, Prince George's County, MD.

119. MS adds: 'After some questions he observed, "I suppose you are one of the bishops who go about under the authority of the congress to ordain." I told him I was one of those who lately ordain'd at Baltimore.'

120. MS adds: 'At Alexandria I met with poor John Shaw who lives with brother Bushby. I visited in this place General Roberdeau, he is not in Society, but loves us most affectionately.'

me to be in the *West-Indies*. A friend who lives in *Alexandria*, came with me over the first run, and every body informed me I could easily cross the second, if I crossed the first. When I came to the second[121] (which was perhaps two hours after I had crossed the first) I found that I had two streams to pass. The first I went over without much danger: but in crossing the second, which was very strong and very deep, I did not observe that a tree brought down by the flood, lay across the landing place. I endeavoured but in vain, to drive my horse against the stream, and go round the tree. I was afraid to turn my horse's head to the stream, and afraid to go back. In this dilemma I thought it most prudent for me to lay hold on the tree, and go over it, the water being shallow on the other side of the tree. But I did not advert to the danger of loosening the tree from its hold. For no sooner did I execute my purpose so far as to lay hold of the tree, (and that instant the horse was carried from under me,) but the motion that I gave it, loosened it, and down the stream it instantly carried me. Some distance off, there grew a tree in the middle of the stream, the root of which had formed a little bank or island, and divided the stream; and here the tree which I held, was stopped. Instantly there came down with the flood a large branch of a tree upon my back, which was so heavy, that I was afraid it would break my back. I was now jammed up for a considerable time (a few minutes appeared long at such a season) expecting that my strength would soon be exhausted, and I should drop between the tree and the branch. Here I pleaded aloud with God in good earnest; one promise which I particularly urged, I remember well, *Lo, I will be with you always, even to the end of the world.* I felt no fear at all of the pain of dying, or of death itself, or of hell, and yet I found an unwillingness to die. All my castles which I had built in the air for the benefit of my fellow-creatures, passed in regular array before my mind, and I could not consent to give them up. It was an awful time! However, through the blessing of my Almighty preserver, (to whom be all the glory,) I at last got my knee, which I long endeavoured at in vain, on the tree which I grasped, and then soon disengaged myself, and climbed up the little bank. Here I panted for

121. A later reference to this incident (p. 165 below) identifies this as the Accotenk Creek, somewhere near Pohick. The surrounding countryside is low-lying and liable to flooding after heavy rain.

breath for some time: and when I recovered, perceiving the water between the little island and the shore not to be very deep, or very strong, I ventured through it, and got to land. I was now obliged to walk about a mile, shivering, before I came to a house. The master and mistress were from home, and were not expected to return that night. But the principal negro lent me an old ragged shirt, coat, waistcoat, breeches, &c. and the negroes made a large fire, and hung my clothes up to dry all night. Before bed time, a man, who came to the run on a small horse, and perceived mine near the brook, concluded the rider was drowned, and wanting to cross the stream on urgent business, mounted my horse, and being well acquainted with the run, came over safe; he then perceived the footsteps of a person on the side of the water, and concluded they were made by the person to whom the horse belonged; and following the track, brought horse and bags safe to me. As he seemed to be a poor man, I gave him half-a-guinea.[122] At night I lay on a bed on the ground, and my strength having been so exhausted, slept soundly all the night. Thus was I wonderfully preserved, and I trust shall never forget so awful, but very instructive a scene.

On Thursday I got to *Fredricksburg*, a very wicked, ungodly town. I began now to find that I could say with the apostle, 'I know how to *want*, and how to abound:' for I had advanced so much money to pay for the Minutes of the Conference, the sermon on the Godhead of Christ, and towards the binding of the Prayer-books,[123] that my finances were grown very low, and travelling is very dear in *America*. This evening as I was on the road, I asked a man the way, and whether there was any inn near; he told me there was one on the other side of the wood, and he was the landlord. I found him a decent man,[124] and gave him some little books, and he gave me entertainment for myself and my horse *gratis*.

Saturday 12. — By inquiring at the plantations, I found out an old gentlewoman who formerly received the preachers. But they have left that county (*King William's*) on account of the little good

122. MS adds: 'The horse was the same easy charming creature which Mr. Gough lent me to go to Philadelphia.'

123. MS adds: 'and travelling.' The reference is to John Wesley's revision of the 1662 *Book of Common Prayer*, which he published under the title *The Sunday Service of the Methodists in North America*; printed in England, but brought over by Coke in sheets ready for binding in America.

124. MS adds: 'who sometimes heard the Baptist ministers.'

they did there. Here I staid all night, although I had made but two-thirds of a day's journey. I believe it may be well to try the county once more.[125] This morning I called at a plantation to procure intelligence about the road. The mistress of the house perceived something in me, I suppose, of her own spirit, and desired me to alight. I found she was a real seeker after salvation.[126]

Sunday 13. — I was obliged to travel the whole Lord's day in order to reach my appointed engagements. At dinner time I found another old gentlewoman,[127] who desired me to alight, and gave me and my horse very good entertainment: she is a mourner in Zion. In the evening I reached *Williamsburg*[128] after hunting in vain for one of our friends who lives within five miles of it. On inquiring of my landlady whether there were any Methodists in the town, she informed me that one of the principal men in the town was a Methodist.[129] I called upon him, but found that he was a good old Presbyterian. However when I apologized for my mistake, and was retiring, he insisted on my staying at his house, and sent for my horse. He loves God.

Monday 14. — I reached *Smithfield*.[130] The innumerable large ferries in this country make travelling very expensive, and they charge three shillings sterling for a night's fodder and corn for a horse. But it is not so dear in the north.

Portsmouth, Virginia, Tuesday 15. — I got into my work, blessed be God, (having only part of a dollar left,) and preached here to an attentive but chiefly unawakened congregation, and baptized.

Wednesday 16. — I arrived at brother *Jolley's*,[131] at whose house I preached to a little congregation and took up my lodging that night at the house of a neighbouring gentleman, of much candour, but no religion.

Thursday 17. — I preached at (what they call) the *Brick Church,* belonging to the Church of *England,* or rather at present to us, as we perform regular duty there every other Sunday. The people in

125. MS adds: 'especially as the Baptists have now left [*Arminian Magazine:* 'it'].'
126. MS reads: 'I found they were Baptists, and real seekers after Salvation.'
127. MS: 'Baptist gentlewoman.'
128. Asbury gives a vivid impression of the derelict state of Williamsburg in 1782, after the state capital had been moved to Richmond (*Journal,* 1:434).
129. MS gives his name as 'Mr. Holt.'
130. In Isle of Wight County, VA.
131. Perhaps the 'brother Jolliffe' mentioned by Asbury on 28 November 1796 near Portsmouth, VA (*Journal,* 2:105-6).

general in this neighbourhood seem very dead; but our friends, I believe, found it a tolerable good time at the sacrament. After duty I went to sister *Kelsick's,* a widow, and a most excellent woman. She has considerable property. The whole family indeed which is numerous seems all awakened.

Friday 18. — I preached at *Mojock,*[132] to a small congregation. I have now found out a secret. My plan was to cross over from the *West-Indies* to *Portsmouth,* and to take the circuit in which I am now engaged: and this plan was given last Conference to the respective assistants whom it concerned. But brother *Morris* (the only preacher in this circuit) neglected to publish me, so that the people have hardly had any notice; for which reason, I suppose, my congregations will be comparatively small throughout the circuit. Indeed he has committed a much worse neglect than this; for he has not preached in most parts of the circuit these two months, and in some places not these ten weeks, although the people have regularly attended at the accustomed times, and gone away like fools. His wife, it seems, has expected her time these ten weeks, and he cannot leave her till she lies-in.[133] After preaching I went to Colonel *Williams's*[134] who is an excellent Christian, and a true friend to the cause. If it had not been for his activity, I suppose nobody would have known of my coming.

Coenjock, Saturday 19. — I preached in a pretty chapel, which, I believe, belongs to the Church of *England;* but we do regular duty in it. The congregation was not large.

Sandy-Hook-Church, Sunday, March 20. — Here we had a tolerable number, owing to our friends riding out of the way to inform the people from place to place, but there was no preparation for the Sacrament in any of these places, the notice being so short, and in general, so uncertain. I rode after preaching to one Colonel *Burgess's.*[135] His lady is a truly pious woman.

Pasquatank,[136] Monday 21. — I had not been published here. However I collected about thirty, and gave them a sermon in the

132. Probably Mobjack in Mathews County, north-east of Williamsburg.
133. MS adds: 'If I knew of another preacher to supply his place I would suspend him immediately.'
134. MS: 'Holliwell Williams'; *Arminian Magazine:* 'Hollowell Williams.'
135. MS adds: 'Mr. Burgess is quite the gentleman and the man of reading, and so very candid that I am in hopes he is not far from conviction.'
136. Pasquotank County is in north-east North Carolina.

court-house. The swearing, drinking landlord would charge me nothing for my entertainment. His wife had good desires. From hence I rode to *Nixon-Town,* where as before I had not been published. They gathered together a tolerable congregation for me, to whom I gave a sermon in the evening. But the people in this country are so scattered, that the notice must be very public, otherwise they cannot attend. So much for Mr. *Morris's* circuit. I lay this night at one Mrs. *Adams's,* a widow-lady of fortune, who has not yet joined the society.

Tuesday 22. — I rode to the Rev. Mr. *Pettigrew's*.[137] He is gone to the West-Indies for his health; but Mrs. *Pettigrew* received me very kindly.

Wednesday 23. — I went to *Edington*,[138] a most wicked place. Here Mr. *Pettigrew* preaches; but the church is like a pig-stie. The people in general seemed to prefer the court-house, which is an elegant place; so I went there and preached to a very large congregation. The preachers ought really to take this place into their plan, and there is a person who will receive them. There seemed nothing but dissipation and wickedness in the tavern at which I set up, and yet the landlord would take nothing for my entertainment. In the afternoon I went with brother *Dameron,* one of our preachers who came to meet me, to Mrs. *Boyd's,* a widow lady, who rode to *Edington* to hear me. She lives about seven miles on my way, and has good desires.[139]

Thursday 24. — I arrived at Colonel *Campbel's*, in *North-Carolina,* the gentleman and the christian united. He sat in the Senate of this State as long as he chose, and I have been persuading him to resume his seat. He is the first of our friends in the Upper House, that I have met with. I am vastly pleased with him. On the 25th, I preached in the parish church, in which we do regular duty; but, alas! Religion is at a very low ebb in this neighbourhood.

Saturday 26. — I preached in the house of one Mr. L—,[140] a rich man, but of no religion. We usually preach in the church. But he has the gout, and therefore requested me to preach in his house, which is large. It was really a profitable time.

St. John's Chapel, Sunday 27. — This belongs to the Church of

137. The Reverend Charles Pettigrew, Anglican parson at Edenton, Chowan County, NC. Methodist preachers used the chapel on his plantation as well as the Edenton court-house (Asbury, *Journal,* 1:451).
138. I.e., Edenton.
139. MS adds: 'I suppose Mr. Pettigrew does as much good in Edenton [as] a little chicken.'
140. MS: 'Mr. Outlaw.'

England, and we do regular duty in it. I preached here to an attentive people, and administered the Lord's-Supper.

Bridge's Creek Church,[141] Monday 28. — This also belongs to the Church of *England,* and we do duty in it whenever we please. I had a large congregation, but our friends thoughtlessly neglected to provide the elements for the Lord's-Supper. I have been travelling in a very low, wet country for these three weeks, and it is astonishing what a number of frogs there are here.[142]

Tuesday 29. — I preached at the house of *Anthony Moore,*[143] an Israelite indeed, in whom there is no guile. The Lord has not been, I think, more present with me since I came to *America,* than he was this day.

Roanoak Chapel,[144] Wednesday 30. — I found in this chapel a serious, attentive people. Here I met with Mr. *Jarrat.*[145] After duty

141. Bridge Creek chapel was 'an Anglican chapel and a regular preaching place for the Methodists' in 'the old colonial precinct of Bertie' (Asbury, *Journal,* 1:488). There was a Bertie Methodist Circuit. Asbury himself preached here just after this, on 26 April, and wrote: 'I was very ill, and was tempted to think the Lord was about to lay me aside, or take me away, and detain Doctor Coke in America.'

142. MS adds: 'There has been lately a remarkable mortality among the people in these Southern States. Vast numbers of them have been carried off.'

143. Of Northampton County, NC. Coke was about to cross into Virginia on his way back north.

144. An Anglican church, whose exact location is uncertain, though it seems to have been on the Virginia side of the state border, in Mecklenburg or Brunswick County (Asbury, *Journal,* 1:223).

145. The Reverend Devereux Jarratt, one of the few Anglican clergy still *in situ* in postwar America. He had been friendly towards the Methodists, travelling extensively in Virginia and North Carolina to provide them with the sacraments. But he disapproved of the steps taken at the Christmas Conference (all the more because he had not been apprised of them beforehand) and also, as Coke surmises, of the Methodist stance on slavery. His account of his meeting with Coke at Roanoke challenges several of Coke's statements (which he had read in the version in the American *Arminian Magazine,* 1789): 'After saying he met me at Roanoke he says, first, "That I went with him eight miles." I did not go one step with him. Second: "We talked largely about the minutes on slavery." The whole conversation on that subject would not have taken up three minutes time. Third, he says, "I would not be persuaded." I don't know that he used one word to persuade me. Fourth, The secret is, says he, that I have twenty-four slaves. God knows me better, and so do you. Fifth, He intimates that I mightily oppose their rules. Everyone that knows me, knows this to be so far from the truth, that it was quite the reverse.'

The issue may have been less one of principle than a matter of personal incompatibility. Coke may well have felt ill at ease, or even threatened, in the presence of a fellow clergyman who had earned the respect and gratitude of the American Methodists, and been thrown on the defensive by the reservations of a loyal Anglican. He was certainly not above taking himself and his role too seriously, and Jarratt was not alone in finding him pompous: 'His little soul, I believe, was exasperated at me, for laughing at his Episcopal credentials, which he vainly drew out upon me, with Mr. Wesley's hand and seal annexed forsooth. The sight to me was truly farcical and ludicrous in the extreme—I could not forbear smiling—but my pleasantry, on viewing the parchment, was too serious a matter for the doctor; his pride could not brook it—and so he has shewn his spleen by holding me up in his journal. . . . I freely forgive him, and I pray to God to forgive him, and cause him to know himself' (Asbury, *Journal,* 3:82–83, citing Jarratt's autobiography).

he went with me to one brother *Seaward's* (in the State of *Virginia*) about eight miles off. We now talked largely on the minutes concerning slavery: but he would not be persuaded. The secret is, he has twenty-four slaves of his own: but I am afraid, he will do infinite hurt by his opposition to our Rules.

Thursday 31. — I came to one *Isham Malone's*[146] and preached in his dwelling-house, where we had an excellent time, especially at the Sacrament. In the afternoon I rode to brother *Jordan's*,[147] who lent me a fresh horse, and will meet me at a place about forty miles off on my return from the South in about three weeks time, which will save my horse about four hundred miles.

Friday, April 1. — I preached in a chapel belonging to *Isaac Johnson*. I now began to venture to exhort our Societies to emancipate their slaves.

Saturday 2. — At noon I preached in the dwelling-house of brother *Downing*, a man of property, and we had considerable refreshments at the Sacrament. Sister *Downing* is a blessed woman.

Sunday 3. — We crossed a dangerous ford, where a man was lately drowned. The river was rather full, but I followed the foremost, and my company and self got safe over. I preached at noon at the house of brother *Almond*.[148]

Tuesday 5. — I rode to sister *Bedford's*. Here I dared for the first time to bear a public testimony against slavery, and I do not find that more than one was offended. On Wednesday 6, I preached the late Colonel *Bedford's* funeral sermon.[149] But I said nothing good of him, for he was a violent friend of slavery, and his interest being great among the Methodists in these parts, he would have been a dreadful thorn in our sides, if the Lord had not in mercy taken him away.

Thursday 7. — I went some miles to a dying friend, and spent about half the day with him in drawing up his will, in which he emancipates at the times there specified his eight slaves. This is a

146. Of Mecklenburg County, VA (Asbury, *Journal*, 1:377).
147. Perhaps the Thomas Jordan mentioned in Asbury's *Journal*, 22 February 1802 (2:329).
148. MS adds a further paragraph: 'Monday 4th. This being the day of the general Election for the county, I don't preach but stay quietly at brother Almond's, where I have a room to myself.' The reference is to Edward Almond of Charlotte County, VA.
149. Colonel Bedford of Charlotte County, VA. Later references in Asbury's *Journal* are presumably to another Colonel Bedford, perhaps a son.

good beginning. In the evening I crossed over a dangerous run of water, and lay at the house of brother *Ward*.

Friday 8. — According to my plan I was to preach in a church called *Royster's* Church at noon.[150] After riding about twenty-five miles, I got, as I found afterwards, within a furlong of the church; but the church being out of sight in an immense forest, and the path which led to it hardly trodden, and having no guide, (the person who was to accompany me, having disappointed me) I rode about eighteen miles more, backwards and forwards, generally on the full stretch, and found it at last by the direction of a planter, whose plantation was the only one I saw for some hours. When I came there, which was two hours after the time, there was nobody to be seen. I returned to the planter's, who gave me and my horse some refreshment, and recommended me to go to one Capt. *Philps*,[151] a Methodist about five miles off. After travelling till nine at night, and expecting frequently I should be obliged to take up my lodging in the woods, with the assistance of two negroes and two shillings I found out the house. I now was informed that I had not been published in *Royster's* Church, or any part of that circuit, the two Preachers not having been at the last Conference, and the neighbouring preachers not having sent them a copy of my plan. However our brother *Philps* and his family and several other friends intended to set off the next morning for a quarterly-meeting about sixteen miles distant. Their quarterly-meetings on this continent are much attended to. The Brethren for twenty miles round, and sometimes for thirty or forty, meet together. The meeting always lasts two days. All the Travelling Preachers in the circuit are present, and they with perhaps a local Preacher or two, give the people a sermon one after another, besides the Love-feast, and (now) the Sacrament. On Saturday 9, I set off with the friends to Brother *Martin's*, in whose barn I preached that day. The next day I administered the Sacrament to a large company, and preached, and after me the two travelling Preachers. We had now been six hours and a half engaged in duty, and I had published myself to preach in the neighbourhood for the following days, so

150. Asbury had preached there and administered the sacrament on 15 January that year. Location not identified.

151. Asbury's *Journal*: 'Phelps,' who appears to have lived at Newtown, now Stephens City (*Journal*, 1:760).

they deferred the second Love-feast till Wednesday. There were thirty strangers, I think, in Brother *Martin's* house only; which obliged us to lie three in a bed. I had now for the first time a very little persecution. The testimony I bore in this place against slave-holding, provoked many of the unawakened to retire out of the barn, and to combine together to flog me (so they expressed it) as soon as I came out. A high-headed lady also went out, and told the rioters (as I was afterwards informed) that she would give fifty pounds, if they would give that little doctor one hundred lashes. When I came out, they surrounded me, but had only power to talk. Brother *Martin* is a justice of the peace, and seized one of them: and Colonel *Taylor*, a fine, strong man, who has lately joined us, but is only half-awakened, was setting himself in a posture of fighting. But God restrained the rage of the multitude. Our Brother *Martin* has done gloriously, for he has fully and immediately emancipated fifteen slaves. And that sermon which made so much noise, has so affected one of our brethren (Brother *Norton*) that he came to Brother *Martin*, and desired him to draw up a proper instrument for the emancipation of his eight slaves. A brother (whose name is *Ragland*) has also emancipated one.

Monday 11. — I preached at Brother *Baker's*. Here a mob came to meet me with staves and clubs. Their plan, I believe, was to fall upon me as soon as I touched on the subject of slavery. I knew nothing of it till I had done preaching; but not seeing it my duty to touch on the subject here, their scheme was defeated, and they suffered me to pass through them without molestation.

Tuesday 12. — I rode to Brother *Kennon's*,[152] preaching a funeral sermon in the way at a planter's house for a little child, and reading our burial service in the wood over the grave. They have a funeral sermon preached in these parts for every human creature that dies except the Blacks. Brother *Kennon* has emancipated twenty-two slaves. These are great sacrifices: for the slaves are worth, I suppose, upon an average, thirty or forty pounds sterling each, and perhaps more.

Wednesday 13. — I had a good time at the Love-feast after preaching at Brother *Kennon's*. Brother *Martin's* wife is an excellent saint.

152. Probably the C. Kennon for whom Asbury expressed 'great affection' as 'one of the most sensible Calvinists in these parts' (*Journal*, 1:422) or else his brother mentioned by Coke on April 14th.

Thursday 14. — We rode about forty miles to a Brother of Mr. *Kennon*. There are nine of the family in the Society. I have now done with my testimony against slavery for a time, being got into *North-Carolina* again, the laws of this State forbidding any to emancipate their negroes. Friday 15, I preached here to a small congregation.

Saturday 16. — I rode to a Dissenting Meeting-house,[153] in which the pious minister (Mr. *Patillo*) gave our friends leave to hold their Quarterly Meeting. Mr. *Patillo*[154] and I preached that day and Sunday, and one of our preachers also on the Sunday.

Monday 18. — I rode to Colonel *Taylor's*,[155] a sincere friend and brother, who is overjoyed at our late regulations.[156] They got a little company together in the evening.

Tuesday 19. — We came to Brother *Greenhill's*,[157] where we held our Conference. There were about twenty Preachers, or more, in one house, and by laying beds on the floors, there was room for all. We spent three days from Wednesday to Friday inclusive, in Conference, and a comfortable time we had together. In this division we have had an increase of nine hundred and ninety one this year: and have stretched our borders into *Georgia*. *Beverly Allen*[158] has all *Georgia* to range in.[159] We also sent an Elder and a Preacher to *South-Carolina*. Mr. *Asbury* has met with great encouragement in his visit to *Charles-Town*; a merchant, (Mr. *Wells*) opened his house to him, and was convinced and justified before he went

153. MS reads: 'a Presbyterian Church' and adds: 'Our people in the neighbourhood, I found (who have been brought up Presbyterians) had desired Mr. Patillo to administer the Sacrament to them, not knowing of my coming to see them; so for the first time of my life, I partook of the Sacrament in the Presbyterian way. I lay at Mr. Patillo's.'

154. The Reverend Henry Patillo of the Grassy Creek Presbyterian Church, NC, a good friend to the Methodists.

155. MS: 'Edmund Taylor's.'

156. MS: 'our late change.'

157. Major Green Hill of Louisburg, NC. It was the first Annual Conference to be held since the formation of The Methodist Episcopal Church. Their host was a prominent public figure and an owner of many slaves. Coke and Jesse Lee clashed over the slavery issue, and the Conference reached a compromise, agreeing to petition the North Carolina General Assembly for an act legalizing the emancipation of slaves by owners willing to do so.

158. Allen began preaching in 1778 in his home area around the present Durham, Chapel Hill, and Raleigh. He was ordained at this Conference, but earned Asbury's displeasure by staying in the Carolinas despite his appointment to Georgia. Asbury had recognized his rebellious spirit early on. After several years in and around Charleston he was expelled in 1792 on moral grounds.

159. MS reads: 'Beverley Allen has all South Carolina to range in' and adds: 'We have ordained him Deacon and Elder at this Conference.'

away. We have now one hundred and ten Members in that State by the assiduity of a local Preacher, who lately settled there. We have also drawn up a petition to the General Assembly of *North-Carolina* signed by the Conference, intreating them to pass an act to authorize those who are so disposed, to emancipate their slaves. Mr. *Asbury* has visited the Governor, and has gained him over.

Mecklenburg County, Virginia, Saturday 23. — We rode about forty-five miles to brother *Tignel Jones's*,[160] to a Quarterly Meeting which we held on the Sunday and Monday. Here I bore a public testimony against slavery, and have found out a method of delivering it without much offence, or at least without causing a tumult: and that is, by first addressing the negroes in a very pathetic manner on the duty of servants to masters; and then the whites will receive quietly what I have to say to them. Sister *Jones* is a very precious woman. I had a fine congregation at five on Monday morning. The people in general in this part of the country, and also in the back parts of *North-Carolina*, eat only two meals a day; the first about nine in the morning, and the second about four or five in the afternoon. They eat flesh at both meals. Our people in general drink coffee with the first meal, and water with the second. The people of the world drink either coffee or cyder with the first meal, and grog or cyder with the second. Their animal food is almost entirely pig-meat, with some times shad-fish. I have hardly eat anything these ten weeks of the flesh kind, except swine's-flesh and shad-fish. Blessed be God, I have been enabled to set apart Friday as a day of fasting or abstinence ever since Christmas, except one day when I forgot, and one day when I travelled fifty-two miles. In the morning I eat a little bread, and drink some milk, and in the afternoon eat some greens, (the only garden-stuff they have got in this part of the country) and some fruit-pie. They have a great variety of fruit-pies, peach, apple, pear and cranbury, and puddings very often. I esteem it one great blessing, that I prefer the Indian corn to the wheat. Besides, they do not in general manage their wheat properly in the South, so that the wheat-bread is but very indifferent. The people in general, and more especially our own friends, go to bed very early (about nine o'clock) and rise early, about five, or day-break.

160. Tignal Jones of Wake County, NC, near the present Apex, south-west of Raleigh (Asbury, *Journal*, 1:367).

Tuesday 26. — I again visited kind brother *Downing*, and preached that day, and the next morning at five. On Wednesday I set off for the Quarterly-Meeting at brother *Rogers's* in *Brunswick*-County, and had a very refreshing time: in the way I preached an awakening discourse, which, I have some reason to think, did good.

Saturday 30. — I set off with a company of Preachers, who by this time had met me, for the *Virginia* Conference. In the morning I preached and administered the Sacrament at brother *Merrit's*.[161]

Sunday, May 1–4. — About twenty Preachers met Mr. *Asbury* and me at brother *Mason's*.[162] One night we all slept at the same house: but it was so inconvenient to some of the Preachers, that they afterwards divided themselves through the neighbouring plantations, by which we lost about an hour in the mornings. A great many principal friends met us here to insist on a Repeal of the Slave-Rules; but when they found that we had thoughts of withdrawing ourselves entirely from the Circuit on account of the violent spirit of some leading men, they drew in their horns, and sent us a very humble letter, intreating that Preachers might be appointed for their Circuit. We have increased about two hundred in this division in the course of the last year. After mature consideration we formed a petition, a copy of which was given to every Preacher, intreating the General Assembly of *Virginia*, to pass a law for the immediate or gradual emancipation of all the slaves. It is to be signed by all the freeholders we can procure, and those I believe will not be few. There have been many debates already on the subject in the Assembly. Many of our friends and some of the great men of the States, have been inciting us to apply Acts of Incorporation, but I have discouraged it, and have prevailed. We have a better staff to lean upon, than any this world can afford. We can truly say, 'The harvest is great, but the labourers are few.'

Thursday 6.[163] — I took an affectionate farewell of my Brethren: and on the 7th passed by the house of Mr. *Jarrat*, that violent asserter of the propriety and justice of negro-slavery.[164] At noon I preached at *White Oak* Chapel,[165] and lodged that night at the

161. Merritt's Chapel?

162. William Mason, who built a chapel near Gasburg, Brunswick County, VA (Asbury, *Journal*, 1:166; for Asbury's account of this Conference, see ibid., p. 488).

163. This and the following dates are wrongly printed. The MS gives them correctly as Thursday 5th and so on until Monday 9th.

164. See note 145 above.

165. Near Devereux Jarratt's home in Dinwiddie County, VA (Asbury, *Journal*, 1:355).

house of brother *Rees*,[166] one of our local Preachers, a friend of God and man. He lives just by Mr. *Jarrat,* and is the great bar in the hands of God to that fallen man's ruining our whole work in that neighbourhood. For his influence among those who are both within and without, is I believe three times as great as that of Mr. *Jarrat.*

On the 8th I preached at ten in the morning at brother *Spain's*, and at six in the evening at brother *Mann's.*[167] On Sunday 9th, I preached at brother *Grange's* and brother *Finney's.* Brother *Finney*[168] is one of our Committee, whom we have appointed to conduct our business relative to our petition to the General Assembly. He is a good local Preacher, and a man of fortune and family; an honor to our connexion. On Monday 9th, I preached at brother *Briscoe's* and *Johnson's,*[169] and on Tuesday the 10th at brother *Ogee's* and *Bransford's.*[170]

On Wednesday 11. — I rode through the heavy rains to a Church in a forest, where I was engaged to preach. Every body told me that no one would come—that no one would imagine I would attend on such a day. And I found it true: so after being wetted to the skin, and the very linen in my saddle bags drenched with rain, we rode (brother *Bowen,*[171] the Preacher who travelled with me through this Circuit, and myself) to the house of a kind Physician,[172] who gave us a very hospitable reception. On Thursday the 12th, I preached in a Church about fifteen miles from the place where I had lodged, to a considerable and attentive congregation.

Friday 13. — I preached at *Bent*-Chapel, belonging to the Church of *England.* At night I lodged at the house of Captain *Dillard,* a most hospitable man, and as kind to his negroes as if they were white servants. It was quite pleasing to see them so decently and comfortably clothed. And yet I could not beat into the head of that poor man the evil of keeping them in slavery, although he has read

166. Henry Rees, a Methodist preacher (Asbury, *Journal,* 2:328).
167. Perhaps Page Mann (mentioned in Asbury, *Journal,* 1:375).
168. John Finney of Amelia, VA, described by Asbury as 'a serious man and a preacher' (*Journal,* 1:379).
169. A Benjamin Johnson, described as the leader of one of the earliest societies in Virginia, is mentioned in Asbury's *Journal* (1:167; 2:176).
170. MS adds: 'Brother Ogee is certainly a good man.'
171. Thomas Bowen.
172. MS reads: 'the house of a kind Baptist, a physician, who. . . .'

Mr. *Wesley's* Thoughts on Slavery, (I think he said) *three times over:* but his good wife is strongly on our side.

Saturday and Sunday 14, and 15. — I preached in a handsome Church. On the Sunday I had a very large congregation. During the sermon, after I had spoken very pointedly concerning the impropriety of going in and out during divine service, two dressy girls walked out with such an impudent air, that I rebuked them keenly. After the public service, whilst I was administering the Sacrament, baptizing, and meeting the Society, their father, who is a colonel, raged at the outside of the church, declaring that as soon as I came out, he would horse-whip me for the indignity shewn to his family. But his two brothers (all unawakened) took my part, and insisted that I had done my duty and the young ladies deserved it. However, finding that our preaching in that Church, which we do regularly, chiefly depends upon him, I wrote a letter of apology to him as far as the truth would permit, when I came to my lodging. We had a good time during the sermon and the Sacrament. But when I enlarged to the Society on *Negro-Slavery*, the principal leader raged like a lion, and desired to withdraw from the Society. I took him at his word, and appointed that excellent man (brother *Skelton*) leader in his stead. When the Society came out of the Church, they surrounded brother Skelton. 'And will *you*,' said they, 'Set your slaves at liberty?' (He has many slaves) 'Yes,' says he, 'I believe I shall.' I lodged that night with dear brother *Skelton*.

Monday 16. — I preached to a most polite congregation at *New-Glasgow*, and lodged at Colonel *M—'s*.[173] They gave me great attention. Colonel *M—* is a very sensible and polite man. He acknowledged the force of my arguments concerning the negroes, but (I evidently saw) did not chuse to take any active part for fear of losing his popularity. His son is a member of the House of Delegates, and he wants himself to get into the Senate. His lady wishes to be religious. On Tuesday the 17th, I preached in a court-house at noon, but in a very wicked neighbourhood. However the congregation gave me their ear, while I endeavoured to shew them the necessity of the New-birth. At four in that afternoon, I preached at one Mr. *L—'s*,[174] a drunkard. The Preachers find this

173. MS: 'Mr. Meredith.'
174. MS: 'Loving's.'

a convenient half-way house; so they take it in their way out of a kind of necessity. How strange it is that so many will do anything for the cause of religion, but part with their besetting sin. I now was met by our dear valuable friend Dr. *Hopkins*. He brought me that evening to his house, though it was dark before we reached it. Here I found myself locked up in the midst of mountains. So romantic a scene, I think I never beheld. The wolves, I find, frequently come out to our friend's fences at night, howling in an awful manner; and sometimes they seize upon a straying sheep. At a distance was the *Blue Ridge,* an amazing chain of mountains. I have been for a considerable time climbing up and descending the mountains. I prefer this country to any other part of *America:* it is so like *Wales,* my native country. And it is far more populous than I expected. On Wednesday the 18th, I preached at the Doctor's to a little, loving congregation, and administered the Sacrament: and the Lord was with us.

Thursday 19. — I preached to a quiet, unawakened congregation, at brother *Tandy Key's,* who is lately come into that neighbourhood. He told me, as we rode together, that he was determined to emancipate his slaves (about twenty) although his miserable father, I suppose, will never give him any further assistance, if he does. I pushed on in the evening, with an intention of reaching his father's, Mr. *Martin Key's,*[175] but at nine o'clock at night was glad to take up my lodgings at a tavern, in a little town called *Charleville,*[176] more especially as I had a dangerous river to cross before I could get to Mr. *Key's.* Nor am I sorry that I did not go thither; for when I called the next morning, I found that he had shut his door against the Preachers, because he has eighty slaves. For some years, I think, we preached at his house. His youngest son is a local Preacher, and I believe, soon will take a larger field. His eldest son is a child of Satan,[177] and therefore, I suppose, will have all his possessions when he dies. I drank a little milk here, (it being Friday,) and before I went away, cleared myself of the blood of the old man, which, I evidently perceived, not a little pleased his pious wife.

175. Of Amherst County, VA.
176. Possibly an error for Charlottesville.
177. MS adds: 'like himself.'

Friday 20. — I preached at brother *Grimes's*, where I had many dressy people to hear me: and at five the next morning had a very good congregation.

Saturday 21. — I preached at a chapel in a forest, which we call the *New-chapel*, and administered the Sacrament, and was here met by our valuable friend (brother *Harry Fry*)[178] one of the members for *Culpepper*-County. Our society is not numerous in that county, and they long, but in vain, solicited him to become a candidate. At last, a little before the election, he consented, and he and his colleague out-polled the other candidates, though supported by most of the principal gentry in the county; which enraged them to that degree, that they were almost mad. One of them cried out at the poll booth, 'These Methodists and Baptists will never rest, till they get their knives into our bellies.' On Sunday 22, I read prayers, preached, and administered the Sacrament in Mr. *Fry's* great room, which he had built for a *Ball-room*. But, I think, before he had used it for one ball, the Lord caught hold of his heart, and he turned it into a preaching-room. He is a precious man, and, I trust, will be eloquent in the House of Delegates for the emancipation of the slaves. He is to present our petition.

Monday 23. — After the falling of heavy rains, I set off with one of the Preachers for *Alexandria*. This day I met with many difficulties. In crossing the water in one place, that I might reach the bridge under which the main stream ran, the water was above the top of my boot. In another place, where we endeavoured to drive our horses over the run, (the bridge being broke,) we were likely to lose our beasts, the stream being too strong for them, and carrying them down. At last we got them out, and with great labour and some danger, patched up the broken bridge with the loose boards, and got over with our horses safe. After riding about forty miles, it grew so dark, and our horses and selves were so fatigued, that we lay at an inn upon the road, though we were within five miles of our friend's house where we intended to lodge.

Tuesday 24. — We were locked up by the waters, so much rain having fallen the night before. We arrived, however, at brother *Watson's*, a local Preacher, and he procured for me a little congregation.

On Wednesday the 25th, I set off again: and after many doubts, and I confess, with trembling, was prevailed upon to walk over a

178. Henry Fry of Culpepper County (later Madison County), VA (Asbury, *Journal*, 1:425).

long pine-tree, which lay across a strong and deep stream of water, in which I must have been inevitably drowned, if my foot had slipped. A man went before, leading me by the hand. But here as every where, the Lord was at my right hand, that I should not fall. On this day I crossed the very same run of water in the afternoon, where *the awful scene* happened, which, I trust through the blessing of God, I shall never forget. We dined at a friend's house by the way, and reached brother *Bushby's*[179] at *Alexandria*, about seven in the evening. Here I met according to appointment, that dear, valuable man, Mr. *Asbury*. He had informed the people that when I arrived, the court-house bell should ring, and about eight o'clock, I had a very large congregation in the Dissenting Meeting-house,[180] to whom I insisted on the necessity of the *witness of the Spirit*.

Thursday 26. — Mr. *Asbury* and I set off for General *Washington's*.[181] We were engaged to dine there the day before.[182] The general's seat is very elegant, built upon the great river *Potomawk;* for the improvement of the navigation of which, he is carrying on jointly with the State some amazing plans. He received us very politely, and was very open to access. He is quite the plain country gentleman.[183] After dinner we desired a private interview, and opened to him the grand business on which we came, presenting to him our petition for the emancipation of the negroes, and intreating his signature, if the eminence of his station did not render it inexpedient for him to sign any petition. He informed us that he was of our sentiments, and had signified his thoughts on the subject to most of the great men of the State: that he did not see it proper to sign the petition, but if the Assembly took it into

179. William Bushby who, from Asbury's *Journal* (2:138), appears to have been living outside Alexandria.

180. MS: 'Presbyterian church.'

181. Washington had resigned his commission in December 1783 and retired to his estate, Mount Vernon, overlooking the Potomac. He was unanimously elected first President of the United States in 1789. Two of Coke's biographers, Jonathan Crowther and Samuel Drew, confuse this courtesy visit with the later presentation of a loyal address from the American Methodists in 1789. Coke's *Journal* remains understandably silent on the latter event.

182. MS adds: 'General Roberdeau, an intimate acquaintance of General Washington's, who served under him in the war, paved our way by a letter of recommendation. We lay at General Roberdeau's the night before, and he was to have gone with us; but Mrs. Roberdeau was so ill after lying in, that he did not chuse to leave her.' Brig. Gen. Daniel Roberdeau (1727–95) had served with the Pennsylvania militia during the war and then settled in Alexandria. Washington's diary confirms that Roberdeau and the two preachers had been expected the previous day.

183. MS adds: 'and he is a *friend* to [*Arminian Magazine:* 'of'] *mankind.*'

consideration, would signify his sentiments to the Assembly by a letter. He asked us to spend the evening and lodge at his house, but our engagement at *Annapolis* the following day, would not admit of it.[184] We returned that evening to *Alexandria*, where at eight o'clock, after the bell was rung, I had a very considerable congregation.

Friday 27. — Mr. *Asbury* and I rode to *Annapolis*, in the State of *Maryland*, where the general Court (the supreme Court of Judicature of the State) was sitting. This prevented my preaching in the court-house. However I had a noble congregation in the play-house, and most of the great lawyers to hear me. And surprising! the fine ladies and gentlemen attended at five the next morning, so that I had one of the largest morning congregations that I have had in America. We have no regular preaching here yet, but I trust shall soon see good days.[185] One lady was so desirous of my coming, that she sent word to Mr. *Asbury* that she would advance two guineas for a carriage to bring me there from *Alexandria*: but that I did not accept of.

On the 28th, we reached our kind friend Mr. *Gough's*, having spent a few hours in *Baltimore*, and travelled about fifty miles.

Sunday 29. — I preached and administered the Sacrament at the *Falls*,[186] as it is called, our church being near a great fall of water. It was the quarterly-meeting. We returned to Mr. *Gough's*, where I preached in the evening.

Monday 30. — We rode to *Abingdon*, where we agreed to give Mr. *Dallam* sixty pounds sterling for four acres of ground, which we had fixed upon as the site of our college, and had proper bonds drawn up.[187] We returned in the evening to Mr. *Gough's*.

184. MS adds: 'I was loth to leave him, for I greatly love and esteem him and if there was no pride in it, would say that we are *kindred spirits*, formed in the same mould. O that God would give him the witness of his Spirit!'

185. For more than ten years, from 1774, the Annapolis play-house was used by the congregation of St. Anne's parish while their church was being rebuilt. The first Methodist chapel was built soon after Coke's visit. See p. 214 below.

186. I.e., Gunpowder chapel, near Gunpowder Falls, not far from Perry Hall.

187. Cokesbury College at Abingdon, north-west of Baltimore, had a short and chequered history. Asbury's initial enthusiasm for the venture was blunted by the demands made on his time and energy by the necessary fund-raising. Wesley's caustic comment, despite the venture being modelled on his own Kingswood School, is well known: 'But in one point, my dear Brother, I am a little afraid both the Doctor and you differ from me. I study to be little: you study to be great. I creep: you strut along. I found a school: you a college! nay, and call it after your own names! O beware, do not seek to be something! Let me be nothing, and "Christ be all in all!"' (Letter to Asbury, 20 September 1788). The college opened in 1787 and was destroyed by fire in 1795. Only the site now remains. Cf. Baker, *Incredible Methodists*, 65-73.

Tuesday 31. — We rode to *Baltimore,* where I endeavoured in the evening to shew the people the necessity of union with Christ.

Wednesday, June 1. — We opened our conference.[188] As I expected to sail the next day, my brethren were so kind as to sit in the Conference till midnight. I endeavoured to shew them at noon the necessity of being faithful in the ministry of the word. We thought it prudent to suspend the minute concerning slavery, on account of the great opposition that had been given it,[189] our work being in too infantile a state to push things to extremity. However, we were agreeably informed that several of our friends in *Maryland* had already emancipated their slaves.[190]

Thursday 2. — I met my brethren early in the morning, and at eleven o'clock endeavoured to enforce St. *Paul's* awful exhortation to the elders of the church of *Ephesus,* Acts xx.[191]

And now I took my leave of my friends, and set out in a boat for the ship Olive-Branch, which had sailed down the river the day before, and of which I got on board in the evening. In my younger days, one of the greatest afflictions in life to me during the time it lasted, was to be torn away from my friends whom I dearly loved. This through the extensiveness of my acquaintance, and the constant change of my place of abode, and partly perhaps through the grace of God, has for late years considerably worn away. But I think for many years I have not felt myself so effeminate (shall I call it?) as I did on parting with my *American* brethren, the Preachers: and the sensation continued very painful for a considerable time after I left them.

From Friday, June 3, to Sunday 12. — All this time we have been sailing about seventy leagues, having been locked up for five days in a place called *Moxat-Bay.* However this delay gave me an opportunity of writing forty or fifty letters to my friends on the continent.

188. MS adds: 'and were driven to the painful task of suspending a member, and he no less than an elder, a man who for ten years had retained an unblemished reputation. "Let him that thinketh he standeth take heed lest he fall."'

189. MS reads: 'We thought it prudent to suspend the minute concerning slavery for one year, on account of the great opposition that had been given it, especially in the new circuits. . . .'

190. MS adds: 'But we agreed to present to the Assembly of Maryland, through our friends, a petition for a general emancipation, signed by as many electors as we can procure, similar to that which we agreed to present to the Virginia assembly.'

191. MS adds: 'After which we ordained five Elders, brothers Boyer, Tunnell, Pigman, Baxter and Foster. The day before we ordained them Deacons, as also brothers Ringold and Michael Ellis.' It has often been wrongly assumed that Coke ordained John Baxter during his first visit to Antigua in December 1786 (see Vickers, *Thomas Coke,* 99n.1, 151n.3).

There is no other passenger in the ship, so that I have the state-room always to myself, and the cabin most part of the day. It is a blessed opportunity for fellowship with God and the improvement of my mind. O that I may husband it accordingly! That I may return to *England* in the fulness of the blessing of the gospel of Christ.

1786-87

Extracts of the Journals of the late Rev. Dr. Thomas Coke's Second Visit to North America and First to the West Indies

Introduction

In 1786 Coke issued his Address to the Pious and Benevolent *advocating fresh missionary initiatives in certain areas. He had learned important lessons from his abortive* Plan of the Society for the Establishment of Missions *of two or three years earlier. For one thing, he made certain in advance of Wesley's support and printed a commendatory letter from the older man. For another, his proposals now embraced what later generations would call 'home' and 'overseas' missions.*

Two overseas mission fields were in his sights: the British North American territories and the Caribbean islands. The British Conference of 1786 adopted his Plan *by appointing two preachers, William Hammett and John Clarke, to Newfoundland and William Warrener to Antigua— the latter in recognition of the pioneer work of Nathaniel Gilbert and John Baxter in that island. The ship on which they sailed from Gravesend on 24 September was severely battered by Atlantic storms, and was forced to run for the Caribbean. So, instead of arriving in Halifax, Nova Scotia, they found themselves landing in the little port of St. John's, Antigua, early on Christmas morning, just three months after they had embarked, and the memorable encounter with John Baxter, the shipwright-turned-preacher, took place.*

During the month that followed, accompanied by Baxter, Coke also visited Dominica and St. Vincent in the Windward Islands to the south, then returned north to St. Kitts and the neighbouring Nevis and St. Eustatius. Warrener remained in Antigua in accordance with the Conference stationing; but in other respects Coke took upon himself to respond to what he saw as the dictates of Providence and the situation he found in the islands. There were clear openings on St. Vincent and St. Kitts, so Clarke and Hammett respectively, were left there instead of going on to Newfoundland as intended. That this was God's will was, to Coke, 'as clear as if it was written with a sunbeam,' though why God had not made his will known earlier, during the Conference's deliberations, he did not venture to explain.

Having completed this first Caribbean sortie and taken stock of some of the openings, in February 1787 Coke sailed for Charleston and the first Conference of the Methodist preachers in South Carolina. From there he and Asbury travelled northwards through North Carolina, Virginia, and Maryland to New York, meeting in Conference with the itinerants in each state. As Wesley's lieutenant, Coke found this a particularly uncomfortable mission. There were contentious issues to be resolved arising out of Wesley's determination to maintain a firm hold on the reins of Methodist affairs in the United States. The preachers, for their part, as citizens of newly independent American states, were not prepared to accept what they saw as foreign interference; so confrontation followed by a process of painful accommodation was unavoidable. An incident during the Conference in Baltimore nicely captures the prevailing spirit among the preachers. At one point in their deliberations Coke is said to have interrupted Nelson Reed, saying, 'You must think you are my equals.' To which Reed retorted: 'Yes, sir, we do; and we are not only the equals of Dr. Coke, but of Dr. Coke's king.'[1] The principle was firmly established that they would, under Asbury's superintendence, determine their own stationing and the times and places of their gathering in Conference. Wesley's choice of Richard Whatcoat as a fellow superintendent with Asbury was firmly rejected, and (unkindest cut of all!) Wesley's name was deleted from their Minutes. Coke was driven on the defensive and agreed to sign an instrument of partial abdication from the position of authority given him by Wesley, undertaking not to exercise his authority

1. Warren A. Candler, *Life of Thomas Coke* (Nashville: Cokesbury, 1923), 121-22; but Edward J. Drinkhouse, *History of Methodist Reform* (Baltimore: Methodist Protestant Church, 1899), dates the incident in 1796.

when out of the country and to limit his activities when there to ordaining and presiding over Conferences. This must have been humiliating for him at the time and embarrassing when he had to report to a disgruntled Wesley on his return to England. Describing himself as God's 'weak, sinful worm' may all too well have expressed his feelings at the time he sailed from Philadelphia!

Section I

Antigua, Jan. 2, 1787

By the powerful hand of God we have been brought to this island, as you will see by the following journal:

On Sunday the 24th of September, we sailed from *Gravesend*, and the next day were opposite the *Isle of Wight*. The wind then turning against us, we did nothing for five days and nights but sail, for four hours, in the midst of blustering winds and surging waves, from the *Isle of Wight*, towards the South of *France*, and the next four hours back again; and so alternately. We were most part of this time sick. How surprizing it is that any would think of riding this great monster, except for the service of God. But, for Him

> Labour is rest, and pain is sweet.[2]

On Thursday the 28th at night, we had a very providential deliverance from being run down by a large coal-ship, about three times as large as our brig. It was with great difficulty that we slipped on one side of her, after receiving from deck a general alarm of danger; but the Lord was with us. On the day before, the Lord was extraordinarily present with me in my little bed-chamber: he did indeed pour out the consolations of his Spirit largely: and streams of filial, penitential tears did, in an unusual manner, flow from my eyes.

I esteem my little bed-chamber (or state-room) a peculiar gift of God. It is taken out of the steerage; and is so far, on the other hand, from the common sailors, and, on the other, from the cabin-

2. 1780 *Collection of Hymns*, no. 205, st. 2, line 3 (Wesley, *Works*, 7:336).

passengers, that all is still and quiet, and here I can be with God: and, blessed be his name, he does make it my *sanctum sanctorum*, the Holy of Holies, filling it (my soul at least) with light and glory. Here is no one to disturb me but the two cabin-boys, who are separated from me by a partition, and whom I am able to keep in good order.

On Saturday the 30th, we were obliged to take shelter in *St. Helen's*,[3] and the next day got up to *Spithead*, which gave me an opportunity, with my brethren, of visiting our friends in *Portsmouth*.[4] Brother *Warrenner*[5] preached in the town in the afternoon, and I gave our friends a sermon on the necessity of the New-birth in the evening on the common. On Monday evening my congregation was larger than on the day before, when I endeavoured to lead the people to Christ, by the star which the wise men saw in the east. On Tuesday evening I took my leave of that kind people, shewing them the necessity of a death unto sin, and of having their lives hid with Christ in God, after preaching we concluded with the Lord's Supper: and our Lord did assuredly condescend to acknowledge his own sacred ordinance. It was a precious time.

About midnight, the tide being a little in our favour, I set off for our ship, being engaged to return every night. I had seven miles to sail, viz. to the *Mother-Bank*,[6] near the *Isle of Wight*; and the wind was so boisterous, that my kind pilot (who is master of the Commissioners' yacht) after rowing me about two miles, advised me to return to his yacht, which lay in the harbour. He and his men accordingly rowed me there, where, after some refreshment, I lay down on a couch (there being no bed) and slept for about three hours. How much better off was I than my most honoured Master, who had not where to lay his head! — Early in the morning they brought me to the brig; and for eight days more we were detained by the winds.

On Thursday the 5th October, we had the highest storm that has

3. A bay on the east coast of the Isle of Wight.
4. It was about this time that the Portsmouth society, still quite small, moved from a room in Warblington Street to a chapel in Oyster Street.
5. William Warrener (1750–1825) was for seven years in British circuits before being appointed to the West Indies. He served in Antigua and St. Kitts, returning home in 1797 on health grounds. Until he retired in 1818 he continued to advocate the overseas work.
6. A sandbank in East Solent, off the north coast of the Isle of Wight between Fishbourne and Ryde.

been remembered on that coast for these six years, according to the accounts of the neighbouring inhabitants. A small sloop got entangled in the cable of one of our anchors, which was likely to do us much damage, and to ruin the sloop; but what small things are these, to those whose anchor is cast within the vail. On Sunday the 8th, we read prayers and gave a sermon to the cabin passengers, the sailors not appearing.

On Wednesday the 11th, we removed to *Yarmouth Harbour,* in the *Isle of Wight,* and the next were in great danger of being run down by a frigate, which by mercifully endeavouring to avoid us, run on shore; but the shore consisting chiefly of mud, the frigate received no damage. On Thursday the 12th, we sailed into the Channel, and got to the *Land's End* on the 14th.

Sunday the 15th, brother *Warrenner* read prayers and I preached, endeavouring to explain the nature of our christian calling, the necessity of walking worthy of it, and the way thereto, with a close application of the whole: the sailors for the first time were present.

Sunday the 22nd, I went on deck about half an hour before sunrise, and had the pleasure of seeing the most glorious sight I ever beheld, except once on my former voyage to *America.* The eastern sky was covered with a most beautiful canopy of purple, which was all over decorated with spangles of gold. The heavens did indeed declare the glory of God. I would, I think, at any time go ten miles to see so noble a display of the handy work of my Maker. And this God is *my* God: what a ravishing consideration! — Twice this day we read the prayers of our Liturgy. In the morning I enlarged on the nature of Repentance and Justification; and brother *Clarke*[7] in the afternoon gave a rousing sermon on those impudent words of *Pharaoh,* 'Who is the Lord, that I should obey his voice?' But, alas! they are all like the deaf adder, that refuses to hearken to the voice of the charmer, charm he never so wisely.[8]

Tuesday the 24th. — We have had little else but storms and squalls since we sailed. But this morning a most alarming circumstance called forth all our attention. A leak was observed in that

7. John Clarke, appointed with Hammett to Newfoundland, was in the event left in St. Vincent, where he served until 1790 before disappearing from the stations. His name reappears as a member of the St. Vincent society in 1806. Cf. George G. Findlay and W. W. Holdsworth, *The History of the Wesleyan Methodist Missionary Society,* 5 vols. (London: Epworth, 1921), 2:50.

8. Psalm 58:4.

part of our ship which lies under the cabin; and we are now about half way between the two continents. However, after long examination, it was found that the leak was above the surface of the water, and that the water came in only when the ship *heeled* (as they term it.) It was the opinion both of the captain and mate, that nothing could be done to stop the breach; but that our pumps could easily command it, if it did not increase.

Last night they were obliged to shut up all the hatches, and for some time past they have shut all the windows in the cabin. This is indeed a time for the exercise of resignation. May I duly improve it, whether it end in life or death. The sailors, this night, for the first time, joined us in family prayer.

Friday the 27th. — Last night was the most tempestuous I ever knew at sea. The captain says that he has not known such a night these ten years. Though we lay to, they were very apprehensive that the wind would break the main-mast, and about midnight sent down for two hatchets, that they might cut it away if necessary. But our Lord sitteth above the water-floods. This morning we found that the leak lets in more water than it did yesterday. I retired in the morning to meditate seriously on that circumstance. I considered, What reason have I to desire to live? I have really forsaken all for Christ, and have neither motive nor desire to live but for the Church of Christ. And why should my desires be so strong on that account? With what perfect ease can the Lord fill up my province with one that is infinitely better qualified? I am therefore willing to die. I do love my God, and have an indubitable assurance that whatever is wanting he will fully supply, before he takes me into the world of spirits.

Sunday the 29th. — During divine service, most of the sailors being present, I delivered my soul: insomuch that one of the passengers, a gay, irreligious young man, retired after the service, and wrote me a letter, informing me that I was not his pastor, and insisted on receiving the usage which as a passenger and a gentleman he had a claim to. A few fair words brought him into good humour.

Tuesday the 31st. — We find that our leak has not increased. I seem now to be sea-proof, and can devote my whole day to reading, writing, and religious exercises. A considerable part of the time I spend in studying the French language, particularly the

Grammar and the French Exercises. Three or four hours I employ daily in conversing in French with our ever blessed Lord and the inspired Writers. Sometimes, for a little variety, I read Virgil; and every day a Canto out of the works of *Edmund Spenser,* the English Virgil. I am astonished the writings of *Spenser* are not more read. His genius and strength of imagination were amazing; and from his allegories may be extracted some of the most instructive lessons of religion: indeed I grudge not the twenty shillings I gave for his works. With such company as the above, I think, I could live contentedly in a tub.

Wednesday, Nov. 1. — We are likely to have a long passage: but this single consideration—that I am in the very place where God would have me to be, and am going on the very business which God has allotted for me—is a sufficient support under every trial: and this assurance blessed be God, I do possess fully and satisfactorily.

Nov. 5. — I endeavoured to enforce the necessity of believing on the Lord Jesus Christ, after explaining the nature of Faith, and the Salvation which proceeds therefrom. O that the Lord would open their dull ears!

Nov. 7. — Brother *Hammet*[9] was taken ill with a fit of the ague; but by administering to him an emetic on the next day, and a purge on the following, I trust it is gone, through the blessing of God.

Sunday 25. — This day one of the main-stays of the main-mast broke, but it has been tolerably repaired.

Monday 26. — The other main-stay has also given way, but is now repaired. Our tackling has received great injury from the severe gales of wind which we have met with, with hardly any interruption from the time we sailed. Brother *Clarke's* hair falls off wonderfully; but he bears himself up with great courage, as do the other brethren.

Thursday 30. — A dreadful gale blew from the north-west. At ten at night, I heard the captain's wife crying out in the most dreadful fright, and presently Mr. *Hilditch,* (one of the passengers) came running and crying, 'Pray for us, Doctor, pray for us, for we

9. William Hammet(t) (ca. 1756–1803) was an Irish preacher, appointed with Clarke to Newfoundland. In the event he was stationed in St. Kitts and served there and in other Caribbean islands. From 1789 he worked in Jamaica, in the face of persecution. In 1791 Coke took him to Charleston, SC, where he instigated the schismatic 'Primitive Methodist Church.'

are just gone!' I came out of my state-room, and found that a dreadful hurricane (I assuredly may call it) had just arisen. The ship was on her beam-ends. They had not time to take down the foresail, and were just going to cut away the main-mast as the last remedy, expecting every moment that the ship would be filled with water and sink. My brethren and myself at this awful moment retired into a corner to pray, and I think I may say we all felt a perfect resignation to the will of God. Through grace, I think I may assert, that I was entirely delivered from the fear of death. But brother *Hammet* was superior to us all in faith for the occasion. His first prayer (if it could be called by that name) was little else than a declaration of the full assurance he possessed that God would deliver us: and his second address to God was a thanksgiving for our deliverance. It was not till after this, and after we had sung a hymn together, that the foresail was shivered in pieces, and by that means the masts were saved, and probably the ship itself. It is awful to hear the captain and one of the passengers who was on deck during this tremendous tempest, give a relation of it. It appeared to them as if the clouds, the air, and the water, were all mixed together. After the immediate danger was over, we drove with the wind, which carried us with nothing but the bare poles, at the rate of six miles an hour for eight hours and a half.[10]

10. An anecdote relating to this voyage is recorded in Samuel Drew, *The Life of the Rev. Thomas Coke* (New York: Soule & Mason, 1816; London, 1817), 160-61: 'It has often been observed, that British sailors, notwithstanding their courage have long been proverbial, are, in many instances, strongly tinctured with superstition. Of this fact the following circumstance, frequently mentioned by Dr. Coke, though not recorded by him in his journal, furnishes a convincing testimony.

'It was during the utmost violence of the tempest, while accomplishing their perilous voyage, that Dr. Coke and his associates addressed themselves to God in prayer for the preservation of the ship, and of the lives of all on board. The captain, instead of approving their piety, or joining in their devotions, became visibly agitated, and betrayed symptoms of an approaching storm within; attributing the calamities, with which they were surrounded, to the means made use of to avert the growing danger. At first he paraded the deck, muttering in a species of audible whisper, "We have a Jonah on board—We have a Jonah on board;" and consequently it was natural for him to conclude, that a Jonah's conduct deserved a Jonah's fate. In this condition he continued, until his fears, superstition, credulity and agitation, had wound him up to such a state of phrenzy, that he entered the Doctor's cabin, and, in a paroxysm of fury, seizing his books and papers, threw them immediately into the sea. He was about to proceed further; but on seizing "the Jonah," he satiated his vengeance, by grasping him with angry violence several times, and by giving loose to his passion in expressions of horrible imprecations. He did not in fact offer him any further outrage; yet on retiring, he swore that if ever the Doctor made another prayer on board his ship, he was fully resolved to throw him into the sea, as he had thrown his papers. But the gust of passion was of no long continuance. The removal of danger soothed the spirit of superstition to rest; and the cessation of the storm without, reduced to a calm the tempest that raged within.'

We must presume that the manuscript of Coke's journal was not among the papers tossed overboard.

Second Visit to North America and First to the West Indies

Monday, Dec. 4. — This night was most dreadful. The sailors were just like the messengers of *Job*, coming one after another with dismal tidings, that now one rope was broke, and now another. All the hatches were closed, as they had been twice before. And now the whole ship began to ooze at every joint. The next morning we held a little council. The captain being convinced of the impossibility of reaching the port of *Halifax* this winter, it was the unanimous opinion of all, that no other refuge was left us, under God, but to sail with all possible expedition for the *West-Indies*. At present our sails appear like wafers. Our ropes are quite white, all the tar being washed off; in short, the ship may already be said to be half a wreck. We have this day agreed to enter upon an allowance of water and several other things: but the greatest trial of all to me is, the having hardly any candles remaining: but to the glory of God I can say, That to me to live is Christ, and to die is gain. It is very remarkable, that since we came near the banks of *Newfoundland*, I have had a strong persuasion, and I believe, a divine one, that we shall be driven to the *West-Indies*. For about three weeks past, we have gained upon the whole but one hundred and twenty miles; doing nothing in the general but lying at the mercy of the waves.

Dec. 15. — This day we had the pleasure of seeing one of the tropic birds with a most beautiful plumage. Several of the clouds also in the morning appeared in columns in a manner I had never seen before.

A remarkable phenomenon appeared a few nights ago. The Captain and all on deck saw a light, like the light which a ship holds out when it passes by another ship. They all said they could swear that they saw it. It seemed quite near to them. The Captain called for his trumpet to speak to the people of the ship: but before the trumpet came, the light was gone, and we knew no more of it.

Dec. 25. — This day we landed in *Antigua*, and in going up the town of St. *John's* we met brother *Baxter* in his band, going to perform divine service.[11] After a little refreshment I went to our Chapel, and read prayers, preached, and administered the

11. John Baxter, a shipwright from Chatham, who arrived in Antigua in 1778 and, as a local preacher, took over the Methodist society established by Nathaniel Gilbert. At the 'Christmas Conference' in 1784 he was one of those appointed elders of The Methodist Episcopal Church and was ordained by Coke at Baltimore the following summer; hence the reference here to 'his band.' He later took charge of the Carib mission on St. Vincent.

sacrament. I had one of the cleanest audiences I ever saw. All the negro women were dressed in white linen gowns, petticoats, handkerchiefs and caps: and I did not see the least spot on any of them. The men were also dressed as neatly. In the afternoon and evening I had very large congregations.

Jan. 5, 1787.[12] — I have preached in this town twice a day. The house used to be filled in the evenings about an hour before the time of preaching; and I have made it a rule to begin about half an hour before the time. Our Society in this island is near two thousand: but the ladies and gentlemen of the town have so filled the house, that the poor, dear negroes who built it, have been almost entirely shut out, except in the mornings: and yet they bear this, not only with patience, but with joy. Two or three times I have preached in the country. Our friends who invite us to their houses, entertain us rather like princes than subjects: herein, perhaps, lies part of our danger in this country. The country is very romantic. The cocoa-tree[13] is very magnificent; and the milk which the nuts yield, is most cooling and delicious. Every thing is new, and therefore the more pleasing. Last week my Brethren with myself were invited to dine with Prince *William Henry*[14] by the company of merchants, and, (thought I do not like those great feasts, yet) lest we should seem disloyal, which would be one of the farthest things from my heart, I consented to do myself the honour of going, with my Brethren. This day a gentleman with whom I dined, intimated that if five hundred a year would detain me in this island, I should not leave it. God be praised, five hundred thousand a year would be to me a feather, when opposed to my usefulness in the Church of Christ.

We have held an Infant-Conference. A pressing invitation has been sent us[15] to visit St. *Vincent's;* and this evening we are to sail for that island. Brother *Warrenner* is to remain here. We have about twenty recommendatory letters. There is, as far as we can at present judge, a fair opening in St. *Eustatius.* A little while ago brother *Baxter* received two warm letters of recommendation for that island: and brother *Hammet* has just received one for St. *Kitt's.* We

12. In the original, '1788' in error.
13. I.e., the coconut palm.
14. William Henry, Duke of Gloucester (1743–1805), son of Frederick Louis, Prince of Wales.
15. Presumably by the Mr. Claxton mentioned on 9 January 1787.

are all in remarkable good health. All is of God. I have no doubt but it would be an open resistance to the clear providences of the Almighty, to remove any one of the Missionaries at present from this country.

SECTION II

Dominicia [sic], Jan. 15, 1787[16]

On Friday the 5th inst. I sailed with brothers *Baxter, Hammet,* and *Clarke,* from *Antigua*. On Sunday the 7th, we landed at this island. The night before we stopt on the coast, and brother *Baxter* and I landed, being informed by our Captain of one Mr. *Burn,* a planter, a generous young man, who lives within half a mile of the sea, and who probably would be very glad to encourage a Mission in the island. After walking a quarter of a mile we came to a little river which we waded through, and on calling up Mr. *Burn,* who was gone to bed, he received us, and entertained us courteously, and gave us every encouragement we could expect from an unawakened man; assured us he should be glad to entertain the minister whenever he should visit his estate; that there were about four hundred negroes in the neighbourhood, and that he had no doubt but the few neighbouring planters would give us the same encouragement. Here we met with two old negroes, who, I apprehend, had been formerly among the Moravians[17] at *Antigua,* who exceedingly rejoiced at the thought that they were likely to have the gospel preached to them again.

16. In the original, '1788' in error.
17. In his *Address to the Pious and Benevolent* of 1786 Coke wrote appreciatively of the pioneer missionary work of the Moravians. As late as 1810, in his *History of the West Indies* (2:424-25) he elaborated on this: 'Their Missionaries were the first Protestant ministers of the gospel who, with a holy and disinterested zeal, directed their labours to the pious and benevolent purpose of converting the negro slaves in the West Indies. With these views they settled among them in different islands, and laid the foundation of a Christian church in Antigua.... The arrival of a [Methodist] Missionary they considered as an acquisition to the cause in which they were engaged; they afforded them a kind reception, and treated them as fellow-labourers in the common vineyard of their Lord. The success which has attended the exertions of the Moravian Brethren in the island of Antigua has been great and uninterrupted.... In 1787 [they] had under their care in this island five thousand four hundred and sixty-five negro slaves, many of whom they had reason to believe were truly converted to God.'

When we came to *Roseau (Dominica)* on Sunday, we went to the house of a Mrs. *Webley*, a Mulatto-gentlewoman of some property, with whom brother *Baxter* had some acquaintance at *Antigua*. She received us with great joy and kindness, and gave notice I should preach in her house at four in the afternoon. The congregation was considerably larger than the house could contain, and heard in general with deep attention, whilst I endeavoured to display to them the elect, precious Corner-Stone, and the way of being built upon Him. I would have taken the street, if the brethren had not thought it best for me not to be too bold, till I had waited on the Governor, which I intended doing on my return. We also visited the barracks, and there found two soldiers who had been in our Society in Ireland, and expressed very earnest desires that a Mission might be fixed in this island. In the evening we got into our schooner, and after sailing by *Martinico* and St. *Lucia*, we landed at *Kingston*, St. *Vincent's*, on Tuesday the ninth.

Here we have a very fair prospect. Brother *Baxter* introduced us to one Mr. *Claxton*, a man of property. He was awakened by the ministry of Mr. *Gilbert*[18] and met in class at *Antigua* for some time, but had never heard brother *Baxter*. He has much of the spirit of a Methodist: his wife also fears God. The evening after we landed, I preached in his house to a large congregation. On Wednesday the 10th, we set off for the plantation of Mr. *Clapham*, a gentleman of fortune, nearly related by law to sister *Baxter*. He was previously informed of our intentions to wait upon him, and sent horses for us. He lives about nine or ten miles from *Kingston*. We were received with very great kindness. In the evening I preached in his large parlour; and on informing him that brother *Clarke* was to remain in the island, he gave him a pressing, general invitation; observed, it was possible he might have accidentally some company who would look upon a sermon as an intrusion, but in that case Mr. *Clarke* at the proper time might convene the negroes into a large boarded room which was separate from the house: and that he would speak to Mr. *Jackson*, a neighbouring gentleman, who, he did not doubt, would readily enter on the same plan. In my way to Mr. *Clapham's*, I called at the house of one Mr. *Morgan*, a gentleman

18. Nathaniel Gilbert (d. 1774) had met Wesley in London and heard him preach. Returning to Antigua in 1760 he began to preach to his slaves and formed a Methodist class. This was in effect the beginning of Methodism outside the British Isles.

of large property, whose lady (he not being at home) informed us that Mr. *Clarke* would be always welcome to instruct and preach to their negroes at proper hours.

On my return to *Kingston*, I found that our friend *Claxton* had fitted up with seats a large warehouse or cellar for a preaching-house; and also two small rooms for the Preacher, one for his bed-chamber, and the other for his study. We also waited on the President of the Council, who acts as Governor, the late Governor being dead, and the vacancy not yet filled up. He also received us with great courtesy, wished us success, and gave permission to brother *Clarke* to preach in the Court-house on Sundays. A gentleman of fortune in *Kingston*, Mr. *Steward*, who keeps a very large shop or warehouse, and with whom we dined, is rejoiced above measure at our visit. He made me a present of a large cocoa-nut shell very curiously engraved and set in silver. To brother *Hammet* he gave a seal, worth, I suppose, three or four guineas; and to brother *Baxter* a pocket dressing-table for shaving, &c. worth I suppose, two guineas. To brother *Clarke,* he said, he would make no present then; for, says he, I shall have him near me when you are gone, and he shall never want. He was many years ago in our society in *London,* and through various vicissitudes is become a very rich man, though once poor. He and Mr. *Claxton* are beginning already to talk about ground for a preaching-house. I formed a class of six whites as an introduction. Besides these, there are six or seven of the soldiers in the barracks who are deeply serious; one of them exhorts. They have built a hut for their public and private meetings within their barracks, and constantly meet together at five in the morning, except when military duties interfere, and then they meet at half past four in the morning. Their ill-natured commander in chief will not suffer brother *Clarke* to preach within the barracks, but the poor soldiers were to meet him in class at Mr. *Claxton's,* on the day after I left St. *Vincent's.*

On Friday the 10th, we dined, by invitation, at Mr. *Otley's,* a member of the Council, and one of the principal men, perhaps the second in the island: he lives about seven miles from *Kingston*. He is a very agreeable man, and his lady has something serious in her. Notwithstanding there were two thoughtless officers at dinner with us, he gave brother *Clarke* a general invitation to make his house his home. Sir *William Young,* on whom I waited at *Antigua,*

and who received me with very great courtesy, has a large estate just by Mr. *Otley's*.

In short there is a little circuit opened to us already in this island: nor shall I be surprised if brother *Clarke* has, in a few weeks, five hundred Catechumens under his care. In *Kingston* it is surprising, with what eyes of affection the poor negroes look upon us, when we pass by them: and one of them was overheard telling his companions, 'These men were imported for us.' There is a member of the assembly, to whom I had strong letters of recommendation, on whom I had not time to call. There is also another gentleman who is personally known to brother *Baxter*, and who has six of our pious *Antigua* negroes on his plantation, on whom also we had not time to wait. It is impossible to have any doubt concerning the will of God, in respect to the appointment of a Missionary for this island: in respect to *Antigua* and St. *Vincent's,* all is as clear as if it was written with a sunbeam.

The Island of St. *Vincent's* is romantic beyond any thing I ever saw before. The hanging rocks, sugar-canes, cotton and coffee plantations, &c. make such a beautifully-variegated scene, that I was delighted with it: but, I trust, did not lose sight of the great Author of the whole.

Monday, January 15, we landed again at *Roseau (Dominica.)* We intended being here yesterday, but were prevented by a calm. After breakfast we waited on the Governor, who received us very politely, and signified his approbation of our plan of establishing Missions among the negroes. Afterwards we came to the plantation of Mr. *Charrurier*[19] brother to Mr. *Charrurier,* one of the leaders of our Society in *Dublin.* He expresses his great desire of having a Missionary fixed in the island, assuring us that he will readily contribute to his support, and encourage his usefulness. I think the Lord will soon have mercy on this island.

This evening we examined minutely that wonderful little insect, the Fire-fly. It appears as if he had a real spark of fire continually burning in his belly. We could see what a clock it was in a dark room with the help of one of them.

19. Or 'Cherrurier' as in Coke's *History of the West Indies,* where he is described as 'a gentleman who had shewn himself friendly towards that cause which we were endeavouring to support.'

Second Visit to North America and First to the West Indies

Tuesday the 16th, we set off for St. *Christopher's*,[20] where we arrived on Thursday. On our arrival, we found that intelligence had been sent here from *Antigua*, of our intention of visiting this island: and a house was provided for us to lodge and preach in. Mr. *Cable*, a Mulatto gentleman, a printer, has shewn us the utmost kindness and attention. A Mrs. *Seaton* also, a Mulatto gentlewoman, has been very kind. The two last mentioned, deeply fear God. One Mr. *Bertie*, a Jeweller, is likely to become a sincere friend. On Thursday evening I had a good congregation, considering the notice given.

On Friday the 19th, we went with some recommendatory letters to the island of *Nevis*, which is very near St. *Christopher's:* but it proved to all appearance the most useless as well as the most expensive journey that we have taken. We were received politely, but every door seemed shut against our ministry.

On our return to St. *Christopher's* we received an invitation to preach in the Court-house. Brother *Hammet* preached on Sunday afternoon, and I in the evening. The crowd was prodigious in the evening. Six or seven principal gentlemen of the town have invited us to their houses, to some of which we have gone. Among the rest, was the parson of the parish. Our friends have rented a convenient house for brother *Hammet*.

A gentleman in the island of *Nevis*, (Mr. *Brazier*, a member of the assembly) has sent an invitation to brother *Hammet* to come over to preach to the negroes. An illegitimate son of the President of the Council of *Nevis*, has also given brother *Hammet* an invitation to preach in his house at *Charleston*, the principal town in the island of *Nevis*. So that our journey to that island has not been so fruitless as we imagined. We have lately seen a curious fish exactly like a land hedge-hog, but when dressed, it eats as well as a turtle.[21]

20. I.e., St. Kitts, which Coke mentioned specifically in his 1786 *Address:* 'In the island of St. Christopher's we have received considerable encouragement. And the planters in general are constrained to acknowledge, that the negroes who are united to us and the Moravians are the most labourious and faithful servants they have: which favourable sentiment, through the blessing of God, has laid open the whole country to our labours among the blacks; and we seem to want nothing but preachers, under the divine influence, to gather in many thousands of them.'

21. Difficult to identify, but probably a member of the pufferfish family (e.g., a porcupine puffer, burrfish, or spiny boxfish) or possibly some kind of urchin (sometimes mistaken at that time for a fish).

On Wednesday the 24th, we sailed from *Basse-Terre*, St. *Kitt's*, and stopped at *Sandy-Point*, a town in the same island, where we called on one Mr. *Sommersal*, a gentleman of property, at whose house Mr. *Tunnel*,[22] one of our American Elders, who took a voyage to St. *Kitt's* for his health, once preached. He promised that he would consult with some of his friends in the neighbourhood, and with them endeavour to procure a proper place for Mr. *Hammet* to preach in.

In the afternoon we landed at St. *Eustatius*,[23] and were met by two black men, who asked us whether we were not some of the brethren (I thought they meant the Moravians, but afterwards found they meant the Methodists,) I told them we were of the same kind: then, said they, if you will come with us, we will shew you your home. I told them that we wanted to see Captain *de Lion;* the Captain of the Blacks, to whom we had recommendatory letters. You had better, said they, go home first. And accordingly they brought us to a very comfortable house belonging to a family of free Blacks, where we have been most hospitably entertained. Some serious free Blacks had received intelligence, I find, from St. *Kitt's* of our intention to visit them, and had joined together to bear the expense of supporting us. In the evening a pretty congregation, without any regular notice, was gathered together: but being now in the dominions of a foreign power (*Eustatius* belonging to the *Dutch*) I thought it prudent to inform people that I should not preach that evening, as I had not waited on the Governor: and yet, notwithstanding, we were obliged to pray three times, and sing twice, before they would go away. The Lord raised up lately a negro-slave whose name is *Harry*[24] (who was brought here from the continent, and who was formerly a member of our Society) to prepare our way. *Harry* did so grieve in spirit at the wickedness of the people around him, that at last the fire broke forth, and he bore

22. John Tunnell (1755–90) of Fredericksburg, VA, was converted in 1776 and became an itinerant the following year. He died in 1790 after eight years of declining health: 'a simple-hearted, artless, childlike man . . . a good historian, a sensible, improving preacher, a most affectionate friend, and a great saint' (Asbury, *Journal*, 1:645).

23. St. Eustatius was a Dutch possession, where the memory of an incident just six years before would still have been fresh. Admiral Rodney had attacked and looted the island, leaving it devastated. This does much to explain the hostility of the Dutch authorities towards the English missionaries, as Coke must have realised, though no mention is made of it either in his journal or in his *History of the West Indies*.

24. Not to be confused with Harry Hosier, 'Black Harry,' the Negro preacher whom Coke had met in America in 1784 (see p. 35 above).

a public testimony for Jesus. The Governor came to hear him, and approved of what he said: but in a little time the poor slaves were so affected under the word, that many of them fell down as if they were dead, and some of them would remain in a state of stupor for some hours. One night sixteen of them fell down in this manner. Then the Governor sent for *Harry*, and forbad him to preach any more under severe penalties. He would have ordered him to be whipped, if the Fischal or supreme Judge, who was present at the same time, had not observed that he had done nothing worthy of corporal punishment. *Harry* has awakened about twenty souls, who are willing immediately to be put into Class. There is also a black woman here who came from *America*, who loves God. The day after *Harry's* mouth was stopped, we landed, to the joy of his poor little flock; and on the day we landed, the Governor was taken ill.

Thursday the 25th, we waited on the captain of the island who now represents the governor, and on the Fischal or Judge. The Fischal told us that we must be private, till the court had considered whether our religion should be tolerated or not. The Captain also ordered us to prepare our Confession of Faith and Credentials, and to present them to the court on Saturday; with all which we complied. We have been since informed that they were highly satisfied with our confession: but they ordered us to wait till the next court for an answer, which will be held on Wednesday in the next week. They could all speak English, except the Fischal, and yet they would converse with us only through an interpreter: this is, I suppose, the custom. Indeed, there is much more English than Dutch spoken in this island.

Sunday the 28th, a private message was sent me that the captain and council would be glad to meet me in the afternoon in a private house, to which the captain of the blacks would bring me; and hear me preach. I met them accordingly at the time appointed, and preached before them on 1 John v. 12. *He that hath the Son, hath life.* Our friend Captain *De Lion* tells me they were highly pleased, and in the evening the interpreter of the court sent us one of his black maid-servants to be instructed and prepared for baptism: she really seems, in some measure, to feel herself a sinner.

We have seen here a most curious fish. It is small, but has two horns on the top of its head, two horns behind, and a tail like a

paddle; its head and eyes are exactly like those of a hog. When dressed it eats like the flesh of chicken.[25]

Tuesday the 30th, I waited on the captain again, to resolve two questions: 1. Why do you call yourselves Methodists? 2. How are your ministers supported?[26]

Section III

On Saturday, Feb. 10, I set sail from St. *Eustatius* in a large Dutch ship, and after an agreeable voyage of eighteen days arrived at *Charleston* harbour. On taking leave of my poor black friends, they heaped upon me such a quantity of seed cakes, sweet biscuits, oranges, bottles of jelly, &c. that we had not consumed above one-half of them on our voyage, although there were seven in the cabin to partake of them. Before I left St. *Eustatius*, I formed six regular classes; and I have no doubt but they are all (one person only, perhaps, excepted) at least deeply awakened: and *that one* has evidently good desires. If I had staid there one day more, I think I should have formed a seventh class. Three of them I gave to the care of *Harry*, which, I expect, will soon multiply; two to our North American sister, and one to a black named *Samuel*.

The captain of our ship read some prayers and a portion of sacred writ to his people every morning and evening, and a sermon on the Lord's-day; and though, I fear, there was no vital religion among them, there was the greatest decency and propriety of conduct I ever saw in a ship; and this, I have been informed, is the case with most of the ships of *Holland*. During this voyage we were very successful in catching dolphins.

On the first of March I landed at *Charleston*, and spent a comfortable month with the infant society in this city. Soon after I came

25. Most probably a kind of cowfish.
26. Coke's original letter to Wesley, as printed in 1787, continued: 'I must conclude lest I should lose the English Pacquet. The beginning of next week I intend to sail, God willing, for Charleston, but I shall preach in this island with or without leave, the Lord being my helper.

'Give my most affectionate love to our London Society. Never does a day pass, I think I may say, but I bear them fervently and particularly before the Throne. The only return I desire is, that they will do the like for me.'

here, I had the pleasure of opening a new church,[27] which will contain about fifteen hundred people. From that time my congregations were very large. At five in the morning, about three hundred used to attend. Since my visit to the islands I have found a peculiar gift for speaking to the blacks. It seems to be almost irresistible. Who knows but the Lord is preparing me for a visit in some future time to the coast of *Africa*?

About a week before my departure from this city, Mr. *Asbury* gave me the meeting. Our interview at first was rather cool, but soon the spirit of peace and love came upon us, and all jealousies were immediately removed. The preachers who labour in this State and *Georgia*, also met us here, according to the direction of Mr. *Asbury:* and in our Conference which we held together, the spirit of concord and love did eminently preside. All was peace and harmony.[28] And at the public ordination of two deacons, the Lord was pleased to pour out his Spirit largely upon us. As there are no more than forty whites here in society, the building of a church worth a thousand pounds sterling, has filled the people in general with amazement. Great has been the work of God both in this State and that of *Georgia*, for the little time we have laboured in them. While my soul is exulting in the prosperity of Zion, I feel an additional pleasure in the thought that *Georgia* was the residence and sphere of Mr. *Wesley's* usefulness for some years; everything that is likely to give him pleasure, administering a proportionable pleasure to me.

Mr. *Asbury* (who is assuredly a great man of God) has treated me with much respect; for he has not only provided me a good horse with its proper attire, but (as there is no time to procure a regular publication of me at the places through which I am to pass) has delivered up to me his own plan and intends to accompany me to *New-York*.

Much of the glory and of the hand of God have I seen in riding through the circuit called *Pee-Dee*, in *South Carolina*. When I was in

27. The Cumberland Street Church (also known as 'the blue meeting house') was one block from St. Philip's Episcopal Church, 'a plain wooden structure sixty by forty feet in size, with galleries for Negroes.' Asbury describes it as 'a spacious house' with 'crowded and solemn congregations' (*Journal*, 1:535).

28. This was the first Conference held in the state and, according to Jesse Lee, was the first occasion on which the term 'bishop' was substituted for 'superintendent' (cf. Asbury, *Journal*, 1:535).

America before, there were but twenty in society in this circuit: and it was much doubted at the Conference, whether it would be to the glory of God to send even one preacher to this part of the country. But now, chiefly by the means of two young men, *Hope Hull*[29] and *Jeremiah Maston*,[30] the societies consist of eight hundred and twenty-three members; and no less than two and twenty preaching-houses have been erected in this single circuit in the course of the last year.[31] The preachers here ride about one hundred miles a week on an average; but the swamps and morasses they have to pass through in the winter, it is tremendous to relate! Though it is now in the month of April, I was above my knees in water on horse-back, in passing through a deep morass, and that very late in the evening, when it was almost dark, in order to reach the house of Mr. *De Busse* (one of our friends), in whose neighbourhood I was to preach the next day; but we had with us a faithful guide.

In the course of our journey through *North Carolina*, I preached (among other places) at the house of Mr. *Hodgins*,[32] near the town of *Salisbury*. He was formerly a dancing-master; and has amassed a considerable fortune, with which he has purchased a large estate: and is now a friend of the gospel, and some of his family are indeed friends of God. He has the finest prospect from his dwelling-house of open lands, woods, and water, that, I think, I have seen in America. We have in this State got up to the *Cherokee-Indians*, who are in general a peaceable people. I trust, the grace of God will in time get into some of their hearts.

In travelling through *Virginia*, our rides were so long that we were frequently on horse-back till midnight, after preaching in the middle of the day. Since I left *Charleston*, I have got into my old romantic way of life, of preaching in the midst of great forests, with scores, and sometimes hundreds of horses tied to the trees, which adds much solemnity to the scene.

29. Hope Hull (1763–1818) of Worcester County, MD, later became a Methodist pioneer in Georgia. After his marriage in 1795 he settled in Athens, GA, and became a founding trustee of the University of Georgia (Asbury, *Journal*, 1:535, 723).

30. Received on trial in 1785 and ordained deacon in 1787, he located in 1790.

31. The Pee Dee Circuit had reported a mere ninety-nine members in May 1784. With five circuits in existence, South Carolina Methodism was growing rapidly.

32. According to Asbury (*Journal*, 1:537) this was a Mr. Huggins.

In the course of my journey through this State, I visited the county of *Halifax*, where I met with a little persecution on my former visit to this continent, on account of the public testimony I bore against negro-slavery.[33] I am now informed that soon after I left the county on my former tour, a bill was presented against me as a seditious person before the grand jury, and was found by the jury: and ninety persons had engaged to pursue me, and bring me back again; but their hearts failed them. Another bill was also presented in one of the neighbouring counties, but was thrown out. Many of the people, I find, imagined that I would not venture amongst them again. However, when I came, they all received me with perfect peace and quietness; and my visit, I have reason to believe, was made a blessing to many. Indeed I now acknowledge that however just my sentiments may be concerning slavery, it was ill-judged of me to deliver them from the pulpit. A man who pursued me with a gun in order to shoot me when I was in this neighbourhood before (but this circumstance was then secreted from me) is now converted to God, and become a member of our society.

In *Mecklenburg* County in this State, where the Lord is not only increasing but deepening his work in a very glorious manner, we held our second Conference.[34] After some little jealousies were removed, we renewed our love more closely than ever, and our whole business was conducted with great dispatch and most perfect unanimity. On the Lord's-day I had the largest congregation I ever saw in *America,* although there was no town within a great many miles of the place: I think there were about four thousand hearers. We here ordained five deacons in public, and it was a very solemn and profitable time, I believe, to very many.

One circumstance at this Conference gave me very great pleasure. Brother *Hawes*,[35] one of our elders, who last year was sent with a preacher to *Kentucky,* on the banks of the *Ohio,* near the *Mississippi,* wrote to us a most enlivening account of the prospect

33. See p. 55 above.

34. According to Asbury this took place at the home of William White in Charlotte County.

35. This was James Haw who, with Benjamin Ogden, was sent in 1786 to introduce Methodism into Kentucky. Methodism was beginning to spread beyond the Appalachians, following the latest wave of westward migration. Cf. Emory S. Bucke, editor, *The History of American Methodism* (New York & Nashville: Abingdon Press, 1964), 1:386.

in his district, and earnestly implored some further assistance. 'But, observe!' added he, 'No one must be appointed for this country, that is afraid to die! For there is now war with the Indians, who frequently lurk behind the trees, shoot the travellers, and then scalp them: and we have one society on the very frontiers of the Indian country.' After this letter was read, a blessed young man (brother *Williamson*)[36] offered himself as a volunteer for this dangerous work. What can we not do or suffer, when the love of Christ constrains!

In a few days after this, we arrived at *Richmond*. Many of the inhabitants, I was informed, had said that I would not dare to venture into that town (which is the seat of government in *Virginia*) on account of a petition for the abolition of negro-slavery which had been presented to the General Assembly, and had been subscribed by a very respectable body of freeholders, the origin of which was attributed to me. But they did not know me; for I am a plain blunt man, that goes directly on. However, instead of opposition, the governor of the State who resides there, ordered the court-house to be opened to me, and a very respectable and very attentive congregation I was favoured with.

From *Richmond* to *Alexandria*, which is a hundred and twenty miles or thereabouts, we have no societies. At one of the inns we joined a company of agreeable men, who were not unacquainted with the Methodists, though they were unacquainted with God. These gentry laid a plot for us, I have reason to believe. For in our first dish of tea there was a little taste of rum; in our second a little more; but the third was so strong, that on our complaining of a conspiracy, it seemed as if the rum had sprung into our tea of itself, for both company and waiters solemnly protested they were innocent.[37]

On the last day of April, Mr. *Asbury* and I arrived at *Baltimore;* and on the next day our third and last Conference began; when, behold! Satan exerted his utmost subtilty.

Never surely was more external peace and liberty enjoyed by the church of God or any part of it, since the fall of man, than we enjoy in *America:* and every things [sic] seems to be falling before

36. Thomas Williamson became an itinerant in 1785 and was ordained elder by Asbury in May 1890.

37. Asbury remained silent on this incident in his *Journal!*

the power of the word. What then remained for the infernal serpent, but to sow the seeds of schism and division among ourselves. But, glory be to God, yea, glory for ever be ascribed to his sacred name, the devil was completely defeated. Our painful contests, I trust, have produced the most indissoluble union between my brethren and me. We thoroughly perceived the mutual purity of each other's intentions in respect to the points in dispute. We mutually yielded, and mutually submitted; and the silken cords of love and affection were tied to the horns of the altar for ever and ever.[38]

The Lord has done marvellous things in this land in the course of the last year. No less than six thousand six hundred, have been added to the society on the balance in the United States alone. And, praise be the Lord, the work is deep, as well as wide. O that I myself may be watered under this glorious shower, and lose nothing of my share in the blessings which the heavens are pouring down.

At this Conference another young man offered himself as a volunteer for *Kentucky:* and the two preachers are to be sent off as soon as possible, breathing the true spirit of Missionaries.

I felt much of the power of God in all my public administrations at *Baltimore;* and I have no doubt but many of my hearers felt it too. The divine Comforter was also very graciously present at the ordination of two elders and eleven deacons.

On Tuesday, the 8th of May, Mr. *Asbury* and I paid a visit to our new college,[39] which will be opened (we expect) between this and Christmas; and we trust, will unite together those two great ornaments of human nature—*Genuine Religion* and *Extensive Learning.* The situation pleases me more and more. Our object is (not to raise Gospel-ministers, but) to serve our pious friends and our married preachers in the proper education of their sons.

38. Asbury says, more succinctly and soberly: 'We had some warm and close debates in Conference; but all ended in love and peace'—though he also refers to 'much fatigue and trouble.' The main issues, as noted above, arose from Wesley's attempt to direct the affairs of the American connexion from a distance, with Coke as his go-between. Wesley's appointment of Richard Whatcoat as superintendent alongside Asbury was rejected, and Wesley's own name was deleted from the list of superintendents in the Minutes. That this and the adoption of the title 'bishop' annoyed Wesley is hardly surprising. It provoked the hurt pride of his letter to Asbury of 20 September 1788.

39. A boys' school at Abingdon, MD, which they named Cokesbury College, was planned at the time of the Christmas Conference and opened in the autumn of 1787. Coke was its main advocate; Asbury's enthusiasm and support were qualified. The school closed in 1797 after a second disastrous fire.

We now visited our affectionate societies in *Philadelphia* and *New-York*. In each of these cities we want a second church, and I believe, the Lord will soon enable them to bring this to effect.

Not meeting with a suitable ship in the port of *New-York*, (and after taking an affectionate leave of my dear friend Mr. *Asbury*) I returned to *Philadelphia*. On the road I waited on Mr. *Ogden*, of *Elizabeth-Town, New-Jersey*, a minister of the Church of *England*, and a minister also of Jesus Christ. He is the only regular minister I have met with, that enforces the Methodist discipline among his people. He has many classes under his care: and much of the life of God, I doubt not, is among them. In the evening I preached in his church.[40]

On Sunday, the 27th of May, after preaching a farewell-sermon to our friends in *Philadelphia*, I embarked on board a merchant ship for *Dublin*. The captain, his wife, and another gentlewoman, who are my company, manifest as much decency, courtesy, and respect, as can be expected from unawakened persons. But God is with me, his weak, sinful worm, glory be to his blessed name.

On Monday, the 25th of June, by the mercy of God, I arrived safe in *Dublin-bay* after a passage of twenty-nine days: and was received in much love by our Irish brethren.[41]

40. The Reverend Uzal Ogden (1744–1822), of Elizabeth, south of Newark, was a prominent Anglican evangelical who offered friendship and support to the Methodists (Asbury, *Journal*, 1:467).

41. From 1782 on, Coke frequently presided in place of Wesley at the Irish Conference.

1788–89

Extract of the Journals of the late Rev. Dr. Thomas Coke's Third Visit to North America and Second to the West Indies

Introduction

Coke was by now the main instrument in Wesley's attempts to retain remote control of his American followers, though one whose usefulness had been severely curtailed by the preachers meeting in Baltimore in 1787.[1] The pattern of biennial visits to America, enabling Coke to convey Wesley's wishes and instructions (by no means always welcome or accepted) and to bring back firsthand reports, was to be broken by Wesley's death early in 1791. On these visits to the American mainland Coke also took in the Caribbean islands where missionary work had already begun or was about to be launched.

On this second tour of the West Indies, in 1788, Coke was accompanied by three young men appointed by the Conference as missionaries. Benjamin Pearce was left in Barbados, where they made landfall, while Robert Gamble and Matthew Lumb went on to take up the work in St. Vincent. When he joined them there, Coke renewed acquaintance with John Baxter, and together they visited the western part of the island to investigate the possibility of a mission among the Carib tribes still living there. A report on this primitive people, written at Coke's request by

1. See pp. 88-89 above.

Dr. George Davidson, forms Section III of Coke's *Journal of this tour*. Davidson's report had originally been published separately[2] as the basis for a financial appeal. The introductory paragraphs from the earlier version were omitted from the 1816 edition, but are included in their original location here.

Coke then made his way northwards, visiting Dominica, Antigua, St. Christopher, and the Virgin Islands, before going on to pay his first visit to Jamaica. He also took in the Dutch territories of St. Eustatius and Saba, where the missionaries were to encounter fierce opposition from the local authorities.

Sailing from Port Royal in Jamaica, Coke arrived in Charleston on 24 February 1789 and had to hurry forwards to catch up with Asbury, who had given up waiting and had set out for the first of a series of Annual Conferences, beginning in Georgia. Coke's *Journal* gives graphic descriptions of the still largely virgin country through which they passed in Georgia and the Carolinas, and of the hazards and hardships of the journey (on which Asbury's *Journal* remains largely silent).

Although there was general agreement among the preachers on restoring Wesley's name to the Minutes as a gesture of respect for his unique position in the Methodist world, any move to recognise his authority over them was firmly rejected. Coke himself came under pressure to relinquish his episcopal office and to appear among them in future as plain 'Dr. Coke'.

A visit to Cokesbury College near Baltimore found it in a flourishing state that gave no forewarning of its ill-fated future.

A notable event during the New York Conference was the presentation of a loyal address to the newly elected President Washington. Coke's published *Journal* remains significantly silent on this. But he was involved both in drafting the address and in witnessing its presentation, despite his British citizenship and continuing Tory leanings. For this he was severely criticized in the New York press and, on his return home, had to face further condemnation at the British Conference.[3]

2. *The Case of the Caribbs in St. Vincent* (1787).

3. For this incident, see Vickers, *Thomas Coke*, 126-29. Asbury's *Journal* is equally silent on the incident. See also Samuel A. Seaman, *Annals of New York Methodism* (New York: Hunt & Eaton, 1892), 462-64; and Nathan Bangs, *A History of the Methodist Episcopal Church*, 2 vols. (New York: Mason & Lane, 1839), 1:279ff.

Section I

Bridge-Town, Barbadoes, Dec. 9, 1788.

On the 4th instant we landed on this island after a voyage of five weeks and four days.

Our voyage, all things considered, was perhaps as pleasant a one as was ever sailed. In the turbulent Bay of *Biscay,* my brethren were very sick. From Cape *Finisterre* to this island, the wind was favourable all the way.

And here I must not omit to bear the most unfeigned testimony of gratitude in behalf of the captain of the ship. Our accommodations in every respect were very excellent: and he left nothing unprovided, which he thought might be necessary, or in any wise commodious for us; and his whole treatment of us from the beginning to the end was affectionate and generous to the last degree.

Captain *Sundius,*[4] being a man who sincerely fears God, we had full liberty to sing and pray as often as we pleased, and he never neglected to join us. In all my voyages till this, I do not recollect that we were serviceable to any sailor except one: but the first time I preached in the Hankey,[5] (on those words of our Lord, *Verily, verily, I say unto thee, except a man be born again, he cannot see the kingdom of God:*) the whole crew seemed deeply affected, and the consequent labours of my brethren and myself, deepened the impressions they had received. They were eager to read any books we gave them. Instead of the loose songs they sung among themselves at the beginning of the voyage, they delighted in meeting together to read our books. When we parted, the tears trickled down many of their cheeks: they shewed the greatest earnestness to squeeze us by the hand: and when our boat dropped astern, they gave us three as hearty cheers (which is one of their ways of expressing affection) as, I believe, ever were given by a company of sailors.

4. Presumably the Swedish army officer Christian (or Christopher) Sundius, who had served in the British navy and later joined the City Road society in London. (His second wife was the granddaughter of Wesley's wife, Mary Vazeille.)

5. Not in the *Oxford English Dictionary,* but possibly connected with the Scottish word 'hank,' which refers to the widest part of the ship towards the stern.

As we knew no one in the island,[6] and the expenses in this country at the inns are enormous, I embraced the opportunity, as soon as we landed, of sending Messrs. *Lumb*[7] and *Gamble*[8] to our friends on the island of St. *Vincent,* by a merchant-ship, which sailed that very evening. As Mr. *Pearce*[9] (who remained with me) informed me that a company of soldiers who resided some time ago at *Kinsale,* in *Ireland,* and among whom there were several pious persons, were now, he believed, in *Barbadoes,* I desired him to go in search of them. In two hours he brought back with him one of the soldiers; and soon afterwards we were joined by a serjeant, who on seeing Mr. *Pearce,* and recollecting him, seized him in his arms in the most kind and affectionate manner.

Our friends the soldiers soon informed us, that the love of Christ had constrained them to bear a public testimony for God; and that a Mr. *Button,* a merchant of the town, had provided for them a large room which he formerly used as a warehouse, in which they exhorted. We immediately determined to make a visit to this kind merchant the next morning; but he prevented us by an invitation to breakfast with him, being previously informed by the soldiers of our arrival.

To my great surprise I found that Mr. *Button* knew me well; and though I had no personal acquaintance with him, he had frequently heard me preach at *Baltimore,* in *Maryland.* Four of his black servants had been baptized by me at that time, and one of them (a woman) is truly alive to God. His lady is a native of this island. His house, his heart, his *all* seemed to be at our service. We discharged our bill at the inn, and found an asylum indeed with this our benevolent friend. After breakfast, Mr. *Pearce* and I paid our respects to the governor of the island,[10] who received us with great politeness. In the evening I preached at Mr. *Button's* house to about three hundred persons, about twice as many being obliged

6. The British were the first to visit Barbados, the most easterly of the Windward Islands, in 1605, and it remained thoroughly English.

7. Matthew Lumb (1761–1847) had been an itinerant since 1783. He served in Antigua, St. Vincent (where he was imprisoned for preaching to the slaves), and Barbados, before returning home in 1793. He was then stationed in English circuits until his retirement in 1826.

8. Robert Gamble had entered the itinerancy only in 1785. He died in 1791, after being beaten up by a gang of ruffians on St. Vincent.

9. Benjamin Pearce became an itinerant in 1784 and died in Grenada in 1795.

10. A Mr. Parry; see p. 133 below.

to go away for want of room. The next evening I had as large a congregation as on the former. Many heard with deep attention, whilst I endeavoured to shew them how the Comforter convinces of sin, righteousness and judgment.[11] In the morning I rode into the country to visit a gentleman, (*Henry Trotman,* Esq.) for whom my kind friend Mr. *Dornford, of London,* had procured for me a letter of recommendation, in order to open a way for Mr. *Pearce* into the country: but very providentially there were two gentlemen of the same christian and surname in the island, and I was led to the house of the gentleman of that name, for whom my letter was not intended. He received me with the utmost politeness, and after I had breakfasted and dined with him, and laid before him our plan of operations, he informed me that his house should be always open to my friend Mr. *Pearce,* and his slaves at his command at all proper hours. He has about two hundred.

On Sunday morning, after Mr. *Pearce* had preached at seven o'clock, we breakfasted according to invitation with the curate of the parish, who received us with great civility. After dinner a note was sent me by the master of a free-school, offering me his great school-room for my evening's duty; where I had a very large and attentive congregation, many of the principal gentry of the town attending. In the evening Mr. *Errington,* one of the magistrates and post-master-general of the island, made us a visit and supped with us. Between thirty and forty years ago he had frequently heard Mr. *Wesley* and his brother preach in our chapel in *Newcastle-upon-Tyne.* He expressed the greatest satisfaction and approbation of our designs, warmly invited Mr. *Pearce* to visit him frequently, and told us he should be happy on all occasions to yield us any service in his power.

On Monday morning, I visited the Mr. *Trotman* whom I had in vain sought on Saturday. He is a plain country gentleman, has about two hundred and fifty negroes on his plantations, and after dinner informed me that he would himself take the first opportunity of waiting on Mr. *Pearce,* and should be happy in having any of his slaves instructed by him.

Having thus finished the business which lay before me in this island, I took a place in a vessel bound for St. *Vincent's,* and expecting to sail in the evening, desired Mr. *Pearce* to preach: as the

11. John 16:8.

violent heat into which preaching throws us in this climate, would have rendered it very hazardous to have gone on the water: and I had the pleasure to find that he gave universal satisfaction to a large congregation.

At Mr. *Button's* there were three ladies on a visit who have a plantation and many negroes, and have, I trust, in some degree received divine impressions by our means. Their house will be opened to Mr. *Pearce* whenever he pleases: and our soldiers have engaged to hold prayer-meetings in different parts of the town three or four times a week.

Thus by a series of remarkable providences a wide door seems to be opened for us in Barbadoes. This island is most favourably circumstanced for the increase of the work of God. It is twenty-two miles long, and fifteen broad. It is said to contain about seventy thousand blacks, and from twenty-five to thirty thousand whites. The island is also in general divided into very small farms or plantations, so that even among the whites, there are thousands whose incomes are very small, and many who are very poor, and who cannot therefore indulge themselves in all the extremes of sensuality, in the manner too many do in this luxuriant country.

Section II

On the 11th instant, I landed at St. *Vincent's*[12] and in a few hours after set off with Mr. *Baxter* for the *Caribb* country, preaching in the evening to a lovely company of negroes in a little town called *Caliaqua*.[13] The next day we were joined by Messrs. *Gamble* and *Clark*, and reached the house of our hospitable friend, Dr. *Davidson;* who set off with us in the morning to visit the *Caribbs*. The roads, or rather narrow paths over the mountains which form the boundaries between the *English* and the *Caribbs*, are the worst and the most tremendous I ever rode. Some time ago Mr. *Baxter* nearly lost his life in crossing them. His horse fell down a precipice of thirty feet perpendicular, and the hind legs of the horse were just over

12. At Kingston in the south-west of the island.
13. Calliaqua, near the southernmost point of the island.

the precipice before he was alarmed, when he immediately threw himself off. In one place we could not even lead our horses, till a company of *Caribbs* who were passing by, lent us their cutlasses, with which we at last cut open a way. When we had descended the great mountain, we came into one of the most beautiful plains I ever saw in my life, it is but seven miles long, and three broad, but I think it is as beautiful as uncultivated nature can make it. It forms a bow, the string of which is washed by the Atlantic ocean, and the bow itself surrounded by lofty mountains. Here the *Caribbs* chiefly dwell. As we passed by their villages, they stood at their doors in ranks, crying out, *'Bou jou, bou jou,'* (a corruption of *Bon Jour,* a good day:) others cried out, *'How dee, how dee:'* and many of them on being asked, delivered their cutlasses into our hands, which is the highest proof of confidence they can give. We had with us at this time one of the sons of the grand chief of the *Caribbs* (*Chateaway*). He has been under the tuition of Mr. and Mrs. *Baxter* for some time, and speaks a good deal of English. His name is *John Dimmey,* a fine young man, and of a princely carriage. His father the grand chief was gone from home; if I could have seen the father, I believe I should have obtained his consent to take his son with me to *England.* His sentiments are highly refined for a savage. 'Teach me your language, *Dimmey,'* said Mr. *Baxter* to him one day, 'and I will give you my watch.' 'I will teach you my language,' replied the young chief, 'but I will not have your watch.'

When we entered into the house of one of the chiefs whose name is *De Valley,* Mr. *Dimmey* whispered to Mr. *Baxter,* that the family would not be satisfied, if we did not take some refreshment, to which we consented: and they soon brought a large dishful of eggs and cassada-bread, and a bowl of punch. Mr. *Dimmey* alone could be with difficulty persuaded to sit down with us at table, the rest would serve. A little son of the chief also, (a very beautiful boy for his colour, who had been under the instruction of Mr. *Baxter,* and had been already taught to spell) gave us high entertainment by the convincing proof he afforded us of an infant genius.

But in the midst of all this kindness there was some degree of jealousy: for I perceived that Mr. *Baxter* several times informed them that I received no pay from the King. Mr. *Baxter* seemed to live in their affections; and he has already made a considerable progress in their language. I could not help entreating him to

spend two years among them, and give them a full trial. Great as the cross was to that good man who expected to return to his beloved *Antigua*, he immediately consented. On our return from the *Caribb* country, I visited our new school-house, and found it much larger than I expected, and far too large for one family. I therefore ordered the workmen to divide it: one half of which I appropriated to the use of Mr. and Mrs. *Baxter*, and the other half to that of Mr. and Mrs. *Joice*.[14] As Mrs. *Baxter* intends to educate some of the *Caribb* girls, we shall now have three teachers among them. The conduct of Mrs. *Baxter* in this instance is not to be overlooked. Though born of a considerable family in *Antigua*, and brought up in all the softness and luxury of the country, she readily consented some years ago, that her husband should sacrifice a place of four hundred a year currency which he held under government, that he might devote his whole time and strength to the work of God; and now was perfectly willing to go with him among savages, and spend her time in forming their totally uncultivated minds.

I was very uneasy when I found that little had yet been done by Mr. *Joice* in the education of the children; but when all the difficulties were laid open, in the proper settlement of the land on which the house was built, in bringing the materials for building to the proper spot, the illness of Mrs. *Joice*, and some other particulars, my mind was satisfied, and I trust every thing will soon have the most favourable appearance through the blessing of God.

I feel myself much attached to these poor savages. The sweet simplicity and cheerfulness they manifested on every side, soon wore off every unfavourable impression my mind had imbibed from the accounts I had received of their cruelties—cruelties originating probably with ourselves rather than with them. They are a handsomer people than the negroes, but have undoubtedly a warlike appearance, as their very women frequently carry cutlasses in their hands, and always knives by their naked sides.

We now returned to *Kingston*, preaching by the way, and received by the planters with every mark of kindness and respect. Indeed the whole body of the people seemed to wish us success. Many were the proofs of affection shewn us at our departure,

14. The Joyces were members of the Deptford society. Mattias Joyce (d. 1814) had volunteered to serve in the Carib mission (Coke, *History of the West Indies*, 2:264).

especially by one whose delicacy will not admit of my mentioning his name.

Having appointed Messrs. *Gamble* and *Clark* to labour in the English division of the island (Mr. *Baxter* now and then making them a visit) I hired a vessel for *Dominica;* and with Mr. and Mrs. *Baxter* (who were desirous of making one visit to their old friends in *Antigua* before they settled among the *Caribbs*) and Mr. *Lumb,* set sail on Tuesday the 16th for *Dominica.*

It may not be improper in this place to add a short account of the *Caribbs.*

Section III

Introduction

The native population of St. Vincent remained unmolested for many years after the first visit of Europeans in 1498, but like the indigenous inhabitants of other parts of the world, they eventually suffered from the advance of what passed among Europeans for civilization. British occupation of the island was confirmed by the Treaty of Paris in 1763. In 1773 a further treaty established a reserve for the Caribs in the north of the island. After a brief interlude of French occupation (1779–83), St. Vincent reverted to British rule. A Carib rising was quelled in 1796, and most of the Caribs were deported to British Honduras. A much more detailed (but far from impartial) history of the island's vicissitudes is found in Coke's History of the West Indies *(vol. II, chapters XXI–XXV). His main concern there is the growth of the Methodist mission, and he posits a link between 'the rejection of the gospel by the Charaibees' and the disaster that overtook them, wasting little sympathy on those who defied the British crown.*

Dr. George Davidson's account below was first published by Coke in 1787 under the title The Case of the Caribbs in St. Vincent, *where it served as the basis for an appeal on behalf of the proposed mission. It was dated 'Byera, St. Vincent, July 24, 1787' and followed by a two-page subscription list, headed: 'To promote the purposes of this laudable Plan, among a Variety of other Donations, the following have been received.' The account was later included at this point as a section of Coke's* Journal

of his second visit to the West Indies, but without his opening statement, which is dated from the 'New Chapel, City Road, London' and reads, in part, as follows:

> The Reverend *Thomas Coke*, Doctor of Civil Law, late of *Jesus College* in *Oxford*, a Presbyter of the Church of *England*, and Superintendent of the Methodist Societies in *America*, sailed from *Gravesend* in the autumn of last year [i.e., 1786] for the province of *Nova Scotia*; but was driven by stress of weather to the West Indies....
>
> During his continuance [on St. Vincent] the miserable and wretched state of the poor savage Caribbs, who are utterly destitute of every privilege enjoyed by civil society, affected him much; and, upon an application to the legislative body of the island, a grant was given of one hundred and fifty acres of valuable land on the borders of the *Caribb* country, for the purpose of raising a School-house, and a dwelling house for the teacher or teachers, for the civilization and pious education of the children of the Caribbs.... Two teachers, well qualified for the work, are now provided....[15]
>
> This institution is so manifestly calculated to produce the most salutary effects, whether it be considered in a political, commercial, or more general point of view, especially as founded on the motives of true benevolence and philanthropy, that little need be urged to influence the true lovers of mankind in general, and of their country in particular, to reach forth their kind assisting hand for its establishment and support.
>
> But the expences of the buildings, as well as of the teachers, will, especially in the first instance, be very considerable. Dr. Coke will, therefore, take the liberty of waiting on those competent and benevolent persons, to whom he has the opportunity of conveying this plan for the civilization of the Caribbs, at their own houses, to receive any contributions they may think proper to make.
>
> Subscriptions will be received by Messrs Hanbury, Lloyd, Bowman and Co., Bankers, in Lombard Street.

Davidson originally prefaced his 'Account' with the following statement:

> You have requested that I would answer several inquiries concerning the Caribbs. I thank you for the opinion you have conceived

15. Mr. and Mrs. Joyce; see p. 98 above.

of the manner in which I would conduct the inquiry; and though sensible I am in some measure unequal to the task, I feel myself encouraged by your obliging confidence. A residence near the boundary for two years, some turn for observation, and the footing on which I stand with them, will, I flatter myself, apologise for the attempt.

Towards the end, in a section later omitted by Coke, Davidson says:

In short, the grand point at present to be aimed at is the civilization of them, and making them industrious, thereby rendering them first human beings before you attempt to make them Christians.

and he concludes:

Thus, my Dear Sir, I have given you an account of my savage neighbours, not such as I would wish to present you with, but such as I was able, considering the short time I had to finish it in. As you wished to send it by the packet, I have had only a few hours to write on a subject, which required a longer time to have been properly digested.

A short account of the CARIBBS in the Island of St. Vincent.[16]

By the best accounts which I have been able to collect, the *black Caribbs* originally sprung from the cargo of a *Guinea* ship, which was wrecked on one of the *Grenadilloes*. They were brought over to this island by the *Yellow Caribbs,* who were the *Aborigines* or native inhabitants, with many of whom they were soon connected, forming a motley mixture, such as we now see; but in which the negro-colour and features chiefly prevail. They continued in this interchange of good offices, till such time as the *Black Caribbs* perceived their superiority to the others in number and strength, who then drove the *Yellow Caribbs* to the leeward part of the island, where a few of them only now remain. The greater part of the latter went to the islands of *Tobago* and *Trinidad,* in both of which islands their posterity are to be seen at present.

It is unnecessary to follow them through the detail of their wars, and of their treaties with the *French,* who at length formed a settle-

16. Coke's 1789 *Journal* included here the note: 'I was furnished with the materials for the following account, by Dr. Davidson, a physician, who resides on the borders of the Caribb-country.'

ment in the island. At the treaty of peace in 1763, the *Caribbs* possessed the most valuable part of this island. By the treaty which was made with them in 1773, they gave up an extent of country, comprehending about fourteen miles in length, and from three to four in breadth; only part of which was settled in 1779, when the *French* invaded the island. Their jealousies and hatred of the *English,* which had been industriously kept up by the *French,* joined with some private causes of dissatisfaction, led them to take an active part against us: and the dread of their barbarities had no small effect in inducing the inhabitants so soon to capitulate. The settlements on the ceded lands were almost totally abandoned, after the most shocking cruelties had been exercised by the *Caribbs* on the wretched victims of their rage. The *French,* during the time that the island belonged to them, left the *Caribbs* in the quiet and peaceable possession of their lands. Since the island has been restored to us, we have once more attempted a settlement on the ceded lands, and hitherto without interruption; and we sincerely hope that the present good disposition of the *Caribbs* will long continue.

It is a very difficult matter to fix precisely on their numbers, for reasons which are too obvious to need being mentioned. The best informed on the subject speak with uncertainty. However, few have fixed their numbers below five thousand: I would rather suppose even that calculation to be short. From their temperance; their being unaccustomed to hard labour, the healthiness of the climate, their early marriages, and the fruitfulness of their women, we may easily account for their rapid increase. — We may add to these considerations, the fruitfulness of the soil, and the ease with which the few necessaries of life are procured.

It is a difficult matter to say what ideas they have of a Supreme Being. The *French* took but little pains to instruct them in Religion. They have some faint ideas of a Supreme Cause which created all things, but they conceive that God commits the government of the world to subordinate Spirits. They make use of several incantations against Evil Spirits to prevent their malignant influence.

The black *Caribbs,* differing so little from the negroes whom they saw employed in the occupations of the field, soon perceived the necessity of a discrimination founded on more obvious marks than that of complexion; and therefore adopted a plan of flattening their children's foreheads, which is done by applying to the forehead a

small board defended by soft cotton and tied behind. The child, the moment it is born, is submitted to this operation, which is continued for two or three months. Some exceptions are, however, to be made to this general rule. Twins, from a supposition of their being weakly, and children who are sickly at their birth, are exempted. The operation is also longer continued upon the male, than on the female child. Horrid distortions of the countenance, squinting, &c. occasioned by the board's being unequally or ill applied, are frequently observable.

The marriages of the *Caribbs* take place at an early age, and are generally made by the parents of both parties without consulting the inclinations of the female; a house is erected for them, and the little furniture which they require, is provided. The wife is soon made aquainted with the labour of the field; she plants the cassada, the yams, potatoes, &c. and prepares and dresses them for the indolent male, whose sole occupation is either shooting wild pigeons, Indian rabbits, and manna-rous, (the *Opossa*,) or fishing. When the husband finds himself in the situation of taking more wives, he obtains them from their parents: many of them have four or five. On that event, they build separate houses for each wife, spending their time alternately with them. So entirely, however, are the wives devoted to the despotism of their husbands, that quarrels among them are never known. Adultery is punished with death. In no part of the world are the women more chaste, owing, possibly to the severity with which incontinence is punished.

When a husband leaves any of his wives, they are not at liberty to marry again till his death: in that case only is it in their power to make an election. No slavery can be conceived more wretched than that of the women, the whole labour without and within doors devolving on them. Nor is this all, whenever frequent childbearing, or any other cause, has made them look old or ugly, their husbands leave them for other wives; for whom, and their children, they are likewise obliged to do all the most laborious offices. Their husbands frequently, in their scenes of drunkenness and debauchery, wound and maim them with their cutlasses, and even shoot them.

Nor is there among them the smallest traces of policy or natural justice. The *Lex Talionis* is their only rule, provided the party has the power or abilities to redress himself. A little time ago an instance

happened shocking to humanity. — *Manuel*, a *Caribb*, had a sister remarked by her sable lovers, for her beauty and handsome person, of whom she had not a few. She could, however, be only the lot of one; and he to whose lot she fell, was the friend and intimate acquaintance of *Manuel*. Her husband and she lived for some time peaceably and comfortably together, till a quarrel happened between his sister and his wife; they proceeded to blows, when the husband interposed between them with his cutlass, made a push at his wife, and wounded her under the eye, of which wound she immediately expired. The only redress which *Manuel* required for the loss of his sister, was—that the husband should put to death his own sister; which he did by carrying her down to the River *Colonorie* in the forenoon, and murdering her with the greatest barbarity.

The *Caribbs* are naturally temperate in their meals, their food chiefly consisting of roots and other vegetables, here produced by the indulgent hand of Providence in the utmost profusion. *Cassada*, however, furnishes them with the greatest supply, which they bake into cakes on thin plates of iron, procured from the *Europeans*. They make but little or no use of salt; sometimes only they indulge themselves with a kind of soup called *Tumallen*, which is prepared in a singular manner. They take equal parts of the juice of the Cassada (which by the by, without this preparation is poisonous) and sea water, with crabs or cray fish bruised, and a large proportion of pepper. The whole is well boiled, and used as sauce to their otherwise insipid Cassada. At their feasts they use a fermented liquor prepared from Cassada, Pines, &c. called *Vicou* or *Ouicou*; the preparation of which is sufficiently disgusting to the sight of an *European*; the Cassada being sometimes previously chewed before infusion. The saliva occasions a quicker fermentation of the drink, which is soon fit for use. Since their acquaintance with the *Europeans*, the means of intoxication are more common.

Their houses were originally built of long pliant boughs bent in a semicircular form, and fixed in the ground at each end, about fourteen feet in length, and twelve feet in breadth; and they are very neatly thatched with the leaves of the *Roseau*. Since their acquaintance with us, they have improved in the structure of their houses, which are now formed of hard wood posts fixed in the ground, plates and rafters; and are still thatched with the *Roseau* or *Reed*. The sides of them are wattled, and closely covered in, so as

to exclude the wind. The doors are rudely formed out of the *White-Cedar*, and move upon little pivots; for they employ very little iron in the fabrick.

The whole furniture of the house consists of seats formed out of logs, their hammocks, the calebash formed into cups and spoons, a cassada-grater, a serpentine press, a wooden trough and a cassada-iron-plate, and sometimes a few articles of earthen-ware.

The whole labour of the field, as formerly mentioned, is performed by the women. The cassada-sticks are planted in little hillocks which they raise at two feet distance. At the end of nine or twelve months they are pulled up, clean washed, scraped with a blunt knife, and rubbed on a grater, which is formed of a piece of board, into which small pebbles are struck. One end of the grater leans against their breast, the other end declines into a large wooden trough, into which the grated cassada falls: it is then put into a press, which is very ingeniously made of the fibres of a plant resembling the wild plantain, and formed into the shape of a snake about the thickness of a man's thigh. The press being filled with the grated cassada, they suspend it from the house or from a tree, and affix weights to the other end, whereby the poisonous juice is strongly expressed: the cassada is then passed through a sieve which they likewise make very ingeniously, on a plate of iron put over a fire; and being strongly pressed with a wooden spatula, it forms itself into a cake, which, when sufficiently toasted on one side, is turned, and toasted on the other. — This makes the constant food of the *Caribbs*, except when the men can procure an *agouty* (an Indian rabbit,) or a wild pigeon, or sometimes the crab or the cray-fish, and at other times the sea-fish, which they are very dextrous in catching. But their principal dependence in respect to fish, is on those which they procure by poisoning the rivers: for this purpose the men of the whole district are summoned; part of whom are employed in procuring the plants which are used for that purpose, viz. the *dogwood-bark* or *erythrina lina*, and the *sigesbeckia:* others divert the course of the river, if it is too large, leaving no more water than they conveniently can poison. The weeds are then strongly beat, and their juices expressed and mixed with the water, and presently communicate their inebriating effects to the finny inhabitants, which soon swim with their bellies on the surface of the water, and allow themselves to be easily taken. — It is

observable, that though thousands of the young fry are destroyed, no ill effects ever happen from the use of the fish. This is a practice, however, which should be particularly discouraged, as it almost entirely destroys the fry.

Another practice they observe, which is very destructive: the river-fish in these parts commence spawning about the end of July, when they drop their ova at the mouths of the rivers, which are then crowded with innumerable shoals of sea-fish, such as snappers, groupers, king-fish, &c. The young fry instantly attempt to force their passage up the rivers, and are in such numbers as to blacken the waters. A single person may in a few hours catch a bushel of them. Hundreds of *Caribbs* may be then seen repairing to the rivers, and loading themselves with the *tritrixes* (so the *French* name them after the *Caribbs*.) — They are very delicious, and by drying them in the sun will keep for some time.

The *Caribbs* in the general, both men and women, go naked, with the exception of a piece of cloth a yard in length and about a foot broad, which they wear round their middle, open to the left side: this is always dyed of an orange colour with the *rocou*. The women also wear a garter below each knee, bound pretty tight. The unmarried women and the widows omit the right garter. Both sexes paint their bodies with streaks of *rocou:* the men only colour their faces black on certain occasions. But on all occasions the men carry with them a sabre or cutlass, and in general a loaded musket, which is ever on the cock. Quarrels are so frequent among them, that they are ever in dread of meeting with some one with whom they are at enmity. Murders and assassinations are therefore very frequent, and their animosities perpetually kept up. Every district of two or three miles in length, has its peculiar chief, who, however, has not the smallest shadow of authority except in time of war.

They are very ingenious in making baskets, hammocks, and fishing-lines of the silk-grass; but the principal article of their commerce is the tobacco, with which they chiefly supply the *Martinico* market, where it is manufactured into a snuff called *Macouba,* from a district in *Martinico,* which formerly raised the best tobacco in the *West-Indies.* From *Martinico* they import muskets, gun-powder, flints, ball, and cutlasses, some wine, and an inferior kind of rum called *Taffia.*

They carry on their intercourse in canoes of their own making; some of which are large enough to contain fifty of them. Nothing can equal their skill in managing them in the most tempestuous seas.

Their intercourse with *Martinique* certainly tends to debauch their morals, and to increase that prejudice and aversion, which they have always had against the *English* government. As many of them speak the language with the inhabitants of *Martinique,* and have been long acquainted with them, they have no jealousy or suspicion of any designs which they can entertain against their liberty, and therefore are the more ready to listen to their suggestions. It is at *Martinique* also where their wants are best supplied; and it is only there where they can vend their tobacco. The comparison of the *French* island with ours, in respect to wealth, population, shipping, grandeur, &c. is by no means in our favour.

But we cannot expect to have much intercourse with these people till public schools are established to teach their children the English language, reading, and writing, and they are afterwards brought up to husbandry, or some trade or occupation. — The girls may likewise be brought up, and taught by school-mistresses in sewing and knitting stockings. In the *Spanish* island of *Trinidad,* the *Indians* have been brought up and instructed in the principles of the Roman Catholic religion with amazing assiduity and success. There is a remarkable manufacture of stockings carried on by the *Spanish Indians,* which sell from three to six dollars per pair.

They have already got among them the *rocou,* which they manufacture and carry to *Martinique.* — This also should be encouraged. The *la pitte,* or silk-grass, affords the strongest cords in nature, and the threads are so fine as to be employed in sewing cambrick. With it they form fishing-lines.

Their language is by no means difficult to be acquired. The number of words are but few, sufficient to express the ideas of their savage life. Their language, like their nature, is harsh and dissonant. They speak with the utmost impetuosity, as if they were constantly in a passion; but the *French* language is very much spoken by them.

THE JOURNALS OF DR. THOMAS COKE

SECTION IV

Jamaica, Feb. 3, 1789

On Friday the 19th, we landed at *Roseau*, in *Dominica*, and found our former kind friend Mrs. *Webley* ready to receive us. She had been informed by one of our local Preachers of St. *Kitt's*, who had lately made a visit to this island, of my intention to visit her soon; and accordingly with some other friends hired a large room for a preaching place. After waiting on Governor *Orde*, who, I think, is as polite a man as ever I was in company with, I preached in the evening, and on the Sunday following: Mr. *Baxter* also preached two sermons, whilst I made a visit to my old friend Mr. *Charrurier*, and opened a door or two among the blacks in his neighbourhood. Before we left the island, we formed a little society of twenty-four desiring souls, some of whom had been members of our connexion in *Antigua* and St. *Kitt's*; and determined that Mr. *M'Cornock*[17] should take the care of this island.

On the 24th, we landed at *Antigua*.[18] Surely this island is the favourite of Heaven. It is supposed that it contains 7,000 whites and 30,000 blacks: and out of these 2,800 are in our society; and I believe, the Moravians have not fewer than 2000 in theirs. So great a leaven is not known perhaps in so small a country throughout the world. My congregation in St. *John's*, and one more in the country, would not have disgraced even those parts of *England*, where we have met with the greatest success.

I should not forget to acknowledge the usefulness of Mr. *Warrenner* in this religious island: though Mr. *Baxter* has been indeed the father, under God, of this blessed work. Mr. *Warrenner* has added not less than a thousand worthy members (I have reason to believe) to this society.

Nor should the beautiful proof of love which our society in this island give to their sick members, be overlooked. They attend

17. William M'Cornock was an Irish preacher who entered the itinerancy in 1778. In 1788 he headed the list of missionaries sent to the West Indies. He gave himself unstintingly to the pioneering work in Dominica, but within six months had fallen victim to the climate. He was not replaced until 1794. The Conference in Antigua in February 1793 noted that the twenty members still reported in Dominica 'were some of the remains of Mr. McCornock's labours.' Cf. Findlay and Holdsworth, *History*, 2:44, 55; and Norman W. Taggart, 'The Irish Factor in World Methodism' (Ph.D. diss., Queens University Belfast, 1981), 71.

18. Antigua had been settled by the British in 1632 and was the seat of government for the Leeward Islands.

them in their respective neighbourhoods with the greatest diligence and patience; and where it is wanting, provide every kind of medical help for them, without regarding the expense.

Till lately the island was annually governed by martial-law on Christmas-day and the two days following, the negroes always being allowed those three days for themselves, on which many tumults and even robberies had been committed: but religion has now rendered this custom needless, and the declaration of martial-law is become a mere matter of form.

On the 27th of December, we set sail for the island of St. *Christopher*. In our way we touched at *Montserrat*;[19] but our only friend in that island, one of the most respectable characters in it, not being at home, we resumed our voyage.

On the 29th, we landed at *Basse-Terre*, the principal town of St. *Kitt's*. And here justice obliges me to bear a testimony of the good which has been wrought by Mr. *Hammet*, who has been the instrument of one of the greatest works of God I have known in the circle of my labours, considering the time he has been employed in it, and the nature of the work in which he has been engaged. In two years he has raised in this island, which was barren of all religion at the commencement of his labours, a society of seven hundred members, a great part of whom, I have reason to believe, are members of Christ. Here the Lord has poured out the spirit of prophecy; two preachers being raised in this society, who are capable and willing to devote themselves entirely to the work of the ministry in this part of the world.

The second morning after my arrival, we were visited with a tremendous earthquake. The beds, the rooms, the whole house in which we were, shook most terribly for several seconds. The shock was felt in other islands.

From St. *Kitt's* we visited St. *Eustatius*.[20] On Wednesday the 31st of December we landed there, and were received by Mr. *Lindsey*, one of our friends, with every mark of kindness. We soon found that poor *Harry*[21] was banished from the island. When he stood

19. One of the Windward Islands, to the south of Antigua. In 1793 a small Methodist society was reported there, but financial constraints and the predominance of Roman Catholicism delayed the arrival of the first Methodist missionary until 1820.

20. St. Eustatius and the smaller island of Saba were Dutch dependencies to the northwest of Antigua. Here the missionaries encountered some of the fiercest opposition from the authorities, with the result that Coke eventually visited The Hague to obtain protection for them from the Dutch government.

21. See p. 82 above.

before the Governor and Council, to answer for the unpardonable crime of praying with the people, one of the council observed to him, 'Harry you must be flogged:' to which he calmly replied, 'Christ was flogged, and why should not I?' Soon after which they condemned him to be publicly whipped, imprisoned and banished. The whipping was executed in a most unmerciful manner under the direction of one *Isaac de Lion*,[22] a black man, and an enemy to all righteousness—such a picture of Satan for subtilty and barbarity, never, I think, before did I behold. He is the great executioner of all the cruel edicts of the court for the persecution of the children of God.

The most famous, or rather most infamous edict which the rulers of this island have published, is as follows:

> That if any white person should be found praying with his brethren—for the first offence he should be fined fifty pieces of eight: for the second, one hundred pieces: and for the third, he should be whipped, his goods be confiscated, and he should then be banished the island. That if a coloured man should be found praying—for the first offence he should receive thirty-nine lashes; and for the second, if free, he should be whipped and banished; but if a slave, be whipped every time.

This, I think, is the first instance known among mankind, of a persecution openly avowed against *religion itself*. The persecutions among the Heathens were supported under the pretence that the Christians brought in strange Gods. Those among the Roman Catholics were under the pretext of the Protestants introducing heresies into the church. But this is openly and avowedly against *prayer*, the great key to every blessing. How such a diabolical persecution can be suffered in this liberal and tolerating age, is really surprising!

However, we ventured to baptize about one hundred and forty of our society. And even under this heavy cross and hot persecution, our numbers amount to two hundred and fifty-eight; and of those, we have reason to believe, that one hundred and thirty-nine have tasted that the Lord is gracious.

22. Coke's 1789 *Journal* included here the note: 'The very same man who received me with so much kindness on my former visit.' See pp. 82, 83 above.

On Thursday the 1st of January, we hired a sloop to carry us back to St. *Christopher's*. But, behold! as soon as we began to sail, we found that all the sailors were entirely drunk, the captain excepted. In a little time they drove the sloop against a large ship and damaged the boom and the yards of the mainmast. Soon afterwards, when we came to the end of the island, instead of crossing the channel to St. *Kitt's,* the sloop was carrying us into the open sea in its shattered condition. We then determined to return; but there was no one to turn the sloop about, till with great difficulty my friends, the Missionaries, unacquainted with such business, brought it round: and after running against another ship, by which the rudder was broke, and the stern much damaged: and after bribing the captain with ten dollars, to save his own life as well as ours; we were landed again on the island of St. *Eustatius*.

This series of misfortunes which obliged us to return, appeared a loud call of Providence, for me to bear a public testimony for Jesus Christ: and, therefore, lest any of our friends should suffer whipping, confiscation of goods, or banishment, by admitting me to preach in their houses, I hired a large room for a month, and the next day preached to a quiet and attentive congregation, and published myself for the Lord's-day following. — All was peace till late in the evening, when the governor sent for Mr. *Lindsey* at whose house I was, and threatened him with terrible punishments.

In the morning, while we were at breakfast, the marshal of the court entered with great form, and delivered us a message from the Governor and Fischal, which was, that they required us to promise, that we would not, publicly or privately, by day or by night, preach either to whites or to blacks during our stay in that island, under the penalty, on default, of prosecution, *arbitrary punishment*, (that was the very expression,) and banishment from the Island. We withdrew to consult; and after considering that we were favoured by Providence with an open door in other islands for as many Missionaries as we could spare, and that God was carrying on his blessed work even in this island by the means of secret Class meetings, and that Divine Providence may in future redress these grievances by a change of the Governor, or by the interference of the superior powers in *Holland* in some other way, we gave for answer, 'That we would obey the government;' and having nothing more at present to do in this place of tyranny, oppression

and wrong, we returned to St. *Kitt's*, blessing God for a British constitution and a British government.

But let me entreat, let me implore, all those who read or hear this Journal, to remember that dear persecuted people in their daily prayers, that the God who heareth prayer, may be graciously inclined, either to turn the hearts of the rulers of St. *Eustatius* to mercy and truth, or the hearts of their superiors in *Holland* to disarm them of their so much abused power.

From St. *Kitt's* we also made two visits to the island of *Nevis*.[23] Here we were obliged to lie on the floor for two nights upon our hammocks, but God has opened in this island a wide door for the Gospel. And the kindness of two or three gentlemen, particularly the Judge of the Admiralty, to whom we are highly obliged, rendered our situation tolerably comfortable. We formed here a Class of twenty-one Catechumens, and left the care of the island to Mr. *Owens*.[24]

On Wednesday evening, the 14th of January, we set off for the island of *Saba*, which belongs to *Holland*. We had left at St. *Eustatius*, Mr. *Brazier*,[25] one of our Missionaries, who had been raised under Mr. *Hammet:* and who had not been included in the wonderful message sent to us by the Governor and Fischal, there having been only three mentioned, Mr. *Hammet*, Mr. *Meredith* and myself. However, the Governor of St. *Eustatius*, all on fire to persecute, soon found him out, and by his threatenings dislodged him. Mr. *Brazier*, by the advice of a gentleman of the island, a man in power, but a *Nicodemus*, removed to the island of *Saba*.

When we landed, we were obliged to walk up a rock of a mile in length, which was in several places nearly perpendicular. Being informed that Mr. *Brazier* was at the house of the Governor, we immediately went there, and were received with the utmost kindness and hospitality by him, his family, and the inhabitants in general.

23. Hammett had visited Nevis from St. Kitts. Later, during the ministry of John Brownell, the society faced persecution, but continued to grow in spite of it.

24. Thomas Owens had been an itinerant only since 1785. He served twelve years in the West Indies. For his refusal of the offer of a living on Grenada see p. 184 below. In 1794 he moved to St. Vincent in the wake of persecution there. He died in 1808, having in his closing years been 'severely afflicted with fits of a peculiar kind.'

25. William Brazier was a local preacher from St. Kitts who volunteered for service on St. Eustatius and, after moving to Saba, was expelled on the orders of the Governor of St. Eustatius. He was later forced by ill health to retire from Jamaica to his native island.

The little island of *Saba* contains about one thousand whites and about two thousand blacks, men, women and children included. For seventeen years that simple-hearted people have been without a regular minister. The Governor, Council and people petitioned that Mr. *Brazier*, who had preached three times in the church, (which is no contemptible building) might remain among them. I informed them of our economy, and particularly of our grand and indispensable custom of changing our ministers. They were willing to comply with every thing, to grant to our minister the parsonage-house, and to allow him a sufficient maintenance. What could I do? Mr. *Brazier* was appointed to labour under Mr. *Hammet*, at *Jamaica:* but I could not bear that this delightful people should perish for lack of knowledge. I left therefore Mr. *Brazier* behind me, having spent two pleasing days with these inhabitants of the rock. May they all be built on the Rock of Ages!

My heart is too much engaged in the interests of this plain, honest colony, for me to omit transcribing the sentiments of a celebrated *French* writer, concerning them and their island.[26]

> This is a steep rock, on the summit of which is a little ground, very proper for gardening.[27] Frequent rains which do not lie any time on the soil, give growth to plants of an exquisite flavour, and cabbages of an extraordinary size. Throughout *America* there is no blood so pure as that of *Saba;* the women there preserve a freshness of complexion, which is not to be found in any other of the *Carribbee* islands. Happy colony! Elevated on the top of a rock, between the sky and the sea, it enjoys the benefit of both elements without dreading their storms. The inhabitants breathe a pure air, live upon vegetables, cultivate a simple commodity, from which they derive ease without the temptation of riches; are employed in labours less troublesome than useful; and possess in peace all the blessings of moderation, health, beauty and liberty.
>
> This is the temple of peace, from whence the philosopher may contemplate at leisure the errors and passions of men, who come like the sea, to strike and dash themselves on the rich coast of *America*, the spoils and possession of which they are perpetually

26. The following excerpt is from Abbé Raynal, *A Philosophical and Political History of the Settlements and Trade of the Europeans in the East and West Indies*, 4 vols. (Dublin: John Exshaw & William Halhead, 1776), 3:243–44.

27. Coke's 1789 *Journal* included here the note: 'This little island is about fifteen or sixteen miles in circumference.'

contending for and wresting from each other. Hence may he view at a distance the nations of *Europe,* bearing thunder in the midst of the ocean, and burning with the flames of ambition and avarice under the Tropics, devouring gold without ever being satisfied, wading through seas of blood to amass those metals, those pearls, those diamonds which are used to adorn the oppressors of mankind; loading innumerable ships with those precious casks, which furnish luxury with purple, and from which flow pleasures, effeminacy, cruelty and debauchery. The tranquil inhabitant of *Saba* views this mass of follies, and spins in peace the cotton which constitutes all his finery and wealth.[28]

On the 17th, we landed at *Tortola*.[29] This island which contains about 1,000 whites and 8,000 blacks, is indeed ripe for the Gospel. It seems to be the general cry of the negroes throughout the island, 'Let us have, if possible, a Methodist Minister.'

After giving the inhabitants of *Road-Town,* (the principal town of this island) two sermons, we sailed for *Santa Cruz,*[30] an island belonging to *Denmark.* — This last mentioned island is supposed to contain about 30,000 inhabitants, who in general speak the *English* language. It is highly cultivated; and the town of *Basse-End,*[31] its capital, is far the most beautiful I have seen in the *Caribbee* islands. The Governor-general, through the warm recommendation of a worthy and respectable friend in *London,* received us with great courtesy, and promised us all the protection and encouragement in his power.

Two gentlemen in the town shewed us many marks of respect, and an old Quaker-lady permitted me to preach in her house, and afterwards informed me that it should be always at our service.

And now I found myself in the utmost doubt, and knew not which way to turn. Mr. *Hammet* was appointed for *Jamaica;* and there was no other Missionary to secure the advantages which the Lord had given us in these two islands. At last we determined that

28. Coke's 1789 *Journal* included here the note: 'Soon after I left the West-Indies, the Governor of St. *Eustatius* who is Governor-general of all the *Dutch Caribbee* islands, with the most implacable spirit of persecution, forced the Governor and Council of *Saba* to part with Mr. *Brazier,* though they did it with sorrow and reluctance, they afterwards assured me by letter.'

29. One of the British Virgin Islands to the east of Puerto Rico. The pioneering work here was done by William Hammett.

30. I.e., St. Croix to the south of the Virgin Islands.

31. I.e., Christianstäd, sometimes known as Bassin.

Mr. *Hammet* should divide his labours between *Tortola* and *Santa Cruz*, till two Missionaries are sent from *England* to prosecute the openings which Divine Providence has afforded us, and, which, I doubt not, Mr. *Hammet* in the mean time will greatly improve. I shall also, God willing, visit *Jamaica*, to prepare his way in that populous and important island.

After my return from *Santa Cruz* to *Tortola*, I had a very providential escape, in going late in the evening from the quay to the ship, in which I was to sail the next morning for *Jamaica*. In the midway between the shore and the ship, about the distance of a mile from each, a young man who sat behind me, observed with some surprise, that the water came over the stern of the boat. — I put my hand over the side, and found that the edge of the boat was within an inch of the water. Immediately I observed, that the boat, the bottom of which was very deep and leaky, had let in so much water, and had sunk so low, that on every motion the water came in over the stern, as well as from below; so that in a few minutes we should probably have sunk, if our awful situation had not been just then discovered: but after using proper means to throw out the water, we got safe to the ship through the blessing and interference of our never-failing Friend.

We have now through the blessing of God on our endeavours, a prospect of much good in ten of the islands, which unitedly contain about two hundred and sixty thousand inhabitants, near four-fifths of whom are covered with heathenish darkness.

[The remainder of this section, giving current statistics for the West Indian work, appears in the 1789 version of the *Journal*, but is not included in 1816.]

Before I conclude, it may not be unpleasing to add an account of the stations of our Missionaries and of the numbers in Society.

1st. The Stations of our Missionaries
1. *Antigua*, Matthew Lum[b], John Harper
2. *St. Christopher's*, William Warrenner
3. *St. Eustatius*, George Skerret
4. *Nevis*, Thomas Owens

5. *St. Vincents,*
 In the Caribb-Division, John Baxter
 In the English Division, Robert Gamble, and John Clark
6. *Dominica,* William M'Cornock
7. *Barbadoes,* Benjamin Pearce
8. *Saba,* William Brazier
9. *Tortula* and 10. *Santa Cruz,* William Hammet

	2dly. The numbers in Society
1. *Antigua*	Whites 70
	Blacks 2740
2. *St. Christopher's*	Whites 50
	Coloured People 650
3. *St. Eustatius*	Whites 8
	Coloured People 250
4. *St. Vincent's*	Whites 250
	Coloured people 139
5. *Dominica*	Coloured People 24
6. *Barbadoes*	Whites 6
	In all 3949*

*Besides Catechumens

Section V

On the 19th of January, I landed at *Port-Royal,* in *Jamaica.* When I landed, Mr. *Fishley,* master-calker of the harbour, to whom I brought a letter of recommendation, received me with every mark of kindness and respect, and introduced me the next day to Mr. *Bull* and Mr. *Treble,* of *Kingston,* who proved my very valuable friends. In Mr. *Treble's* house I preached four times, to small, but increasing congregations. At last, a gentleman of great benevolence (Mr. *Burn,* a Roman Catholic,) observing the inconveniences the congregation was put to, in Mr. *Treble's* small, though neat house (which would have been large enough, I doubt not, for all inhabitants of *Kingston,* if it had been as large as his heart) most generously offered me the use of a very large room in one of his houses, which room has been frequently used as a public Concert-room, and is the largest but one in the whole town.

The first evening I preached there, the congregation was considerable, and received the word with great decency, and great attention. Whilst I was pointing out to the unregenerate, the fallaciousness of all their hopes, and the impossibility of reversing the decree, 'Except a man be born again, he cannot see the kingdom of God,'[32] and seriously inquiring of them, whether they had found out some new gospel as their directory, a poor negro-woman cried out, 'I am sure you are a new Priest.' The second evening the great room and all the piazzas around it were crowded with people. I believe there were four hundred whites present, the largest number of whites I ever preached to at one time in the *West-Indies*, and about two hundred negroes, there being no room, I think, for more. After I had preached about ten minutes, a company of gentlemen, inflamed with liquor, began to be very noisy: till at last, the noise still increasing, they cried out, 'Down with him, down with him.' — They then pressed forwards through the crowd in order to seize me, crying out again, 'Who seconds that fellow?' On which my new, but gallant friend Mr. *Bull*, stepped forth between the rioters and me, saying, 'I second him against men and devils.' A lady also of great worth, who in her younger years had been a member of our Society in *London*, but through the various vicissitudes of life was now a resident of *Jamaica*, who had lately been dangerously ill, and during her illness, when all her former religious impressions returned with all their weight to her mind, had received a clear manifestation of the pardoning love of God—notwithstanding all the delicacy of her sex, and her own peculiar amiableness of disposition, stood up, and reasoned with the rioters on the impropriety of their conduct. They now, I believe, were convinced that nine out of ten of the congregation disapproved of their behaviour, and gave up the contest, still crying as they descended the stair-case, 'Down with him, down with him.'

The spirits of the congregation were so deranged[33] by this unhappy incident, that I gave out a hymn, and then chose a new text, and preached a sermon, with some degree of liberty, I bless God, to a serious, attentive audience.

Having now received a message from the captain of the brig in which I had taken a passage for *Charleston*, desiring me to repair to

32. John 3:3.
33. In Coke's *History of the West Indies* this reads 'discomposed.'

Port-Royal in order to go on board, I returned to that little town, where I preached three sermons, which many of the white people attended, the blacks in that place not seeming to regard the gospel.

I am fully satisfied that great good might be done in the island, if the gospel was regularly preached here with power. A small Society of awakened persons might even at present be formed both among the whites and blacks in *Kingston.*

Indeed this valuable and populous island demands and deserves much of our attention and exertions, as it probably contains above 300,000 inhabitants, the slaves alone, in the year 1768, amounting to 217,000; and in *Kingston* only they have been nearly doubled since that time.

This I must add in honour of the island, that I never visited any place either in *Europe* or *America,* in which the gospel was not preached, where I received so many civilities as I did in *Jamaica,* four or five families of property having opened to me their houses, and, very evidently, their hearts also, and assured me that any Missionaries we shall in future send to that island, shall be welcome to beds and every thing their houses afford.

One the 24th of February, I landed at *Charleston.* Mr. *Asbury* had arrived there several days before from the North in order to meet me; but set off three hours before I landed to be present at the Conference in *Georgia.*[34] The next day I followed, and riding in two days as much as he had in three, overtook him.[35] The first day we rode forty-seven miles, for about two miles of which our horses were up to their bellies in water, with two great invisible ditches on the right and left. Our Elder stationed at *Charleston,* accompanied me.

One of the grandest objects to be seen in this country, is the fires in the woods in the spring. — The inhabitants set fire to the grass and little shrubs, in order to burn up the dry leaves which cover the ground, that the grass which grows up afterwards may be accessible to the cattle. Late one evening I saw the most astonishing illumination, I think, I ever beheld in my life, whilst I was travelling through the woods. I seemed surrounded with great,

34. Coke and Asbury rode north together, attending the Conferences in each of the states from Georgia to New York. Asbury's account of each Conference in his *Journal,* though usually more succinct, supplements and occasionally corrects Coke's.

35. This was at M. Bruten's, near Bamberg. Asbury says that Coke came in 'some time in the night' (*Journal,* 1:592).

extensive fires: and question whether the King of *France's* stag-hunt in his forest by night, which he sometimes has given to his nobility, would be more wonderful or entertaining to a philosophic eye. Sometimes the fire catches the oozing turpentine of the pine-trees, and blazes to the very top. I have seen old, rotten pine-trees all on fire: the trunks, and the branches (which look like so many arms,) were full of visible fire and made a most grotesque appearance.

The weather was as cold, as it had been, according to the information of the people, in any part of the winter, and was felt by me just come from the torrid zone, with peculiar severity. Although I clothed myself almost from top to toe with flannel, I could but just bear the cold. We had congregations all the way, after I met Mr. *Asbury*; but our journies in the back parts of *South Carolina* and *Georgia* were frequently very trying. Sometimes we lost our way. In one instance we lost twenty-one miles. A great part of the way we had nothing in the houses of the planters but bacon and eggs, and Indian corn bread. Mr. *Asbury* brought with him tea and sugar, without which we should have been badly off indeed. In several places we were obliged to lie on the floor, which, indeed, I regarded not, though my bones were a little sore in the morning. The Preachers in Europe know but little, in the present state of Methodism, of the trials of two-thirds of the Preachers on this Continent. And yet in (what I believe to be) a proper view of things, the people in this country enjoy greater plenty and abundance of the mere necessaries of life, than those of any country I ever knew, perhaps any country in the world. For I have not in my three visits to this Continent, in all of which I have rode about 5,600 miles, either met with, or heard of, any white men, women, or children, that have not had as much bacon, Indian corn, and fuel for fire, as they wanted, and an abundance to spare: nor are they badly off for clothing.

The great revival however, and the great rapidity of the work of God, the peculiar consolations of God's Spirit which he has favoured me with, and the retirement I met with in these vast Forests, far over-balanced every trial. Many other circumstances also amply compensated for the disagreeable parts of my journey. Sometimes a most noble Vista of half a mile or a mile in length, would open between the lofty Pines. Sometimes the tender fawns and hinds would suddenly

appear, and on seeing or hearing us, would glance through the woods, and vanish away. Frequently indeed we were obliged to lodge in houses built with round logs, and open to every blast of wind, and sometimes were under the necessity of sleeping three in a bed. Often we rode sixteen or eighteen miles without seeing a house, or human creature but ourselves, and often were obliged to ford very deep and dangerous rivers, or creeks (as they are here called.) Many times we ate nothing from seven in the morning till six in the evening; though sometimes we carried refreshments with us, and partook of our temperate repast on stumps of trees in the woods near some spring or stream of water.

On the 9th of March we began our Conference in *Georgia*.[36] Here we agreed (as we have ever since, in each of the Conferences) that Mr. Wesley's name should be inserted at the head of our small annual Minutes, and also in the form of discipline: in the small Minutes as the fountain of our Episcopal office, and in the form of discipline, as the father of the whole work under the divine guidance. To this all Conferences have cheerfully and unanimously agreed.[37] We have 2,012 in Society in the state of *Georgia:* the increase in the last year has been 784. At this Conference we agreed to build a College in *Georgia:* and our principal friends in this state have engaged to purchase at least 2,000 acres of good land for its support: for this purpose there was 12,500 pounds weight of Tobacco subscribed in one congregation, which will produce, clear of all expenses, about 100£. sterling. We have engaged to erect it, God willing, within five years, and do most humbly intreat Mr. Wesley to permit us to name it Wesley-College, as a memorial of his affection for poor *Georgia,* and of our great respect for him.[38]

On the 17th we opened our Conference in *Charleston,* for the state of *South Carolina*.[39] My congregations were very large in this city,

36. The Georgia Conference was held in a chapel five miles east of Washington, Wilkes County, built by the storekeeper Daniel Grant. It was the earliest Methodist chapel in Georgia (Asbury, *Journal*, 1:593-94).

37. Wesley's name had been erased from the American *Minutes* in 1787. See pp. 68, 89 n. 38 above.

38. Wesley's well-known letter to Asbury and Coke of 20 September 1788 strongly rebuked them not only for adopting the term 'bishop' in place of 'superintendent,' but for vaingloriously (as he saw it) naming the college at Abingdon after themselves. This resolution was obviously an act of appeasement or an olive branch.

39. Asbury's account is: 'It was a time of peace and love. My mind was much hurried with book, and other temporal concerns. We had an unkind attack published against us relative to our slave rules; it was answered to purpose. I had not much doubt who the author of this unworthy work was' (*Journal*, 1:594).

as well as Mr. *Asbury's*, and great liberty the Lord was pleased to give me. We were bitterly attacked in the public papers, but our mild answer, I believe, did us more service, than the illiberal attempts of our persecutors did us hurt. In this state we have 3,377 in Society; the increase is 907. In my way from this city I preached three sermons in a small town called *George-Town*, in the Courthouse, where most of the principal people of the neighbourhood attended every time, and heard with deep attention, though we never had any Society or regular preaching there. As the pious master and mistress of the house where I was most hospitably entertained, with their truly religious daughter (though but young,) were desirous on partaking of the Lord's Supper, I administered it in their dwelling-house, and gave permission to any serious persons of the congregation who desired it, to communicate with us: in consequence of which, near twenty well-dressed persons (chiefly women, and some of them, as I was afterwards informed, women of property) all of whom had seriousness engraved on their countenances, joined us in that holy ordinance. In this part of the country I met with a sweet potatoe, which, when roasted, eats exactly like a roasted apple, and can hardly be distinguished from mellow apples in pies or puddings: how bountiful is Providence! I am daily filled with surprise, in meeting with such large congregations as I am favoured with in the midst of vast wildernesses, and wonder from whence they come. O that God may grant me the only hire I desire for my labours—the salvation of souls!

On the 12th of April[40] we opened our Conference for the state of *North Carolina* at the house of a planter in the country (brother *McKnight*)[41] on the borders of a fine river called the Yeadkin.[42] Nineteen Preachers met us there, some of whom came from the other side of the *Alleghany*-Mountains. The numbers in this State are 6,779; the increase 741. We here received most reviving letters concerning the progress of the work in *Kentucky*, the new Western World (as we call it.) In these letters our friends in that country

40. Asbury dates the opening of this Conference as Friday, 10 April, and says that they 'were blessed with peace and union. Our brethren from the westward met us, and we had weighty matters for consideration before us' (*Journal*, 1:595-96).
41. George McKnight (1765–1847) lived near the present Clemmons, Forsyth County, NC. He built a chapel for the Methodists, but later joined the Moravians (Asbury, *Journal*, 1:537).
42. I.e., the Yadkin.

earnestly entreat to have a College built for the education of their youth, offering to give or purchase three or four thousand acres of good land for its support. We debated the point, and sent them word, that if they will provide five thousand acres of fertile ground, and settle it on such Trustees as we shall mention under the direction of the Conference, we will undertake to complete a College for that part of our Connexion within ten years.

In travelling from this Conference to *Virginia* we were favoured with one of the most beautiful prospects I ever beheld. The country, as far as we could see from the top of a hill, was ornamented with a great number of Peach orchards, the Peach trees being all in full blossom, and displaying a diversity of the most pleasing colours, blue, purple and violet. On the opposite side of a beautiful vale which lay at the foot of the hill, ran the river Yeadkin, reflecting the rays of the sun from its broad, placid stream: and the mountains which bounded the view, formed a very fine back ground for the completeing of the prospect. The two days following we rode on the ridge of a long hill, with a large vale on each side, and mountains rising above mountains for twenty, and sometimes, I suppose, forty miles on each hand.[43]

In *Halifax*-County (*Virginia*) where I met with much persecution four years ago, almost all the great people of the county came in their chariots and other carriages to hear me, and behaved with great propriety: there were not less than five Colonels in the congregation. On the 18th we opened our first Conference for the state of *Virginia* in the town of *Petersburgh*, and both in the public and private meetings the Lord was very present with us.[44] Thirteen Preachers were received on trial, all well recommended: in the former Conferences there was not a sufficient number of new Preachers to answer all our calls, but in this Conference every deficiency was supplied.

From *Petersburgh* we set off for our second *Virginia* Conference, which we held in the town of *Leesburgh*, visiting *Richmond* by the way. At this Conference also we had a very comfortable time.[45] The numbers in Society in *Virginia* this year, are 14,226: the increase 2,023.

43. Asbury notes more prosaically that they had about two hundred miles to ride in four days and that they had 'a tedious ride to Almond's,' which was in Charlotte County, VA.

44. Asbury's account was less up-beat: 'I had disagreeable feelings while here. There is a spiritual death among the people' (*Journal*, 1:596).

45. 'We found a little rest comfortable to man, and advantageous to beast' (Asbury, ibid.).

From *Leesburgh* we set off through *Alexandria* and *Annapolis* for *Baltimore*. At *Alexandria* I preached in the great Presbyterian Meeting-house which has been built in that town, and, praised be God, gave huge offence to the unregenerate rich, and great joy to the pious poor, by the testimony I then bore against sin.

At *Annapolis* in *Maryland*, after my last prayer on Sunday the 3rd of May, the congregation began to pray and praise aloud in a most astonishing manner. At first I felt some reluctance to enter into the business; but soon the tears began to flow, and I think I have seldom found a more comforting or strengthening time. This praying and praising aloud is a common thing throughout *Virginia* and *Maryland*. What shall we say? Souls are awakened and converted by multitudes; and the work is surely a genuine work, if there be a genuine work of God upon earth. Whether there be wildfire in it or not, I do most ardently wish, that there was such a work at this present time in *England*. In one Meeting in this State we have reason to believe that twenty souls received full sanctification; and it is common to have from twenty to fifty souls justified in a day, in one place.[46]

Our first Conference for the state of *Maryland*, begun in *Baltimore* on Tuesday the 4th, in which we were all unanimous and truly affectionate. On the Wednesday evening after I had preached, and Mr. *Asbury* exhorted, the congregation began to pray and praise aloud, and continued so to do till two o'clock in the morning. Out of a congregation of two thousand people, I suppose two or three hundred were engaged at the same time in praising God, praying for the conviction and conversion of sinners, or exhorting those around them with the utmost vehemence: and hundreds more were engaged in wrestling Prayer either for their own conversion or sanctification. The great noise of the people soon brought a multitude to see what was going on, for whom there was no room in the Church, which has been lately built, and will hold a larger congregation than any other of our Churches in the States.[47] One of our Elders was the means that night of the conversion of seven

46. Asbury also records the 'lively meetings' they had in Baltimore: 'Multitudes came to hear, and great cries were heard among the people, who continued together until three o'clock in the morning. Many souls professed to be convicted, converted, sanctified' (*Journal*, 1:597).

47. This was the Light Street Church to which the Lovely Lane congregation had moved in 1786.

poor penitents within his little circle in less than fifteen minutes. Such was the zeal of many, that a tolerable company attended the preaching at five the next morning, notwithstanding the late hour at which they parted. Next evening Mr. *Asbury* preached, and again the congregation began as before, and continued as loud and as long as the former evening. This praying and praising aloud has been common in *Baltimore* for a considerable time: notwithstanding our congregation in this town was for many years before, one of the calmest and most critical upon the Continent. Many also of our Elders who were the softest, most connected, and most sedate of our Preachers, have entered with all their hearts into this work. And it must be allowed, that gracious and wonderful has been the change, our greatest enemies themselves being the judges, that has been wrought on multitudes, on whom this work begun at those wonderful seasons.

On Friday the 8th, we set off for our College, which is about twenty-eight miles from *Baltimore*. I was highly pleased with the progress they have made towards the completeing of the building; the situation delights me more than ever. There is not, I believe, a point of it, from whence the eye has not a view of at least twenty miles: and in some parts the prospect extends even to fifty miles in length. The water-part forms one of the most beautiful views in the United States: the *Cheasapeak-Bay* in all its grandeur, with a fine navigable river (the Susquehanna) which empties itself into it, lying exposed to the view through a great extent of country.

During my stay at the College, I had several long conversations with Dr. *Hall*,[48] our President, and am satisfied beyond a doubt, that he is both the Scholar, the Philosopher, and the Gentleman: he truly fears God, and pays a most exact and delicate attention to all the rules of the institution. Our Classic Tutor is a very promising person: he is not yet the polished Scholar, like the President; but his manifest strength of understanding, and perservering diligence, will soon, I doubt not, perfect every thing that is wanting. And our English and Mathematical Master gives us considerable satisfaction.

On Saturday morning the 9th, I examined all the Classes in private: and in the afternoon we had a public exhibition of the different

48. Jacob Hall of Abingdon, successor to the Reverend Levi Heath as President of Cokesbury College.

abilities and improvements of our young students. Two young men displayed great strength of memory, and great propriety of pronunciation, in the repetition of two chapters of *Sheridan* on Elocution,[49] and were rewarded by Mr. *Asbury*, as a small testimony of our approbation, with a dollar apiece. One little boy, a son of Mr. *Dallam's*,[50] a neighbouring gentleman, delivered Memoriter, a fine speech out of *Livy*, with such an heroic spirit, and with such great propriety, that I presented him with a little piece of gold. Three other boys also so excelled in gardening, that Mr. *Asbury* rewarded them with a dollar each. But what is best of all, many of them are truly awakened. However, we were obliged to undertake the painful task, in the presence of the Trustees, Masters, and Students, of solemnly expelling a young lad of fifteen years of age, to whose learning we had no objection, but whose trifling, irreligious conduct, and open ridicule, among the Students, of experimental religion, we could not pass over: as we are determined to have a College, in which religion and learning shall go hand in hand together, or to have none at all. But nothing relating to this institution perhaps has given me greater pleasure, than to find we are already enabled to support four students fully, and two in part, (Preachers' sons and orphans) on the charitable foundation.

On Wednesday the 14th, we opened our second Conference for the State of *Maryland* in *Chester Town*, where also we had nothing but love and unanimity. The numbers in Society in *Maryland* are 11,117; the increase 1,107. On both the first and second days of the Conference, there was much praying and praising aloud in the congregation. — The second day they began at three in the afternoon, immediately after the Sacrament, so that we could not hold a Love-feast, as we intended, and continued till eight in the evening; when brother *Everitt*,[51] one of our Elders, preached. After preaching, while he was giving out his last hymn, they began again, and continued till eleven at night. A lawyer who came there

49. *A Course of Lectures on Elocution* (London: Dilly, 1762) by Thomas Sheridan, father of Richard Brinsley Sheridan.

50. Richard Dallam of Deer Creek, Harford County, had given the site of the college. See pp. 41, 43, 64 above.

51. Joseph Everett (1732–1809) was born of Anglican parents in Queen Anne's County, MD, became a Presbyterian under Whitefield's influence, and was strongly critical of the Methodists until won over by Asbury and the reading of Wesley's writings. He became an itinerant in 1780, was present at the Christmas Conference and was ordained deacon in 1786, elder in 1788, and presiding elder in 1789, retiring in 1805.

out of curiosity, and who is eminent for his good sense, and great abilities in his profession, was constrained in the midst of this work to acknowledge, to some who were near him, that he believed it proceeded from the interference of a Divine Power.

On the 18th, we began our Conference in *Philadelphia* for the State of *Pennsylvania*, in which, as usual, we had perfect unanimity. The numbers in this State and the little State of *Delaware*, in which two States the circuits are so mixed that the numbers cannot easily be separated, are 2,000. There has been in these districts a decrease on the whole of 56 members. On the third evening we were favoured with some breathings of the Spirit, which, I hope, will prove the beginning of better days in this city.

There is a custom perculiar to the *American* Preachers, which is this: If there be more Preachers than one in a congregation, the Preachers that have not preached, give each of them a warm exhortation. And as far as I can judge by external effects wrought on the congregations, and by consequent inquiry and information, more good has been done in most instances by the exhortations than by the sermon: more souls have been awakened and converted to God.

In our Conference which began in *Trenton*, on the 23rd, for the State of *New Jersey*, all the Preachers seemed full of love.[52] The few friends we have in this town, did every thing, I believe, that they could conceive, to make us comfortable: but, alas! the work is, and ever has been, at a very low ebb in this place. The numbers in *Jersey*, are 1,751: here also there has been a decrease of 295. This will necessarily happen sometimes in so extensive a work; yea, where the ministers have been most faithful. Rotten members, be they ever so numerous, must be lopped off, or we should soon become like other men. We have three Indians in this district: and who knows but they are the first fruits of a glorious harvest among that people.

On the 28th, we opened our last Conference in *New-York*, for that State—a Conference, like the others, all peace and concord.[53] Glory, glory be to God! In this city we have a great revival, and a great

52. Asbury says: 'We . . . opened our conference in great peace. We laboured for a manifestation of the Lord's power, and it was not altogether in vain' (*Journal*, 1:597).

53. At John Street Church. Asbury's account concurs: 'All things were conducted in peace and order. Our work opens in New York State. New England *stretcheth out the hand* to our ministry, and I trust thousands will shortly feel its influence' (*Journal*, 1:598).

increase; in consequence of which we are going to build a second church. In the country parts of this State, *Freeborn Garrettson,* one of our Presiding Elders, has been greatly blessed; and is endued with an uncommon talent for opening new places. With a set of inexperienced but zealous youths, he has not only carried our work in this State as high as *Lake Champlain,* but has raised congregations in most of the States of *New-England,* and also in the little State of *Vermont,* within about a hundred miles of *Montreal.* The numbers in the State of *New-York,* are 2,004; the increase 900. The whole number in the United States, is 43,265: the whole increase 6,111; which is very great, considering that not more than eight months, or thereabouts, have elapsed, since the last Conference. Of the above-mentioned number, 35,021 are whites; 8,241 are blacks, and three are Indians.[54]

We have settled our printing business, I trust, on an advantageous footing, both for the people individually, and the connexion at large; as it is fixed on a secure basis, and on a very enlarged scale. The people will thereby be amply supplied with books of pure divinity for their reading, which is of the next importance to preaching: and the profits of the books are to be applied, partly to finish, and pay off the debt of our college; and, partly, to establish Missions and schools among the Indians.

And through the blessing of God we are now determined to use our efforts to introduce the gospel among the Indians: in consequence of which, my indefatigable brother, Mr. *Asbury,* is to set off soon for *Fort-Pitt,*[55] where we are in the first instance to build a church and a school, as the grand chief of a nation or tribe of Indians who lives not far from that Fort, and who are at peace with the States, has expressed an earnest desire of having christian ministers among his people. O that the day of God's visitation to those poor outcasts of men, may now be arrived!

On the 5th of June, I took my leave of Mr. *Asbury,* the Preachers of the *New-York* district, and my other kind friends of *New-York;*

54. On these membership figures, Candler comments that 37,370 of the total were reported from the states of Maryland, Virginia, North and South Carolina, and Georgia. 'An obdurate Calvinism prevailed to the hindrance of Methodism in all the States north of Maryland, while in the Southern States the word of the Lord had free course and was glorified by great triumphs' (*Life of Coke,* 137). While undoubtedly true, the comment reflects Candler's predilections as one born and bred in Georgia who became a bishop of the Methodist Episcopal Church, South.

55. Now Pittsburgh. These plans were not immediately realized.

and set off in the ship *Union*, for *Liverpool*, at which Port we landed on the 10th of July. The captain and crew were at least in my presence, decent and well-behaved, and the Captain himself very kind and attentive to please. Most of them had been brought up in the Presbyterian church, and very cheerfully admitted morning and evening family service, as well as a sermon every Lord's-day, and attended very regularly. Many of them joined us in singing hymns at the several services. But not one of them, I am afraid, is truly awakened, though I observed some of them reading the little books which I gave them, with great attention; and a solemn spirit rested on the whole company, the last time I prayed with them.

Divine Providence has favoured us with a quiet and pleasant voyage on the whole. My books, my papers, and, above all, fellowship with GOD, have made the whole way agreeable. Captain *Cook's* Voyages to the Pacific Ocean, and Captain *Carver's* Travels among the Indian nations in *North-America*,[56] afforded me great entertainment. But what an awful observation is that of Mr. *Foster's*, who published a Journal of his Voyage with Captain *Cook*, the second time the Captain sailed round the World! 'It is,' says he, 'unhappy enough, that the unavoidable consequence of all our Voyages of Discovery, has always been the loss of a number of innocent lives: but this heavy injury done to the little uncivilized communities which Europeans have visited, is trifling when compared to the irretrievable harm entailed upon them by corrupting their morals.' 'If these evils,' adds the benevolent writer, 'were in some measure compensated by the introduction of some benefit in these countries, we might at least comfort ourselves, that what they lost on one hand, they gained on the other; but I fear that hitherto our intercourse has been wholly disadvantageous to the inhabitants of the South Seas.'[57]

What a pity is it, that the pure intentions of one of the best of Sovereigns,[58] the great patron of the Arts and Sciences; as well as all the expense of the different voyages; should thus be unaccompanied with any beneficial effect. But if the salvation of many souls

56. Jonathan Carver, *Travels through the Interior Parts of North-America, in the Years 1766, 1767 and 1768* (London: for the author, 1778).

57. George Forster, *A Voyage Round the World in His Britannic Majesty's Sloop 'Resolution,' commanded by Captain James Cook*, 2 vols. (Dublin: W. Whitestone, 1777), 1:173-74.

58. King George III.

was to be the glorious consequence, his Majesty and every person concerned that loves our Redeemer, would have a compensation indeed. — And I might add, in respect to any temporal benefits that might arise either to the islands of the Pacific Ocean, or to our own country, such an intercourse would necessarily be opened between them and us, if Missions for the establishment of the gospel among them were set on foot, and through the blessing of God succeeded, as would probably make any benevolent scheme of a civil or political kind, not only feasible, but easy.

On Saturday, July 4, some time before sun-set, I was indulged with one of the most delicious entertainments of the kind, I was ever favoured with; which was a set of the most grand and beautiful calm-clouds,[59] as the sailors term them, I ever beheld, rising up on the edge of the horizon on the north. No pencil can describe, or tongue express their beauty. Being not far distant from the coast of Ireland, I apprehended for a moment that I discerned the most beautiful land-prospect, gilded over by the horizontal beams of the setting sun. The colours and appearances were so strong, and all the tints so very lively, that the imagination could with the utmost ease realize sloping hills, perpendicular rocks, magnificent turrets seated on beautiful eminences, and here and there an opening glade or lawn, and sometimes even a town or village. Those who are not acquainted with the seas, or have never minutely attended to the beauty and grandeur of these calm-clouds, have no conception of the pleasure I felt on the occasion; especially as my mind was enabled in some measure to ascend up to the celestial limner, whose glory and handy-work were so visibly displayed before me. 'But they were mere clouds,' says the phlegmatic scorner. And what is the work of a Raphael, but canvas and paint? All is cloud and vapour, but the enjoyment of God! In about half an hour the delightful scenery disappeared.

On the 8th, in the morning, the captain informed me that we had been in imminent danger the night before, from a very sudden and violent squall of wind on the Devonshire coast, the ship having run in the night time, through a mistake of the captain, too far to the south, instead of sailing along the Irish coast. Great as, it seems, the noise and alarm was on the occasion, I was fast asleep the whole time; but the Keeper of Israel neither slumbered nor slept.

59. Cf. the more detailed description during his sixth voyage to America (p. 206 below). The term has not been traced elsewhere.

On the 9th, we passed by the awful rock in the Irish channel, called the *Middle-Mouse*, where two years ago, Mr. *Wesley* and myself with about ten of the preachers, were nearly lost, our ship striking against the rock about forty times in an hour and five minutes, and our deliverance appearing to have been a very extraordinary answer to prayer.[60] O that the solemn providences of God, which have brought me many a time to the very jaws of a watery grave, and then stept in with saving powers, may perfectly unfetter my soul from earth, and bring it, through divine grace, into the closest union with my God.

60. According to Wesley's diary (12 July 1787) the rock on which the *Prince of Wales* packet ran aground was the Little Mouse (Wesley, *Works*, 24:43n, 215). There was also, however, a Middle Mouse rock in the same area.

1790–91

Extracts of the Journals of the late Rev. Dr. Thomas Coke's Third[1] Visit to the West Indies

Introduction

Before the end of 1790 Coke was again in the Caribbean, on his way to the United States. In the interval back in England he had issued two appeals for support from a growing list of 'benevolent subscribers' to the missions and was now accompanied by two more missionaries. James Lyons was to be stationed on St. Kitts and Thomas Worrell in Jamaica.

On St. Vincent, Coke found that the Carib mission was already foundering, but a new opportunity opened up on Grenada, thanks to the encouragement and support of the island's governor and of a friendly clergyman who had already given them his encouragement in Barbados. On St. Eustatius, on the other hand, he found continuing hostility, despite a change of governor.

Most of the islands on which Methodist preaching was now to be found were visited en route to Jamaica. Here Coke found William Hammett weakened by fever and took him to recuperate when he embarked for the southern States.

1. Wrongly described in the 1816 edition as his *fourth* visit, but correctly identified as his 'third tour through the West-Indies' when first printed in 1791 as two letters to Wesley. For the fourth tour, see pp. 177-200 below.

Section I

Grenada, Nov. 28, 1790

On the 16th of October, we sailed from *Falmouth*. Sir *John Orde*,[2] Governor of *Dominica*, the captain, master, surgeon, Mr. *Lyons*,[3] Mr. *Werrill*,[4] and myself, were the company in the cabin. The captain was very kind and attentive to us, and we had an abundance of every thing we could desire to make the voyage comfortable. Every Friday we observed as a real fast: and every evening we had family-prayer with the sailors, but could not prevail to have prayer in the morning. The sailors excused themselves by saying they had not time. On each Lord's day I read prayers on deck, and one of us preached. The boatswain, we have no doubt, was under genuine conviction long before we arrived at *Barbadoes*; and on a mature and minute examination before we landed, we have great reason to hope that two more were awakened. On the 22d inst. we landed on the island of *Barbadoes*, having been five weeks and two days on our voyage. The pleasing prospect of *Bridgtown* and the plantations around it, with the ships and harbour, which forms one of the most beautiful prospects of the kind in the West Indies, had a very pleasing effect on the minds of the two Missionaries, Messrs. *Lyons* and *Werrill*.

I preached three times in *Bridgtown,* and was favoured, particularly the last evening, with large congregations. The Preaching-house will hold about seven hundred people, is very airy, and in every respect commodious. Mr. *Pearce*, our Missionary in this island for the two last years, has undergone very great persecutions;

2. Sir John Orde (1751–1824) had served in the British navy during the War of Independence. He was appointed Governor of Dominica in 1783 and created baronet in 1790 for his services there. Promoted to admiral in 1805, he was Member of Parliament for Yarmouth, Isle of Wight, 1807–24.

3. James Lyons, an Irish itinerant, was appointed to St. Kitts, but disappeared from the stations within two years 'through unworthiness,' though Coke reports that 'he did not fall into any of the grosser sins' but 'became vain and conceited' (*Account of the . . . Methodist Missions*, 1804, 7).

4. Thomas Worrell, an Irish itinerant since 1789, accompanied Coke to Jamaica and was left at Spanish Town, but met with little success there or at Port Royal. He fared better in Kingston, but died of fever in 1792, having exhausted himself in the work. Cf. Taggart, 'Irish Factor,' 72-73.

but the Lord at last inclined the heart of one of the Magistrates towards him, who defended him with spirit, and reduced all to peace. A very extraordinary name has been fixed on the Methodists in this island—'Hallelujah.' Even the little negroes in the streets call them by the name of *Hallelujah*, as they pass along. On the morning after I landed, I paid a visit to Governor *Parry*,[5] who received me with much courtesy. A foundation for a great work, I am persuaded, has been laid here, though the society at present is very small.

Having left Mr. *Lyons* behind me with directions to meet me at St. *Christopher's*, I sailed on the 23rd after preaching in the evening, with Mr. *Werrill* for *Kingston*, St. *Vincent's*, where I arrived on the day following, time enough to preach in the evening to a full house. Our chapel in *Kingston* formerly belonged to the Roman Catholics, but has been lately purchased by us. It will hold about two hundred and twenty. The next day I set off with Mr. *Baxter* and Mr. *Werrill* to visit the Societies on the windward side of the island. The country is very hilly, and singularly full of picturesque scenes. The steep mountains with their sharp peaks, the cocoa trees and plantains, the grew-grew[6] whose trunk is smaller at the bottom than the top, and which is frequently quite covered (branches, leaves and all) by a plant like the ivy, the sugar-canes planted on the gentle declivities of the mountains, (vales there are none in this island, except in the *Caribb-Country*) the coffee and cotton plantations, the *Atlantic Ocean* constantly in view, the milk-white foam of the sea between the rocks and promontories, some times covering a great expanse of water, and the burning sun exulting in his strength and gilding the strong perpetual verdure of the whole vegetable creation—form such scenes as persons unacquainted with the torrid zone have hardly any conception of. Mr. *Werrill* was so charmed with the prospects, that he confessed he felt himself perfectly reconciled to the *West-Indies*.

5. Major David Parry, who had arrived on the island in January 1784, but was forced to resign because of poor health in 1793. He was seen as one of the best governors, 'beloved' by the Council, the Assembly, and the people; cf. Robert H. Schomburgk, *The History of Barbados* (London: Longman, Brown, et al., 1848), 349-52. Coke called on him on each of his visits to the island and found him accessible and courteous (cf. *History of the West Indies*, 2:136, 139). Nevertheless he seems to have been unable or unwilling to curb the persecution faced by the Methodist missionaries in the island.

6. Or 'gru-gru'; probably *acrocomia aculeata* (otherwise *sclerocarpa*), a species of palm found in the Caribbean and South America.

We rode to the borders of the *Caribb-Land*. — Poor people! When Mrs. *Baxter* took her leave of some of them, she wept bitterly, and prayed they might have another call, and might accept and not reject it as they did the late one. As we returned, a negro-woman ran up to us out of a field to shake us by hand. 'Do you love God,' said Mr. *Werrill* to her. 'Yes,' said she, 'I do, otherwise I would not have come to you. I have felt the Redeemer's life and death in my soul.' The answer of an old negro to his Leader in *Kingston* a short time past, contained in it all the religion of the celebrated conversation between Dr. *Tauler*[7] and the beggar. 'If your driver should lay you down and flog you, what would you do?' said the Leader: 'Me should love him still,' said he. 'But if you should not get meat, what would you do then?' added the Leader: 'Me eat,' replied he, 'Me tank me fader; me no eat, me tank me fader: me live, me tank me fader; me die, me tank me fader.' I find the converted negroes in these islands generally speak of God under the denomination of father. There is certainly a prospect of a great flame throughout the island. Even many of the Roman Catholics themselves, of whom there are several families here, prefer our Missionaries to their own Priests, and have sent for Mr. *Baxter* to baptize their children. Mr *Lumb* has also laboured very faithfully and successfully in this circuit.

Section II

On the 27th of Nov. 1790, I sailed with Mr. *Baxter* for the island of *Grenada*,[8] where we arrived on the next day about eleven o'clock. We first called on Mr. *Lynch* of the town of St. *George*, who formerly lived in *Antigua*, and was then an acquaintance of Mr. *Baxter*. At his house we found a very comfortable lodging. Being the Lord's-day, we went to church as soon as we had dressed ourselves. The

7. John Tauler, the fourteenth century German Dominican, was influenced by Meister Eckhart and achieved a balance between inward spirituality, external piety, and virtuous living.

8. The 'Island of Spices' was the seat of government for the Windward Islands. Admiral Rodney's victory over the French in the Battle of the Saints in 1782 had ensured its possession by the British.

minister, Mr. *Dent*,[9] was in the midst of his sermon. After the sermon was over, we waited on him in the Vestry-room, where he received us with true christian kindness, and introduced us to several serious coloured people, who were then with him in the Vestry-room.

Mr. *Dent* was curate of *Bridgtown*, in *Barbadoes*, when I visited that island two years ago. He is the only clergyman in these islands that has shewn any regard for the Methodists. He defended us in every company, till he himself began to fall into reproach: when that amiable, that admirable man, General *Matthews*, the Governor of *Grenada* and Commander-in-Chief of the Forces in the *Caribbee Islands*, singled him out, and gave him the Living of St. *George's, Grenada*.

Soon after we left Mr. *Dent*, we waited on the General. He honoured us with about an hour's conversation concerning the design of our visit, and begged we would send Missionaries to the island; 'For,' said he, 'I wish that the negroes may be fully instructed, and there will be work enough for you and the clergy of the island.' I thought I could not but promise him a Missionary, which I accordingly did. We dined with him. Among the company at dinner, were the President of the Council, the Speaker of the Assembly, &c. The Speaker, during the conversation, expressed a strong desire that I would visit him at his seat in the country, offered to supply me and my friend with horses, to ride with us through the Island, and to introduce me to most of the gentlemen in it: but my plan would not admit of it. In the evening I preached in a large room to a numerous and deeply attentive congregation. About the middle of the discourse two or three young men at the door were very noisy for a minute or two; but on my observing to them that there were magistrates in that Island who would do us justice, they thought proper to withdraw. After preaching I found that a Society of about twenty seeking souls had been formed by one *Painter*, a free *Mulatto*,[10] and some time a member of our Society in *Antigua*.

9. The Reverend Samuel Dent was appointed to Christ Church, Barbados, in 1772 and became the minister at St. George's, Grenada, in 1790. In letters to Beilby Porteus, Bishop of London (in the Fulham Papers at Lambeth Palace Library), he mentions his absence from the parish because of ill health and reports problems over church lands on Grenada.

10. Sam Painter was converted under John Baxter and had just moved from Antigua to Grenada. He is thought to have worked as a pan boiler on a sugar plantation. His house became the meeting place for the Methodist class he formed in Grenada.

The following morning at six o'clock Mr. *Baxter* preached, and the room was nearly filled. In preaching he found his soul so moved towards the people, that he promised them he would himself return as their Pastor, if no one else could be nominated at the Conference.

A negro called on me to inform me that Mr. *Baxter* had nearly finished his discourse (as I staid at home to write, but was desirous of taking my leave of the people) and the poor man observed to me, that a little time ago he dreamed that two Ministers came to the Island for the benefit of the Blacks; he added, that as soon as he saw Mr. *Baxter* and me enter the Church, he knew us immediately to be the very same persons who had been represented to him in his dream. I went and gave the people a short exhortation, after which a very genteel black woman, who was free and of some property, came up, and taking brother *Painter* by the hand said, 'Sir, this good man had kindled a spark among us, and I hope you will send us assistance that it may be preserved and increased.' We breakfasted with Mr. *Dent;* and afterwards made a visit to Mr. *Williams,* Comptroller of the Customs, and Member for the town of St. *George.* Mr. *Williams* has heard the Gospel in *England,* and, I believe, loves it. He gave us great encouragement, expressed his desire that we would visit him at his country-house, and assured us that he would be glad to open the way of any Missionary we should send, as far as he could.

About eleven in the morning we set off on a journey of about thirty miles over the highest hills in the Island. On the top of the highest we could wear our great coats buttoned. On this hill there is one of the best Inns I have met with in the *West-Indies,* for the kindness of the people, and the reasonableness of their charges: it is also very commodious. It is called *Grand Etang* from a great Lake which is near it. This Lake is very deep, and supplies (I am informed) by subterraneous passages the twelve rivers (*brooks* we should call them) which water the Island. The lake is surrounded by large Peaks covered with wood. If I was to turn hermit, I think I should fix on this place, where I would make circular walks, and fix an observatory on one of the Peaks, and spend my time in communion with God, and in the study of Astronomy and Botany. At the tavern we met with a servant of the gentleman (*John Rae,* Esq;) whom we were going to visit, who brought us by the nearest but a

wretched way to his master's house, about nine at night. The gentleman of the house, who is the Agent of two principal *West-India* merchants in *London*, from one of whom I brought him a recommendatory letter, treated us with every attention and kindness, and informed us that he had nine hundred negroes under his direction; and that they were (as far as his influence went) open to the instruction, and his house to the entertainment of any Missionary I should recommend. We shall have some difficulty with those negroes, as the Romish Priests have too great a footing among them.

The next day we rode to a town called *Guave*, where we took shipping again; and after touching at St. *Vincent's* and taking up Mr. *Lumb* and Mr. *Werrill*, arrived in *Antigua* on the 5th of December.

Here I indeed found myself at home; and spent four comfortable days in this Island. At the baptism of three adults we had a memorable time. One of them was so overcome, that she fell into a swoon, and all she said for some time, but with an enraptured countenance, was, 'Heaven! Heaven! Come! Come!' On the last evening, after I had preached, three drunken *gentlemen* (so called) attacked Mr. *Baxter* in a most rude manner at the door of the chapel. He made some reply, on which they seized him: and one of them cried out, 'I'll murder thee, *Baxter*, I'll murder thee.' Mrs. *Baxter* hearing the horrid expressions, seemed to be almost distracted: and many of the negroes cried, 'Mr. *Baxter*, our own Mr. *Baxter* is murdered.' Many who were in their own houses, and did not distinctly understand the cry, apprehended there was a fire: so that soon the whole town was in an uproar. Two magistrates however with great spirit and discretion, at last reduced every thing to order; and sent to Mr. *Baxter* to inform him that if he would lodge an information in the morning, the rioters should be severely punished. We returned our thanks by letter in the most courteous and grateful manner we were able; but informed them that we took greater pleasure in forgiving than in prosecuting, and therefore begged leave to drop our information.

The work of God deepens in this Island; and the converted negroes give a more pointed and more scriptural account of their experience than they used to do. On Wednesday the eighth, at eleven at night we set sail for St. *Christopher's*, and after touching

at *Montserratt* (where I trust we shall soon have a mission) we landed on St. *Kitt's* on the ninth at ten at night.

Three of the Preachers being not yet arrived I set off with Mr. *Baxter* to visit St. *Eustatius* on the tenth. Landing late in the evening we delayed our visit to the new Governor (who has been lately sent out from *Holland*) till the morning. When we waited on him, he received us with very great rudeness indeed. Finding from inquiry that the truly-serious had liberty to meet together without molestation, we judged it best to leave the Island as quietly as possible. However, we called on our kind friend Mr. *Lindsay*, who had received me and my brethren with so much love and hospitality two years ago: but alas! we found him and left him in the depth of despair. The only reason he gave us for his deplorable situation was, that the Lord had very powerfully called him time after time to preach, and that he had as often resisted the call; till at last he entirely lost a sense of the favour of God. He seemed to have no hope left. We endeavoured to raise his drooping head, but all in vain. By this time our arrival on the Island was well known: and while we were at breakfast in the Inn, one of the brethren, a white man of the name of *Ryley*, called on us, and informed us that upwards of two hundred met regularly in Class under their respective Leaders,—that the Lord had raised eight exhorters among them, of whom he was one; that they all looked on themselves as Methodists;—and that if I would correspond with them from time to time by the way of St. *Kitt's*, they would punctually perform all the directions that should be given them, concerning the management of the Society. He also informed me that a considerable number of the brethren and sisters that were free negroes, intended being at St. *Kitt's* on Christmas-day, in order to enjoy the ordinances with one of our Ministers. I promised to correspond with them, and desired them to refer all their difficulties to the advice and decision of our Assistant-Minister in St. *Christopher's*. The above-mentioned brother *Ryley* was awakened about four years ago by poor black *Harry*, of whom I can hear no tidings.[11] We afterwards set sail for the Island of *Nevis*, where we arrived in the evening.

11. For Black Harry, see p. 82 above. Persecution of the Methodists on the Dutch islands of St. Eustatius and Saba continued, and early in 1794 Coke spent some time in The Hague, attempting to alleviate their situation. But there was no relief for them until the death of Governor Rennolds in 1811.

My old hospitable friend Mr. *Ward*, the Judge of the Admiralty, received me with every kindness and civility. On Sunday the 12th, I preached twice, and Mr. *Baxter* once in our Chapel in *Charlestown*, the only town in this island. In the course of the day we held a love-feast, where I enjoyed much satisfaction in the accounts given by some of our brethren concerning their experience. One young black man particularly, who spoke better English than the rest, gave us a very pleasing detail of the circumstances of his conviction and conversion—how he was drawn (to use his own words) out of the dark shades, and from the power of Satan, into glorious liberty. The next day we paid short visits to several of our friends in the country, particularly Mr. *Richard Nesbitt*, the most pious white man I believe I have ever met with in the *West-Indies*, the Missionaries themselves perhaps excepted. He has met with many misfortunes in life, but he is truly crucified to the world, and the world to him. He is not ashamed to assist us in instructing and exhorting the numerous bodies of negroes on the several estates of his first cousin Mr. *Walter Nesbitt*, on one of which he resides. From his house, and with him, we went to dine with *Walter Nesbitt*, Esq; who has, concentered in him, every thing that can constitute the man of honour and the gentleman. I never knew, till my present visit to this island, that the sensitive plant[12] is a native of the *West-Indies*. And now, for the first instance, I found time to examine the whole process of sugar-making.

In the evening I preached and lodged in the house of Mr. *Kane*, a planter and a friend, where that dear man Mr. *Richard Nesbitt* concluded the day with us, and promised to make us a visit at St. *Kitt's*, which he accordingly performed. The next morning we returned to St. *Christopher's*, and our absent brethren soon after arriving, we began our Conference on Wednesday the fifteenth of December. It continued for two days and part of a third, and was conducted and concluded in great peace.

Section III

At Sea, near *Cape Florida*, Jan. 4, 1791.

On the 18th of December I sailed for the island of St. *Vincent*, as I could hear of no vessel bound for *Jamaica*, in any island leeward.

12. *Mimosa pudica*, a prickly-stemmed herb, native to South America.

The time would not allow me to visit any of the *Virgin-Islands*. I was obliged to overlook even *Tortola* itself, though our testimony for the Lord Jesus has been more blessed for the time in that island than in any other. A remarkable circumstance which lately happened in this place deserves to be noticed. Mrs. *Lilly*, a Quaker-Lady, in whose house at *Santa Cruz* I preached about two years ago, came over to *Tortola* on a visit. At that time the Missionaries were under a warm persecution. And Mrs. *Lilley*, who is well known and respected in the island, went from house to house among the principal inhabitants of *Roadtown*, testifying against their conduct, and declaring her full persuasion that the Missionaries were men of God. 'But are not you a Quaker, Mrs. *Lilly*,' said several of them? 'I am' said she, 'both a Quaker and a Methodist; and I tell you, you are injuring both yourselves and your community by your opposition to those holy men.' Her testimony had a very good effect on many.

I spent my Christmas very comfortably and profitably to myself, and I trust to others in that romantic island, St. *Vincent's*. On Monday the 27th, I went with Mr. *Werrill* on board the ship *Jamaica* bound for *Montego-Bay*, the third town in the island of *Jamaica*. Our company were Captain *Sherry* and his agreeable wife, (who is my country-woman, from Wales) and three other agreeable ladies. The ship was lately built in *Bristol*, is very large, and had the best accommodations of any ship I ever sailed in. After a very agreeable passage we landed at *Montego-Bay* on the 5th of January.

This town probably contains about five thousand inhabitants: and the trees and plantations are so interspersed, as to give it the most rural appearance of any town, I think, I ever saw. But we were without a friend or single acquaintance: and to those who are endued with the tenderest social feelings, this is no small trial: though I do know in the general, to the glory of the grace of God be it acknowledged, that the Lord is a sufficient consolation in every place. I had however a strong persuasion that there was work for us to do in this town: we therefore went to a lodging-house, where we were very kindly treated. A recommendatory letter which I brought with me from a friend in *Cork*, to a principal gentleman in the neighbourhood, procured for us an elegant din-

ner, but no advice or help as to our main design. I walked about the streets, peeping and inquiring, but could hear of no place in which I could preach; and to preach out of doors is almost impracticable in this burning clime: besides, the negroes in general are not able to attend till the evening, when the heavy dews would render it in a high degree imprudent and dangerous to preach abroad. In this dilemma we should have set off as soon as possible for *Kingston,* if I could have got our boxes out of the ship, and sent off my heaviest things to *Charleston* before me; but this we could not bring to bear for three or four days.

While we were dining on the following day at an ordinary, I simply told the company of the business on which I was come, and complained of my hard lot in being prevented of the opportunity of preaching to the inhabitants of the town for want of a place. One of them observed that the large Assembly-room which was frequently used as a Play-house, and was formerly the Church where divine service was performed on Sundays, would be very commodious. Immediately after dinner we waited on the proprietor of the Assembly-room, whose name is *Brown,* a private gentleman, who has a large family and small property, but whom I shall ever remember with gratitude and esteem. He very generously gave me the use of the room, which has two small galleries, and will contain about five or six hundred people, gratis, and also lighted it at his own expense. The first evening I had most of the principal people of the town to hear me; who attended invariably during the four evenings I preached there: but hardly any of the coloured people attended that evening, the man whom I sent round the town calling only at the houses of the whites. But every evening afterwards the blacks attended, and their numbers increased beyond expectation. Each evening the congregation in general heard with deep attention. A few rakes only clapped their hands, and cried out, 'encore, encore,' the first and second evenings after I had concluded; but were from that time prevented by the interference of two or three gentlemen. On the Sunday morning we went to Church: but a little rain falling, the congregation consisted only of half a dozen or thereabouts at the exact time of beginning, on which the Minister walked out: if he had condescended to have waited ten minutes longer, we should have been I believe, about twenty. The Sunday before also there had been no service. In some

of the parishes of this island there is no Church, nor any divine service performed, except the burial of the dead, and christenings, and weddings in private houses, though the livings are very lucrative. But I will write no more on this subject, lest I should grow indignant. The Church in this town is small, but peculiarly elegant. It has been newly built at the expense of about twelve thousand pounds sterling.

In the evening I had about five hundred hearers. After as faithful a sermon as I was able to give them on the necessity of the new-birth, I informed them that Mr. *Hammet*, I believed, would soon visit them, whom I strongly recommended; nor did they seem displeased. Two or three poor blacks embraced an opportunity of squeezing my hand, and dropt some words which convinced me they had been much affected with what they had heard.

Having now settled all matters in respect to my boxes; and opened, I trust, a little door for the gospel at *Montego-Bay*, I set off with Mr. *Werrill* for *Kingston* on the 10th of January. Finding that we could not hire horses for this journey under £18 sterling or thereabouts, I purchased two poor, weak horses to carry us and our saddle-bags. It is so extraordinary, so perfectly new in this country for any one to ride with saddle-bags, that we were stared at, while we jogged along on our poor little creatures, as two phenomena in nature. O how sweet it is to drink of the cup of Christ! The distance from *Montego-Bay* to *Kingston* is one hundred and twenty-six miles, which is a very long journey in that burning climate, especially as the roads were very deep in the plains, through the vast quantity of rain which had lately fallen; and we had two mountains to cross.

In the course of the first day we met two negroes, one of whom was crying for the loss of his hat, which a sailor had stolen from him a little before. I proposed to Mr. *Werrill* to return and overtake the sailor, which we accordingly did. He had a companion with him: and both of them were very strong, and might soon have conquered us and our pitiful horses; but Providence restrained them, though I spoke many keen things to the thief. At last a gentleman came up in his carriage, to whom I applied for help; but he drove away unconcerned. I then was obliged to keep the sailors at bay, till two gentlemen came up on horseback, with whose assistance I recovered the hat to the great joy of the poor sufferer and his black

companion: but they wist not how much I had their spiritual interests at heart. We lay the first night in a little town called *Martha-Bray*. A company adjoining the room in which we sat, were uncommonly rude. One of them sung as obscene and blasphemous a song as language, perhaps, could afford. I imagine it was full as bad as the Essay on Woman.[13] O what a wicked country is this!

The next day we rode through the parish of St. *Anne*, which exhibits a delightful prospect. Though not so picturesque as some of the prospects in St. *Vincent's*, it was incomparably more noble. The high mountains on the right, the placid ocean on the left, and the fine plain betwixt them, crowded with rich green plantations of sugar-canes, yielded a grandeur of appearance superior to any thing I had before seen in this Archipelago. The plain is more like the vale of *Glamorgan*, in *Wales*, than any other place I can recollect.

At the tavern where we dined, we met with a poor negro-woman who was brought here from *South Carolina*, and evidently possessed the fear of God. She seemed to seek for opportunities to wait upon us, and drank in every word concerning religion with the utmost greediness.

We began to ascend the mountains on the 12th, upon the top of one of them we found an abundance of orange-trees, of the species which we call *Seville*. They looked exceedingly beautiful, and their beneficent Creator seemed to say to us in the trees, 'Come, ye weary travellers, and quench your thirst.'

About four in the afternoon, we arrived at the foot of a great mountain called by no other name than *Mount-Diable*, of which we had received from various persons most dreadful accounts. The landlord of the tavern at the foot of the mountain where we dined, told us of the dreadful precipices, and of the fall of many over them who were never after heard of, &c. After dining, and resting our wearied horses for a couple of hours, we set off by the light of the moon in order to conquer this tremendous hill at the earnest importunity of my companion, though I acknowledge my great imprudence in yielding to him. The precipices far exceeded my

13. An obscene parody of Pope's 'Essay on Man,' 'An Essay on Woman' by John Wilkes was first published in 1763. It may reasonably be assumed that Coke knew of it only by repute, though he might have encountered it in his student days at Oxford. For a modern edition, see Adrian Hamilton, *The Infamous Essay on Woman: John Wilkes seated between Vice and Virtue* (London: Deutsch, 1972).

expectations in the awfulness, and horror of their appearance. Nor is it at all improbable that many have been lost through intoxication, or unruly horses. Even my miserable poney wanted much to crop a fine tuft of grass on the very edge of one of them. However, with much labour and patience, and the aid of a gracious Providence, we arrived at a tavern on the other side of the mountain about eleven at night. In the last day's journey we saw an abundance of very fine pasturage, and a great quantity of cattle. The Guinea-grass, (a native of *Africa*,) which grows in the long days to six feet in height, and in manured ground, will seed six or eight times in the year, (if cut down to the ground each time after feeding,) is the chief food of the cattle in the hilly parts.

We had solemn pleasure on the next day of riding through a part of the country which contains the greatest curiosity in *Jamaica*, within about thirteen miles of *Spanish-Town*. Of a sudden, one seems to be locked up among the hills without any passage forwards: till in a moment, a narrow, crooked pass, between two immense rocks, hid from the view of the traveller, till he comes fully upon it, opens to him. Between these two vast rocks we rode about a mile or two with a beautiful purling river on our right. I think *Dover cliffs* are inferior to these rocks in height. *Penmanmawr* in *North-Wales* is higher. But the scene has superior advantages here, from the rocks being on each hand, and almost equally high, and perfectly perpendicular.

In the afternoon as we drew near *Spanish-Town*, the seat of government and the second town in the island, our horses could hardly move through fatigue; so that Mr. *Werrill* was obliged to lead his beast for three miles; and to keep up his spirits, which I thought began to droop, I dismounted and walked with him. From the violent flush I observed in his countenance, I was very apprehensive he would be attacked with a fever.

Soon after our arrival in *Spanish-Town* we waited on Dr. *Tittford* of that place, whose brother I have the pleasure of being acquainted with in *London*. I brought to the Doctor a gold medal from the Society of Arts and Commerce, for his improvements in the preparing and exporting of Cashew-gum. The Doctor did indeed both that day and on my return, shew me and my friends many marks of kindness and attention. I now found a strong desire of opening a work of God, with the divine blessing in this

place; and for that purpose made various applications in vain, for a room to preach in, till at last a Tavern-keeper told me that his long room was at my service. It was now too late to send notice round the town, so I deferred my attempt till another opportunity.

The next morning, (Jan. 14th,) we set off for *Kingston*, which is distant thirteen miles from *Spanish-Town;* to which place our poor weary horses, after being rested once at a Tavern, and twice on the road, where there happened to be a large spot of grass, brought us with great difficulty about dinner time.

Notwithstanding our various trials—the novelty, beauty and grandeur of the different prospects we met with on the way, and perhaps a peculiar turn of mind which the Lord has blessed me with, of extracting out of these innocent, transitory things all the sweetness they are capable of yielding, together with the approving smile of heaven, made the journey very agreeable. In this Island the rivers are comparatively large. In the other Islands there were hardly any singing-birds: but here we had many. Their notes indeed are far from being so melodious as those of our birds at home, though their plumage is far more beautiful.

I might enter into a description of the many very curious trees of different species and wonderful make, which we met with on our way;—a subject which would, I believe, be very entertaining and profitable to some, but tedious to others.

> These are thy glorious works, Parent of good!
> Almighty! thine this universal frame,
> Thus wondrous fair; thy Self how wondrous then!
> Unspeakable! who sitt'st above these heavens,
> To us invisible, or dimly seen
> In these thy lowest works: yet these declare
> Thy goodness beyond thought, and pow'r divine.[14]

The most valuable of all the trees is the Plantain, which answers to the bread-tree of the Islands in the Pacific Ocean, so celebrated by Captain *Cook.* The fruit is cylindrical, from eight to eighteen inches long, and an inch and a half or two inches in diameter. When drawn before they are ripe, split and roasted, they are, I think to my taste, equal to bread: and I am certain I should soon be able

14. John Milton, *Paradise Lost*, bk. V, lines 153-59.

to bring myself to prefer them to any bread. The negroes in general give them the preference. When buttered they eat very well with tea and coffee. The ripe fruit is exactly like mellow apples, and would answer the same end in pies. I think the Planters in this Island are not sufficiently attentive to the raising of the blessed Tree, which I believe will grow almost in every soil, but best in the little gullies between the mountains; and would secure the negroes from any danger of a famine, unless after a violent hurricane, which these trees are not able to withstand. The Island of *St. Vincent* abounds with plantations of these Trees, which make the year smile with abundance of plenty.

Our Chapel in *Kingston* is situated on a very beautiful spot, called the parade. It commands from the Balcony a prospect of part of the town, of the harbour, and of the fields, which I could have admired for an hour.[15]

But the persecution which has been experienced in this place, far, very far exceeds all the persecutions we have met with in the other Islands unitedly considered. Mr. *Hammett's* life has been frequently endangered. Mr. *Bull,* whom I have mentioned in a former journal,[16] and who continues our steady friend, has several times narrowly escaped being stoned to death: particularly one night, when he eluded the vigilance of the rioters by being disguised in a suit of regimentals. Often our most active friends were obliged to guard the Chapel, lest the outrageous mob might pull it down to the ground. The refraining from preaching by candle light, which perhaps was a measure necessary for the occasion, was a means of abating the persecution. At last, the rioters rose one night between eleven and twelve o'clock, and broke down the gates of the court leading to the Chapel: on which four of the Magistrates interfered, through the strong remonstrances of a gentleman of influence in *Kingston,* who esteems us, though he is not in our Society. They

15. Coke's 1791 *Journal* added here a note: 'It is eighty feet in length, and forty in breadth, and will contain about one thousand five hundred people. It has galleries on three sides, and is built exactly on the plan of our Chapel at *Halifax* in *Yorkshire,* known to and admired by numbers of our friends in *England.* The only difference is, that our Chapel in *Kingston* is above stairs, the other on the ground. Underneath we have a hall, (which is absolutely necessary in this very hot country) four chambers, and a large School-room, where one of our friends, brother *Fosbrook,* whose mother is a member of our Society near *Castle Dunnington, Leicestershire,* keeps school, under this condition that the resident Preacher shall nominate one child out of ten, who shall be instructed gratis.'

16. See p. 116 above.

accordingly published an advertisement, which kept the rioters from that time within tolerable bounds. But the News-papers were full for several months of letters for and against us. Many stood up in our defence under feigned signatures, two of whom were masterly writers. Every thing that was bad, was said of Mr. *Hammett;* every name that was disgraceful was given to him. In respect to me they published an anecdote of my being tried in *England* for horse-stealing, and flying to *America* to escape justice. Some of the rioters were prosecuted, and the Jury acquitted them against the clearest evidences. Nay, the Grand Jury gave it as their public opinion that both Mr. *Hammett* and the Chapel ought to be prosecuted as nuisances. Some of the persecutors were going one night to beat, if not murder a young man, whom they met in one of the streets, and took for Mr. *Hammett,* but happily the mistake was discovered in time.

On the first evening of my arrival I ventured to open the Chapel again for preaching by candle-light, and had a numerous audience: but some of them were very rude; however I thought it most prudent to pass them by unnoticed. My dear friend Mr. *Hammett* lay dangerously ill of a fever and ague, and a violent inflammation in one of his eyes, and was worn almost to a skeleton with opposition and fatigue. He had not been able to preach for near a month. His enemies had often killed him in report, and even insinuated that he had been buried by his friends in a clandestine manner. They were now waiting for the joyful moment when they might triumph in his decease, and, as they apprehended, the extinction of the work. I had a private interview with his Physician, Dr. *Harris,* a man of great honour as well as great skill, who assured me that there was not the least hope of his recovery, but by his removal for some time to a colder climate. As I was persuaded nothing should be omitted that might any way contribute to save so valuable a life, I determined to take him with me through *North America;* after which he might, if restored, return to *Jamaica,* and settle a Mission in *Montego-Bay* and its neighbourhood, through the blessing of God. He has been employed in the most arduous undertakings during the time he has been in these Islands. The two most flourishing Societies in the *West-Indies,* (*Antigua* excepted)—those of St. *Kitt's* and *Tortola,* were raised by the means of his indefatigable labours in the midst of much

opposition: and there are but few in the world with whom I have been acquainted, that possess the proper apostolic spirit in an equal degree with him. This testimony I feel myself obliged to bear concerning him, because he is worthy of it.

Mr. *Brazier,* our other Missionary appointed for the *Kingston* Circuit, arriving there a few days before me, I took him with me to *Spanish-Town* on Monday the 17th, leaving Mr. *Werrill* to preach in *Kingston.* In the evening I appeared in the long room of the Tavern according to the before-mentioned permission, having previously sent notice round the town. When I entered the room I found it nearly filled by the young Bucks and Bloods of the town, (as we used to term the debauchees at *Oxford,*) and not a single Lady was present. Soon afterwards many of the coloured people of both sexes came and filled the vacant places. During my sermon the Bucks behaved so rude, that I observed before I concluded, that if any House-keeper would lend me a hall, I would preach again the next evening, otherwise I should probably be obliged to leave the place. 'Farewell, Sir,' said one; 'Good luck to you, Sir,' says another; and thus they went on till I withdrew.

When Mr. *Brazier* and I consulted together on the subject, we were fully persuaded from the countenances and behaviour of the coloured people, that the Redeemer's kingdom might be enlarged by the preaching of the gospel in this place *to them:* and that we ought not to give up the point. Before bed-time two Gentlemen came to me at my lodgings, and offered me their halls to preach in: but alas! when I called on them the next morning, they had been, I suppose, frightened by their friends, and both of them retracted their promises. We were then determined to move on the true gospel-plan, 'from the least unto the greatest.' Accordingly we hired a poor cheap house (if it might be called by so lofty a name) in the outskirts of the town, of a Mulatto, from month to month. Here I preached in the evening to a considerable number of coloured people; and notwithstanding the poverty of the place, some of the Bucks attended and were ruder if possible than the night before. During the height of the noise I felt a spirit which I think I never felt before, at least in the same manner. I believe it was a spark of the proper spirit of Martyrdom. At the conclusion therefore of a pointed, though short address to the rioters, I told them I was willing, yea desirous to suffer Martyrdom: and my

words seemed to have a considerable effect on their minds. I then published myself for the Thursday evening following: and in the morning, after giving directions about the making of some wooden candlesticks to be fastened against the wooden walls, we returned to *Kingston*.

In the evening I had a large congregation, and, I believe a considerable part of our enemies present. My sermon was partly addressed to the Deists, partly to the Socinians, and partly to the Arians. At first they began according to their custom to be noisy; but I was happy enough to command their deep attention during at least three-fourths of the discourse. On the next day (Thursday) I returned to *Spanish-Town*, and had a considerable number of the coloured people to hear me in the evening, and some of the Bucks, whose attendance I could have excused. They were not near so noisy as they had been before. After sermon I plainly told them of our full determination of going forward, and of applying for justice to the legal powers of the country, if perseveringly insulted and abused. I also observed, that if no justice was to be found in *Jamaica*, we were sure of obtaining it completely at home. Early in the morning after preaching, I enlarged on the nature of our discipline as far as I thought it prudent to speak of it in so early a stage of the work, to about thirty attentive coloured people. Afterwards I bought some boards to be made into benches for the preaching house, and leaving Mr. *Werrill* behind me for the three following days, I returned to *Kingston*, my poor horse falling down with me on the way out of mere weakness. When I arrived, I desired that the two horses might run in some pasture for a month or two, and then be sold, the money to be applied for the supporting of the work in *Spanish-Town*.

On Sunday the 23rd, I held a Love-feast in *Kingston*, after morning preaching; and was highly satisfied with the testimony which many bore to the glory of the grace of God. The number in Society in this town is about one hundred and fifty: in the whole Circuit two hundred and thirty four: which is an increase of eighty-four since the last accounts I received before my arrival.

A little occurrence may perhaps be of use to some, if it be noted here. I tried an experiment on a poor negro, servant of my friend Mr. *Bull*, who was nearly blind, and had been declared incurable by two physicians. I got his hair shaved off on the crown of his

head, about the bigness of a crown-piece or more; and applied a poultice made of the yolk (only) of an egg, beat up with salt to a proper consistence, to the part that was shaved; on the second day another poultice was made in the same manner, and applied over the first: on the third day a third poultice was made as before, and applied over the other two: on the fourth day the whole was taken off, and the part dressed after the manner of a blister. And from this remedy in a few days, under the blessing of God, the negro recovered his sight.[17]

Mr. *Hammett* had two or three interviews before his illness, with a young *African* Prince, a son of the King of *Mundingo*.[18] This is the second tour which the young Prince has voluntarily taken with the Captain of the ship in which he sailed from *Africa*. He had lost a sister many years ago, who, as the family supposed, was stolen away: and to his great surprise he found her in *Kingston*. — She had been stolen as her family conjectured, and is now a member of our Society, as is her husband, who is a free black, and also a Leader of a Class, and an exhorter. The prince promised Mr. *Hammett* that he would send two Slaves from home, as the purchase of his sister, that she might return to her native country, and bring her husband along with her.

On the Sunday afternoon I went to *Port-Royal*, to be ready for the Brig, in which I had taken a passage for myself and Mr. *Hammett* to *Charleston*, and preached in the evening to a considerable congregation in the house of Mr. *Fishly*, the first friend I met with in *Jamaica*, on my former visit two years ago, who has been raised to the office of Master-Shipwright, the second in the harbour, from that of Master-Calker. There had been some persecution in this place, many of the outrageous in *Kingston* having agreed to assassinate Mr. *Hammett* here; but the Magistrates behaved with such spirit and intrepidity, that the persecutors were glad to hide their heads.

On Tuesday evening, the 25th of January, we went on board the Brig *Success*, *John Maziere*, Master, and sailed the next morning. Our Captain was at St. *Vincent's* when I was there, and for some

17. Coke's source for this remedy is unclear. Wesley's *Primitive Physick* gives no cures for blindness, but Wesley does prescribe a similar remedy for curing vertigo.

18. Probably the Mande kingdom on the Guinea coast in West Africa, which was also known as Mandinka.

time after I left it. He informed me that soon after my sailing for *Jamaica*, some rioters broke into our Chapel by night, injured the benches and other things, and afterwards seized on the Bible, took it to the public gallows, and hanged it on the gallows; where it was found hanging the next morning. The Magistrates of St. *Vincent's* very nobly advertised a hundred pounds reward for the discovery of any of the perpetrators of this audacious villainy. What a comfort it is, that Jesus Christ, the God of heaven and earth, is the King of the Church!

The day before I sailed, Mr. *Werrill* came from *Spanish-Town* to take leave of me; and brought me the reviving tidings, that for the three days he successively preached there, he had peaceable, attentive congregations of coloured people; and had begun to form a Class of Catechumens *among them.*

1791

Extracts of the Journals of the late Rev. Dr. Thomas Coke's Fourth Visit to North-America

Introduction

According to the journal of his third West Indian tour (above), Coke sailed from Port Royal, Jamaica, on 26 January 1791. After a lengthy and hazardous voyage, he and William Hammett landed on Edisto Island on 21 February and made their way north to Charleston just in time to meet the South Carolina preachers before their Conference dispersed. Leaving Hammett there (soon to prove himself a trouble-maker), Coke set out once more northwards.

Coke was at this time in a mood for reconciliation with the Episcopalians and, unknown to Asbury, had contacts with both Bishop William White of Philadelphia and Bishop Samuel Seabury of Connecticut. The news of Wesley's death, which reached him at Port Royal, Virginia, on 28 April, brought this attempted rapprochement and Coke's fourth American tour to a premature end. In any case, when he chanced to learn of it, Asbury gave the proposed reunion no support, and the window of opportunity was effectively closed. Understandably, once more, Coke's Journal *remains silent on the matter, though in due course news of the exchanges leaked out and Coke faced criticism from those on both sides of the Atlantic who had no desire for such a reconciliation.*[1]

1. For this whole incident, see Vickers, *Thomas Coke*, 176-91.

Coke meanwhile lost no time in finding a ship that would take him back to England and the first Conference following Wesley's death, in which he confidently expected to play a vital role.

Section 1

On the 27th of January, 1791, Mr. *Hammett* and myself sailed in a Brig from *Port-Royal* in *Jamaica* for *Charleston* in *South-Carolina*. In this voyage the hand of the Most High was wonderfully revealed in our behalf. O what an ample compensation for any danger is it to behold the gracious interference of our Almighty Friend!

Soon after we had doubled the Cape of St. *Anthony*, which is the most western point of the Island of *Cuba*, we ran in the night-time among a crowd of little Islands called the *Martyrs*, from the number of shipwrecks that have been made upon them. They lie south of *Florida*, the most northern of them being very near the Continent. They are very small: mostly, if not entirely uninhabited, and the whole group are about one hundred and forty miles in length, and about forty in breadth. A few months before, four or five vessels had been wrecked among these Islands.

In two days, or thereabouts, we were delivered from this imminent danger, and immediately ran into another. On the morning after we left the *Martyrs*, about day-light, the watch discovered that we were almost close to a steep rocky Coast on the Island of *Cuba*, not far from the *Havannah*. If the night had continued for about half an hour longer, we must, without a miracle, have been inevitably lost. When Mr. *Hammett* went on deck, he overheard a sailor saying to another concerning the ship, 'I don't know what was the matter last night; she would not go through the water in the manner we might expect from the wind which blew.'

The gulph of *Florida* in which we then were, is in one part contracted into a very narrow Channel, of fifteen leagues in breadth, by the *Martyrs* on one side and the *Bahama Islands* on the other. Immediately after we passed this strait, a violent gale sprang up, which obliged us to lie in a great measure at the mercy of the winds and waves for forty eight hours. If this gale had blown,

whilst we were in the narrow part of the gulph, we should have been in a very hazardous situation.

But, Sunday, the twenty-first of February, was our most tremendous day. We knew we could not be very far from *Charleston*, and yet were perfectly ignorant of our exact situation: indeed the Captain was totally unacquainted with the Coast. The morning was very foggy; and the Captain brought the Brig into four fathom water in order, he said, to discover the land, and find out our situation. About nine o'clock the vessel struck against a sandbank, but was got off. In half an hour more she struck three times against another bank, but was again cleared off. About ten she struck again, and fastened. From this time till noon she continued striking with such force, that we could hardly stand on the deck; and great pieces were broke off from the false keel, and seen awfully floating on the water. Now the land was clearly in view, about three miles from our Brig: and we heard with joy the command given that the boats should be hoisted out.

The small boat was first ready. But when the long-boat was let down, it was so very leaky, that they were soon obliged to draw it up again in order to calk it: which, as we were afterwards informed, employed them for several hours. However, to our great satisfaction the Captain ordered that four of the men should go on shore in the small boat to look for assistance; and my friend and myself gladly improved the opportunity.

As soon as we came to shore, Mr. *William Eding*, a gentleman for whom I shall ever retain a deep sense of gratitude, and who was taking a ride on the Beach, stood ready to receive us, as if sent there by Providence, (and no doubt but he was,) and brought us to his mother's house, (which was nearer to us than his own,) where we dined. The sailors being informed that the land which we had reached was called *Edisto-Island*, about fifty miles South of *Charleston*, and that no assistance could be given that day to the Brig, were obliged to return.

My friend *Hammett* lodged at the house of the benevolent Mr. *Eding*, and I at the house of Major *Jenkins* in the same neighbourhood. The Captain and crew left the Brig in the evening: and Mr. *Eding*, and his mother provided them all with lodging and every comfort, except the Captain, who could not be persuaded to leave the shore, but lay on the ground within sight of his vessel during the whole of the night.

It was but five or six days before, that a Brig was wrecked on the same bank; and another also in the course of the past year.

The *Methodists* never had visited *Edisto-Island:* nor had the inhabitants, though amounting to about five thousand (Whites and Blacks,) at that time any minister of any kind. But more hospitality, kindness and attention could not, I think have been shewn to any in like circumstances, than were shewn to us by some of the courteous, compassionate inhabitants of that little Island.

Our dear friend Mr. *Eding* furnished us the next day after dinner, with horses and a guide: and after crossing a ferry of a league in breadth, we lodged at the house of an old Gentleman who treated us with great hospitality. Soon after we entered his house, and told him our situation, he swore several times: but when we had reproved him with all possible softness, and he found we were Ministers, he almost tired us with apologies. On Tuesday night we lodged at the house of a Mr. *Grigg,* a great Indigo-Planter, where we met with most polite entertainment; and on the next day were conveyed in a large, half-covered boat, to *Charleston,* which was twenty-five miles from Mr. *Grigg's.*

The next week, my kind host *Major Jenkins,* brought in his boat to *Charleston,* all our things which we had left behind us in the Brig, a little towel only excepted. We were then informed that a violent gale of wind which rose the night after the Brig was deserted; instead of breaking her in pieces as was expected, drove her off the bank to sea: and in a day or two afterwards she was boarded by the crew of a small vessel, and brought by them into a safe place, which entitles them, by the Laws of the States, to a third part of the cargo.

Thus were we wonderfully delivered from impending danger. O none can conceive the awfulness of the situation in which we were on the sandbank, but those who have been in similar circumstances. And yet I must add to the glory of the grace of God, that I felt on this occasion an entire resignation to the Divine Will, whether it was for Life or Death.

'O that men would therefore praise the Lord for his goodness, and declare the wonders that he doeth for the children of men! That they would offer to him the sacrifice of thanksgiving, and tell out his works with gladness.'[2]

2. Cf. Psalm 107:21-22 (and n.b. the verses that follow).

We had been a whole month coming from *Jamaica* to *Charleston*, which was double the common time. In consequence of this, the Conference for *South-Carolina* had finished all their business when we arrived: but the Preachers had agreed to stay one day longer in the city in hopes of seeing me. I therefore had the pleasure of spending that day with them in many solemn and useful conversations.[3]

I now had the great pleasure of finding out a very able Missionary for *Edisto-Island*, Brother *Beverly Allen*.[4] If I can be the means of sending the gospel with power to the dear people of that Island, it will be a glorious compensation, and the only one I can make, for their many kindnesses to me, when I was a stranger and pilgrim among them.

During my stay at *Charleston*, a striking proof was given of the regard which is paid in this country to religious liberty. We employ a poor negro, a member of the society, to snuff out the candles in our Chapel: and a stranger from *North-Carolina* beat him unmercifully with a stick, because the poor black only desired him not to talk whilst the minister was preaching. The next day we applied for justice to the chief Magistrate, and got the rioter safely locked up in prison, where he remained when I left the city, as he was not able to give sufficient bail.

I had here the pleasure of performing a cure on one of our sister's eyes, which were exceedingly weak, by the recipe which is mentioned in the Journal of my late visit to *Jamaica*.[5] Before I left the city, her eyes were quite recovered.

3. This bland summary studiously ignores the divisive issue of the 'Council,' a short-lived body comprising the bishops and presiding elders that had been set up in 1789 to operate in the intervals between Conferences. James O'Kelly, who opposed this move, had written to both Wesley and Coke, and the latter had returned in 1791 determined to support O'Kelly, probably with a mandate from Wesley himself. Asbury was more explicit: 'Long-looked-for Doctor Coke came to town: he had been shipwrecked off Edisto Island. I found the Doctor's sentiments, with regard to the council, quite changed. James O'Kelly's letters had reached London. I felt perfectly calm, and acceded to a general conference, for the sake of peace' (*Journal*, 1:667-68).

4. If the editors of Asbury's *Journal* are correct at this point (*Journal*, 1:669n23), it is difficult to understand Coke's judgment and inexplicable that he should have let the sentence stand. On this occasion, as on others, Coke proved himself a poor judge of character. Beverley Allen had been ordained elder at the Christmas Conference and had proved an outstanding preacher. But he later gave Asbury much trouble, was expelled in 1792, and eventually fell foul of the law.

5. See pp. 149-50 above.

On the eighth of March I set off for *Giveham's Ferry* in my way to the *Georgia* Conference; Mr. *Asbury* and his company taking the road which leads to *Savannah*, and I and mine that which leads to *Augusta*. In the afternoon we lost our way, by consenting to follow one of our Preachers, who undertook to guide us through the woods a much shorter way than that which is commonly taken. Nine o'clock came, and we knew not where we were, except that we were in the midst of large Morasses. About ten the moon would set: and we agreed to make our abode for the night on some dry spot, if we could not before that time find out a hospitable shelter. But under the blessing and guidance of Providence we came again unexpectedly into the great road, and found ourselves near the house of our friend Mr. *Giveham*,[6] the light of which soon glistened delightfully in our eyes. When we entered the house, we found that our kind host had provided for us a roasted turkey, which was just taken off the spit. A congregation had waited for me a long time, and had broke up in despair of our coming. This is the fourth congregation I have disappointed, but not intentionally, in my life. O it grieves me much when hurt is done though undesignedly: for I am loth to deduct out of the very little good I have done in my life. But I want more faith: Lord help my unbelief.

March 9th. I have again entered into my romantic way of life. For there is something exceedingly pleasing in preaching daily to large congregations in immense forests. O what pains the people take to hear the gospel! But it is worthy of all pains. 11th I am now come among the peach trees, and they are in full bloom. Truly they assist a little, under the Supreme Source of Happiness, to make the heart gay.

It is one of my most delicate entertainments, to embrace every opportunity of ingulphing myself (if I may so express it) in the woods. I seem then to be detached from every thing but the quiet vegetable creation, and MY GOD. The Ticks indeed, which are innumerable, are a little troublesome: they burrow in the flesh, and raise pimples, which sometimes are quite alarming, and look like the effects of a very disagreeable disorder. But they are nothing when opposed to my affection for my Lord. Yea,

6. In Asbury's *Journal*, 'Givhan' (1:564, 592). He lived on the Edisto River west of Ridgeville in Dorchester County, SC.

> I'll carve thy passion on the bark;
> And every wounded Tree
> Shall drop, and bear some mystic mark
> That Jesus died for me.
> The Swains shall wonder, when they read
> Inscrib'd on all the Grove,
> That Heaven itself came down and bled
> To win a mortal's Love.[7]

On the 16th, our Conference for the State of *Georgia* begun.[8] On the Saturday evening, after the Sermon, whilst the Preachers were successively praying, a man fell down in a swoon. For some time he lifted up his hands, then his fingers only, and afterwards became perfectly senseless. But on a sudden he awoke and cried out 'Where art thou, Sinner: turn, turn, turn.' Then he burst out in a flood of praises and thanksgiving.

On the Sunday afternoon, having spent about three hours with the congregation, we left them almost universally employed in praying, praising or exhorting.

After a few days I left *Georgia*, I preached in the *Court-house* in a town called *Ninety-Six*.[9] Here I expected to find, from the information I had received, hardly any but scoffers and scorners. I enforced upon them those words of the Prophet *Jeremiah* (xlviii. 11) *Moab hath been at ease from his youth, and he hath settled on his lees, and hath not been emptied from vessel to vessel, neither hath he gone into captivity: therefore his taste remained in him, and his scent is not changed.* Instead of scorn I met with the deepest attention: and in the course of the Sermon almost every face was suffused with tears.

It is remarkable how many children have been baptized in this country by the Christian name of *Wesley*. I question whether there have not been some hundreds of instances in all the States.

On the 23rd of March we had three large rivers to cross.[10] But through the kind assistance of friends, who procured boats or canoes, we had but one to ford, which was very steep and rocky.

7. The editor of the 1791 *Journal* added a note that the poem was by 'Dr. Watts.' It is in fact 'Meditation in a Grove,' from *Horæ Lyricæ* (1706), where the first line of the stanza reads: 'I'll carve *our* passion on the bark.'

8. At Scott's meeting-house. Asbury wrote: 'We sat very closely to our work; and had some matters of moment to attend to in the course of our deliberations' (*Journal*, 1:670).

9. Ninety-six Town, east of Greenwood, SC.

10. According to Asbury, the Ennoree, the Tyger, and the Broad (*Journal*, 1:670).

We now made a visit to the *Catawba-Indians*. Their nation is reduced to a very small number, and chiefly live in a little town, which in *England* would be only called a village.[11] They possess a quantity of land, fifteen miles square, on the river *Catawba*. A very small part of this land they cultivate themselves: a much larger part they let out in long leases to the white people. They raised for us a little rude tent in one of their fields, where we preached. Most of them, I believe attended, though we had many more whites than *Indians*. Our plan is to erect a school among them, which we think the most probable way of doing them good in the first instance, as the generality of them understand nothing of the *English* language.

Their *General*, who is a tall, grave, old man, walked with a mighty staff in his hand. Round his neck he wore a narrow piece (I think) of leather, which hung down before, and was adorned with a great variety of bits of silver. He also had a silver breast-plate. Almost all the men and women wore silver nose-rings, hanging from the middle gristle of the nose; and some of them had little silver hearts hanging from the rings.

In general they dressed like the white people. But a few of the men were quite luxurious in their dress, even wearing ruffles, and very showy suits of clothes made of cotton. The little money they save by their small plantations (for they are not fond of labour) they lay out, I suppose, in purchasing these things of the whites. Their houses are not uncomfortable—far superior to the mud-houses in which the poorest of the people in Ireland dwell; though we could not procure a single table from one of their habitations, to stand upon whilst we were preaching: but chairs they had in abundance.

One of their chief men, who spoke the *English* language, came to Mr. *Asbury* and me, before we began to preach, desiring us in the name of his Nation to intreat the Whites to assist them against some *Indians*, who, they had reason to believe, were at that time lurking in the neighbouring woods in order to destroy them.

We found on inquiry that parties of *Indians* from a distant nation, whose inveteracy against this little handful of people is not to be erased, have made frequent incursions upon them, and have been too successful in their devastations. We therefore spoke in behalf of

11. In York County, SC (Asbury, *Journal*, 1:670n).

this poor little nation, as far as prudence would justify on so delicate a subject.

A little time ago (we were informed,) one of the *Indian* girls of this little town with whom a gentleman not far distant had been criminally intimate, carried her child to him, informing him he was the father. The gentleman would by no means allow he had ever seen her: on which she took her child by the heels and dashed its brains out before his face, and left it on the ground. O that the Lord would look down with pity on that miserable people, and open a Gospel-door among them!

On the 30th of March I met a Preacher whose name is *Cowles*.[12] Six years ago he lived with his mother near *Williamsburg* in *Virginia*. None of the family were converted, or acquainted with the *Methodists* at that time. In the course of my Tour through the States in the year 1785, I called at their house for some reasons which I have forgot. Before I parted with them, I made them a present of the extract of Mr. *Law's* treatise on the nature and design of *Christianity*,[13] which is printed among us. By means of this little tract they were so stirred up to seek the Lord, that now the mother, the Preacher, six children who are married, and their husbands and wives, fourteen in all, are converted, and have joined our society. Indeed, the young Preacher is a flame of fire. How blessed an employment it is to be sowing the divine seed every where—to be instant in season and out of season! O how willing the Lord is to be gracious!

Alas; What a feeble mortal am I! The little Ticks have quite overcome me. They have bit my body in such a manner, that I am afraid to walk out into the woods, notwithstanding my almost excessive love of retirement.

April 2. We began our Conference for *North-Carolina* at the house of Brother *M'Knight* on the river *Yeadkin*.[14] There were in all about thirty Preachers, several of whom came from the other side of the *Appalachian* mountains.

At this Conference, a remarkable spirit of prayer was poured

12. Samuel Cowles, whose mother is mentioned in Asbury's *Journal* on 14 November 1795 (2:67).

13. An abridgement of the first chapter of William Law's *Practical Treatise upon Christian Perfection*, which Wesley had first published as early as 1740.

14. Cf. Asbury's *Journal*, 1:671. The location of this conference was somewhere between Salisbury and Salem, NC.

forth on the Preachers. Every night, before we concluded, heaven itself seemed to be opened to our believing souls. One of the Preachers was so blessed in the course of our prayers that he was constrained to cry, 'O I never was so happy in all my life before! O what a heaven of heavens I feel.'

At each of our Conferences, before we parted, every Preacher gave an account of his experience from the first strivings of the Spirit of God, as far as he could remember; and also of his call to preach, and the success the Lord had given to his labours. It was quite new, but was made a blessing I am persuaded, to us all.

On Monday, the 11th of April, we arrived at *Dicke's Ferry* in *Virginia*.[15] Our ride on that day was remarkably pleasing. The variety arising from the intermixture of woods and plantations along the sides of the broad, rocky river *Dan*, near which we rode most part of the time, could not but be a source of great pleasure to an admirer of the beauties of nature. Indeed, all was delightful, except the sight of a great, cruel hawk, who was devouring a little squirrel on a rock.

April 15th. Hitherto I might be said to have travelled with the spring. As I moved from South to North, the spring was, I think, as far advanced when I was in *Georgia*, as when I came into *Virginia*. But now it has evidently got the start of me. The oaks have spread out their leaves: and the *dogwood*, whose bark is very medicinal, and whose innumerable white flowers form one of the finest ornaments of the forests, is in full blossom. The *deep-green* of the pines, the bright *transparent-green* of the oaks, and the *fine white* of the flowers of the *dogwood*, with other trees and shrubs, form such a complication of beauties, as are indescribable to those who have only lived in countries that are almost entirely cultivated.

For about eight hundred miles which I have rode since I landed in *South Carolina*, we have had hardly any rain. But this day, the 16th, we were wetted to the skin. However, we at last happily found our way to the house of a friend by the Preacher's mark—*the split bush*.

This circumstance may appear to many immaterial: however as it may convey some idea of the mode in which the Preachers are obliged to travel in this country, I will just enlarge upon it. When a new Circuit is formed in these immense forests, the Preacher,

15. Asbury's *Journal* (15 April 1787) indicates that this was on the North Carolina border.

whenever he comes in the first instance to a junction of several roads or paths, splits two or three of the bushes that lie on the side of the right path, that the Preachers who follow him may find out their way with ease. In one of the Circuits the wicked discovered the secret and split bushes in the wrong places on purpose to deceive the Preachers.

On the 20th of April we opened our Conference at *Petersburg* in *Virginia,* at which about thirty Preachers were present. Whilst I was preaching one day during the Conference on 1 *John* v. 12. *He that hath the Son, hath life.* A refreshing shower of grace did indeed descend on the congregation. It was a time much to be remembered.

At this Conference, a zealous lively young man (*Samuel Rudder*) offered himself as a Missionary for the *West-Indies,* and was accepted.[16]

On the Lord's-day, April 24th. I preached in *Richmond,* in the *Capitol* where the Assembly sits to the most dressy congregation I ever saw in *America.* However they give great attention whilst I spoke for an hour to *the Deists, Socinians,* and *Arians.*

In the afternoon I rode to Colonel *Clayton's,*[17] about twenty-five miles from *Richmond,* where we held another Conference with seventeen Preachers. *The York-river,* and the large plantations, woods, &c. round the Colonel's house form a very beautiful situation. Nor was that of Dr. *Shore* with whom I dined, after preaching on the 26th, less beautiful or romantic.

April 27th. I lay at the house of brother *Pope*[18] after preaching in the neighbourhood. A little before bed-time some *Phenomena* in the heavens attracted our attention for a considerable time. Three great lights were observed at the same time at the edge of the horizon, one in the East, another in the South, and another in the North. Each of them appeared as if several houses were on fire. That in the South, was abundantly the largest and brightest.

April 28th.[19] I am now come among the *Cedar-trees.* They are not

16. There is no trace of Rudder in the stations in the British Minutes at this period.

17. In Hanover County, VA. Asbury says that the Conference was held not at the Colonel's, but at the house of his son, because the Colonel was ill (*Journal,* 1:672).

18. Pope's (Chapel?) in Caroline County, VA, appears a number of times in Asbury's *Journal.* Whether this refers to the Henry Pope who appears in Georgia later in the *Journal* is not clear. There was also a Pope's Chapel in North Carolina.

19. Incorrectly printed as '20th' in the original.

large, but their spreading boughs, and their conical appearance are very grand.

This evening we arrived at *Port-royal* in *Virginia*, where a numerous and very dressy congregation had been waiting for us about two hours with wonderful patience. The Preachers had overloaded us this day with labour. The congregations to which we preached, were situated too far from each other. Besides, we were not fully acquainted with the distance, otherwise Mr. *Asbury* and I might have separated, and taken each of us singly a congregation in due time.

However, the congregation at *Port-royal*, notwithstanding they had waited so long, were as still as night whilst we preached to them on Col.iii.3,4. *Ye are dead, and your life is hid with Christ in God. When Christ who is our life shall appear, then shall ye also appear with him in glory.* The people by this time had been so long in the preaching house, that we thought it best they should be discharged. Otherwise, we generally gave the congregation two sermons, and perhaps an exhortation or two besides, if we did not administer the Lord's supper.

After preaching I received messages from two or three of the Ladies, intreating they might have a sermon in the morning. But when we considered we were engaged to preach about ten or twelve miles off at ten o'clock, and had a broad *Ferry* to cross, where we might be detained for an hour or two, we thought it our duty courteously to refuse. But alas! alas! here ended all my plans for the good of the people during my present visit on the *Continent*.

A gentleman of the name of *Hipkins*, a capital merchant in the town, sent us a genteel invitation to sup with him, and lodge at his house. I accepted of it. Soon after I came in, he observed that the *Philadelphia* Paper had informed the public of the death of Mr. *Wesley*. I gave no credit to the account, but, however, intreated the favour of seeing the paper. He sent immediately to a neighbouring merchant who took in that paper; and about ten o'clock the melancholy record arrived. I evidently saw by the account, that it was too true—that I had lost my friend, and that the world had lost a burning and a shining light.[20]

The next morning I set off for *New-York*, in order to be in time for

20. Asbury says, 'Brother Coke was sunk in spirit, and wished to hasten home immediately. . . . Dr. Coke, accompanied by brother Cox and Dr. Glendenning set out for Baltimore in order to get the most speedy passage to England' (*Journal*, 1:673).

the British Packet. I rode by day and by night. At *Alexandria* the news was confirmed by a letter from *London*. For near a day I was not able to weep; but afterwards some refreshing tears gave me almost inexpressible ease.

On the 29th, I crossed the run of water called *Akatinke,* down which I was carried by the flood on the awful never to be forgotten, ninth of March 1785.[21] How did my heart rise up in gratitude to my God! O how often and how wonderfully has he preserved his sinful child!

This day I passed over the noble river *Potomawk.* The *Locust-tree*[22] grows in great abundance in this part of the country. The blossoms, I think, are a little similar to what is sometimes called in *England* the *Golden-Chain:* only they are white. The fruit grows in the shape of pods from twelve to eighteen inches long, and an inch and a half broad, and is very sweet. It probably is the same as that which is mentioned in scripture as the food of *John* the Baptist.

We were now come into a country abounding with singing-birds. But alas! I could take but little pleasure in them. I felt indeed much communion with God: and yet, the death of my venerable Friend had cast such a shade of melancholy over my mind, and consequently in appearance over everything else, that I could find very little pleasure in the contemplation of the works of nature.

The night being very dark, it was with great difficulty that my friend *Cox* who travelled with me, and myself, found our way through the woods from *Alexandria* to *Blaidensburg.*

Arriving in the town of *Blaidensburg* very late, we did not chuse to disturb our friends, and therefore set up at an Inn, where the kind landlady did every thing that true benevolence could suggest for our comfort and convenience, gratis.

On Sunday, the first of May, we arrived in *Baltimore* in the afternoon, time enough to send to the Preacher, who was then engaged in divine service, to publish me to preach in the evening. The congregation was very large: and I had but one subject, and I may almost say, but one text, *And Elisha saw it, and he cried, my Father, my Father, the chariot of Israel and the horsemen thereof* (2 *Kings* ii. 12.).[23]

21. The editor of the 1791 *Journal* added a note: 'See the Doctor's first Journal' (i.e., p. 47 in this edition).

22. *Robinia pseudacacia* or 'false acacia.'

23. 'At Alexandria Dr. Coke had certain information of Mr. Wesley's death. On Sabbath day he reached Baltimore, and preached on the occasion of Mr. Wesley's death; and mentioned some things which gave offence' (Asbury, *Journal,* 1:673).

As the Packet was not to sail from *New-York* till Thursday, I felt some confidence that I should be there in time, having the opportunity of travelling in the mail stages all the way. (The business of the Post-office is conducted in this country on a plan similar to that in *England*.) But such was not the will of Providence!

At four on Monday morning we set off in the stage. During the whole day I felt some rheumatic pains, probably from having rode so much in the damps of the night. At the head of the *Elke* where we lay, I was called at two o'clock on Tuesday-morning to prepare for the coach: but, behold, I was almost immoveable. I was struck with a sciatic, and lay fixed, as it were to my bed. After many struggles to rise, I let the stage depart without me.

About ten in the morning a Physician was sent for, who gave me a purge and an ointment, and in the afternoon I found myself well.

Still I was within the possibility of reaching *New-York*, time enough for the Packet. And hearing that there was one carriage in the town, a Phaeton, the property of a gentleman; I wrote to him the best letter I was able to draw up, intreating him to lend me his carriage as far as *Wilmington*, which was twenty-two miles distant.

The gentleman soon afterwards called upon me, and told me I should have been perfectly welcome to his carriage, but one of the horses (I think he said) was ill. The other, he observed, was a very fine pacer, and was at my service either to *Wilmington*, or a stage beyond it. I mounted as soon as possible, without hesitation; and arrived at the house of a friend in *Wilmington* about an hour after night.

By this time I began to feel my rheumatic pain returning, and went to bed as soon as the family could provide one for me.

In the morning I was almost as stiff as the day before. A physician was again sent for, who laid his commands upon me, not to move from that town for one day at least. I now clearly saw that the Packet would sail without me.

On Wednesday, the 4th. I set off in the stage for *Philadelphia*. When I arrived there, I found that no ship would sail from thence for any of the three kingdoms for several days, or from *New-York* for a longer time. I therefore rested myself contentedly in *Philadelphia* for nine days, and did what little good was in my power under the grace of God in that populous city, preaching almost every evening, and sometimes in the morning, and three

times on the Lord's day. Our society in this place paid a pleasing mark of respect to the memory of our deceased Father in the gospel, by covering the pulpits of the two Chapels with black cloth. The same proof of regard for our much beloved friend had already been given by our society in *New-York*.

On Saturday, the 14th of May, I set off for *Newcastle*[24] in the state of *Delaware*, accompanied by several of my friends, to take shipping in the *William-Penn* bound for *London*. That next day I preached at *Wilmington* in the afternoon, and at *Newcastle* in the evening; and lodged at the house of my kind friends Mr. and Mrs. *Bond*,[25] late of *Lambeth* in *Westminster*.

The next morning Mr. *Asbury* and some of the Preachers who were on their way to *Philadelphia*, and who had received a letter from me informing them of my route, came round to *Newcastle* to take their leave of me: and in the afternoon I embarked.

24. New Castle, a shipping centre south of Wilmington on the Delaware River.
25. Probably the John Bond mentioned in Asbury's *Journal* on 19 September 1790 (1:650) and 11 September 1793 (1:770). See further p. 173 (30 Oct. 1792) below.

1792–93

Extracts of the Journals of the late Rev. Dr. Thomas Coke's Fifth Visit to North America and the West Indies

Introduction

Having hurried back to England on hearing the news of Wesley's death, Coke was back in America before the end of the following year. But this fifth visit was to be a short one, motivated by his determination to be present at the General Conference called for November 1792 in Baltimore. Asbury had agreed that the question of relations with the Episcopalians should be considered at this Conference. But by then any opportunity for a reconciliation between the two Churches had receded, and more attention seems to have been given to the problems raised by James O'Kelly's challenge to Asbury's authority, especially in the stationing of the preachers. Coke presided in the absence of Asbury, who was unwell. He preached a Conference sermon on the witness of the Spirit and managed to prepare a new edition of the Discipline *before embarking at New York for the West Indies.*

This was to be Coke's fourth and last tour of the West Indian islands. His companion, William Black, had been a pioneer of Methodism in Nova Scotia and was ordained by Coke in 1789 as superintendent of the work there. Coke's intention now was to put him in charge of the Caribbean missions. On their tour they found that persecution had broken out on St. Eustatius and also on St. Vincent, where Matthew Lumb was

languishing in prison for preaching without a licence. Coke's reaction to these set-backs and the suffering of the Negro members of society was very far from any conventional resignation to the divine will! (See below, p. 178 below.)

Missionaries stationed in Grenada, Dominica, and Jamaica had succumbed to the tropical climate of the islands, and much of Coke's time and efforts during the rest of his life was devoted to finding and supporting new volunteers for the mission field that he was never again to revisit but that remained closest to his heart.

Section I below, describing the outward voyage, was written as a letter to the itinerant William Thompson and headed 'On board the Pigou, *near the Delaware Bay. October 28, 1792'. It and the remainder of this journal were first published in the* Arminian Magazine *in 1793–94 and in the collected edition of his* Journals *in the same year.*

Section I

On the first of September, 1792, we went on board at *Gravesend*, and next day set sail. Our company in the cabin were, the Captain; who is an amiable man, and I believe fears God; the Mate, an agreeable, sensible man; my friend Mr. *Graham*,[1] the Missionary for the *West-Indies*, and a few others. About nineteen sailors with sixteen steerage-passengers, made up the rest of the ship's company. One pleasing circumstance was, that the Captain *first* desired to have prayers in the ship. My birth, (as they call it) or state-room, is large and convenient: here, I trust, I shall hold much sweet communion with God during the voyage.

We have been long delayed (thirteen days) in the Channel, I now doubt whether the chief end of my voyage, viz. to be at the general Conference in *Baltimore*, on the 1st of November, will not be defeated. But the Lord knows what is best. O that my will may be swallowed up in his!

About the time of our leaving the *English* channel, the Captain of a *French* Brig from the *West-Indies* took great pains to come up with us, in order to inquire what longitude we were in. After receiving

1. Daniel Graham, an Irish itinerant since 1788, was stationed in Barbados, but died of yellow fever within months of commencing work there (cf. Taggart, 'Irish Factor,' 73).

the information he wanted he left us. But while he was still within hearing, our Mate cried out in *French*, 'The King is a prisoner; and all the *Swiss* Guards are killed!' The *Frenchman* turned his ship about, and made after us with all expedition. Our Captain seeing this, backened his sails, and gave opportunity to the vessel to overtake us; when the *French* Captain received full information concerning the state of *France*, which he heard with all the eagerness that can well be conceived. He then began to leave us, but as if recollecting something he had forgot, turned again to our surprise, and asked us with all the courtesy of a *Frenchman*, 'Whether he could be so happy as to supply us with anything his ship afforded;' though he had been at sea about seven weeks, and we only a fortnight.

Sept. 23. My poor dear friend Mr. *Graham* is exceedingly ill, as indeed he has been ever since we first sailed. But now he looks just like a corpse; and complains of excruciating pains in his bowels: he can hardly sit or lie down, and he stands and walks almost double. I am afraid he will die during the voyage. Lord, save his life, if it be only on account of the poor negroes! I find a ship a most convenient place for study: though it is sometimes great exercise to my feet, legs and arms, to keep myself steady to write. From the time I rise till bed-time, except during meals, I have the cabin-table to myself, and work at it incessantly.[2] I never was accustomed to dream much till now; but I seem to be at my pleasing work even whilst I sleep. I have six Canary-birds over my head, which sing most delightfully. Surely they have been brought here by the kind hand of Providence, in order to entertain me whilst I am labouring for my Lord.

Sept. 28. Brother *Graham*, blessed be God, is now recovered. I really was afraid we should have lost him. He had quite given himself up, and thought of nothing but going to heaven immediately. One particular pleases me much: I have observed that the Captain enters into his private log-book (or account-book) our several times of holding public worship: I am therefore in hopes that the owners of his ship are pious men. For some time past I had given up all hopes of being at the general Conference; and found much profit in the exercise of resignation. But now an easterly breeze springs up, which affords me some glimmering hope.

2. He was beginning work on his *Commentary on the Holy Bible*, as requested by the recent British Conference.

Oct. 6. We had this evening the most beautiful sun-set I ever saw, such as a land-view I apprehend could not possibly give. A great cloud, like a mountain of flaming fire, stood apparently upon and above the sun. Just above this cloud, or mountain of fire, was a smaller one, equally splendid, exactly in the shape of a crown; and the horizon to the right and left, for an immense way seemed all on fire. Some of the common men came to the head of the ship to view this singular phenomenon, and confessed, that as many years as they had been at sea, they never saw such a setting sun. But when we can view God in all things, these scenes are very pleasing.

Oct. 8. One of the Canary-birds, through the neglect of the steward, died for want of food. I was really sorry, that the innocent creature, which had often entertained me, should suffer so miserable a death, for want of sacrificing three minutes in the day, to examine the cages. For though none of the birds are mine, I possess as much property in their music as any one. The little creature sung almost incessantly the morning preceding its death, hoping, I suppose, to gain our attention, and induce us to fill its seed-box. A misfortune of this kind may seem ridiculous to many on land: but to those who are surrounded with an immense ocean, the loss of a favourite bird is great; and their feelings will, at least, be excused by ingenious minds.

Oct. 9. On a sudden the weather is changed from very fair, to rainy, dark and gloomy. What a comfort it is to be able to retire into God at all times, in all places, and in all weathers! This is my birthday.[3] I am now forty-five. Let me take a view of my past life. What is the sum of all? What have I done? And what am I? I have done nothing; no, nothing; and I am a sinner! God be merciful to me!

Oct. 13. Now there is a change of wind in our favour: and a possibility that I shall gain the desired port in time; but nevertheless, Father, not my will, but thine be done.

Oct. 20. I renewed my Covenant with God this morning, in as solemn and happy a temper as ever I experienced; my first espousals to God not excepted.

Oct. 21. The comfortable frame of mind I experienced yesterday still continues. How kind is our Lord, in giving his children such heavenly cordials in the course of their pilgrimage.

3. Coke was baptized on 5 October 1747. The apparent discrepancy is accounted for by the change of calendar in 1752, by which 28 September (OS) became 9 October (NS).

Oct. 28. I am afraid we have done but little good to our congregation. One of the steerage passengers has been a member of our society in *Sheffield,* and all the ship's crew say, that man is certainly a Christian! The mate also is under some degree of conviction, and will even shed tears when he is sometimes conversing with Mr. *Graham* on religious subjects. Another of the steerage passengers, whose name is *Flint,* has written me a very pleasing letter of thanks for my ministerial labours, and expresses himself as truly concerned for his soul.

A pilot is just come on board, and in all probability, I shall be in *Baltimore* in time! The Lord does all things well: glory, and honour, be ascribed to him for ever!

Section II

On Tuesday, October 30th, 1792, I landed at *Newcastle,* in the State of *Delaware,* leaving my friend Mr. *Graham* to go up to *Philadelphia* in the ship, as he was desirous of visiting his brother, who had resided in *Lancaster-county, Pennsylvania,* for many years. I immediately proceeded to visit Mr. and Mrs. *Bond,* formerly of our society in *Lambeth-Marsh, London,* but now residing on a large plantation within half a mile of *Newcastle.* I had seventy miles to ride in the space of a day and a few hours, in order to be in time for the general Conference in *Baltimore.* Mr. *Lee,* however, son-in-law to Mrs. *Bond,* most kindly relieved me in my distress, by lending me his one-horse-chaise, and one of his servants to drive me. I am quite astonished at the never-failing and complete provision, which the Lord makes for me under every difficulty. O why is not my soul filled with gratitude: O why do I not rejoice continually with joy unspeakable and full of glory, when I have such an almighty Friend always to accompany me, always to assist me!

In the evening I lay at a town called the *Head-of-Elk,*[4] sixteen miles from *Newcastle,* and the next morning set off by moon-light for *Baltimore.* About noon our chaise-horse began to fail; but stopping to dine at a little village called *the Bush,* I providentially met

4. Elkton, Delaware; perhaps at Hollingsworth's Tavern (Asbury, *Journal,* 1:49n).

with an old acquaintance, Mr. *Richard Dallam*,[5] who with the utmost readiness changed chaise-horses with me, which placed us in a condition, with the help of God, to reach *Baltimore* by night. About seven in the evening, it being quite dark, our carriage was overturned by the stump of a tree. I received very little injury, but the servant hurt his collar-bone, and head. We were not able to raise up the chaise and horse, but Providence brought a person to the spot at the very time, with whose assistance we set the carriage right. How astonishing is the loving kindness of my God; how innumerable are the dangers seen and unseen, from which he is continually delivering me.

> O how shall words with equal warmth,
> The gratitude declare,
> That glows within my ravish'd heart:
> But thou canst read it there.[6]

About nine o'clock, Wednesday night, Oct. 31. I arrived at the house of my friend Mr. *Philip Rogers* of *Baltimore*;[7] just time enough to take some refreshment, and a little sleep, before the General Conference commenced.[8] Mr. *Asbury* and the Preachers who were at Mr. *Rogers'*, were surprized to see me at that critical moment. They had almost given me up, but intended to spend ten days in debating matters of the smallest importance, in prayer, and in declaring their experiences, before they entered on the weightier business, if I did not sooner arrive.

We continued our conference for fifteen days. I had always entertained very high ideas of the piety and zeal of the American Preachers, and of the considerable abilities of many: but I had no expectation, I confess, that the debates would be carried on in so

5. See p. 41 etc. above.

6. Stanza 2 of a hymn published by Joseph Addison in *The Spectator*, no. 453 (9 August 1712) that begins 'When all thy mercies, O my God.'

7. Rogers was a leading member of the Baltimore society and a trustee of Cokesbury College.

8. This met at Light Street Church and was the first quadrennial General Conference, replacing the short-lived 'Council' (see p. 157 n. 3 above). The main cause of contention was a proposal by James O'Kelly that preachers should have a right of appeal against their appointment to a given circuit. (See Bucke, *History of American Methodism*, 1:435-40.) Asbury's account reads: 'We had heavy debates on the first, second, and third sections of our form of discipline. My power to station the preachers without an appeal was much debated, but finally carried by a very large majority. Perhaps a new bishop, new conference, and new laws would have better pleased some' (*Journal*, 1:733-34).

very masterly a manner; so that on every question of importance, the subject seemed to be considered in every possible light.

Throughout the whole of the debates, they considered themselves as the servants of the people, and therefore never lost sight of them on any question. Indeed, the single eye, and spirit of humility, which were manifested by the Preachers throughout the whole of the Conference, were extremely pleasing, and afforded a comfortable prospect of the increase of the work of God throughout the Continent.

They determined that the next General Conference shall be held on the 1st November, 1796: and that in the mean time the Districts respectively shall hold annual Conferences.

On Thursday the 15th, after the Conference finally broke up, I preached on James i. 27. 'Pure religion and undefiled before God and the Father is this, to visit the fatherless and widows in their affliction, and to keep himself unspotted from the world.' A solemn awe rested upon the congregation; the meeting was continued till about midnight, and twelve persons, we have reason to believe, were then adopted into the family of God. This was a glorious conclusion: a gracious seal from heaven to our proceedings.

Next day I set off for our College, which is about twenty-five miles from *Baltimore*. Here I spent three days in examining the students, &c. and the progress of many of them pleased me much, especially those who studied the different branches of the Mathematics. Dr. *Hall*, our President, and the three Tutors, do honour to the Institution. We have now upwards of seventy Students, great and small, fourteen of whom are upon the foundation. Many from the Southern States are sending their young men there, to finish their education. Some principal persons of the State of *Maryland* have informed us, that the Legislature is willing to incorporate the College, and to authorize us to confer degrees under due limitations. But perhaps it may be best for us to go on in our present little way. The Students are divided into Classes, and are regularly met by our Elders in their course; and such inquiries are made, and advices given, as are most likely to profit them. Indeed, the fear of God seems to pervade the whole College.

On Tuesday the 20th, I arrived in *Philadelphia,* and spent eight days with that loving people. They are but a small Society for so large a city. The whole amount of the number does not, I think,

exceed 300: but they are in general a solid and established people in the grace of God. Here I prepared a new Edition of our form of Discipline, with all the regulations, made at the Conference.[9]

On Thursday, the 29th, I preached in the Church of Mr. *Ogden*[10] of *Newark, New Jersey*, a truly pious Clergyman of the Church of England, whom I have spoken of in my former Journals; and on the next day reached *New-York*. In the afternoon I had a deliverance never to be forgotten. I went to the Wharfs, to look out for a convenient vessel to carry me to the *West-Indies*, and in ascending the side of a Brig, my foot slipt. I alighted on something at the edge of the water, which supported me; and with the assistance of those who were near, was raised on board. But when I looked back on the situation in which I had been a few moments before, it was most awful. A pole had been tied to the side of the Brig, to preserve it from being damaged by striking against the Wharf. This pole received me in my fall, otherwise in a second or two I must unavoidably have been crushed between the Brig and the Wharf. Six times, I have been in the very jaws of death, upon or near the water, and yet am still preserved *a monument of mercy in every respect!*

Being detained in this City for twelve days, I was able to perform my engagement to the General Conference, by preparing for the Press a Sermon, which I had preached before them, on Rom. viii. 16. 'The Spirit itself beareth witness with our spirit, that we are the children of God.'[11] In the course of near twenty Sermons which I preached here, my ministry was much blessed in the establishment of believers. How the Lord delights to use the foolish things of the world for his glory! Some also were awakened: and some, I believe, were justified. In meeting the Select Society,[12] I was much

9. *The Doctrines and Discipline of the Methodist Episcopal Church in America. Revised and Approved at the General Conference Held in Baltimore . . . in November 1792* (Philadelphia: Parry Hall, 1792).

10. See p. 90 above.

11. *A Sermon on the Witness of the Spirit. Preached at Baltimore . . . On Sunday, November 4th 1792 . . . Published at the Request of the Conference* (Philadelphia: John Dickens, 1793).

12. In some of the larger societies Wesley organized smaller groups known as 'bands' and in some cases even more exclusive groups known as 'select societies.' The term first appears in the Minutes of the 1744 Conference. The main requirement was evidence of growth in grace. Wesley looked to them as 'a select company to whom I might unbosom myself on all occasions without reserve' (*Plain Account of the People Called Methodists*, §VIII.2). References to their existence in American Methodism are sparse. But Henry Carter, the Methodist smuggler, refers to the 'select bands' in the New York society in 1790 as being composed of 'those that were sanctified, and those believers that were pressing hard after it' (*Autobiography* [1894], p. 43).

satisfied indeed. But I had one doubt on my mind, which I was very desirous of having resolved. The Society in this City, before the war, consisted of about 200 members: it now consists of about 600; and very few of the present Society, were members of the former. I was therefore very desirous to know in which of the two Societies religion flourished most. Mr. *Staples*,[13] a native of *Germany*, who has been a Leader in our Society at *New York* for about twenty years, and is one of the most excellent men upon earth, gave me full satisfaction. He assured me, that he had not the shadow of a doubt, but *in proportion to the numbers,* there is incomparably more genuine religion in the present Society, than there was in that which subsisted before the war: and every one that knows Mr. *Staples,* will acknowledge him a proper judge. There are few things more delight me, than satisfactory proofs *of the increase of Religion.*

On the 12th of December, we sailed from *New York* in the Brig Friendship, and on the 31st arrived at *St. Eustatius* in the *West Indies.* Never before was I so long a time in the midst of dirt and filth. My situation was exceedingly nasty: but by the force of custom, I felt myself tempted to become a contented *Hottentot.* Mr. *Black,*[14] our Presiding-Elder in the Provinces of *Nova-Scotia* and *New-Brunswick,* accompanied me, which was some consolation to me in my voyage: but what was infinitely more, the consolations of God did sometimes superabound. Several times, when lying upon my bed, I felt such extraordinary assurance of the love of God, and his care for me, as enabled me to rejoice and triumph in him, and sweetly to retire into him as my blessed Asylum and my only Home. At the same time I saw and felt such infinite defects in myself, such want of entire purity, and such a sweet kind of sorrowing before God, as far exceeded any thing of the kind I had ever experienced. Filthy as the place was, the captain, supercargo,[15] mate, and a passenger going to *Santa Cruz,* were very

13. John Staples.
14. William Black (1760–1834), known as 'the apostle of Nova Scotia Methodism.' His family had emigrated from Yorkshire ca. 1775. Converted in 1779, he initiated the first Methodist class meeting and preaching services in the territory. He may have been present at the Christmas Conference in 1784 and was ordained by Coke as superintendent for Nova Scotia at the Philadelphia Conference in May 1789. At that time Coke planned to put him in charge of the West India mission, but he was soon back in Nova Scotia. He remained in the active ministry until 1812.
15. The officer in charge of the cargo in a merchant ship.

good-natured, and hardly ever swore. Besides, I had my papers, and pen and ink, and was enabled to collect a large quantity of materials for the Magazine.

Immediately on our arrival at *St. Eustatius,* we waited on the Governor (Mr. *Rennolds,*) who filled that place during the former persecutions. He received us with his usual acrimony, and seemed, and spoke, as if he was determined to pull down the work of God. The Island belongs to the *West-India* Company of *Holland.* During a vacancy in the Government, the Burgesses of the Island have a right to elect a Governor *ad interim* (during the interval.) Mr. *Rennolds* was formerly Governor, and is so now, in this capacity. The Governor sent from *Holland,* who was mentioned in my last *West-India* Journal, was a rough, rude man, and would not suffer us to preach: however the little society had peace. But as soon as this man was re-elected on the removal of the other, the flames of persecution were kindled afresh. The poor slaves, from one end of the Island to the other, who met together to sing and pray, and converse of the things of God, (the only method they had, in which to hold Divine worship) were cart-whipped, and many of them imprisoned. The consequence has been, that the precious Society we had here, is almost dispersed. About half a dozen little classes meet in corners: and, yet, there is not a single Minister *of any kind* in the Island! What a mystery! that the Great Governor of the Church should suffer it! my grieved, bleeding heart says (I fear with some reluctance) 'thy will be done.' But it also says, with all its powers, 'How long, O Lord, holy and true, dost thou not avenge our blood!'[16] And he will avenge it! He will turn the world upside down, before he will not avenge it! And his church shall have peace, yea, even in this persecuting Island!

I would just add a few remarks on the heroic conduct of two negro women, who were ordered among others to the whipping-post, for being PRESENT at a METHODIST PRAYER-MEETING. Whilst they remained under the severe lashes of the common executioner, and great furrows were made in their bleeding backs, and for some time afterwards, they triumphed in persecution, and in the honour they received by suffering in their Redeemer's cause, in a manner which astonished the numerous spectators. They assured the multitude, in their negro dialect, that they prized the

16. Cf. Revelation 6:10.

torments which they then endured above all the gold and silver in the world: in short, they gave such indubitable proofs of the genuine power of Religion, of patient suffering, and triumphant faith, that some principal Gentlemen of the Island who were present on the occasion, acknowledged it was a thousand pities that those two negroes should suffer at all. But nothing could touch the heart of Governor *Rennolds*. I am persuaded, that there is nothing but the power and the opportunity wanting, to make him as cruel a persecutor as any in the primitive times of Christianity.[17]

On Wednesday the 2nd of January [1793], I sailed for the Island of St. *Christopher's*, in a most miserable Schooner, and arrived there the next day; when I was immediately informed by Mr. *Warrenner*, that a dreadful persecution had arisen in St. *Vincent's*, and that Mr. *Lumb* was at that time in the common prison of the Island, for preaching the Gospel. I set off therefore in a Sloop (a passage boat) which sailed in the afternoon for St. *Vincent's* in order to comfort my suffering brother, and to inquire into the cause of this extraordinary event.

About ten at night, we arrived in the Bay of *Charleston*, near the Island of *Nevis*. As we came to anchor my disagreeable company and situation induced me to go on shore. But my kind friend Mr. *Ward*, the Judge of the Court of Admiralty, being gone to bed, I lay at an Inn, in a room adjoining a Billiard-table; where the blaspheming, dissolute, reprobate Billiard-players, kept me awake till about two in the morning. What a comfort it is to be removed out of the reach of all connexion with such wretched beings! What a Blessing to be closely united with the children of God! Their horrid blasphemies tempted me to get beyond the bounds of charity: they almost made me thankful, that the irregular lives of those pests of Society must necessarily in this torrid clime, soon root them out of the land of the living. After spending a little time in private conversation with Mr. *Pattison*,[18] our Missionary in the Island of *Nevis*, who was then in *Charleston*, and breakfasting at Mr. *Ward's*, I again set off for St. *Vincent's*.

17. Back in England after this visit, Coke appealed to the British government on the plight of the Methodists in St. Vincent. He then took the earliest opportunity to visit the Netherlands, where he obtained an audience with the Stadtholder. His representations on behalf of the Methodists of St. Eustatius, however, fell on deaf ears, and they did not gain any relief until after the death of Governor Rennolds in 1811.

18. Richard Pattison was ordained by Coke on 17 October 1791 and sent out as a missionary to Nevis. After fourteen years in the West Indies, he served in home circuits from 1806 to 1835 and died in 1839.

The next day we touched at *Roseau* in *Dominica* I embraced the opportunity, and spent four hours on shore in order to see whether I could find out any of the flock of my dear deceased friend *William McCornock*. On calling upon a coloured friend whose name I just recollected, the report of my arrival soon circulated; and about twenty of the fruits of that holy man's labours soon assembled. If I could have staid another hour, I should have had a congregation. However, we sung and prayed together; and the power and presence of God were assuredly in the midst of us. The dear man, in a few months, was the means of awakening about 150 souls; and then he left them for a better place. The sword was too sharp for the scabbard. What a pity it is, that now for three years, they should have been left as sheep without a shepherd. The fields are ripe for harvest, but, alas! alas! there are none to reap it.

From *Dominica* we again proceeded on our voyage. But such a wretched crew, and such an infamous set of passengers, I never sailed with before. My friends had furnished me with a few bottles of excellent old rum for my voyage; but after I was in bed, these poor creatures got hold of it, and intoxicated themselves; they sat just under my bed, and sung the most filthy songs I ever heard. I scarce thought it possible that language could have afforded such obscenity.

On the 6th, we landed at St. *Vincent's*; and I hastened immediately to visit my imprisoned brother. I found him in the common jail, and a malefactor with him; afterwards another malefactor was added. Our kind friends supplied him with provisions sufficient for himself and his fellow-prisoners. Soldiers guarded him: and because he spoke of the things of God, through the grates to the poor negroes, who continually flocked around the prison, orders were given that he should be *closely* confined. However, the white people were suffered to visit him: but the guards took care that no coloured person should speak to him even through the grates. And the poor negroes would come up close to the grates, and while they stood silently glancing at him in the prison, the tears would trickle abundantly down their cheeks.

And all this was done, because Mr. *Lumb* had preached the GOSPEL TO THE NEGROES IN OUR OWN CHAPEL, built with our own Money, on our own ground! The Legislature were so determined to prevent the possibility of their negroes being

instructed, that they enacted, that no person, the Rectors of the parishes excepted, should preach without a licence; and this licence should not be granted to any that had not previously resided for twelve months on the Island. This, they knew, militated against our Itinerant Plan. They knew also, that our Preachers would never consent to sit for twelve months with their hands before them, and have their mouths shut, that they might afterwards have the liberty of preaching for a couple of years in the Island of St. *Vincent*. The Act therefore was completely adequate to answer all its infernal purposes.

But we have good reason to believe, that the majority of the white Inhabitants reprobate the Act. Indeed it was hurried through the Assembly at the very close of the Session. They sat a day extraordinary to complete the business: and though the house was very thin, they were by no means unanimous. No Missionary that has ever visited the Island, was more respected than Mr. *Lumb*. They did not attempt even to invent any charge against him, except *'He broke the Law.'* It is true, the very Sunday after the act was passed, he broke the Law; i.e. he preached the GOSPEL OF JESUS CHRIST to the poor negroes; and on the Thursday following was committed to prison.

This infamous Law is exactly parallel to the edicts of the ancient Roman Emperors. They first gently pinched; and proceeded from step to step, till they concluded with Death. And here, for the first offence, the punishment is a fine of ten Johannes, or imprisonment for not more than ninety days, and not less than thirty. For the second, such corporal punishment as the Court shall think proper to inflict, and banishment. And, lastly, on return from banishment, DEATH! How unparalleled a Law in these modern times, and under a government called Protestant; and which boasts of the liberty of its subjects.

No Island, for the time, afforded a more pleasing prospect of the prosperity of religion, than that of St. *Vincent's*. About a thousand of the poor Slaves were stretching forth their hands unto God; and many more of them constantly attended the preaching of the word. Indeed the Negroes of that Island in general, seem ripe for the Gospel. And shall hell and its emissaries be suffered to prevail? Will GOD Almighty suffer it? Can we find no relief?

Our present gracious Sovereign, (as well as his royal Grand-

father before him,) has ever been a Friend of religious Liberty. He, with the advice of his Council, may give us complete relief; and his tender heart will not refuse it to so large a body of his loyal subjects as the Methodists are. He cannot have a wish in his soul, to support a persecution against us in all his dominions; and if not in all, then in none. For the Government which would persecute us in the extremes of its Empire, would undoubtedly persecute us to its centre, as soon as means and opportunity were afforded.

Still, then, I have hope that the great door which the Lord opened for the propagation of the Gospel in St. *Vincent's,* will be opened again: that he who can turn the hearts of men like the rivers of the South, will so interfere by the mighty Power whereby he subdueth all things to himself, as to give us access to the hundreds of Israel, who are now suffering a famine of the Word.

I had given up all thoughts of visiting the Island of *Grenada*, when Mr. *Abraham Bishop*,[19] one of our late Missionaries in *Nova-Scotia,* who came at my request to the *West-Indies,* arrived here. I therefore set sail with him for *Grenada* in order to introduce him, where we landed the next day. The kind reception I met with during this visit, as well as the last, from all ranks of persons, gives me, I confess, a peculiar predeliction for this Island.[20] We found that Mr. *Dent,* the truly pious and worthy Rector of St. *George,* whom I mentioned in my former Journals had already provided, with the assistance of the little Society which Mr. *Owens* had left behind him, a house for Mr. *Bishop;* as I had previously informed Mr. *Dent* by Letter that he might soon expect a Missionary.

Mr. *Dent* intreated me to make his house my home, during my residence in the Island. He has lately built it on the side of a hill, which affords a delightful view of the town, harbour and shipping.

I preached once in Mr. *Dent's* Church on a Sunday morning, and

19. Abraham Bishop, a native of Jersey, offered for overseas service in 1791 and was a pioneer of the work in New Brunswick. His command of French stood him in good stead when he was called to serve in Grenada early in 1793. He threw himself into the work, but in June he died of fever (R. D. Moore, *Methodism in the Channel Islands* [London: Epworth, 1952], 72-73).

20. A letter from the Reverend Walter Carew to Bishop Porteus, 20 October 1788 (Fulham Papers, Lambeth Palace Library), gives a rather less rosy picture. It describes the obstacles in the way of converting the Negroes, including the influence of the Catholic priests on the island, the 'poor character' of most of them, and the licentiousness of the planters. Grenada had been ceded by France to Britain by the Treaty of Paris in 1763, was recaptured by the French in 1779, and re-ceded in 1784. Roman Catholic influence clearly remained strong.

two or three times in Mr. *Bishop's* house. When I met the Society (about thirty in number) they delighted me much. The experience of many was clear; most of them enjoyed a strong evidence of their interest in the Lord Jesus Christ. Mr. *Bishop,* who is a native of *Jersey,* (one of our Islands on the Coast of *France,*) preached both in *English* and *French,* with all that fervour and zeal for the conversion of sinners, which almost eats up his soul.

A little circumstance happened at this time, which so closely touched my feelings, that I cannot forbear relating it. Mr. *D.* who with his amiable Lady, lives quite a retired life, thought his family stood in need of another servant girl. He therefore, one day, went to a sale of Negroes, and fixing his eye on a girl of about ten years of age, said to her, 'Will you come with me?' The poor child, who was totally unacquainted with the *English* language, seemed, nevertheless, to understand him, and nodded her head. He then conversed with the Proprietor about some other Negroes, but afterwards, recollecting himself, turned round again to the girl, and said to her, 'Well, will you come with me?' The little naked child immediately threw her arms around him and burst into tears. His heart was exceedingly touched, and he purchased her, and brought her home. She was immediately well clothed; and, before I left the Island, could speak several words of *English,* and began to sew.

Indeed the gentlemen of *Grenada,* be it spoken to their honour, do, I believe, treat their Negroes better than those of any other Island in the *West-Indies.* The law, which provides Guardians in every parish who are upon oath, to oversee and protect the Negroes from injurious treatment, and are invested with great powers and privileges for the purpose, is a demonstrative proof of their wisdom and humanity. This merciful law was first enacted about three years ago; and very soon afterwards, a lady was fined 500£. for cruelty to her negro; an act of justice which did honour to the guardians, the judges, the jury, and the whole Island.

On the Monday after I landed, I took Mr. *Bishop* with me to visit the Hon. Mr. *Smith,* one of the members of the council, who lives near the town of *Guaave*. With this hospitable gentleman I spent a day, and was highly delighted with the sweet retirement which the woods, with a fine rivulet running through them, formed round his house. He has allotted a large out-house to Mr. *Bishop's* use, in

which he is to preach, and instruct the negroes from time to time. From Mr. *Smith's* we went to the Rev. Mr. *Carew's*, the rector of *Guaave*,[21] who received us with great courtesy, and informed us that Mr. *Bishop* should always be welcome to his house; and his negroes (about two hundred) would be collected to receive instruction, whenever Mr. *Bishop* visited him. The view of land and sea from Mr. Carew's house, forms one of those grand prospects which are so common in the West Indies.

But I must not pass over the noble sacrifice, which Mr. Owens, one of the Missionaries, lately made in this island. He was highly esteemed by General Matthews, the Governor of the island: and the living of Cariacou, one of the Granada Islands, being then vacant, the General offered Mr. *Owens* the living, if he would go to England (under the General's recommendation,) and be ordained by the bishop of *London*. The living is worth 400£. currency, per annum, which is regularly paid out of the treasury of the island of *Grenada;* and the surplice fees, which are very large, make nearly as much again. But our brother, with all the fortitude of a man of God, and with the deepest sense of the great generosity of the General, declined the offer, and continued a poor dependant Methodist preacher!

After remaining about a week in *Grenada,* I set off in the Dashwood packet for the island of Tortola. In our way we spent about twenty-four hours at Nevis, during which time I waited on my constant friend Mr. *Ward*, and two of the principal planters of the island, who are very kind to the missionaries.

On Saturday, Jan. 26, we landed at St. Kitt's, and continued at that island forty-eight hours; during our stay I visited Dr. *Bull*, a physician, and one of the members of the assembly, who lives on the side of a burning mountain. This gentleman's garden is the best I have seen in the *West-Indies.* The situation is sufficiently cool for raising all the esculents of England; and yet a part of the mountain, near the summit, is so hot, that one can hardly bear to walk over it; but there is no danger of[22] living near it, as the mountain has never thrown up any lava since the Europeans have been acquainted with the island. The manner in which two streams

21. The Reverend Walter Carew. A letter from Samuel Dent, 22 October 1793, reports Carew's death (Fulham Papers, Lambeth Palace Library).

22. I.e., 'in.'

have been brought from the burning mountain to the garden, might employ the attention of the philosopher, and afford him much delight for a considerable time. While I was walking in the garden, I more than once forgot myself, and, for a second or two, imagined I was in my native country. The elegant bath was also very refreshing. At dinner, out of many dishes, I prefered the rarest I had ever eat under the torrid zone, viz, beans and bacon. The doctor made me a present of green peas, which I carried to the packet, and which I think, were as good as I any ever met with in *England*.

Sunday the 27th was indeed a refreshing day to my soul and the souls of many. I had great liberty in preaching, and every hearer seemed to be watered from on high. At the love-feast, it was most animating to hear the lively and clear accounts of their conversion, with which we were favoured by many of the negroes.

On the 28th, we left St. Christopher's, where religion flourishes like an olive tree in the house of God; and on the 30th reached Tortola. In the evening I had a large and attentive congregation. The island is very small; and yet on this little spot, and some other small islands in the neighbourhood, we have one thousand four hundred awakened negroes in society, blessed be God. For a considerable time there was a warm persecution here; but the address and good management of Mr. *Owens* have, under a gracious Providence, entirely extinguished it. I cannot help acknowledging, with gratitude, the kindness and attention shewn me by Captain Roberts, of the Dashwood packet. Indeed, both from him and Captain *Bouldeston*, of the Halifax packet, with whom I sailed two years ago, from *Falmouth* to *Barbadoes*, I received every degree of kindness and attention, which could possibly be desired.

After employing myself in a very comfortable and profitable way for three days at *Tortola*, I hired a small sloop (being the cheapest method,) and set off with Mr. and Mrs. *Harper*, and Mr. and Mrs. *Owens*, for *Antigua*, where we were to hold our little conference. We touched at St. *Kitt's*, and took up Messrs. *Warrenner, Black,* and *M'Vean*.[23] We stopped at *Nevis*, on Mr. *Pattison's* account; and the night being dark, and the weather tempestuous, lay at our kind

23. John McVean's first appointment was to Tortola. In the stations for 1794 he is down for Antigua and the following year for Jamaica. Though still listed under Jamaica in 1797, he died that year.

friend Mr. *Ward's*. Next morning we again weighed anchor, and sailed into the channel which divides the islands of *Nevis* and *St. Kitts*. The weather now grew so tempestuous, and the skies darkened to that degree, that by the advice of the captain, we ran into a small bay, and anchored there; but seeing no probability of the tempest's abating for that day, we went up to the plantations, and divided ourselves among our friends: Mr. *Black* went with me to the mansion-house of *Walter Nesbit*, Esq. a member of the council, who receives the Missionaries, and whose negroes are constantly instructed by them. This benevolent gentleman has prepared a very convenient chapel for us, where the Missionary preaches to the negroes. In the evening I collected the blacks, and endeavoured to profit them as far as I was able.

An affecting circumstance lately happened here, which may be worth relating. Mr. *N*. purchased a company of negroes from a Guinea ship; and some time after made also a purchase from another vessel. When the negroes who were bought in the last instance, were brought up to the estate, a young girl of that company fixed her eye in a moment on another of nearly the same size, who had been purchased in the first instance. The latter seemed equally affected; and they both stood like statues for a considerable time, with the deepest attention to each other that can be imagined. At last, as if satisfied with their mutual recognition, and recovered from their mute astonishment, they sprung into each other's arms, kissing, and bathing each other with their tears, till they were disengaged, with some degree of violence, from their mutual embraces — They were sisters!

In the afternoon of the next day, there was an appearance of moderate weather, when we again embarked in our little vessel, and arrived in Antigua on the 8th of February. Our friends in that favoured isle rejoiced to see us, especially as they had received intelligence of us by a strong swift sailing vessel, which had seen us on our passage, and were exceedingly uneasy on account of the storm.

The preachers being arrived from the Windward Islands, our Conference began on the *9th*, and continued five days. We examined all the important minutes of the preceding Conferences, and left nothing unconsidered, I think, which would be useful to each other, or to the work in general. Our debates were free and full. All

the Preachers seemed to speak their whole mind on every important subject; and, I believe, much profit will accrue to the work, from the regulations which we then made. One of the sermons which I preached before the Conference, was accompanied with peculiar unction. It was indeed one of my best times.

The Preachers were stationed as follows:
1. *Antigua*, John Baxter, Wm. Warrenner.
2. *Barbadoes*, Daniel Graham, Benjamin Pearce, Supernumerary.
3. *Grenada*, Abraham Bishop.
4. *St Christopher's*, W. Black (in his absence John Harper,[24]) Robert Pattison, Jos. Telford.
5. *Nevis*, John Kingston.
 N.B. The unmarried Preachers of *St. Christopher's* and *Nevis* are to change every half year.
6. *Tortola*, Thos. Owens, John M'Vean.
7. *Jamaica*, William Fish.

The numbers in the Society were as follows:

1. *Antigua*	Whites	36
	Coloured People	105
	Blacks	2279
2. *Barbadoes*	Whites	34
	Coloured People	7
	Blacks	10
3. *Grenada*	Coloured People and blacks	30
4. *St Vincent's*[25]	Whites	4
	Coloured people and blacks	450
5. *Dominica*[26]	Coloured people and blacks	20

24. Coke's 1793 *Extracts* added the note: 'The climate of the West Indies does not agree with Mr. Harper. It was therefore agreed, that Mr. Black, whose station is in Nova Scotia, shall change with Mr. Harper, as soon as Mr. Black can bring his family to the Islands.'

25. Coke's 1793 *Extracts* added the note: 'There were near a thousand in society in St. Vincent's when we were driven out of the island by the persecution mentioned above; but near half the number still continue their private religious meetings, notwithstanding they are without a minister.'

26. Coke's 1793 *Extracts* added the note: 'These were some of the remains of Mr. Mc.Cornock's labours, as mentioned before.'

6. St. Christopher's	Whites	32
	Coloured people and blacks	1522
7. Nevis	Coloured people and blacks	394
8. Montserat[27]		12
9. Tortola	Whites	6
	Coloured people and blacks	1400
10. Jamaica	Whites	24
	Coloured people	46
	Blacks	170

In all, 6570

The Blacks, who nearly make up the whole of this number, have been brought out of heathenish darkness, more or less, to a knowledge of the truth, and a knowledge of themselves. They have left, as far as we can find, all their outward sins, even polygamy itself; and a considerable part of them give so clear and rational an account of their conversion, and of the influence of religion upon their hearts and lives, as is exceedingly animating and encouraging to their pastors, the Missionaries.

After the Conference, I rode to English Harbour, where we have a small society. This harbour is the finest and most commodious of any, perhaps, in America, except that of Halifax, in Nova Scotia. I also preached on the estate of Sir George Thomas, where I had the large hall full of a serious praying people.

After preaching on some other estates, I returned to *St. John's*, the metropolis of *Antigua*. This island has been lately visited with an epidemic disorder, which carried off about fifty of the principal inhabitants, besides a great number of negroes. It is worthy of remark, that whenever there is a large crop of sugar, the people are obliged to pay for it by a great mortality. The heavy rains necessary for a large crop, and the consequent dampness of the air in this low

27. Coke's 1793 *Extracts* added the note: 'We have no opening at present for a mission in the island of Montserat, on account of the persecuting spirit of the Irish Roman Catholics, who make a considerable part of the people. However, a little company, of about twelve persons mentioned above, who are under the influences of divine grace, are regularly met by a pious coloured person once a week.'

island, never fail to produce an epidemic fever. Mr. *Pearce*, one of the Missionaries, who had before enjoyed a remarkable share of health, was seized with the reigning disorder, and brought to the point of death; but the Lord has raised him up again from the bed of sickness, and kindly spared him for his church a little longer. He was given over by his physicians, who were astonished to find him, next day, entirely out of danger. Our dear and much respected brother, Mr. *Baxter* has also experienced some attacks on his constitution, which have much impaired his health. But religion makes ample amends for all the temporal evils and inconveniences; for genuine piety has here raised up her head, and flourishes abundantly, both among us and our Moravian brethren.

February 15th, I embarked for *Barbadoes* with Mr. *Graham*, and Mr. *Pearce* and his family. In our way we made another visit to St. *Vincent's*, but still found the door of usefulness shut against us by that most iniquitous act, which has been already mentioned. Even some of the Whites, who have no connexion with us, complain that the legislature are banishing the gospel from the island. However, our societies in and near the town of Kingston and Caliaqua, still assemble together in small companies, for singing, prayer and Christian conversation. 'O God, upon my bended knees I pray thee, to remove the iron hand of persecution which, now rests upon thy little flock. Can it be consistent with thine holy attributes, that *these* should perish through the malignity and wickedness of *thine* enemies? That by far from thee to do after this manner, to slay the righteous with the wicked: and that the righteous should be as the wicked, that be far from thee: shall not the judge of all the earth do right?'

On the 26th, we landed at *Bridgetown, Barbadoes*, when my worthy old friend, Mr. *Button*, merchant, received me with great hospitality. After waiting on the Governor, and preaching twice, I set off on my country visits. I had received intelligence that Mr. *Henry*, a gentleman of property and respectability, had made frequent inquiries concerning my name, person, &c. adding, 'He certainly is my old friend *Coke*, with whom I was so intimate at *Oxford*.' I made one of my first visits to him: and as soon as we came in sight of each other, we mutually recognized an old and intimate acquaintance, and embraced with all that warmth of affection which juvenile friendships inspire into the breast. I spent a great part of two

days with him, repeating old adventures, and endeavouring to mix with them useful observations. His house and estate have been already opened to the Missionaries, and I doubt not he will be a real friend to them, if it were only for the sake of his old acquaintance, whom he has loved long, and loved well. I also spent a day or two at Mr. *Harding's*, the manager of a large plantation, who has besides an estate of his own. He is our friend indeed: both he and his family are truly actuated by the fear of God; and some good has been done among his negroes by Mr. *Lumb*. Indeed, I have met with but few families in the islands like to this. Another white family also, who reside about a mile from Mr. *Harding's* have received much benefit from Mr. *Lumb's* ministry. After visiting Colonel *Skeate,* Sir *Philip Gibbs,* and other Gentlemen of the Island, and preaching upon many of the estates, I returned to *Bridgetown.*

The little Society in this town, is, I think, proportionably to its numbers, the most devoted to God of any in the *Windward* Islands; for this there is much due, under the grace of God, to the labours of Mr. *Pearce*. Not must I forget to acknowledge that our faithful brother Mr. *Lumb,* (with his colleague Mr. *Kingston,*) has been indefatigable in his labours. The negroes of *Barbadoes,* for some reasons which I cannot explain, are much less prepared for the reception of genuine religion than of any other Islands in the *West-Indies:* but constant dropping, 'tis said, will wear out a stone. I therefore trust that the day will soon arrive, when the Lord will give us such an access to their hearts and understandings, as we have not at present.

Barbadoes is the most like *England* of any Island I have ever seen. The inland part has much of the appearance of the finest lands in the *West-Riding* of *Yorkshire*. The numerous houses which are scattered about, and most of them white washed, with the hills at a little distance, make a very fine view. There are more white inhabitants in *Barbadoes* than in the great Island of *Jamaica;* a considerable part of it being broke into very small estates of only a few acres; so that many of the whites are very poor; nay, some are even supported by the parish; a circumstance, I believe, not known in any other part of this Archipelago. I therefore expect we shall do much good among the whites in *Barbadoes,* the luxury and intemperance of the rich not being within the reach of the poor. The Lord has raised up two Local Preachers here: one (Mr. *Brown* brother-in-

law to Mr. *Pearce*) who is concerned in the Fishery-business; and another who is in the Artillery. I am in hopes that the former will soon give himself wholly to the work of a Missionary: he is one of the most pious men I know. But I cannot omit mentioning Mrs. *Shoreland*, an aged widow-lady, and her son, at whose house I preached in the course of my tour through the Island. They seem to breathe the spirit of the English Methodists; and made me feel myself perfectly at home.

On the 22nd of March, I set sail, in the Duke of Cumberland Packet, from the Island of *Barbadoes* for *Kingston* in *Jamaica*. A French Count, an English Officer, and myself, were the passengers. The Count was a very pleasing man, and, like his countrymen in general, all life and spirit, even in the midst of misfortunes. He informed us that he had been a Member of the Assembly of the States General in *France*, and consequently of the first National Assembly; but his fervent Loyalty for the King obliged him to fly to *England*; and his estates in *France*, which were considerable, were confiscated. He had two estates in St. *Domingo*, and was going to *Jamaica* in hopes of procuring some information concerning them. But he was dreadfully frightened when he came within sight of *Hispaniola*, and could neither eat, drink, nor sleep, for fear of being taken by a French frigate or privateer. At our first meal on board, he turned round to me, and with all the pathos of the Frenchman, cried out, 'Sir they have murdered my King!' Then he addressed the company and said, 'I beg your pardon that I have been born a Frenchman!'

When we were near the Island of St. *Vincent's*, which lay in our way to *Jamaica*, the English Officer desired to be set on shore, in order to see a friend, to which the master of the packet, *John Long*, immediately consented; I earnestly entreated the same favour, but the surly man refused, although the boat was along side our vessel, and I was deprived of the opportunity of taking another farewell of my friends in the Island.

On the 29th, we arrived at *Kingston*, with the news of war.[28] Our Society in this town is small, in proportion to the size of the place. It hardly exceeds 200: many of them, however, are much devoted to God. We have also some Local Preachers here, both among the

28. Following Napoleon's annexation of Belgium, France declared war on Britain and Holland in 1793.

whites and blacks, who promise to be useful. Mr. *Forzbrook*,[29] a merchant's clerk, (whose mother was a member of our Society in *Castle-Dunnington, Leicestershire,*) is well qualified to be a Travelling Preacher. I hope, the impediments which his present situation throws in his way; will soon be removed. Mr. *Guirey*, also, a young man from *America*, is, I believe, a tolerable Exhorter: his father had been a respectable Merchant in *Philadelphia*, but met with misfortunes in life, which the greatest integrity, and most genuine piety, could not prevent. O how difficult is it, and yet how comfortable, to believe that 'all things work together for our good:' Mr. *Guirey*, the Father, did thus believe; and though reduced from affluence to a low estate, continued to trust fully in the Lord.

Young Mr. *Guirey* arrived lately from Cape *François*,[30] the Capital of the French part of the Island of *Hispaniola*.[31] Soon after he landed at Cape *François*, he was informed, that, being an American, he might safely visit the negro-army. He accordingly went; and, being surrounded by a body of troops, was brought before the General. The General was a Sam-boy, i.e. the offspring of a Mulatto and a Black, with whom he dined. Several of the General Officers dined with him: and when one of them, whose face appeared perfectly black, accidentally opened his breast, Mr. *Guirey* just observed that the skin was white: so that his face must have been painted. The description which Mr. *Guirey* gave of the state of the country was dreadful indeed. The whole seemed to be utterly laid waste. When the cane-grounds were set on fire, many of the Planters were seized by the negro soldiers, and thrown into the fire, and burnt alive. Indeed, the destruction of property, and loss of lives, is hardly to be described.

And is it to be wondered at? For Mr. *Guirey* informed me, that the inhabitants of Cape *François* were arrived at such a height of wickedness, that fornication was frequently practised even in the corners of the streets, and in the open day, without the least infamy attending it. Agreeable to this account was that of a Counsellor in the Island of *Tortola*, who had received his education at Brazen-Nose College in *Oxford*, and had taken the degree of doctor of civil

29. Possibly the John Fosbrooke mentioned in the Fulham Papers, Lambeth Palace Library, xxxix, p. 7.
30. An earlier name for Cape Haitien on the north coast of Haiti, formerly the capital of the French colony.
31. I.e., Haiti.

laws in that University. This Gentleman had resided for a few years at Cape *François*, and informed me, that father and daughter were frequently known to live together in an incestuous manner; and yet not the least cognizance was taken of it by the ruling powers. Is it surprising that God should so signally judge such a people as this?

On Monday, April 1, I set off with Mr. *Fish*[32] and Mr. *Guirey*, for *Montego-Bay*, in order to improve the opening, which I was favoured with about two years ago. After riding in the heat of the sun for a whole day, we came to a place called *Old Harbour*.[33] When we entered the inn, I perceived that I had never been there before. On inquiry, I found that we had got to the very opposite side of the Island to what we intended; that we travelled leeward, instead of windward. However, from the Landlady's account and from a map of the Island, it appeared, that we had lost nothing; it being impossible to go through the Island in a direct line, on account of the steep and lofty Mountains; and we only took one side of it instead of the other. And that if we crossed one high Mountain called *May-Hill*, we should have no more to travel one way than the other. The next morning Mr. *Fish* complained of a violent headache: and, as he had some time ago a seasoning fever, I begged of him to return, lest he should suffer a relapse.

After travelling a few miles we came between the high Mountains, and began to enjoy the romantic prospects, with which *Jamaica* abounds. On our journey, Mr. *Guirey* gave me the following account of a persecution which happened about twelve months before, at *Salem*,[34] in the state of *New Jersey*.

> A mob were, several times, very riotous in our Chapel: but on application to the magistrates, we obtained effectual relief, which has been universally and invariably the case in the states of *America*. The rioters not being able to disturb us, took another method of injuring the cause of Christ. They assembled in a place of their own, and *acted* Love-feasts, Band-meetings, Class-meetings, &c. to the

32. William Fish (1764–1843) had entered the itinerancy in 1785. He was appointed in 1792 to Jamaica, where he built up the Montego Bay mission. A letter from him to Joseph Butterworth, 9 March 1804 (in the Fulham Papers, Lambeth Palace Library), reports that though he is in poor health the local magistrates will not license anyone to assist him. His health forced him to return home in 1805.
33. Twenty miles west of Kingston.
34. In south-western New Jersey.

great entertainment of their profane auditors. One night, when they performing a public Band-meeting, a young woman stood up on a bench to profess her experience: and after speaking several things which commanded the mirth of the assembly, she cried out, (at the same time beating her breast,) *'glory be to God, I have found peace, and am sanctified, and am now fit to die.'* As soon as she had uttered these words, she dropt down *dead* upon the spot, to the inexpressible terror of the whole company, which immediately broke up, and they stole away in the greatest consternation, except a few who remained with the corpse. The persecution immediately ceased; and not a tongue moved afterwards against the Gospel, or its Friends.

After travelling through a champaign country, our views, near sunset, were extraordinary [sic] romantic. The hanging rocks and trees formed a most grotesque and awful appearance. All the rocks were white, and so perforated, that they seemed like immense heaps of white moss. About sun-set we arrived at a solitary inn in the midst of the mountains, after riding thirty mile in the heat of the day; and made our dinner and supper at one meal. The place was called the *Green-Ponds*. Next morning before sun-rise, we began to ascend *May-hill*, a vast, steep mountain, and about eleven o'clock gained the summit, which contained a few square miles of ground. Here we found a tavern, at which we breakfasted: and on inquiring the name of the Parish (Elizabeth Parish) I recollected that the little handful of Moravian Brethren who reside in this Island could not be far distant from me. My landlord confirmed my ideas, and informed me that we could easily reach the house of Mr. *Angel*, one of the Brethren, by night. I then remembered that Mr. *Angel* was brother-in-law of Mr. *Joseph Bradford*, one of our Travelling Preachers.[35] When we arrived at Mr. *Angel's* it was just dark: but he was from home, and the chief person in his storehouse informed us, that five miles further was the settlement of the Brethren, where we should meet with a hospitable reception. As Mr. *Angel's* house was a large one, I felt it unkind to be sent five miles through the dews of the night, which very few of the planters, through that whole *Archipelago* would have done. I therefore hired

35. Bradford married Mary Angell at Newport, Isle of Wight, on 26 July 1779. The family home was in Charlotte Street, Fitzroy Square, London. For other members of the family, see Charles Angell Bradford, *The Life of the Rev. Joseph Bradford* (London, 1932).

a guide, who brought us to the place. Mr. *Lister*[36] and Mr. *Bowen*[37] the Ministers, together with their wives, received us with the utmost courtesy; and here, indeed we found ourselves at home. O how comfortable is it, in a country where so little even of the form of religion exists, to meet with pious persons, of congenial spirits with ourselves! The kindness and attention of this simple-hearted family, made ample amends for our dark and dewy ride. With them we could sweetly speak and sing of the Love of Jesus; and our Lord was truly present, both in conversation, and in prayer. After an early breakfast, these loving people conveyed us one stage in their one horse chair, whilst the guide they had provided, brought our horses. May our common Lord and Saviour reward them!

When we arrived at the end of our stage, we found that we should be obliged to cross a great number of cattle-penns and plantations, and should meet with no more inns till we reached *Montego-Bay*. We accordingly set off across the country, and arrived about noon on a Plantation, of which Mr. *Leard*, a Scotchman, is the manager. This gentleman received us with the greatest civility and politeness; but we had not been here long, before the rains poured down like torrents, and we were thankful to divine Providence, and the master of the house, for this comfortable assylum [*sic*]. Next morning I was favoured with the company of Mr. *Leard*, and two or three of the principal men of the island, for fifteen miles. One of the gentlemen, who had an elegant saddle-horse as well as a phaeton, perceived that I was a little fatigued with the heat, and insisted on my riding in his phaeton most part of the way, whilst he rode on horseback. The gentlemen at parting, advised us, by all means to stop as soon as possible, and to rest for the remainder of the day, lest too violent exercise might bring on an inflammation of the blood; and gave me leave to use their names at the penns and plantations. The first at which we called the gentleman was not at home; and we were refused admittance. This was the first instance

36. Christian Lister, born in Spen, Yorkshire, 1750. From 1771 to 1788 he was a missionary in Labrador, where he married Johanna Sophia Hoffmann (1750–1822) on 3 September 1779. They returned to Europe in 1788, but in 1789 were called as missionaries to Jamaica. Lister died in Jamaica on 23 December 1803; his wife in 1822.

37. John Bowen (dates of birth and death not known) was ordained at Haverfordwest, Pembrokeshire, in 1792. He and his wife, Elizabeth (née Woolcock), arrived at the mission station, Old Carmel, on 8 January 1793. He died there on 24 February 1794. Carmel lies north-west of Blackriver and east of Bluefields.

of the kind I ever met with: yet, probably, the master of the house, would have received us cheerfully; for there are no men I have ever been acquainted with, more generous and hospitable to strangers, than the West-India planters. We then retired to some distance from the house, and sat down on the grass to rest ourselves, whilst our horses were cropping the herbage around us. From thence we went to a plantation called the *Seven-Rivers;* Mr. *Price*, the manager, whom I found to be my countryman, gave us a hearty welcome. Being now refreshed, we proceeded on our journey, and came to a plantation called *Montpellier*, where we abode for the night.[38]

Next morning, April the 5th, we set off at day-break, and breakfasted in *Montego Bay.* Immediately after I called upon my old acquaintance Mr. *Brown*, the Proprietor of the Assembly-room, who again generously gave me the free use of it. The next business was to send a Messenger round the town from house to house, to give notice of my preaching in the evening, in consequence of which I had a very considerable congregation. After I had enforced on the audience the great truths of Christianity, a company of rakes, with a printer, whose name was T. at their head, kept up a loud clapping of hands for a considerable time. I then withdrew into Mr. *Brown's* dwelling-house: but my companion Mr. *Guirey* lost me, and going out of the room into the street, was instantly surrounded by the rakes, who shouted, and swore they would first begin with the servant: on which an officer of the army drew his sword, and stretching it forth, declared he would run it through the body of any one who dared to touch the young man; on which they all slunk back, and withdrew.

Next morning I went to Church, and in the afternoon preached to a small, but deeply attentive congregation in the Assembly-room, from 1 John v.12. 'He that hath the Son, hath life;' and all was peace.

Having no engagement to dine, I went to the ordinary, where a gentleman took me aside into another room. After many apologies, and expressing his great regard for me, he intimated that he was an admirer of the Writings of Baron Swedenburgh. He likewise informed me, that a plot was laid, and intended to be put in

38. Montpelier is now a town in St. James Parish, eight miles south of Montego Bay, in a fertile agricultural region.

execution against me, at the Assembly-room in the evening, and that powder was to be used. He therefore advised me to give up all thoughts of preaching. I thanked him for his well-meant advice, and tender feelings on my account; but observed, that I was in the way of duty, and if my great Master was pleased to take me to himself that evening by the violence of wicked men, or in any other way, I was perfectly satisfied; well knowing that it was easy for him to raise a far better instrument that I was, for his gracious purposes; and that, through the divine assistance, I should endeavour to preach at the time appointed. The evening came, and a crowded congregation attended. At the beginning of the service Mr. T. began to be noisy, on which one of the Magistrates of the town who was present, stepped up to him, and spoke such strong and authoritative words, that Mr. T. and his crew thought proper to be silent from that time.

Mr. Mountague and several other Gentlemen shewed me much respect, during my short residence in this town. Several of the negroes were awakened by my public Ministry, and by calling upon them in their houses; and I might have formed a Class of earnest seeking souls. I know, through the Grace of God, I was an instrument of good. O how wonderfully gracious is he, how infinitely condescending, in stooping to use so unworthy an instrument for his own great Glory, and the salvation of souls!

On the 8th of April we set off from *Montego Bay*, on our return to *Kingston*. I confess it would have given me pleasure, if I could have staid a month longer in a place, where the Lord was pleased signally to bless me; especially as I had no Missionary to leave behind me, to water the seed which had been sown. However, the Will of God concerning me, was clear; and I accordingly proceeded on my journey.

Before we arrived at our breakfasting-place, we were joined by the Captain of a Merchant-ship from *Hull*, who knew me well, being a regular attendant at our Chapel, when he is at home. He was a pleasing and serious companion. After breakfast we rode together to *Martha-Brace-Point* (generally, I believe, called *Falmouth*) about 24 miles from *Montego-Bay*. Here I met with Mr. *Kitchen*, the mate of a London-ship, whose wife is a pious member of our London-Society, I believe, he also is, when in Town. He requested me to dine with him on board his ship, which lay in the

Bay, to which I readily assented: but before we took boat, a Captain of a London Merchant ship, of the name of *Ward*, came up to me with some other Gentlemen, and entreated me to favour the inhabitants of the town with a sermon in the evening. He was seconded by his companions, who engaged to procure for me the Assembly-room, and to give general notice. I had intended to have rode another stage in the afternoon, but thinking that this might be a providential call, I complied; especially, as I was informed that there never had been a sermon preached in the town since it was built, although there is a regular parochial Clergyman, with a handsome stipend, whose sole employment is to perform the offices of matrimony, baptism, and burial of the dead.

A little before preaching I returned from the ship; and at the time appointed, found a considerable congregation collected in the Assembly-room, notice having been sent from house to house. I preached on the New Birth, from John iii.3. and was led to speak in a closer and severer manner, than I am accustomed to do in the opening of new places. For twenty minutes a deep silence reigned throughout the audience, when the very Captain, who had in the first instance so importunately entreated me to preach, broke out in the following words, 'Sir, if what you say be true, we must all be damned: I do not like your doctrine at all.' The Bucks and Bloods instantly took the hint; and from that time there was nothing but confusion. However, I elevated my voice to its highest pitch; and continued my discourse for about twenty minutes longer in the midst of noise and distraction. Several ladies who sat opposite to me seemed perfectly attentive during the whole of the service. One of them, as I was afterwards informed, who was the first Lady in the town, addressed herself, after I had retired, to a young Gentleman, who had been one of the rioters, in the following manner: 'Till this time I always considered you as a decent, virtuous young man; but now I find you are a vagabond; and I forbid you ever to darken my door again.'

When I came into my chamber, my kind friend Mr. *Kitchen* followed me, and begged of me to take a bed in his ship, as there would be nothing but noise and rioting in the Tavern till midnight. I accepted of the kind offer of my friend, though I was rather afraid to venture on the water after the violent perspiration I always experience, when I preach in the evening, and more especially in

that sultry climate. Two pious Captains from *Liverpool* made me also a visit, one of whom, a Baptist, of Mr. *Medley's* congregation, is, I really believe, a shining Christian. He is well known in the northern parts of *Jamaica* under the name of the Preaching Captain. The generous offer of the Captain from *Hull,* whom I have mentioned above, viz. that he would give me a passage home for nothing, if I would sail with him, I shall never forget; but the delay of waiting for a convoy, would, I was certain, prevent me being in *England* in time for the Conference. Before I retired with Mr. *Kitchen,* I called at the stable to inquire after my horse, and found that he had been removed from his stall, and that his corn and fodder had been stolen from him. I immediately returned into the Tavern, and in a circle of Gentlemen, who were in a jovial mood, complained of the usage I had received. One of them, a stout young man, about six feet high, instantly came up to me, and standing by my side, said that he would defend me against the world. On this, he began to swear, and bawl and roar, till the whole family were in a perfect consternation. My horse was immediately replaced, and fresh corn and fodder procured for him. When this was accomplished, the young gentleman took me aside, and staggering, (for he was very drunk) addressed me as follows: 'Sir, I was once a Methodist, of the Countess of *Huntingdon's* connexion in *Bristol;* and had the honour of being for some time a steward of that society. I have now in my custody several letters written with the Countess's own hand: these I have shewn to many in this island. But, O Sir, they only laugh at them, and at every thing which is sacred. And though, Sir, I find myself obliged to live and converse as the rest do, or I should become an object of universal contempt and ridicule, yet,' says he, beating his breast, 'I have it here: I have faith, Sir, I have faith.' Poor young man, thought I; if the great woman, whom you so justly commend, and whose memory will ever be reverenced by the truly pious, were to hear you, she would say, as that eminent minister of God, Mr. George Whit[e]field, observed on a similar occasion, 'I see clearly you are one of my converts, and not a convert of Jesus Christ.'

After spending a very comfortable night in the ship, of which Mr. *Kitchen* was the mate, I returned to shore early in the morning of the 9th; and proceeded on my journey. In the evening we reached St. *Ann's Bay.* Before I retired to rest, the Curate of the parish, with

two others, came into the room where I was. The Curate was exceedingly inquisitive; and being informed by me, in answer to one of his many inquiries, that I had been educated in the University of *Oxford*, he observed, 'I had my education in *Oxford* too.' Pray, Sir, said I, of what house were you? 'House, Sir, house,' said he. 'Of what College, Sir,' said I. 'O Sir, of *Oxford* College, of *Oxford* College.' He seemed a little confounded, apprehending he had made a small blunder; and quoted the first line of the Æneid of *Virgil*, in Latin, and the first verse of the first chapter of St. *John's* Gospel in Greek, but in a most wretched manner. However, finding my mouth perfectly sealed, he and his companions, after a few more observations, were pleased to withdraw to my great joy. They were going according to the custom of that part of the Island, to sit up all night with the corpse of a Lady, who had just breathed out her last. But they took care, first of all, to water their own clay with an abundance of rum and water.

The next day, the 10th, we travelled nearly to the top of *Mount Diable*,[39] of the precipices and romantic views of which I have spoken in a former Journal. The keeper of the turnpike-gate, kept also a small inn, where we were very comfortably entertained. The following night we lay at *Spanish-Town*, and on the 12th about noon arrived at our Chapel in *Kingston*. The next morning I had two or three blessed hours of refreshment in the public ordinances of God with our beloved society in that town. In the afternoon, Mr. *Fish*, with many of the friends, accompanied me to the packet: and in the morning of the 14th, the packet sailed for *England*; and landed us safe at *Falmouth* on the 6th of June.

On the 4th of June, early in the morning, as we were entering the mouth of the English channel, the sailor at the mast-head gave notice of a sail in view. The Captain instantly went to the mast-head, and, after remaining there a considerable time, came down, and informed us that we were certainly chased by a privateer. For twenty-four hours the chase continued till the privateer was within about a mile and a half of our packet. We had no force sufficient to make any resistance. All was despair among the crew and passengers; till behold! appeared Lord *Hood*,[40] with eleven sail of

39. Mt. Diablo, 838m.
40. Samuel Hood, first Viscount (1724–1816), had a long and distinguished naval career, became a Lord of the Admiralty in 1788, and was put in command of the Mediterranean Fleet in 1793.

the Line, and all their accompaniments, bound for the Mediterranean. Joyfully did we sail into the midst of our friends, whilst the Privateer made the best of her way towards the coast of *France*. Thus did providence deliver us. Then 'praise the Lord, O my soul, and all that is within me bless his holy name. Praise the Lord, O my soul: while I live, will I praise the Lord; yea, as long as I have being, will I sing praises to my God!'[41]

41. See Psalms 103:1; 146:1-2; etc.

1796–97

Extracts[1] of the Journals of the late Rev. Dr. Thomas Coke's Sixth Visit to North-America and on his Return of a Tour through a Part of Ireland

Introduction

Four years were to pass before Coke paid his next visit to America. They were years in which the British connexion was busy sorting out its affairs in the wake of Wesley's death and striving, with only limited success, to avert disruption. Although he was not (as he had undoubtedly expected) elected to the presidential chair during these years, but passed over in favour of senior itinerants, Coke was very much in the thick of affairs. Moreover, he was increasingly involved in maintaining the Caribbean missions, which he had initiated with only minimal (and sometimes grudging) support from Wesley and the Conference. A combination of intensive begging tours and personal giving from his own resources barely kept them afloat. But he knew that the young men he had recruited (or at least those who survived the hazards of life in the tropics) depended on him for financial and other support; and though he would

1. This extract was printed in the *Methodist Magazine* (London) 21 (1798).

not visit the Caribbean again, their needs were to remain a pre-occupation for the rest of his life.

By the autumn of 1796 another General Conference of the American preachers was imminent, and Coke was once again crossing the Atlantic for his sixth visit as a bishop of the Methodist Episcopal Church. The voyage was probably the most wretched he ever experienced, but after much delay and frustration he reached Baltimore just in time for the Conference. His account of it is quite brief and couched in the most general terms, hiding the very real tensions that had to be resolved. The most urgent need was for the leadership of the Church to be strengthened, if only to relieve the growing strain upon Asbury. Asbury himself was invited to nominate a new bishop, but hesitated to do so. Coke, who was in the chair, persuaded them to defer the matter until later in the day and then presented them with a formal offer to devote the rest of his life to the American work. Although the offer was accompanied by assurances that he would not seek to usurp any of Asbury's powers, especially in stationing the preachers, this offer met with a mixed reception. Eventually, with Asbury's support, it was accepted, and Coke left for home with a letter to the British Conference asking for him to be released from his other commitments in order to fulfil his episcopal functions in America.

This sixth visit to America is the last for which any journal account has survived, apart from a letter describing his next voyage at the end of 1797, and was relatively short. After the Conference closed, Coke travelled from Baltimore southwards to Charleston before leaving for home on 6 February 1797. At this point his journal becomes much more sketchy, lacking both dates and locations. One reason is that much of his time he was travelling through territory that was still sparsely populated and finding overnight hospitality in isolated homesteads. His exact route is therefore difficult to determine.

The fire that had devastated the buildings of Cokesbury College was, he found, by no means an exceptional occurrence in post-colonial America. Other conflagrations were reported in places as far apart as New York, Charleston, and Savannah. But he was heartened to find in Charleston that the damage done by William Hammett's defection had been short-lived and that the society there was again in a flourishing state.

One reason for the brevity of this visit was that Coke was due to preside over the Irish Conference in the summer of that year, as he had done, alternating with Wesley, throughout the closing years of Wesley's life.

This journal extract concludes with an account of his Irish tour—the only one of which we have any detailed information.

On the 6th of August, 1796, we went on board the ship *Friendship*, at *Gravesend* near *London*, bound for *Baltimore*. The company in the cabin were the captain and his mate, the captain of another vessel which had been shipwrecked, Mr. *Pontavice*[2] (my French Companion,) another passenger, and myself. The winds were so very light, that we were about a week before we cleared the land.

Very soon I found that my friend and myself had fallen into the hands of some of the most wretched of men. To give a minute account of the ill usage I received during a nine weeks' voyage, would, I think, be sufficient to fill a volume. Though I paid the Captain the great price he insisted on, which was eighty guineas for myself and my friend, (as I was obliged to hasten, in order to be present at the General Conference at *Baltimore* and there being no other convenient ship, which I could find at the time,) the provisions he laid in, were very mean; and, when the ship arrived at *Baltimore*, he had only a sufficiency of the common ship's provisions for two days more. But this was a point of small consideration; for the Lord did abundantly feed my soul with the living Bread from Heaven, while he fed me with the bread of affliction. The obscenity and blasphemy of the two Captains, with the various means which they employed to make my passage painful, are not easily to be described. Common delicacy indeed would prevent me from relating various particulars of their conduct. But there was one happy circumstance; the weather was very fair, and they generally spent their mornings, from breakfast to dinner, on deck; so that Mr. *Pontavice* and myself read over *Ostervald's* folio edition of the Old Testament and the Apocrypha, with his annotations,[3] besides other French books. I also spent about half my time

2. Pierre de Pontavice, a native of Fougere, Brittany, was a Roman Catholic converted in Guernsey, where he was in exile from revolutionary France. He was Coke's travelling companion for several years. He entered the itinerancy in 1800 and preached in the Channel Islands in French. He died in France on 1 December 1810 (obituary in the British *Minutes*, 1811).

3. J.-F. Ostervald published *La Sante Bible* at Neuchâtel in 1744, 'revising and modernizing' the Geneva versions of 1588 and 1693.

in preparing some publications for the press. And by the means of these sweet exercises, the voyage was rendered in some measure supportable.

However the cruel usage I received, brought on a fit of illness, which confined me to my bed for three days. During this time the Lord did truly speak to my heart. I received such instructions and blessings from him, as I shall never forget. O how was I weaned from the world and all its follies; and not only so, but became willing to be any thing or nothing, as the Lord pleased; to be employed or laid aside, as he judged proper. This was a spirit I was but little acquainted with before. I had sincerely loved GOD for many years, and had no ambition but to be the instrument immediately and remotely of converting millions to him. I had been long willing to die, but not to be inactive while I lived. But now, through the grace of GOD, I could say, 'Thy will be done.' At the same time I lost, I hope, none of my zeal. I still equally long for the conversion of souls: but I find myself entirely resigned in respect to the instruments he uses. I am sensible I wanted all I have suffered. From that time I have hardly known which to thank my GOD most for, his open or disguised blessings; prosperity or adversity.

One evening, we had a most beautiful set of calm-clouds. They so exactly represented land, that it seemed to be within half a mile of us. Some of them resembled fields after the reaping of the corn. The sunshine was not much too strong. The woods were charmingly depicted. I think the whole was superior to that remarkable set of clouds near the coast of *Ireland*, which I described in a former Journal;[4] and must observe as I did then, that those who have been always confined to land, have very inadequate ideas of their beauty. Persons indeed may take many voyages, and not be indulged with the pleasure of seeing any equal to these. The sailors seem to have no taste for any thing of the kind.

About six weeks after we sailed, on a Sunday morning, when the sea was perfectly calm, we saw a wreck. It proved to be a ship bound to *London* from *Honduras-Bay* in the Gulph of *Mexico*. About five or six days before, in a storm, the skirts of which had reached us, it was overset, and the sailors were obliged to cut down all the masts to restore it to its proper position. It was loaded with mahogany and logwood, the specific gravity of which on the

4. See under 4 July 1789 (p. 129 above.)

whole was lighter than water. This prevented it's sinking. The ship's company, I think, consisted of a captain, a mate, four white sailors, three negroes, an Indian, one woman and a boy. The masts being cut down, the ship soon filled with water. Before this they had brought up all their provisions, and placed them on the securest part of the deck; but the wind rising higher, a few great waves washed off the whole, and the poor woman also. She was the wife of one of the sailors, (I believe of the mate,) had been in *Honduras-Bay* for upwards of twenty years, and had now set off for *London* to make one visit to her English friends before she died. The abundance of fish which were swimming round the wreck, and apparently waiting for their prey, was astonishing. The poor men remained for five days and five nights in this dismal condition, without the least food or drink of any kind, except some bits of leather which they cut off from the cover of the cabin sky-light, and sea-water, of which some drank abundantly, contrary to the entreaty of their Captain,—and another kind of drink too bad to be mentioned. The Captain of our ship, bad as he was, had compassion enough to take them on board. But their looks were exceedingly affecting, their eagerness for water was extreme: and it was with difficulty they were persuaded to swallow down or suck a little biscuit, before they drank. The Captain only was an exception. He behaved like a hero. His face was serenity itself; nor could one have imagined by his countenance, that he had suffered any hardship. He walked down to the cabin, and waited without the least word expressive of uneasiness, till some beef and bread were set before him, and eat [sic] several bits before he attempted to drink. 'O Sir,' said the mate to me, 'you cannot conceive how sweet sea-water is.' One of the negroes, I soon found, was a child of God, a preacher and a Leader of a Class. He had done considerable good in *Honduras-Bay*, and at one time had a congregation; but, as he humbly confessed himself, his hearers in general left him, (except those who were awakened,) on account of the deficiency of his talents for preaching continually to the same congregation. Among his spiritual children were some of the principal women of the place, to one of whom (a lady of fortune) I had a letter of recommendation for Mr. Fish,[5] one of our Missionaries in the *West-*

5. William Fish, an itinerant since 1785, was appointed to Kingston, Jamaica, in 1792 and served for thirteen years, re-establishing Methodism on the island following Hammett's breakdown and departure for the American continent. Despite impaired health, he then spent eleven years in home circuits and lived until 1843.

Indies, who was going to that settlement. Mr. Fish will therefore find a little Society ready to receive him, if the Spanish war does not put an end to the Mission to *Honduras-Bay*[6] at present. I have no doubt but the prayers of that child of God prevailed for the whole crew; for there was but himself among them all, who seemed to have the least trace of religion. Our Captain tied his ship to the wreck, and got cannon, cordage, sails, blocks, &c. from the wreck, which I believe, were worth not less than £200. But late in the evening, while he was returning with a cannon which was tied to the side of his boat, the wind suddenly sprung up, the cord broke which fastened our ship to the wreck, and it was with the utmost difficulty he was saved.

On the 3rd of October we saw American land, and to me it was truly joyful: but, alas! when we came within about a league of the *Chesapeak-Bay*, we were driven leeward by the wind, and obliged to shift off from the coast; and were five days more before we got securely into the *Bay*. This was no inconsiderable trial to me in the dreadful situation in which I was; for the ill usage I received from the two Captains, daily grew worse and worse. But all was good for me!

I confess I had sometimes thoughts of exposing those cruel men in *Baltimore*, where my sincere friends were both numerous and respectable, and even of entering a prosecution against them. But whenever I indulged these thoughts, I perceived something like resentment arising in my breast, which, if further indulged, might possibly have ended in determinate revenge: and that portion of Scripture so frequently and powerfully presented itself to my mind, *'Vengeance is mine, I will repay, saith the Lord,'*[7] that I at last resolved not to move or even to speak on this business, contrary to that Gospel, which says, *'Love your enemies, bless them that curse you, do good to them that hate you, and pray for them that despitefully use you and persecute you:'*[8] and when my whole soul was fully made up to proceed *in this spirit*, I felt a calm and tranquillity which it would be difficult to describe. Indeed I believe their design was to bring on a violent fever, or, if they could, to drive me into a state of

6. The mission to this part of Central America was not, in fact, launched until 1825, when Thomas Wilkinson arrived in Belize.
7. Romans 12:19, from Deuteronomy 32:35.
8. Luke 6:27-28.

insanity, that by any means they might prevent my future service in a cause which they so perfectly hated. But I can say, that during the whole of the voyage, I dropped not from my mouth to any one of them a word which was harsh, or, as far as I can judge, inconsistent with the spirit of love. For this I give all the glory to the grace of God!

When we were able to cast anchor in the *Chesapeak-Bay*, a pilot-boat came up, in which I might have sailed to *Baltimore*, probably in forty-eight hours. But the Captain would not suffer me to take a single article with me. The wind was contrary; but the small boat could have sailed close with the wind, and have made its way, though the ship could not. A point of delicacy now influenced me to remain still in the ship. I was afraid to leave my trunks and boxes entirely in the hands of these miserable beings. I had many manuscripts with me, on which I set a considerable value; and as these were part of my baggage, they were of course not entered in the Custom-house. I therefore had no check against the artifices of these men, unless I left Mr. *Pontavice* behind me; and it appeared to me cruel to leave him by himself in such horrid company. The next day came, and their abuse, blasphemy, and obscenity, still continued. The wind was yet contrary, and likely to be so. I knew, that ships are sometimes detained for a fortnight or three weeks in the *Chesapeak*, before they can be brought up to *Baltimore;* and it was possible I should be too late for the General Conference, which was soon to assemble, if I staid in the ship. Surely, seldom did I pray more earnestly than for the appearance of some small boat, which might carry me to land, and deliver me from the floating hell, in which I was imprisoned. When behold, two boats appeared in sight! I immediately requested the Captain in the gentlest manner I could, to hail those boats: 'No,' said he, 'You might have gone yesterday in the pilot-boat. It will be using the pilot ill to let you go in any other.' I again sat down, and prayed: after which I once more addressed the Captain, and told him, that as he objected to hail those boats which were in sight, because of the loss the pilot suffered by my not embracing the opportunity afforded me the day before, I would pay his pilot the price which he had demanded. On this, to my great joy and surprise, he ordered a jack to be hoisted as a signal to the boats, one of which soon afterwards came up. Two young men, who were in the boat, demanded a

guinea to carry me to *St. Mary's-Bay*[9] to which they themselves were going. I immediately agreed, and after apologizing to Mr. *Pontavice* for leaving him behind on account of the trunks and boxes, and delivering to him two letters of recommendation to our friends in *Baltimore,* lest he should be there before me, I set off with one shirt in my great coat pocket, full of thanks to God for my deliverance, and for the never-to-be-forgotten blessings which I received at his hands by the means of suffering. I am persuaded that this voyage was the most useful season of my life.

I must not omit the concluding instance of the Captain's behaviour, though it could hardly be named a trial or suffering, in comparison to the innumerable instances of his wanton cruelty. When I went into the little Schooner, the young men informed me, that they had hardly any meat remaining, and that we might not reach St. *Mary's-Bay* till the next morning. I therefore requested the Captain to give us a little bread and pork; and though he was now so near the land on each side of the *Bay,* that he could on an emergency have sent his boat on shore for a supply of provisions, he answered, 'I have none to spare.' So I set off with a heart exceedingly light.

Late in the night we arrived in St. *Mary's-Bay,* at the mouth of St. *Mary's* river, and were obliged to remain in the Schooner all the night. I confess that my arms and sides were rather sore in the morning, from lying on the hard wood, with only a blanket under me, and another over me, for the wood was peculiarly hard: yet, notwithstanding, it was a most comfortable night. When I went on deck, I found myself in a little romantic nook of the *Bay,* which was perfectly land-locked. It seemed like a small lake without any entrance into it. The sun shone bright. The plantations within sight were numerous: and so intermixed with wood and water, that, though I have seen innumerable superior prospects, never, I think, did any other prospect so delight me. I only wanted brother *Pontavice* to be with me, to cry out 'Quelles Beautés!'

The boat men informed me, that on the top of the hill within sight lived Captain *Chizzle,* a most hospitable Gentleman. From their account also I found that the inhabitants of that county were chiefly Roman Catholics, but that there were also many members

9. On the north bank of the Potomac River, which empties into the southern end of Chesapeake Bay.

of the Church of *England,* scattered through it, of whom Capt. *Chizzle* was one. I immediately walked up to the Captain's, who received me politely, but observed, that it would be exceedingly difficult for me to get horses from place to place at that time, they being all employed in the field. He therefore advised me to go on the morrow by water in the Sloop of a Gentleman of his acquaintance, who was going at the same time. I could hardly bear the thoughts of returning back into the *Chesapeak-Bay.* However, when breakfast was over, it being the Lord's day, I went with the Captain to Church, where I heard a very tolerable sermon, and afterwards dined with my friend the Captain, the Clergyman, and several others, at the house of a neighbouring Gentleman. Among them was the proprietor of the Sloop: and all things were settled for me to return that day to Captain *Chizzle's,* and the next to sail in the Sloop.

Accordingly, on the next day, after dining at a Gentleman's on the other side of St. *Mary's* river, I went to the house of the proprietor of the vessel, who was a man of great hospitality and refined sense. Another Gentleman was there, who intended going with us in the same Sloop; but they were resolved to stay a couple of days before they sailed. Every attention which could be wished for, was paid me. But I soon found that my two companions had embraced the opinions of *Thomas Payne,* and the other modern Infidels. Having been once a Deist myself, (O what a Miracle of Grace now!) I perhaps was better qualified on that account to meet their various arguments. They disputed with the utmost politeness, and manifested a constant fear of giving offence. Indeed they seemed to be candid inquirers after Truth: but whether my arguments were sufficient to proselyte them, or not, I cannot say. In the evening of the second day we sailed; and when we arrived at the mouth of the great river *Potomawk,* which was seven miles in breadth, and into which the river St. *Mary's* empties itself, we came to anchor for the night. Those who have never visited *America,* have very inadequate conception of the manner in which that immense country is watered. The traveller is continually surprised by vast navigable rivers. The next morning we entered the *Bay.* But the wind was so opposed to us, and one of the Gentlemen grew so sick, that we again put back to the mouth of the *Potomawk,* I now was determined to travel by land at all events, though I was 25 miles farther

from *Baltimore*, than at the place where I first came on shore. In the morning therefore I insisted as far as was consistent with good manners to be brought to land, with which they complied with a great deal of kind reluctance.

I cannot but here notice the gracious kindness of Providence to this country, in bestowing upon it one of the finest bays in the world. The *Chesapeak* for 200 miles, or upwards, through the heart of the country, is in general from seven to thirteen miles in breadth, and receives into its bosom many large navigable rivers, which altogether open such sources of trade to the States of *Virginia* and *Maryland*, as enable them to send off all the superfluous produce of the country, and to receive in return every convenience of life which *Europe, Asia,* or *Africa,* can afford them. A country more extensive than these three kingdoms, lies open to every advantage of commerce by the means of this *Bay* and its rivers.

Near the shore where I landed, was a house to which I immediately repaired. The name of the proprietor was *Robert Armstrong,* whom I immediately informed of my situation, and who I was. 'Sir,' said he, 'though I am not a member of your church, I have heard of you, and have a great regard for your Society. My son-in-law, now dead, was a Methodist Preacher. I have a good horse in the stable at your service: but if I had been obliged to have taken one from the plough, I would have done it for you. You must return back to Captain *Chizzle's,* which is about 25 miles from hence, and I will send a servant for the horse.' I accordingly returned that day to the Captain's, who the next morning lent me a couple of horses and a servant to go to his brother's, which was ten miles further.

By breakfast-time I arrived at Mr. *Chizzle's,* brother to the Captain, and a Senator of the State of *Maryland,* and informed him of my circumstances. 'Sir,' said he, 'there is a sloop on our river, (the *Patuxen*) which will sail immediately for *Baltimore,* and you will be welcome to a place in it.' 'Sir,' I replied 'I will not go again on the water, if I be obliged to walk the whole way to *Baltimore.'* (I was then a hundred miles distant from that city.) 'If then you will stay and dine with me, Sir,' replied the Senator, 'we will consider how to send you on.' I accordingly staid, and spent a few very agreeable hours with him, and two other philosophic gentlemen, who dine[d] with us. After dinner I again expressed a desire of

proceeding on my journey. 'Sir,' said Mr. *Chizzle,* 'if you will take a bed at my house, we will to-morrow morning lay a plan for sending you on.' 'On condition, Sir,' I answered, 'that you promise to send me on immediately after breakfast to-morrow, I will stay with you.' 'I make you that promise,' he replied, smiling. Before tea, I took a walk into the woods. He met me returning. 'What book, Sir,' said he, 'are you reading?' 'Thomas a Kempis's Christian Pattern,[10] Sir,' said I. 'Will you permit me, Sir, to look into it?' he replied. 'If you will do me the honour of accepting it, Sir,' I answered, 'You will confer a favour upon me.' 'I will Sir,' said the Senator; 'and I promise you, that both I and my family will read it through.' After breakfast in the morning he observed, 'Now, Sir, there are two horses ready for you. I will send you to a friend of mine, and will write in such a manner that you shall have no difficulty all the way to *Baltimore.* My friends will forward you on from stage to stage. But to relieve you from all anxiety, if on this plan you find any difficulty, you may take my servant and horses to the end of your journey. Or, as there are I know, many of your Societies at the other end of the country, my servant shall carry you to them. There is one of your friends particularly (Mr. *Child*) who, I believe, is a preacher, and a man of established character, who lives about 30 miles from hence in your direct way to *Baltimore:* if you prefer this later plan, my servant will set you down at his house.' I preferred the latter, and was accordingly set down in the evening at the house of brother *Child*.[11] I certainly shall never forget the kindness of this gentleman. I long to visit him again, and preach the Gospel in his neighbourhood; for I really believe he would prove a friend of the Lord Jesus.

In riding through the woods the autumnal prospects were most delightful. The various colours of the leaves, the flowering trees, and the views of water from time to time, contrasted with my wretched, though most profitable, situation for nine weeks in the ship, exceedingly animated my spirits, and raised my attention and affections, I trust, still more to that God, who, I can say, is the joy of my heart and the delight of my eyes.

10. Coke was probably reading the extract of Thomas á Kempis that Wesley first published in 1735 and recommended repeatedly to his Methodist people.

11. Gabriel Child of Calvert County, MD, who features in Asbury's *Journal* (e.g., 3 June 1782; 6 June 1783).

Though I was greatly pleased with the generosity and hospitality of the Senator, I confess I felt peculiar pleasure in arriving at the house of a Methodist, and especially of one who enjoyed an eminent degree of the love of God. His excellent wife had seen me about 12 years before, when unmarried, in a distant place, and immediately recognized me. When we went to family-prayer, I felt a power in prayer, a prevalence with God, a sacred breathing, which for ten weeks I had not the privilege of enjoying in public. In private indeed, I can truly say the Lord was with me. O he is very good! 'Praise the Lord, O my soul; and all that is within me, bless his holy Name.'[12]

The next day Brother *Child* went with me to Mr. *David Weems*.[13] We reached his house by dinner-time. Brother *Weems* immediately proposed to send round the neighbourhood, and raise a congregation for me. I consented, and preached in the evening to a lovely assembly of perhaps fifty or sixty attentive hearers, in his parlour. O how pleasing it was to enter once more on my public ministry!

The following day, Brother *Weems* sent me to the city of *Annapolis*. Here I spent two days, and preached to two very large congregations. When I first visited this city in 1785, we had no preaching house; but the theatre was opened to me. Pitt, boxes and gallery were filled with people according to their ranks in life; and I stood upon the stage, and preached to them; though, at first I confess, I felt a little aukward. But now things are altered. Soon after my first visit, a small church was erected for us,[14] and the work rapidly increased through town and country. In the city, especially, the meetings frequently continued till the morning, and the prayers and the praises of the people were sometimes exceedingly loud; so that the great and rich heavily complained of the disturbance which was given them, and threatened a severe persecution.

12. Psalm 103:1 (BCP).

13. David Weems, the brother of the Reverend Mason Locke ('Parson') Weems of All Hallows Parish, Herring Bay, in the southern part of Anne Arundel County. Asbury records 'an interesting conversation' with Parson Weems 'on the subject of the Episcopal mode of Church government' and an evening spent with his brother David, on 30 November 1784 (*Journal*, 1:473).

14. The site of the first chapel, a 'little frame meeting house' on a 'very inconvenient' site near Governor Eden's mansion, was donated by John Chalmers in 1784. But in 1789 the congregation moved into what became known as the Old Blue Church in State Circle, the building in which Coke was now preaching. Cf. Isabel Cunningham, *One Hundred and Eighty-Seven Years of Methodism in Annapolis: A Brief History of Calvary United Methodist Church* (Annapolis, 1972), 9-13.

At this time the General Election commenced. The county of *Annapolis* returned four members to the Assembly: and just at the close of the poll for the county-election, by the excellent management of one of our friends, our freeholders came in a body, and carried the election for the four candidates who were the lowest on the poll, and had almost given up their election in despair. At the next sitting of the Assembly of the State, Mr. *Haggerty*,[15] our elder in the city, embraced the opportunity, and as our church was situated in a very inconvenient place, petitioned the Assembly for the grant of a piece of waste ground which was most commodiously situated. Our four members immediately made excellent speeches on religious liberty and impartiality, and a vote was obtained by a majority of two to one, which was afterwards confirmed by the Senate. We had accordingly a new preaching-house on a commodious spot, to the great mortification of our enemies.

Whilst I was in this city, I met with Brother *Ignatius Pigman*,[16] one of our elders, who had been a little before in *Kentucky* on the other side of the Apalachian mountains. In coming back he had a party with him who were also on their return. Having some business to transact, he left his party, intending to follow and overtake them: and imagining that they had proceeded before him, and knowing that they were well stocked with provisions, he took with him only two pounds of dried venison, and a proportionate quantity of biscuits. It may be here necessary to observe, that the Americans in peopling the Western territory, which now forms the States of *Kentucky and Tenessee,* had passed over a great quantity of the wilderness, for the sake of the richer soil, which lay more towards the West; so that a vast tract of forest lay between the old and new settlements. The party before mentioned had about 200 miles to travel through this wilderness, in the line they designed to take. Poor Mr. *Pigman* lost his company, who staid behind longer than they at first intended; and afterwards lost his way, by taking a line which inclined too much to the left. Eleven days he rode and

15. John Hagerty (1747–1823) of Prince George's County was converted by John King. He entered the itinerancy in 1779. He preached in both English and German. He retired on health grounds in 1792, but continued to preach in the Baltimore area (Asbury, *Journal*, 1:194; *Methodist Magazine* [New York], 1824, 209-12).

16. An itinerant since 1780, Pigman was appointed deacon at the Christmas Conference and ordained the following year. He left the itinerancy in 1788. Asbury's *Journal* (2:248) records some kind of lapse on his part.

subsisted on small quantities of his biscuits and venison, till at last the whole was expended. His horse was supported by the grass in the woods, till, at the expiration of the eleven days, the poor creature sunk under his fatigue, and Mr. *Pigman* was obliged to leave him behind him. For five days more he travelled on foot, carrying his saddle-bags on his shoulder or his arm; and at last to his great joy came to a plantation, where his kind hostess, a widow, supplied him with necessary food. By this time his clothes were so torn, that he was hardly decent: and the last day his throat was so sore, that he could scarcely swallow water. Twice he met with a wild bear. Each time he turned round, and looked firmly at the bear: the bear stopped and soon turned away. One night, towards the close of his dreadful journey, he was lying down, resting his head on his saddle-bags, which were his pillow all the way, and of a sudden heard a rustling noise, and could clearly distinguish the footsteps of a man. He had no doubt but he was an Indian, and being confident that he was not far from the cultivated country, he lay quiet till the noise was over, and then fell asleep. I reflected, What have been any of my sufferings in comparison of these! But on more mature consideration, I believe that a mind deeply penetrated with a zeal of the Lord's house, may suffer much more exquisitely from trials in the church of God.

On the 18th of October, I left *Annapolis,* and travelling in the mail-coach, arrived in the evening at the house of my much respected friend Mr. *Philip Rogers,* of *Baltimore,*[17] two nights and a day before the General Conference. This time four years [ago] I arrived but one night before the Conference. I was pleased to find that my two deistical friends, in whose sloop I had attempted to sail, and who had arrived in *Baltimore* before me, had made very kind inquiry after me. Perhaps I was of service to them.

On the 20th, our Conference commenced, which sat for a fortnight.[18] All was unity and love. There was not a jarring string

17. Rogers was a leading member of the Lovely Lane society and a trustee of Cokesbury College. Asbury was frequently a guest at his 'Greenwood' estate on Collington Avenue.

18. This General Conference had originally been arranged for 1 November, but by the decision of the Annual Conferences had been brought forward to 20 October. Asbury's account of the Conference is more measured: '[The preachers] agreed to a committee, and then complained; upon which we dissolved ourselves. . . . No angry passions were felt among the preachers; we had a great deal of good and judicious talk' (*Journal,* 2:103).

One major issue was the need to strengthen the episcopacy which, in Coke's absence, rested upon Asbury's shoulders alone. Coke's offer to devote himself henceforth exclusively to the American work was met with mixed emotions, and he found himself with divided loyalties and responsibilities.

among us. For two or three years past we have had a sifting time, after the great revivals with which we were so long and so wonderfully blessed. But in all I saw the hand of Providence. The preachers now seem to have a full view of the S[c]ylla and Charybdis, the rocks and whirlpools, which lie on either hand; and are determined to avoid them. They are like the heart of one man. Surely this sweet and entire concord must be very pleasing to the Prince of Peace. It came from him, and to him let all the glory be ascribed! Methinks, it affords us a prospect of great days to come. At this Conference the Lord gave us signal proofs of his approbation: every evening he was graciously present; seldom could the congregation break up till near midnight; and seldom were there less than half a dozen brought into the liberty of the children of God. One Sunday morning, when I endeavoured to set forth the Intercession of Christ, seven were justified under the sermon and the prayers which succeeded it. After the service was over, I was attacked at the foot of the pulpit by a Sweidenburgian Lady, as I was descending; and the answers I gave her, brought on a newspaper war between her minister and me. He made the first attack. It was carried on with mutual politeness, and ended to the satisfaction at least, of our own friends.

I now received an exact account of the burning of Cokesbury-College.[19] Not only the Building, but the library and the philosophical apparatus, were entirely destroyed; and what is the most trying consideration, I doubt not but it was done on purpose. The Governor of the State advertised one thousand dollars' reward for the discovery of the person or persons who perpetrated the deed; but all in vain. The gentry, for many miles round, also lamented the loss, not only from more liberal motives, but on account also of the instruction and entertainment they had received, in being admitted, with tickets, to the Philosophical Lectures of Dr. *Hall*, the President. Brother *Asbury* then wished to have nothing more to do with the colleges. Nevertheless, seventeen of our principal friends in the *Baltimore* society met together, and thinking that the honour and credit of the connexion demanded exertion, to supply

19. This was the second fire, which occurred on 7 December 1795. Asbury was unable to disguise his relief, dismissing the venture as 'all pain and no profit, but some expense and great labour' (*Journal*, 3:171). A group of Baltimore citizens nevertheless took the initiative in setting up an 'academy' in Baltimore itself, and this was in its turn burned down in 1796.

the place of *Cokesbury*, they immediately subscribed £1700 currency, (£1020 Sterling,) towards the erecting of a new college. They then applied to the proprietor of a large building in *Baltimore*, which has been erected for balls, concerts, card-parties, &c. for the use of the city (for *Baltimore* has been lately constituted a city) in order to purchase it. This building, which was then vacant, and I think the handsomest in the city, they purchased for £5300. The society at large subscribed £700 and the inhabitants of the city, upon an application from house to house, £600 and the above-mentioned seventeen went security for the remaining £2300. The college, or academy, was accordingly fitted up; masters were appointed, and the whole city seemed to take pleasure in sending their young people to this seminary, which soon flourished beyond what *Cokesbury* had ever done.

On the 4th of November, Brother *Asbury* and I, and several of the preachers, left *Baltimore,* and rode about 18 miles to the house of Mrs. *Daussey*[20] where we gave several exhortations, and found many of her negroes very much alive to God. Her late husband, Colonel *Daussey,* who was awakened under the ministry of Brother *Asbury*, had been a pillar of our cause, and his widow is no less so at present. The following night we lay at Brother *Tucker's*,[21] a good old man; and the next day reached Alexandria in Virginia. My old friend, General *Roberdeau*,[22] at whose house in this town I was accustomed to lodge, was dead. On a former occasion I preached in the Presbyterian meeting-house, and gave great offence to the gay by the testimony I bore against the pleasures of the world. Now we have here a good chapel of our own, in which I preached to a large attentive congregation; and endeavoured to make them amends by spending the precious hour in the softest and most persuasive manner I was capable of, to invite them to Christ. We were published for the new Federal City[23] on the same day, but on due consideration preferred *Alexandria,* and sent two of the Preachers to supply our place.

The two following nights we lay at inns, having rode each day from morning to night; and on the next day arrived at *Richmond,*

20. Elizabeth Dorsey, widow of Col. Thomas Dorsey of Elkridge, MD (Asbury, *Journal,* 1:386n; 2:103n).
21. Possibly the Benjamin Tucker mentioned in Asbury's *Journal* for 25 September 1780.
22. See note 182 on p. 63 above.
23. The site of the future federal capital had been chosen by George Washington in 1790.

where we were most hospitably received by Mr. and Mrs. *Parrott*.[24] Sister *Parrott* was formerly a member of our *Wapping* Society in *London*, and is indeed a pillar in the church of God. She is one of the excellent of the earth. In this town I preached twice, once in the Capitol—in the House of Commons; and the other time in the preaching-house, or rather out-house, which Mr. *Parrott* had kindly appropriated for a place of worship.

From *Richmond* Mr. *Parrott* took me in his one-horse-chair to *Petersburgh*, (25 miles,) where Brother *Asbury* and I, who had separated for a few days, met again, and spent the Sabbath, and found it a very profitable time. In this town, I have been often blessed both in my own soul and to others.

We now set off for our *Virginia* yearly Conference, which was held at a place called *Maybery's* Chapel.[25] About fifty of the Preachers met us here, lodging at the plantations of our friends within a circle of three or four miles from the chapel. Nothing but love, peace, joy, unity, and concord, I may truly say, manifested themselves in this Conference. It was, in respect to love, the counterpoint of our general Conference. Oh what great good does the Lord frequently bring out of evil! The siftings and schisms we have had, have turned out the greatest blessings! Surely, the Prince of Peace and Lover of Concord is about to accomplish great things on the continent of America, by the means of the Methodists! After the necessary business was finished, we spent about two days in band, each preacher in his turn relating the experience of his own soul, and the success of his ministry for the last year. It was a profitable season. I wish this useful method was pursued, as far as possible, in our European Conferences. We all parted on the Lord's day, after I had given the congregation, first, a comment on the 20th chapter of the Revelation, and then a sermon on Luke xiv.26. Brother *Asbury* and I then separated for a time. We had before agreed to take different routs to *Charleston*. He took the sea-side and I the upper country. A preacher went off a few days before me to make publications: but as my plan was nearly the same as that which Brother *Asbury* was to have taken, and which he kindly

24. The Parrotts lived on Main Street, Richmond, where they had fitted up a storeroom as a preaching place. About this time Coke took the first steps towards the building of a chapel (Asbury, *Journal*, 2:104).

25. The chapel, built by Joel Mabry of Greensville, was the fourth built in Virginia (Asbury, *Journal*, 1:167n).

gave up to me, the publications had been already made in many places. I had now about eight or nine hundred miles to travel to *Charleston*, on the zig-zag line which I intended to pursue.

On Monday, I preached in *Rose's* Chapel,[26] and on Tuesday at *Drumgoole's*.[27] Brother *Drumgoole* was one of the first of the native travelling preachers in *America*, and has always preserved a most unblemished character, and is a man of considerable abilities, though his (I believe erroneous) views of things led him to give up the important and extensive itinerant plan, for a much smaller sphere of action in the vineyard of the Lord.

On Wednesday I preached in the house of Brother *Owen*,[28] on Prov. xxiii. 26; and the two following days at *Myrick's* Chapel. At Mr. *Myrick's*,[29] I found a lovely family, and spent much time ingulphed in the woods, and reading the younger *Racine's* celebrated Poem *de la Religion*.[30] Many might imagine, that my natural disposition leads me into busy life; but it is the very reverse. If the principle of duty did not carry me forth into scenes which call for activity and exertion, I should certainly settle in some solitary place, where I might enjoy the company of a very few select friends, and the pleasures of a retired rural life.

On Saturday I preached at Mr. *Lindsey's*,[31] and on Sunday at a place called *Jones's Barn*. Late in the evening, after a very long ride, we reached the house of Brother *Heath*, a Local Preacher, who entertained us with every thing his small abilities could afford. But the rooms in which we lay, were full of holes, open to the outward air, and exceedingly cold: besides, we had not bed-clothes enough, even with our own coats and waistcoats. But what is this, when the love of God warms the heart? I bless his Name, I do know that he loves me! O it is this assurance which sweetens every bitter cup;

26. Rose's Creek Chapel was in Brunswick County, VA (Asbury, *Journal*, 1:222n).

27. Despite Coke's statement about his being a 'native' travelling preacher, Edward Dromgoole (1751–1835) had arrived from Ireland in 1770. He served in the itinerancy between 1773 and 1786, then settled in Brunswick County, where his home became a regular preaching station (Asbury, *Journal*, 1:105n).

28. William Owen of Mecklenburg County, VA, an old friend of Asbury's from his days in the Salisbury Circuit (Asbury, *Journal*, 1:620n; 2:68; see also 1:178).

29. This was either Owen or Matthew Myrick, both located somewhere in Brunswick County, VA (according to Asbury, *Journal*, 2:462), near the 'Olive Branch Chapel' where Edward Dromgoole lived. 'Myrick Chapel' is mentioned in Asbury's *Journal*, 2:227.

30. Louis Racine (1692–1763), younger son of the dramatist. His poem was published in 1742.

31. Not identified, unless it was the Robert Lindsay mentioned several times in Asbury's *Journal*. Jones's Barn is said to have been in Halifax County, NC.

which turns the wilderness into a paradise, and enables me to triumph with the Poet,

> Should (Providence) command me to the farthest verge
> Of this green earth, to distant barb'rous climes.
> Rivers unknown to song,
> 'tis nought to me,
> Since God is ever present, ever felt,
> In the void waste, as in the city, full:
> And where he vital breathes, there must be joy.[32]

The next day I preached at *Sampson's* Chapel,[33] so called, because it was built entirely, I think, at the expense of a pious person of that name, who is now alive, but very old, and through misfortunes reduced to a state of perfect dependence. 'Whom the Lord loveth, he chasteneth.'[34] It is of infinite importance to be thoroughly acquainted with, and perfectly submissive to this truth. But, alas! too many profess high things in the sunshine of prosperity, and are ready to curse God and die in the time of adversity. But the true child sweetly kisses the parent's hand which beats him, and profits by the chastisement.

The next two days I spent at Brother *Shine's*, who was formerly a Travelling Preacher;[35] and from thence went to a Brother *Green Hill's*, at whose house we held our Conference for the State of *North Carolina* in 1785.[36] He is a Local Preacher of some eminence, and once sat in the Assembly of the State. His plantation is very

32. James Thomson, *The Seasons;* from the Hymn that concludes the poem. Among several minor verbal variations, the most noteworthy is Coke's substitution of 'Providence' for 'fate' in the opening line. In his *Recollections of My own Life and Times* (London, 1874), Thomas Jackson says that he often heard Coke repeat these lines 'with inimitable pathos and effect.' They are also found (more fully) in Coke's letter to the American preacher Thomas Morrell, 23 June 1790, where the word 'fate' is retained (this letter was published in *Christian Advocate* and *Journal* 26, no. 14 [3 April 1851]: 53).

33. Sampson County in south-eastern North Carolina was formed in 1784 and named for Col. John Sampson who died that year (William S. Powell, *The North Carolina Gazetteer* [Chapel Hill: University of North Carolina, 1968], 436). The 'pious person of that name' mentioned by Coke was presumably related to him. Asbury's *Journal* (1:562) mentions preaching at 'Samson court house' on 17 February 1788. Joseph Scott's *Geographical Dictionary of the United States* (Philadelphia: A. Bartram, 1805) says that there was a post office at Sampson court-house.

34. Hebrews 12:6.

35. Daniel Shine was received on trial in 1790 and into full connexion in 1792; ordained deacon, 1793, but located in 1795.

36. See p. 56 above.

large; but a murrain among the cattle, which has lately infested that country for a considerable extent, has destroyed almost all the stock on his estate. He has lately visited *Kentucky*, in order to chuse a spot of ground for himself in that new world. He is so highly respected in his neighbourhood, that about a hundred families around him talk of moving to *Kentucky*, if he set them the example. I rested here four days, preaching in a small Chapel which was near the dwelling-house.

On Monday, the 29th, I set off for the town of *Raleigh*, which is the seat of Government for *North Carolina*. That night I lay at the house of a Local Preacher. The next day I was wetted to the skin. O how delightful it is to endure hardships for Christ! I really think I felt more happiness in the honour of being thus wetted for my Master, than I should have done in the finest sun-shine. Twice we stopped at some small houses on the road to dry ourselves. There is nothing, I think, worthy of the name of a cross, but sufferings from the Church, sufferings within the Sanctuary.

At *Raleigh* I lay at the house of Colonel *Sowell*, whose family are already gone to *Kentucky*, or *Tenessee*; and the Colonel intends to follow them as soon as he has settled his affairs. In the afternoon I preached in the House of Commons, having obtained leave of the Speaker through the influence of the Colonel. The Senate and Members of the House of Commons attended, (a few, who were engaged on a committee, excepted.) I had the Speaker's seat. The Speaker himself sat below on my right hand. The attention of the audience was still as night. As I had been beforehand informed that many of my hearers had imbibed the errors of the modern philosophy, I particularly insisted on the Evidences of the Christian religion. As I had reason to believe, that I should have been favoured with the House of Commons as often as I wanted it, at such times as the House was not sitting, and that same congregation would have continued to attend, I was sorry that my engagements prevented me from staying a few days longer in *Raleigh*. Great were the disputes in the evening, as I was informed, at the lodging-houses of the Members of the Assembly, concerning my discourse.

On Wednesday, I preached at the house of Brother *Turner*. The Congregation seemed deeply serious, except three drunken men, who a little disturbed us. Here I received a receipt for a soreness in

the breast, occasioned by cold, or violent speaking, which has, it seems, proved very efficacious to numbers, and may be useful at least to some of the Preachers: viz. 'Take a pound of Tar, and two pounds of powdered or brown Sugar. Boil the whole (without water) on the fire in an iron vessel, till it be perfectly hard. Put about the bigness of a nut of it into the mouth night and morning, and suck it till it dissolve. If any remain, after the sweetness is gone, spit it out.'

From Brother *Turner's* I set out for Brother *Reyney's*, a Justice of the Peace; but was obliged to ride the whole of two days, and for two hours each night, though the atmosphere was very cold and damp in the evenings. In the course of this ride I dined with old Brother and Sister Willis, one of whose sons was a Travelling-Preacher for many years, and has indeed been an honour to the Gospel of our Lord and Saviour, from the time he was first acquainted with God. He was obliged to settle in business for want of health and strength.[37] But his Brother, the other Son, who was one of our Local Preachers, has embraced the sentiments of an eminent schismatic, James O'Kelly,[38] once a most useful Presiding-Elder, but now burning with zeal to make schisms wherever it is in his power. O'Kelly unhappily insinuated himself into the affections of the Local Preacher, who has in consequence prevailed upon his Father to permit O'Kelly to preach in his house. *Our* Preachers, who are now patterns of unity and concord, have determined to have nothing to do with disputes; and therefore, wherever O'Kelly and his associates are admitted, they immediately withdraw themselves without the least noise or disturbance. Poor old Mrs. *Willis,* after dinner, took us into a private room, and with tears streaming down her cheeks, intreated that the Preachers might return there again. But we informed her, at the same time that we endeavoured to console her as far as the case would admit, that it was become an adjudged case among us, that we would exercise no ministerial functions among schismatics, or any who

37. Henry Willis, born in Brunswick County, VA, entered the itinerancy in 1779 and, despite physical weakness, served in circuits ranging from New York to Charleston before retiring in 1794. He died in 1808 at Pipe Creek, Frederick County, MD (*Minutes of the General Conference of The Methodist Episcopal Church,* 1808, 157-58).

38. O'Kelly had been strongly opposed to the proposed 'Council' (see p. 157 n. 3 above). Following the defeat of his motion at the 1792 General Conference to introduce a right of appeal by preachers against their stationing, he led a break-away movement that became known as the Republican Methodist Church.

supported them: but that we were ready to return to them as before, if they would break off all connection with the friends of discord and confusion. O what a horrid thing is the spirit of schism! It has, I believe, injured the work of God in the different ages of the world, more than all the outward vices of mankind. It signifies but little to the individuals themselves, whether they be gross sinners or painted sepulchres: but the spirit of schism enters within the vail, nips in the bud all the fair blossoms of grace, eats up the vitals of religion, quenches the whole spirit of a revival, and substitutes the spirit of party for the life of God.

From Mr. *Willis's* we rode to Mr. *Byron's,* where we lodged that night, and next evening reached Mr. *Reyney's,*[39] where I spent two comfortable days, preaching the first day in his dwelling-house, and the second in our Chapel about half a mile distant. Mr. *Reyney's* family form a lovely company. His Son, who lives on an adjoining plantation, has eight children; and, what is worthy of notice, his Father and he never had a cross word in their lives. His son was just returned from a journey to the western world. In relating to us the particulars of his travels in *Kentucky,* and *Tenessee,* he described to us a remarkable rock, which continually yields a balsamic oil.[40] The oil, of which he shewed us a specimen, is exactly like balsam of sulphur both to the sight and smell, and possesses, I have no doubt, all its properties. It rises from the bottom of a fountain, and covers the surface of the water, from whence the inhabitants skim it off. It cures, they say, the tooth-ache immediately, and is an excellent remedy for rheumatic pains. It is universally used by the people of that part of the western territory, called Cumberland.

I have been led in the course of my travels on this continent, to make many remarks on the population of the country. In the plantations the houses are every where full of children, far beyond any thing I have seen in Europe: but it is very different in the towns, especially near the sea-coasts; which I attribute to the frequent fevers which rage there. According to the last Census, (or calculation of the number of inhabitants,) which was taken in 1790, with the probable increase since that time, there must be now about four millions of Whites, and one million of Blacks, in the sixteen States.

39. Perhaps William Rainey of Orange County, NC (Asbury, *Journal,* 1:621).

40. Oil seeping from rocks is common, but it has not been possible to identify this 'balsamic oil' to which Coke refers.

From Brother *Reyney's* we rode to *Pleasant-Gardens*,[41] where I was agreeably surprised by a large congregation, to whom I preached on the necessity of union with Christ, and found much comfort and liberty. I really expected from the name, to have found there some tolerable gardens, but, alas! like too many other things, it was only a name.

I had again hard rides in the night, till we came to Brother *Russel's*. I now found myself in a very romantic hilly country, the hills being very numerous, and continually dividing themselves into sharp points: and the tall pine-trees, which chiefly covered the country, though mixed with some oak, made the whole a most pleasing prospect, though in the winter-season. We were also favoured with a beautiful golden sky. O how charming does every thing appear, when the Sun of Righteousness shines upon the heart!

After preaching at our Chapel near Mr. *Russel's*, we rode to Mr. *John Randle's*, a most kind friend, truly happy in the love of God, though born deaf and dumb.[42] He is married to a pious and amiable wife, and blessed with religious children. I found it highly entertaining to converse with him by signs, and was astonished at the quickness of his apprehension, and with what ease I could convey my ideas to him by the means of signs: but when necessary, his good wife would assist me by her fingers. A Lawyer, who always boarded at the house during the sitting of the County-Court, would with great delight spend hours conversing with him in this manner.

From Mr. *John Randle's* I rode the next day to his Brother *William's*, where, the weather being cold, and the congregation small, I preached in his large parlour, in preference to our chapel; and the next day went to Brother *Threadgill's*, a Local Preacher and Justice of the Peace, who had a Congregation ready to receive me on my arrival.

Our next engagement was at *Anson's Court-house*,[43] which I reached about noon, after being wet to the skin. Here I had a small Congregation on account of the rain, and after preaching rode about eighteen miles to Brother *Plante's*, where a little company awaited

41. The Pleasant Gardens in McDowell County is in the western part of the state. There is a Pleasant Garden to the south of Greensboro, but this was known as Fentress until c. 1879 (Powell, *Gazetteer*, 388).

42. There was a John Randall in Stanley County, NC, for whom Randall Church, dating from before 1800, was named.

43. Anson County is in central North Carolina, adjoining the South Carolina border. It was formed in 1750 and named for Admiral George Anson. The county seat was Wadesboro (Powell, *Gazetteer*, 11).

me in his dwelling-house. The next day I preached in our chapel, about half a mile from Brother *Plante's*, to a considerable audience, and was favoured of the Lord with one of my best times. After preaching, I rode about twelve miles, and lay at the house of a pious Baptist. We had good beds, but nothing to eat, except very fat bacon: however, our kind friend and his wife gave us the best they had, and angels could do no more. At supper-time, while we were eating our fat bacon, the good man of the house lighted us with a piece of pine-wood, instead of candles. In the morning, as there was neither tea, coffee, nor milk to be had here, we made an apology, set off on our journey, and breakfasted at a tavern on the road. At night we reached another Tavern, where the pious landlady, being apprized of my coming, provided for me a little congregation, and gave us tea, supper, lodging, and breakfast *gratis*. Two families of gentlemen and ladies came in before preaching, and made part of my audience.

The next day we rode to *Campden*[44] in South Carolina, a tolerable town, containing about 200 houses. I lodged at the house of Brother *Smith*, formerly an eminent and successful Travelling-Preacher.[45] It is most lamentable to see so many of our able married Preachers (or rather I might say, almost all of them) become located merely for want of support for their families. I am conscious it is not the fault of the people; it is the fault of the Preachers, who, through a false and most unfortunate delicacy, have not pressed the important subject as they ought upon the consciences of the people. I am truly astonished, that the work has risen to its present height on this continent, when so much of the spirit of prophecy—of the gifts of preaching—yea, of the most precious gifts which God bestows on mortals, except the gifts of his only-begotten Son and his Spirit of Grace, should thus miserably be thrown away. I could, methinks, enter into my closet, and weep tears of blood upon the occasion.[46]

44. I.e., Camden.
45. Isaac Smith (1758–1834) was received on trial in 1784 and into full connexion in 1786 ordained deacon 1787 and elder 1789, but had located by 1798.
46. By 1797 this had become a major concern: whereas Asbury continued to advocate a celibate ministry, Coke was concerned to retain the more able preachers by providing for them after they had married and pledged himself to finance some of them from his own resources. Several of his letters to Ezekiel Cooper at this period revert to the loss of married men from the itinerancy; e.g., his letter of 12 January 1799, where he writes: 'I have known America for fourteen years, and when I consider what a number of holy, experienced, zealous, able men have been cast aside, & rendered comparatively useless through this great evil, I am sometimes grieved above measure' (see Vickers, *Thomas Coke*, 248-49).

Many of the inhabitants of *Campden*, as I was informed, are Deists, so I endeavoured to suit my discourses accordingly. After preaching two sermons in this town, and one at Brother *Lenore's*, a planter, who lives a few miles from *Campden*, we set out for Brother *Lambert's*, who is descended from French ancestors, and of considerable property. On Christmas-day I preached at our Chapel in the neighbourhood, on the History of the Wise Men, and afterwards administered the Lord's Supper. About dinner-time, a son of Brother *Lambert's* related to us the following interesting anecdote: 'A rakish Gentleman at *Columbia* (the seat of Government for *South Carolina*, and not far distant from Mr. *Lambert's*,) had, (about a fortnight past,) drank immoderately for three successive nights; by which he brought on a fever, which ended in his death. A little time before he died, he asked his physician, whether there were any hopes of his recovery. On the physician's answering in the negative, and that he had probably but a few days at farthest to survive, he ordered the people around him to lay him out as a corpse. When this was executed, he desired them to go to several of his rakish friends, and to inform them he was dead, and that he had made it his dying request, that they would come immediately after his decease, and take a parting view of his dead body. His friends accordingly came; and while they were making their remarks on the supposed corpse, he sprung up out the bed in a moment, threw his arms round their necks, and gave each of them a smart kiss; immediately after which he returned into bed, and the next morning expired.' It is astonishing what force there is in the modern Philosophy, to make the conscience as hard as a stone!

From Mr. *Lambert's*, we set off for brother *Moore's*, who was once also a very useful Travelling preacher.[47] The location of so many scores of our most able and experienced Preachers, tears my very heart in pieces. Methinks, almost the whole Continent would have fallen before the power of God, had it not been for this enormous evil. At brother *Moore's* we had a room full of precious souls all alive to God.

On the next day I preached at one of our Chapels not far distant from brother *Moore's*, and administered the Lord's Supper. We permitted a good many to remain spectators at their own earnest

47. Mark Moore (1765–1824) was received on trial in 1786 and into full connexion in 1788; ordained deacon 1789; located 1799.

importunity; and observing that several young women who were not Communicants, were under deep concern, we invited them, when the Sacrament was over, to draw near to the table, that we might pray particularly for them. They did so, with tears streaming down their cheeks; and we were favoured with a most profitable time, not only for them, but for all who were present. I find it is a common custom for our Elders, on such occasions, to invite those who do not chuse to communicate, to draw near to be prayed for; and that almost always some accept of the invitation.

After the service we mounted our horses in order if possible to reach a village called *the Corner*. But there was a great swamp, as well as a broad, ferry, in our way. When we came into the middle of the swamp, it was almost night. In one place the planters had laid down about a hundred logs of wood, which they call *puncheons*, in order to mend the road: these, owing to the heavy rains, were loosened, and floated on the water which covered the road. We first endeavoured to drive our horses over them, but all in vain; we then ventured into a deep ditch, in order to go round them, but in this also we failed; so that we were obliged to return back in the dark through a miserable road, till we arrived at the house of a little Planter. He very kindly took us in, and gave us a roasted turkey for our supper, and the best beds in his house to lie on. In the morning he took us five miles round through the woods, and brought us into the road beyond the puncheons; when to our great surprise we met a Gentleman who had driven his horse over the puncheons: however, he was thoroughly wetted, for the poor beast had fallen with him two or three times. Soon afterwards we crossed the broad ferry; and then, as usual, I saw the hand of Providence: for my horse was exceedingly restive, and would very probably have overturned the boat, if we had crossed in the dark the evening before.

When we arrived at *the Corner*, I expected to preach: but no notice having been given by the Preacher who went before me to make my publications, and being much fatigued with a long journey, I rested that evening; but was afterwards very much grieved, when I was informed, that the people expected to be called together, and to have a sermon in the parlour of the Tavern, and that they had not had Divine Service for twelve years! O what a blessing it is to enjoy the sound of the Gospel! how little value do too many fix on the privileges they enjoy!

From *the Corner* we set off for *Charleston,* and in the evening arrived among our dear friends in that city. Brother *Asbury* came in the same day from his route by the sea side; and we mutually rejoiced to see each other's face. On this day's journey we saw a noble Eagle, standing on the top of a tree, and looking calmly at us. This whole journey was very pleasing. The weather was continually mild, a few days only excepted. The lofty Pinetrees through which we rode for a considerable part of the way, cast such a pleasing gloom over the country that I felt myself perfectly shut up from the busy world, at the same that I was ranging through immeasurable forests. How many blessings of a temporal kind does our God mix in our cup, besides that crowning blessing—the consciousness of his favour! How inexcusable therefore would it be to murmur, when enjoying so many comforts, even in a state of probation! O what must the rivers of pleasure be, which flow at his right hand for evermore!

While I continued at *Charleston,* we held our annual Conference for the States of *South Carolina* and *Georgia,* and for part of *North Carolina;* in which every thing was settled with the utmost harmony and concord. In the Virginia Conference there was a great deficiency of Preachers, which was nearly made up by the surplus in the present. Here we received a pressing invitation to send Missionaries to *Providence-Island,* one of the *Bahamas;* but were all of opinion, that the British Colonies should be supplied from *Britain* or *Ireland.* Indeed our American Societies have neither men nor money to spare. O that God would in his infinite mercy raise more faithful labourers for his work, and incline the hearts of the rich to assist us in carrying on our extensive plan for the enlargement of his Kingdom!

We now received an account of the burning of our Academy and Church in *Baltimore.*[48] Some boys were making a bonfire of shavings in the adjoining house, which set on fire the whole building, and communicated itself to our Church and Academy; which, with several adjoining buildings and ware-houses, were burnt to the ground. By this misfortune, and the burning of *Cokesbury*-College, we have lost about 10,000 £ Ster. Brother *Asbury* and I were now

48. For the academy next to the Light Street Church and the fire that destroyed them on 4 December 1796, see Baker, *Incredible Methodists,* 72. This was the end of an ill-fated venture, to Asbury's relief in particular.

clearly of opinion, that the will of God was evidently manifested; and that the Methodists ought not to enter into such expensive popular undertakings, but bend their whole force to the salvation of souls. O that all this money had been laid out for the support of a married ministry! The Churches, we found, were offered very generally to our friends in *Baltimore;* one of which, the elegant and commodious Presbyterian Church belonging to Dr. *Ellison,* they gratefully accepted of for their afternoon Service. Our two remaining Churches, which are but small, answered every other purpose, though with considerable inconvenience.

Charleston has lately suffered extremely by two conflagrations, both of which happened in the course of a month. About 600 dwelling-houses, besides warehouses, and a large quantity of valuable effects, were destroyed. Some suspected persons were taken up, but there being no evidence against them, they were soon discharged. In *Savannah* in *Georgia,* also, they have had three conflagrations, the last of which nearly consumed the small part of the town, which the two former had left remaining. In *New York,* not less than 40 houses were lately burnt down. Surely the judgments of God are upon the earth! Though the Lord has been pleased in these States, for the present, at least, to sheath the bloody sword, yet the pestilence, inundations, and conflagrations, have made a terrible havock through the land: but, alas! the greatest part of the inhabitants, it is to be feared, have refused to learn righteousness! However, I have flattering hopes, that the uncommon, yea, the perfect concord, which reigns throughout our American connexion, will, under the Divine Blessing, produce the most excellent effects.

Poor *William Hammett*[49] is now come to nothing. When he began his schism, his popularity was such, that he soon erected a Church, nearly, if not quite, as large as our New-Chapel in *London;* which was crowded on the Lord's-day. But, alas! he has now upon Sunday evenings, only about thirty white people with their dependent blacks. He has indeed gained a sufficiency of money to procure a plantation, and to stock it with slaves; though no one was more strenuous against slavery than he, while destitute of the power of enslaving. During his popularity we lost almost all our congregation and Society: but, blessed be God, we have now a

49. See p. 73 above.

crowded church; and a Society, inclusive of the blacks, amounting to treble the number which we had, when the division took place: and our people intend immediately to erect a second Church. I can truly say, that the more I am acquainted with the devices of Satan, the more I detest the spirit of schism!

Our Society of blacks in this city are in general very much alive to God. They now amount to about five hundred. The Lord has raised up a zealous man, Mr. *M'Farland,* a Merchant, and partner with the late Mr. *Wells.* He amply supplies the place of his valuable deceased partner. His weekly exhortations to the blacks are rendered very profitable. It is common for the proprietors of slaves to name their blacks after the Heathen gods and goddesses. The most lively Leader among our negroes in this place, has no other name but *Jupiter;* he has a blessed gift in prayer; but it appears to me extremely odd to hear the Preacher cry out, '*Jupiter,* will you pray.'

A Lady of the name of *Hopeton*[50] lives in this city, a woman of large fortune, and between seventy and eighty years of age. Mr. *Wesley* dined with her, as he was returning home from *Georgia.* When she heard of Mr. *Hammett's* introducing Methodism on Mr. *Wesley's* original plan, she sent him an invitation to her house; and when he entered her parlour, she took him by the hand, and informed him of the honour she had received in the company of Mr. *Wesley;* and that she was happy to shew respect to one who so highly revered his memory, and trod in his steps. But, alas! he has so sickened her of the gospel that I have no hopes that she ever will again attend a Gospel-ministry.

During my stay in *Charleston,* I endeavoured to raise a congregation for my French friend Mr. *Pontavice.* By publishing him in our own congregation, and advertising him in the public papers, about a hundred and fifty or two hundred of the French attended twice. His first sermon, on the evidences of Christ's being the true Messiah, was very excellent indeed; and, notwithstanding all the lightness of spirit which might be easily discerned in the audience, commanded attention. But the second time he wanted liberty. However, I could perceive, that if God was pleased to open a door for him among the French, he would probably be an useful Preacher of the Gospel.

50. Not identified. Wesley left Savannah on 2 December 1737, and reached Charleston on the thirteenth. From there he sailed for home on the twenty-second. There is no extant diary for this period, and his *Journal* does not mention Mrs. Hopeton.

In this city, which contains only about twenty thousand inhabitants, they have two public theatres: and the people in general are much more devoted to pleasure, than in any part of *Great Britain* or *Ireland*. From all the observations I have been able to make, I can perceive that the inhabitants of the United States are verging rapidly into two grand parties—real Christians and open Infidels. I confess, I have my doubts, whether religion had gained ground or not on this Continent, since my last visit. But of one thing I have no doubt—that *O'Kelly* and his schismatic party have done unspeakable injury to the cause of God.

I spent my leisure-hours for the last three months in writing annotations on all the parts of the Methodist Economy. Mr. *Asbury* had before drawn up his thoughts at large on the subject. I therefore endeavoured to unite our ideas; and think that if ever I drew up any useful publications for the press this was one of them, and perhaps the best.[51]

On the 6th of February,[52] 1797, we went on board an American ship bound for *Glasgow*. Our Captain, a Scotchman, was a kind, attentive man; so that our passage on the whole was very agreeable. For twenty-five days we had very tempestuous weather; but the wind was all the way in our favour, and brought us in that time to the mouth of the Southern Irish Channel. The waves, through the violence of the wind, had beat down and carried away on both sides, the wainscot which guarded the deck; so that for a considerable part of the voyage I dared not sit down much less walk upon the deck. One afternoon we were pursued by a ship, which had all the appearances of a privateer; but the night coming on, our Captain steered half a point out of his course, and in the morning we saw no more of our pursuer. Three days we were detained by contrary winds near the Irish coast, till at last the Captain, filled with anxiety for fear of the French, determined to steer for the North Channel, which is the most rocky and dangerous. In this Channel we were kept by almost constant calms for sixteen days. For a whole fortnight we saw no vessel, not even a fishing-boat, coming from either *England* or *Ireland;* which made us apprehend

51. This was the 9th edition of *The Doctrines and Discipline of the Methodist Episcopal Church in America . . . to Which Are Added the Minutes of the General Conference Held at Baltimore, October 20th, 1796* (Philadelphia: Henry Tuckniss, 1797).

52. Asbury's *Journal* says the 10th.

that on some awful account a general embargo had been laid on all the shipping. One day a Liverpool Guinea Ship, a very swift sailer appeared in view, and of a sudden crowded sail, and bore down towards us. Our Captain seemed assured that she was a French Privateer, and gave us up all as lost: but presently she passed by us, and we found it was only a miserable joke. However, the Captain of the Guinea-Ship afterwards made some atonement; for on the following night we suddenly perceived something like a large bright star: but while we were all admiring it, our Captain cried out, it is a light hung out by the Captain of the Guinea-Ship, to warn us of some dangerous rocks; which we afterwards found to be really the case. How graciously and continually does the providence of our God interpose in our behalf!

During our detention in the Channel our Captain manifested something like superstition. I was reading with deep attention a Folio-book on the Bible. Frequently during the calms the Captain cried out, 'I wish that book was finished.' At last he burst forth, 'We shall never have a wind, till that book is finished.' I then told him, that I would lay the book aside. 'No,' said he, 'that will not be sufficient. It must be finished, or we shall have no wind.' I doubt not but he was in some measure confirmed in his opinion; for just as I had finished the book, the wind sprung up and in six and thirty hours brought us into harbour.

Thus did the Lord in his infinite love and condescension bring me through every trial and difficulty safe to my native land. Blessed be God, I have had seals to my ministry during the present voyage. At the *Virginia*-Conference I met with a Welshman who was awakened under my preaching, and is now become a Travelling Preacher in America: let all the glory be given where it is due!

On the 22nd. of March we landed at *Greenock*. The next morning we set off for *Glasgow*, where I spent four very agreeable and profitable days among my Methodist Friends. Surely I can say with the Shunammite, 'I live among mine own people.'[53] It is the best situation this world can afford us, to be conversant with the world only from the Pulpit, and to be at all other times, either on the mount with God, or in company with his Children. On the Sunday evening several hundreds who came to the Chapel, were

53. 2 Kings 4:13.

obliged to return for want of room; and a more attentive congregation I never preached to. Mr. *Warrick*,[54] the Superintendent of the Circuit, had lost his excellent wife a few days before my arrival; so that his house was a house of mourning.

On Monday the 27th. I set out for *Ayr*, where I preached in the evening, and the next day reached *Port-Patrick*. Frequently in this journey I was led into serious meditations on the miserable state of religion in *Scotland*, and of the cause thereof: and to Antinomianism, that bane of inward holiness, I was obliged to refer the whole. There was a time, when *Scotland* was the glory of all the Churches; but that time is passed. Speculative knowledge is the all in all among the generality of the Professors; whilst the Infidels who compose a very considerable part of the nation, beholding nothing in religion but a bare profession—nothing of that image of God, which is the only desirable thing in the universe—fly naturally to Deism for a refuge from hypocrisy. And who can be surprised? For what sensible man in the world can believe, that God would give his only-begotten Son to die upon a Cross, in order to make us *orthodox*? Never will *Scotland* rise again out of its ashes, till the Antinomians and Hypocrites become in general Infidels, and the little City on the Hill begins to shine through the nation. Nor have we, I am persuaded, any object in view, worthy of our present toil and expenses in that Kingdom, but the preservation of a seed of grace to wait for that blessed day! I by no means confine my ideas *of a seed of grace* to the faithful who hold the doctrine of General Redemption. But when the Lord is pleased again to visit *Scotland* with times of refreshing, we shall certainly be glad to give a helping hand, to make that country flame again with the glory of God! There is nothing, which can more clearly evidence the height to which Antinomianism has arisen in *Scotland*, than that single circumstance—that the most zealous Professors in the land should consider one of the most eminent Divines, who have lived since the times of the Apostles, Mr. *George Whitefield*, as an Imp of the Devil! The effusions of the Holy Ghost, the pressing of mourners through the pangs of the New Birth into the liberty of God's Children, the witness of the Spirit, and all those deep experimental truths of Christianity, which, when

54. Thomas Warwick entered the ministry in 1778 and died in 1809. He was in the Glasgow Circuit this one year only.

realized to the soul, form it into the image of God, seem to be entirely forgotten among them.

It was in this city, that several years ago, my congregation was so thickly stowed before I came to the Chapel, that they were obliged to raise me up, and hand me from shoulder to shoulder, till they brought me to the pulpit: they then heaved me over the pulpit-door, as it was impossible to open it, without obliging a part of the congregation to go out of the Chapel.

On the 29th of March we crossed the Channel to *Donaghadee*. A Collector of the Customs gave me some trouble in respect of my friend Mr. *Pontavice*, though with great politeness, and, I believe, from a sense of duty. On promising to deliver a letter from him to the Sovereign, (the Mayor,) of Belfast, he suffered us to depart.

On the 30th, we arrived at *Belfast:* the Sovereign, on my leaving the Collector's letter at his house, waited on me with the Rector of the parish. He brought with him a volume of the Statutes of the Realm, in order to shew me that he did not wish to offend me, but simply to fulfil his duty. Afterwards he informed me, that he could not suffer Mr. *Pontavice*, as a French emigrant, to leave *Belfast*, till he had consulted Mr. *Pelham*, the Secretary of State, to whom he should write in the evening. I also wrote a letter to Mr. *Pelham*, which the Sovereign inclosed in his own; and in three days I received a very polite answer, inclosing the Lord Lieutenant's pass through the whole kingdom, for Mr. *Pontavice*. On all occasions, the Governments of *England* and *Ireland* have been ready to oblige us; and we should be very ungrateful if we were not duly sensible of their favours.

In this town, I had the use of the large Presbyterian Meeting-house, (which is, I think, larger than our New Chapel in London,) during the week I spent in that town.[55] My congregations were much larger than they formerly had been, partly, perhaps, on account of the convenience of the place. On the Sunday evening the Meeting-house was crowded. I preached for about three quarters of an hour, and found considerable liberty in addressing myself to backsliders: when, all of a sudden, a sergeant in the army, who had formerly enjoyed the love of God, but had grievously back-slidden, rose up, and spoke for about ten minutes,

55. The Presbyterian (now verging on Unitarian) meeting-house had opened in 1783. John Wesley preached there on 8 June 1787 and again on 8 June 1789.

giving glory to God for his restoration at that time. The Lord, it seems, during the sermon, had not only deeply convinced him of the error of his ways, but had also, a few moments before he spoke, revealed himself to him, and so filled him with divine love, that he was irresistibly drawn to bear a public testimony of the goodness of God towards his soul. I was afterwards informed that a report had been circulated round the town, and had even reached to Londonderry, that I had bribed the soldier with five guineas to speak at the time and in the manner he did!

On the 5th of April, I visited *Downpatrick* for a couple of days. On the second day, my friends took me to the cathedral, which has been lately rebuilt; where thro' their importunity I was prevailed upon to climb up the high tower of the cathedral for the sake of the prospect. But I was taught a lesson by it. I felt that old age was creeping on me apace; for my limbs were so fatigued, as to feel the effects of it for several days.[56]

On the 7th, I came to *Lisburn*, and stayed there till Monday. Here also I was favoured with the large meeting house: and had the pleasure of seeing again my highly esteemed friends, Brother and Sister *Johnston*.[57] Indeed it is quite a privelege [sic] to look at their cheerful, serene, heavenly old faces! They are truly pillars in the church of God.

On the 10th, I preached at *Ballymena*. In this place there is an innkeeper, who is the most horrid blasphemer of the truths of Christianity, that perhaps exists upon the earth. His expressions, I am informed, are of the most shocking kind which can be conceived. He also takes the utmost pains to bring up his children in the same way; and takes delight in hearing them blaspheme and exert their wit against Christianity. What a merciful God have we to deal with! O how thankful should we be for the difference which Grace has made betwixt such men and ourselves!

56. Coke was, in fact, approaching his fiftieth birthday, having been born in September 1747. But he was already inclined to corpulence.

57. John Johnson (1724 or 1725–1803) entered the itinerancy in 1755 and from 1758 until his retirement in poor health in 1767 was stationed in Irish circuits. He was highly esteemed by Wesley, who for a time treated him as general superintendent of the Irish work. In 1771 he settled at Lisburn, where he was involved in building and then enlarging the first chapel. Mrs. Dorothea King, a widow of Lisburn, became his fourth wife in 1784. As a leader of several classes and bands, she contributed to the growth of the Lisburn society and was one of Wesley's favourite correspondents.

On the 11th, I arrived at *Coleraine,* and remained there till the 14th. One day at breakfast, and another at tea in the afternoon, above a hundred of the Society favoured me with their company in the preaching-house. They sing delightfully; particularly, 'Lo! He comes, with clouds descending, &c' When I took my leave of them, they were greatly affected from an apprehension that they should never see me again on this side the grave. I must leave others to guess at my own feelings; for I cannot express them.

On the 14th, I preached at *Newtown-Limivaddy.* We had here several inattentive hearers, till I spoke so personally to them on the necessity of being born again, that their attention seemed to be a little awakened. After preaching, I had a precious season with the Society at the Lord's Supper.

The next day I arrived at *Londonderry.* On Sunday, I preached in the meeting-house in this city. It was filled with all sorts of people: among others, there were many Roman Catholics. But I forgot myself, and preached too long a sermon. For about three quarters of an hour the whole audience heard me with great patience; and I have no doubt but there were hundreds present, who were more or less affected; but, alas! I continued to preach for about half an hour longer, till at last the rabble, which composed a part of the congregation, became exceeding disorderly. On this, I spoke to them with a degree of sharpness, which I afterwards repented of. O how difficult it is to be always on our guard, and to speak only what will bear the strictest examination and deepest reflection! However, on the next evening, the congregation which filled our preaching-house, made ample amends; for they heard with attention still as night; every word seemed to distil like oil into their hearts.

On the 18th, I preached at *Newtown-Stewart.* Here I found myself in the midst of a zealous people. Their loud Amens, accompanied every animating expression.

On the 19th, I went to *Dungannon,* and lodged at the house of my dear friend *Hethers,*[58] who is nine parts a Methodist, and one a Quaker. His excellent wife received her first religious impressions under my ministry; to Grace be all the glory. While I was preaching

58. George Heather of Charlemont, south-east of Dungannon, entertained the Methodist preachers until his wife died; cf. C. H. Crookshank, *History of Methodism in Ireland,* 3 vols. (Belfast: R. S. Allen, 1885–88), 2:51-52.

here to a large congregation in the Presbyterian meeting-house, a backslider was restored to the liberty of the children of God.

On the day following I went to *Charlemont*. In this little town, I have had many blessings, and always large congregations.

On the 21st, I arrived at *Armagh,* and lodged at the house of my respected friend Mr. *Livingston*. Two years ago, I was confined to my bed in this house with a bilious fever for eleven days; and the kindness and attention of this family, and of Dr. *Atkinson* my physician, can never be obliterated from my memory. For a little time, in the course of the fever, I was delirious, when I fancied that a large congregation was assembled in the grove near Mr. *Livingston's*, waiting for the travelling preacher. (I had once or twice preached in this grove.) My physician, it seemed to me, was standing by my bedside; on which I addressed him, 'Doctor, I am not afraid to die; I therefore conjure you to tell me faithfully my situation.' The physician, I thought, answered, 'Sir, you have not many hours to live, perhaps not more than one.' 'Then, Doctor,' I replied, 'do me the favour of going down to the congregation and send up six strong young men of our society, who may carry me down to the people in my bed, that I may preach for an hour, and die; and let some boards be formed into an inclined plane, on which my bed may be laid.' Everything, I imagined, was done accordingly. The frame of wood was prepared; the six young men came up, and carried me, bed and all down to the grove, placed me on the frame of wood, and I preached for an hour, and died. But when my soul was mounting up to heaven, I first turned round, and suspended myself in the air, to see how things would go on in the congregation. The physician was immediately sent for; who, after feeling my pulse and temples, pronounced me dead: and a very solemn, awe, I thought, rested on the whole audience. The whole scene had made such a deep impression on my mind, that when I came to myself, I remembered exactly every particular. For forty-eight hours I had a dreadful headache: during which time I was continually and involuntarily repeating to myself with some little alteration, those words of the hymn,

> Happy, if with my latest breath,
> I may but gasp his Name;
> Preach him to all, and cry in death,
> Behold, behold the Lamb![59]

59. This is the closing verse of Charles Wesley's 'Jesus, the name high over all'; 1780 *Collection of Hymns*, no. 36, st. 7 (Wesley, *Works*, 7:126).

In this city, as in most other parts of the North of this kingdom, martial law was enforced; though not with the strictest rigour.[60] On the second day of my visit in this place, my friends shewed me the Primate's palace, in which are many capital paintings, particularly those of the present King and Queen, (which were given by his majesty as a present to the late Primate,) King *William* and Queen *Mary*, Queen *Anne*, the Princess *Sophia*[61] from whom the present Royal Family are lineally descended, and her husband. In the library were portraits of all the Primates for several ages; the faces of two of them were heavenly: they indeed evidenced, that the mild gentle, crucified spirit of the Christian, had inhabited the persons, which those faces pourtrayed: I could have looked at them for hours. The present Primate[62] is a man of a very amiable disposition, and of great learning; his Commentary on the Minor Prophets[63] is an indubitable proof of the latter. I knew him at Oxford, when he was fellow and tutor of Hertford College. In the library was an admirable Polyglot, containing the Bible in nine languages, with two Latin expositions. We then visited the demesne, the gardens and hothouses; all of which, with the palace, were the gift of the late Primate, Dr. *Robinson*.[64] Dr. *Robinson* possessed a noble soul. The churches he re-built and endowed, and the charities he instituted, certainly evidenced a very beneficent mind. Before we took our leave of this beautiful place, we visited the chapel, which is within a few yards of the palace. It is neatness, simplicity, and elegance in great perfection; but, alas, it is never used! What harm would it do to the church or the world, if the Methodist Preachers were suffered to preach there the everlasting Gospel of Jesus Christ! At least, the money it cost, might have been made a blessing to hundred of the poor! In this chapel is a window, on which is painted the history of the merciful Samaritan in a very masterly and affecting manner.

60. For the impending Irish trouble, see p. 243 above.

61. The Princess Sophia (1630–1714), electress of Hanover, was the mother of King George I.

62. William Newcome (1729–1800) went to Pembroke College, Oxford in 1745 and was elected fellow of Hertford College in 1753. He became Archbishop of Armagh in 1795, after holding several Irish bishoprics.

63. William Newcome, *An Attempt towards an Improved Version, a Metrical Arrangement, and an Explanation of the Twelve Minor Prophets* (London: J. Johnston et al., 1783).

64. Richard Robinson (1709–94), first Baron Rokeby, had been a near contemporary of Charles Wesley at Westminster School and Christ Church, Oxford. He progressed through several Irish bishoprics to the primacy in 1765. He was remembered for his improvements to the city and Anglican cathedral of Armagh and for providing many of the larger parishes with chapels of ease.

From the Primate's, my friends took me up to the cathedral, which is a very poor place for the metropolitan church of all Ireland. Some of my young brethren ran up to the top of the tower, and called me after them; but I remembered *Downpatrick*, and saved my limbs. But what crowned the whole, is this—that the *Armagh* circuit is in a very flourishing situation; eleven new societies have been added this year; and the Lord is pouring out his Spirit remarkably on the congregations in many parts of the circuit.

On Sunday the 23rd, in the afternoon, I preached at *Tanderagee* to a very large congregation. After preaching I made a visit to the Revd. Dr. *Leslie*, for whom, our late venerable Father in the Gospel entertained a great esteem.[65] The good old gentleman is now eighty years of age, if not more; and the amiableness of his disposition, joined with considerable learning, makes him beloved of rich and poor. In the evening I returned to my worthy friend's, Mr. *Patten*.[66] On my former visit to this town I had the privilege of preaching in a great man's park in this neighbourhood, where the vast congregation before me, and the beauty of the place, rendered the scene exceedingly animating; but, alas! the generous Master of the demesne is dead, and is succeeded by a gentleman of a different disposition; so I was now obliged to preach among the rubbish near our own preaching-house. But these things affect not God; he was peculiarly present, notwithstanding our humble situation.

On the 24th, I visited *Warren's-Point*,[67] where I preached in our little chapel by the sea-side. The situation is romantic, and the society loving. From thence the next day I returned to *Newry*, through which I had passed the day before; where I spent two days, preaching in the large meeting-house. The kind minister, who had lent me his place of worship, particularly pleased me in the following instance. On my return to the vestry-room, after preaching the first evening, he begged to have the liberty of carrying home my scarf. It was very dirty; but the next evening he brought it back with him before preaching, nicely cleaned. Alas! this poor town is torn in pieces by faction and insurrection. The most cruel acts of barbarity are daily perpetrated. What a proof of the depravity of human nature!

65. The Reverend Dr. Henry Leslie was rector of Tandragee, east of Armagh. See Wesley's approving comments on the rector and his parish church in the *Journal* for 13 June 1773.

66. Possibly connected with William Patten, who became an itinerant in Ireland in 1794 and two years later offered for the proposed Foulah mission in West Africa. He left the itinerancy in 1798.

67. Warrenpoint on Carlingford Lough, south of Newry.

On the 30th,[68] after riding thirty Irish miles,[69] I arrived at *Cootehill*. We have here a new preaching house; but as it was not large enough for the congregation, I preached in the Presbyterian meeting house.[70] I am quite astonished, when I consider every circumstance, that the clergy of the Established Church are not more kind and condescending to us than they are! I gave out before preaching two favourite hymns, peculiarly suitable to the text on which I intended to preach, but the congregation could raise no tune to either of them, this induced me to change my text, and herein I afterwards saw the hand of God. For I had reason to believe that my sermon was made a general blessing to the congregation. Ministers of the Gospel frequently perceive the interference of their Lord in matters of this kind, which appear little or enthusiastic in the sight of the world, but are of great moment in the judgment of heaven. On my former visit to this place, one of my friends introduced me to the Earl of *Bellamont*,[71] who is justly reckoned a pattern of politeness. We breakfasted with his Lordship, who made us a present of a piece of ground and twenty pounds, in order to erect a preaching-house in this town; our brethren raised the rest and finished the house. The Earl took us to see the ground, and then accompanied us to preaching. His park and the other parts of his demesne are exceedingly beautiful. What justice do I continually see in those words of our Lord, 'It is easier for a camel to go through the eye of a needle, than for a rich man to enter into the kingdom of heaven.' But, 'what is impossible with men, is possible with God.'[72] He who can with infinite ease compress the matter of the camel to go through the eye of the needle, can save a man of riches and power, surrounded as he is with every temptation to luxury and ambition.

From *Cootehill* I went to *Cavan*, a poor dead place; however the congregation was attentive. Sunday, the 29th, I spent at *Clones*. In

68. An error, since in the next paragraph he is in Clones on the 29th.
69. An Irish mile was 2,240 yards, compared with 1,760 yards in England.
70. John Wesley had preached in this meeting-house on 23 May 1778 to a congregation that included 'Seceders, Arians, Moravians, and what not' (*Works*, 23:88).
71. Charles Coote junior (1738–1800) was created Earl of Bellamont in 1767. He was the grandson of the Thomas Coote who built Bellamont at Cootehill (described as 'Ireland's finest Palladian mansion'). He gave a site rent-free for a chapel at Cootehill and twenty guineas towards the cost of building. Despite this and what Coke goes on to say of him, he had the reputation of a profligate who fathered numerous illegitimate children (Crookshank, *History*, 2:93-94).
72. Mark 10:25-27, etc.

this town I have been often favoured with blessings from the Lord. Some years ago, on a Sunday morning, while I was preaching here on the history of the wise men, a most solemn awe rested on the whole audience. When I had concluded the service, the congregation retired: but some of them in the rear observing a few remain, (as a class-meeting was always held in the preaching-house after the Sunday morning's preaching) they returned, and to our astonishment, the whole congregation returned after them. There being several Preachers present, we held a prayer-meeting, which continued about four hours; in which time thirty mourners were set at liberty; and two bore testimony, that God had revealed his perfect love to their souls.

May 1st, I preached at *Brookborough*[73] in the yard of my friend Mr. *M'Cartney*,[74] to a large attentive congregation. The word seemed to distil like dew into the souls of this simple hearted people.

On the 2nd, I went to *Enniskillen*, where our late venerable Father in the Gospel once nearly lost his life.[75] The mob intended to way-lay him on a bridge, over which he was to pass, and to throw him into the lake which surrounds the town. He probably would have fallen a sacrifice to the fury of that deluded people, if his God, ever watchful over him, had not defeated their nefarious purposes. Mr. *Wesley* received intelligence of their design just as he was sitting down to dinner, and immediately set off. The mob were then just beginning to collect; but Mr. *Wesley* coming so early and unexpectedly upon them, they were not prepared to attack him; so he galloped through them with a preacher before him. I happened, in the course of Providence, to be the first who preached peaceably out of doors in this place. But now we have a little chapel, where I had a good congregation, chiefly made up of the neighbouring societies. How difficult it is to pass through life without displeasing, even when our motives are ever so justifiable. I omitted to visit the precious society at *Sidare*, near this town, whom, I think, I never before had passed by. I found that they were exceedingly hurt. I therefore made a public apology, and promised that if it pleased

73. Brookeborough is east of Enniskillen.
74. An obituary of his son, James M'Cartney of Maguiresbridge, in *Primitive Wesleyan Magazine*, 1872, 315, confirms Coke's spelling of the name. (Wesley's *Journal*, 26 May 1789, gives it as M'Carthy.) The Brookeborough home was a refuge for both Wesley and his preachers.
75. For this incident, see Wesley's *Journal* for 24 May 1773.

Divine Providence to bring me into that country again, I would not neglect them. They deserve my affection, as my own soul has often been remarkably refreshed among them.

From *Enniskillen* I went to *Violet-Hill* (Mr. *Bradshaw's*).[76] Our dear friend Mr. *Bradshaw* has suffered very considerably from some unaccountable cause, a large quantity of the linen in his bleaching-yard being burnt into small holes, as it lay upon the grass. In this country-place an excellent Sunday School has been instituted, of which the three Miss *Bradshaws* are the life and soul. I consider the establishment of Sunday Schools as one of the greatest blessings that these nations have been favoured with. I most sincerely wish that every Methodist Society in the world supported a Sunday School.[77] We do much in this way at present; but if our exertions were unanimous and universal, we should, I believe, prepare the rising generation for a general revival.

Next day I reached *Annadale*, (Mr. *Slack's*). The family of *Annadale* I have long known and loved. But, alas! the Queen of the Dale, Mrs. *Anna Slack*, has suddenly taken her departure to heaven. Here I rested two days, preaching each day in the dwelling-house.[78]

I have now travelled through the province of *Ulster*; but how graciously and wonderfully have I been preserved! The whole province is in a violent agitation, and seems preparing for some astonishing blow. I should not be surprised, unless God be pleased to defeat the designs of the wicked, if a second general massacre take place in *Ireland*.[79]

76. Violet Hill was near Florence Court, south of Enniskillen, County Fermanagh, and in the Ballyconnell Circuit. A descendant of William Bedell, bishop of Kilmore and Ardagh, Daniel Bradshaw came under the influence of Methodism and in 1794 began a flourishing Sunday school in which he and his four daughters taught (*Primitive Wesleyan Methodist Magazine*, 1852, 317-19).

77. The earliest Sunday schools were the result of such local initiatives as the work of Hannah Ball in High Wycombe in 1769 and proliferated after 1780 through the encouragement of Robert Raikes's venture in Gloucester. They did not receive formal support in Wesleyan Methodism until well into the nineteenth century.

78. Mrs. Angel Anne Slacke (1748–96) had been converted through the Dublin Methodists c. 1780. Her home, Annadale, south-east of Carrick-on-Shannon, became a haven for the Methodist preachers (see Wesley, *Works*, 24:29n27).

79. Coke rightly anticipated the civil unrest that erupted the following year. A rising by the United Irishmen, with French encouragement, was brutally suppressed. For Coke's involvement in the events of 1798, see Vickers, *Thomas Coke*, 226; and Coke's letters to Ezekiel Cooper, 18 December 1798; 12 January 1799 (both in Garrett-Evangelical Theological Seminary archives).

1797

LETTER TO JOHN PAWSON, DESCRIBING HIS VOYAGE TO AMERICA

INTRODUCTION

No journal accounts of Coke's last three visits to the United States (in 1797–98, 1800, and 1803–4) have survived, and it is probable that he kept none.[1] *The following letter, published after his death in the* Methodist Magazine *(London) for 1814, pages 125–30, records an incident during the outward voyage in the autumn of 1797. Coke was at this period something of a shuttlecock being lobbed back and forth between the two connexions, each of which had claims on his services. On this occasion he was hurrying to reach the Virginia Conference in order to present a letter from the British Conference requesting his release from his American commitments because he was needed in England following the Kilhamite schism. The Virginia Conference consented to 'his return and partial continuance,' stressing Asbury's increasing age as a reason for needing his presence in America.*[2] *This response was in due course endorsed by the General Conference meeting in Baltimore in May 1800.*

Some details of the voyage are given by J. W. Etheridge in his life of Coke, taken from an unidentified source that I have been unable to trace, though clearly deriving from Coke himself. He embarked on 28 August at

1. For such details of these visits as can be gleaned, see Vickers, *Thomas Coke*, 240-47.
2. Cf. Asbury, *Journal*, 3:167ff.

245

Liverpool on an American schooner named **The President** *commanded by Capt. John Andrew Smith. The ship was delayed by weather in the Irish Sea and then by a leak that forced it to make for Londonderry. In mid-Atlantic it was buffeted by severe storms that continued for more than a month.*[3]

The letter below describes how the ship was then captured by a French privateer and diverted to Puerto Rico. But Coke was allowed to proceed to America minus his baggage. His letters show that he was in New York on 6 December and had arrived back in London by 26 February. Although he was to pay two further visits to America (in 1800 and 1803–4), his involvement in the expanding overseas missions of the British Conference virtually precluded him from settling in America; and the matter was finally determined by his marriage in 1805.

His correspondent, John Pawson, was one of that older generation of British itinerants surviving from the era before Wesley's death; as were Mather, Bradburn, and Atmore, mentioned in the opening paragraph. George Whitfield, to be distinguished from his near-namesake, was an itinerant who at this time was serving as book steward (i.e., the connexional publisher).

Copy of a Letter from the Rev. Dr. Coke to Mr. J. Pawson

Norfolk, Virginia, Nov. 10, 1797.

Very dear and rightly respected Friend,

UNDERWRITTEN I have sent you an account of my being captured by a French privateer, extracted from my Journals. I will entreat the favour of you to have two copies of it taken, and to send one of them to Mr. Mather, and the other to Mr. Bradburn, as I am going to set off for our Virginia Conference, and may not be able to get another copy taken before I leave this place. I hope I shall be able to sail for Falmouth from New York, in the December

3. J. W. Etheridge, *The Life of the Rev. Thomas Coke, D.C.L.* (London: Mason, 1860), 286-87.

Packet; in which case I shall be, God willing, in England early in February, because the winds are always fair for England at that time of the year. My love to Mrs. Pawson, Mr. and Mrs. Atmore, Mr. and Mrs. Whitfield, and all the Preachers and their wives.

I am your most obliged and faithful friend,

Thomas Coke.

On Sunday, the 29th of October, about half past three in the afternoon, two sail appeared in view, both of them brigs; one of which, as we afterwards found, was from the States of America, bound for Guadaloupe, and soon sailed from the other, which immediately made towards us. Our ship being heavily laden with salt, the brig soon drew near to us, hoisting English colours; but our captain, from the time that the brig made sail towards us, seemed persuaded it was a French privateer. About five o'clock, its port-hole became visible; and sometime afterwards a gun was fired. Our captain then judged it high time to slacken his sails and haul to. When the brig came up to us, a person addressed us with his trumpet in perfectly good English, and after a few questions ordered our captain to send off his boat. It was now near sunset, and the suspense we were in, during the absence of our boat, was truly solemn. In about half an hour, the boat returned, filled with Frenchmen; all our sailors were sent to the privateer, (for such it proved to be) except the captain, our black cook, and the cabin boy; and our ship declared a prize. One of the Frenchmen then came up to us, and informed us, that we need not be afraid; that none of our goods should be touched; that their captain had determined that whosoever touched a single article of the passengers' property, should forfeit his part of the prize-money. This afforded us not a little encouragement, and we went down to the cabin, and drank tea with tolerable comfort, the prize-master and his mate having joined us. During tea, one of the French sailors, who afterwards proved himself a most audacious ruffian, came in, and demanded rum; the captain, who had laid in hardly any spirits at Liverpool, (being there informed we were not fond of spirituous liquors) and who had only two quarts on board, informed him, I think, that he had no rum, but that he had a little, and but a little, porter and wine still remaining for the passengers after a nine weeks voyage. The sailor answered, 'Let us then have some porter, and bread and

butter, and we will have rum tomorrow from the privateer.' Four bottles of porter were immediately delivered to him, but he soon afterwards returned and demanded three more; and in the course of the evening, and even in the night-time, they came into the cabin demanding porter. I have since thought, and did so at the time, that our captain's feelings for his passengers, and his desire to save what he could for our use, was rather ill-judged, as our lives as well as our property lay entirely at their mercy. Indeed our captain was one of the mildest, most attentive, most obliging captains I ever sailed with; Captain Sundius,[4] of London, with whom I sailed to Barbadoes, alone excelled him: and this little testimony I am in gratitude bound to bear, in my own name, and that of the rest of the passengers, in behalf of Captain John Addison Smith, of the President.

The captain saw himself, as the world would term it, a ruined man; his ship lost, and his affairs in America in great confusion, and requiring his immediate presence, but he bore the whole with surprising patience. Had his ship been laden only with salt, it would not have been a prize, but as it had a considerable quantity of bale, and dry goods between the decks, and these brought from an English port, it became condemnable according to the existing orders of France. In the evening, the head of our ship was turned for the West-Indies, and we had reason to believe that the privateer intended to accompany us, and to carry our ship to Porto-Rico, where the Spanish Admiralty condemn almost every prize. The French sailors informed us, that a brass cannon for eighteen pounders, which made one of the privateer's guns (most of the guns being only six or nine pounders) was a present given by the governor of Porto-Rico; so that it is very probable, that the governor himself had a share in the privateer. I at first thought that the Lord intended to send me to the West-Indies for some profitable end to his Church: but when I considered the moral impossibility of getting to any English island, unless we were retaken on our voyage, or peace was concluded between England and France, and the news of it had reached the West-Indies before our arrival; there seemed to be no hopes (humanly speaking) of our being delivered out of the hands of these violent men, as they proved to us in the end, but by returning to the continent of America, as well as we

4. For Christopher Sundius, see p. 93 above.

could, in the first ship which sailed thither from Porto-Rico, or whatever port they should bring us to. The great end, therefore, of this adventure appeared to be, on the whole, that through the grace of God, we might be perfected by sufferings. Though I felt no fear, yet the events were so sudden and momentous, that it may be easily imagined, the following night was not favourable to sleep. These and suchlike thoughts and reasonings possessed my mind: 'Should I not have the fullest confidence in my God, that he will never prove, or afflict, or try me, beyond my strength; that he always *proportions* my afflictions: and gives his chastisements as he does his favours, in weight and measure; that in afflicting me, he wills not to destroy me, but to purify and save me, and qualify me for abundantly greater usefulness in his Church; that he who assists me himself bears the crosses, which he himself imposes upon me; that He chastises me as a father, and not as a judge; that the same rod which gives the wound, brings the oil and honey to soften it? He knows all the characters of my heart, and as in afflicting me, his will in Christ Jesus is my sanctification; he knows how far to lay the burden upon me. Alas! what other design can my gracious Lord have in afflicting me? Is he a cruel God, who takes pleasure in the sufferings of his servants, or of any of his creatures? Is he a barbarous tyrant, who finds his grandeur and safety only in the tears and blood of the subjects who adore him? Is he an envious and morose master, who can taste no happiness himself, if he partake of it jointly with his slaves? It is then for my benefit alone that he punishes and chastises me; his tenderness suffers, if I may so speak, from my woes, and yet his love is so just and wise, that he still leaves me to suffer, because he foresees that by terminating my afflictions, he would, in the end, increase my misery, and prevent my usefulness and glory. He is like a skilful surgeon, who has pity indeed on the cries and sufferings of his patient, and yet cuts to the quick all that he finds corrupted in the wound: he is never more kind and beneficent, than when he appears to be most severe; and it is indubitably evident that my afflictions are necessary and useful to me, since a God so good and kind can resolve to lay them upon me. 'O my God, it is thou alone who canst support me under all my trials; I am weakness itself without thee. It is thy grace alone which can sanctify the means, and make the afflictions profitable. Lord, teach me to depend wholly upon thee. It is with

thee alone I desire to forget all my trials, all the creatures. But alas! too often have I wished that the foolish projects of my own heart should serve as the rule of thine infinite wisdom. I have wandered, and been lost in my thoughts; my imagination has formed a thousand flattering dreams; my heart has run after phantoms; I have desired more favour from men, more health of body, more talents, more glory, as if I had been wiser and better acquainted with my true interest than thou, Omniscient Lord God! I have not entered as I might into the gracious designs of thy love in my favour. But O from this time thou shalt be my comforter, and I will seek in the meditations of thy holy law, those solid and lasting consolations which the creatures can never afford.'

Whilst I was thus musing on this trying event, I fell into a doze; but all of a sudden I awoke, and beheld a man standing at the door of my little state room, with a candle in his left hand, and a knife in his right; the weather was so warm (we being far towards the south) that the heat would probably have overcome me if I had shut the door of my little room; I had therefore kept it partly open by means of a cord and other apparatus. But underneath my bed there was a box of candles, which the Frenchmen had discovered in the course of the evening; and it was to have some of these candles that the man came into my room, and in order to cut the cord had taken out his knife. I recollected the box of candles, and immediately leaped out of bed, and asked him if he wanted candles; 'Oui, oui, allez dormir, allez dormir,' Yes, yes, go to sleep, go to sleep, said he, and I accordingly returned to bed. In the morning, whilst, I think, I was engaged in private duties, I heard one of them say with a loud voice to our captain, 'du the,' some tea; the captain observed there was very little tea left for the passengers; I immediately desired the cabin-boy, with a low voice, to run for the tea, and let them have it. After this we breakfasted as comfortably as our situation would admit, the prize-master and his mate joining us; but after breakfast, when our captain went upon deck, he was informed that the ship was a prize, and that the sailors must have the things the ship could afford. Our kind friend, the captain, then came down to us, and informed us of the whole, observing that he could not now even order dinner for us, but that we must be content with anything, and everything, they were pleased to send us. Immediately afterwards, I went up on deck, and was informed

that a brig was sailing with the wind towards the privateer. Instantly a pleasing hope sprung up, that the Lord, who has the hearts of all men under his direction, and can turn them like the rivers of the South,[5] would touch the heart of the captain of the privateer, and influence him to order us on board this brig, if she was not captured; I informed my dear friends, Mr. and Mrs. Suckley, of my hopes. They, who had also received intelligence of the brig, had, I found, indulged the same hopes. We, therefore, went into their state-room to prayer; and the Lord, we can truly say, was present with us; he heard our cry, and about noon a signal was made by the privateer, to speak with our ship, and orders were given, that the passengers should be sent on board this brig. The boat was ordered out, and now began the scene of plunder, in spite of all the commands of the captain of the privateer, if such commands were given; two of them searched me (one of them especially) in a manner which it would be shocking to modesty to describe. They did not leave me so much as a single sixpence; but Mr. and Mrs. Suckley, I expect, have lost not less than £400 in money and goods. About three in the afternoon, we were all on board our new vessel, and thankful to God, that he had so wonderfully delivered us. Soon after we were on board, the captain of the privateer hailed our brig, and inquired whether the women were on board; and on receiving an answer in the affirmative, ordered us to proceed on our voyage.

From the whole conduct of the captain of the privateer, I really judge that he is a man of some humanity, but had little or no influence over his men, in respect to the article of plunder, though I think it probable, that he will have his share of all the spoil; the prize-master also manifested some humanity, by calling for a chair to let down Mrs. Suckley more safely into the boat. Our captain, of the President, who never was inattentive to us, begged that he might be at liberty to put a little porter with us into the boat; but when the hamper was brought up, they inquired how many bottles were in it, and being informed, that there were three dozen, they cried out, two would be enough; but on examination, finding it to be wine, they sent only one dozen; five bottles were broken in the boat, so that seven bottles only (an ample sufficiency) remained. In less than a quarter of an hour after (I believe in five

5. Cf. Psalm 126:4.

minutes) we were all on board, it blew a gale, and so continued all night, so that if we had not been sent on board, just at the time we were, the vessels must have been separated, and all our hopes would have been blasted. But the Lord had mercy upon us, for I have no doubt but the insolence of the privateer's men would have daily increased. I would just remark, as another kind interference of the good providence of God, that as soon as our boat was hoisted out to carry us to the brig, a violent storm of wind and hail commenced; I candidly confess, I prayed as earnestly to the Lord on that occasion, as I ever did in my life. The storm soon abated, and during the short interval between the two gales (the last of which continued) we were delivered from our captivity.

1813–14

Extracts of the Journals of the Late Rev. Dr. Thomas Coke's Nearly Finished Voyage to Asia with the Messrs. Ault, Lynch, Erskine, Harvard, Squance, and Clough

Introduction

As far back as 1784 Coke had been in correspondence with Charles Grant of the East India Company about a possible mission to the East; and though other preoccupations and the lack of any clear opportunity (in addition to the usual financial constraints) long delayed the project, it was never entirely abandoned. In 1800 the British Methodist Conference went so far as to authorize him to send a missionary to Madras, though nothing came of it. By 1805, he was exploring the possibilities through correspondence with Col. William Sandys and the directors of the East India Company. In 1811 Conference again authorized him to make preparations for a mission to Ceylon. Later that year Coke married Ann Loxdale, only to be bereaved for the second time just over a year later. Henceforth he declared himself to be 'dead to Europe, and alive for India': 'methinks I had rather be set naked on the coast of Ceylon, without clothes, and without a friend, than not go there.'[1] Finally, in 1813, the renewal of the company's charter ended official opposition to

1. Letter to Joseph Entwisle, 18 June 1813, in *Memoir of the Rev. Joseph Entwisle,* 2nd ed. (London: for the author, 1854), 252.

any kind of missionary activity in the territory under its control, and Coke saw this as a call to action.

The Conference of that year was still very reluctant to commit itself to such a major enterprise but, not for the first time, was persuaded by Coke's willingness to take financial responsibility for it. Six young preachers were recruited, and the autumn months were spent in urgent preparations for their departure. The missionary party assembled in Portsmouth towards the middle of December and embarked on the thirtieth.[2]

As on his earlier travels, Coke kept a journal of the voyage, but only the opening section of this survived his death, covering the period down to 19 February. This was included in the 1816 edition of his Journals *and is reprinted here. I have supplemented it by accounts of the voyage by other members of his missionary party, bringing the account down to the time of his death and his burial in the Indian Ocean.*

At the Conference, held in *Liverpool*, in August, 1813, it was determined with the help of God, to establish missions in *Asia*; and particularly in the first instance, in the Islands of *Ceylon* and *Java*. For this purpose the six above mentioned Missionaries were appointed to accompany me to that quarter of the globe. But when I returned to *London*, and made inquiry for a ship bound to *Ceylon*, I found that there was not one to sail to that Island. The most intelligent,[3] in respect to Asiatic voyages, of those whom I was able to consult, advised me to take a passage for *Bombay*, as the Monsoons would be in our favour to sail for *Ceylon* immediately on our arrival.

I accordingly took a passage for myself and my six companions, the Messrs, *Ault, Lynch, Erskine, Harvard, Squance,* and *Clough*;[4] and

2. For fuller details of these years of preparation, see Vickers, *Thomas Coke*, 335-58.
3. I.e., 'informed.'
4. *William Ault* (1778–1815), a native of West Bromwich, found himself in the isolated station at Batticaloa on the east coast of Ceylon, but died within a year. His wife's death during the voyage is recorded by Coke on 10 February. *James Lynch* (1775–1858) came from County Donegal and was a convert from Roman Catholicism. He entered the itinerancy in 1808. As the senior of the missionaries, after Coke's death at sea he became the leader of the group. After serving at Jaffna, he left in 1817 to establish a mission in Madras. Returning to Ireland in 1824, he served there until his retirement in 1842. *George Erskine* (1781–1834) entered the itinerancy in 1809 and served in the Sin(g)halese mission until transferring to New South Wales in 1821. *William Harvard* (1790–1857) entered the itinerancy in 1810. After four years in Colombo he returned home in poor health. He later served in France, Madagascar, and Canada, and for two years before his death was Governor of Richmond College, where missionaries were trained. *Thomas Hall Squance* (1790–1868) was born in Exeter, entered the itinerancy in 1812, and served in Ceylon and India until 1822. *Benjamin Clough* (1791–1853) was the youngest of Coke's missionary band, having entered the itinerancy only that year. He served in Ceylon until 1837 and was chairman of the South Ceylon District 1825–37. He published works on the Sin(g)halese and Pali languages.

for Mrs. *Ault* and Mrs. *Harvard*, in two of the Indiamen, bound for Bombay—the *Cabalva*, of which Captain *Birch* is the commander, and the *Lady Melville*, commanded by Captain *Lochner*. It would in many respects, have been desirable for us to have sailed together in one ship; but neither of the above mentioned could have taken us all: and to have gone altogether in one ship, which might have been accomplished, would have cost in all, nine hundred pounds more for our passages. We had therefore no choice: and I have reason to believe the whole was of God.

In the ship, in which I have sailed, there are above 400 souls. Of these 200 are soldiers, who, excepting a very few, are, as far as I can learn, young lads from Ireland, of the Roman Catholic persuasion. — About 50 of the sailors are Lascars,[5] and chiefly, if not entirely, I am afraid (for I have been talking with some of them) Mahometans. The gospel-door, as it respects that people, seems entirely shut. Their religion was established by the sword, and I fear that the sword must go through their nations before they will bow to the sceptre of Jesus.

However, by their own master they must stand or fall. We have among us some Portuguese, natives of India; I wish we may be useful to them. In the dining room our number is twenty-six, inclusive of the Captain and his two first officers. They are very polite; but oh! we want to save souls.

I have a most charming study. It has two large windows that open from the stern to the sea; and my elbow-chair and my table are placed in the most convenient situation possible. I have seen, I think, seventeen ships of our fleet sailing after us. Here I employ almost all my time, and nearly the whole of it, in reading and writing Portuguese, excepting my hours of meditation, which, indeed, I can hardly except; for my chief study is my Portuguese Bible. O how sweet is the Word of God! I have loved it since I came into this ship more than ever I did before:

> Jesus gives me, in his word,
> Food and medicine, shield and sword.[6]

5. I.e., East Indian seamen.
6. Cf. John Newton, *Olney Hymns,* book II, hymn LXIII, st. 1:
> Precious Bible! what a treasure
> Does the Word of God afford!
> All I want for life or pleasure,
> Food and medicine, shield and sword.

I now feel, I think, more than ever the value of retirement, silent and tranquillity of mind; and can say of my God what Virgil did of his Augustus: — *Deus nobis hæc otia fecit.*[7] 'God himself has favoured me with these leisure hours.' — And yet I cannot repent of the thousands of hours which I have spent in the most vile—the most glorious drudgery of begging from house to house.[8] The tens of thousands of pounds which I have raised for the Missions, and the beneficial effects thereof, form an ample compensation for all the time and all the labour. The whole was of God. But what would my heart have felt, if all the Missions already established had been left without support on my departure from England?[9] But it was the work of God. He alone began it, and he alone increased it; and (if I presume so to express myself with humble modesty) he has bound himself to support it. He, therefore, before I sailed said *to the north* 'BRING FORTH,' *and to the south* 'KEEP NOT BACK.' The *west* also is coming forwards. The *sister-island* has taken the flame; and the highly favoured *British-isles* conspire to spread our Missions throughout the world. How light it has made my heart! next to union and communion with my God, nothing could afford me such high satisfaction. I hasten to Asia with alacrity and joy. And yet I must confess, that if the clouds had been ever so obscure—if all human aid had apparently been withdrawn from those Missions, the interests of which are so deeply interwoven with the very strings of my heart—my divine call to Asia has been so indubitably clear, that I should have been obliged to have thrown every thing into the hands of my God, and to have said to Him, 'Here I am, send me' to Asia.

Our fleet when we set sail, consisted of a line of battle ship, of 74 guns, two frigates, a sloop of war, six regular Indiamen, two country Indiamen, (ships built in India,) and about twenty-five smaller

7. Virgil, *Eclogue* 1, line 6.

8. For Coke's unflagging efforts to sustain the growing missions financially, including his begging from door to door, see Vickers, *Thomas Coke*, 261-70.

9. No effective moves were made to relieve Coke of the financial burden of the missions until the eve of his departure for the East. The first District Missionary Society was launched at a meeting in Leeds on 6 October 1813. On the same day, meeting in London, the connexional Missionary Committee approved a proposal to set up such societies elsewhere, and before the autumn was out this had been implemented in Halifax, Hull, Norfolk, and elsewhere so that Coke sailed from Portsmouth confident that his absence would not jeopardize the missionary finances. Despite claims that the Wesleyan Methodist Missionary Society dates from 1813, no missionary society at connexional level was inaugurated until 1818. Cf. Vickers, *Thomas Coke*, 353-54.

merchantmen. The sight of such a floating city is very agreeable; and were it not that the lagging ships, which must be frequently waited for, lengthen out the voyage, would be peculiarly desirable. On a calm, the boats are passing and re-passing from ship to ship. Each of the large ships has its telegraph,[10] composed of colours of various hues and shapes; and, by these telegraphs they convey messages or other intelligence one to the other in a surprising manner; and frequently they compare their respective longitudes.

In leaving England we came very near to the coast of *Cornwall*. We were a little surprised at the movements of our Commodore, as he certainly went out of his way. But we were satisfied when we found he had moved towards the coast to receive some important dispatches from *Falmouth*. Had it been divine will I should have been glad to have spent a few days with my friends in that part of *Cornwall*, and more particularly so because to our generous friends in that county, if we except *London* and the north, our Missions are more indebted than to any other people in the world.

1814: — January the 6th. — Now our winter gales commenced, and dreadful they were almost from the Land's end till we had sailed some degrees beyond *Madeira*. Many of our ships were more or less dismasted. The *Cabalva* suffered very little: a single little mast at the end of one of the booms alone was broke. On the 19th of January one of the merchant-ships was missing, and was not afterwards seen or heard of. What made this incident still more melancholy was that she had been firing guns of distress for some time before; but the gale was so violent that no relief could be afforded her.

January the 24th. — The gale was not abated, and six ships more are missing. One of these is a country Indiaman, the *Fort William*, of twelve hundred tons burden. What is most alarming is, that the *Fort William* was in great distress. She seemed quite unmanageable. There is great reason to fear that she is lost.

January the 26th. — No tidings of the missing ships. We have now given up all hopes of again seeing the frigate which was despatched in search of them: not that we have any doubts concerning the safety of the frigate, but have little reason to expect that she will now find us out in the great ocean, as the violent gales

10. Before the invention of electric telegraphy, messages were transmitted by means of semaphore or other visual signs.

have tossed us about in all directions. What a wonderful Providence! The *Fort William* was the first ship I visited in *London*, and I had serious thoughts of taking a passage in it for myself and all my companions, as it would have saved us a considerable sum of money. But my brethren urged that it was entirely manned (the officers excepted) by *Lascars*, who could not be depended on, in times of danger, in the management of so large a ship, without a mixture of British tars among them. The argument was strengthened on our return from the East India Docks to *Poplar*, where we were informed that, just before, a party of these very *Lascars* had been fighting with knives, and that one of them had been stabbed to death in the scuffle. Indeed, the most intelligent of naval affairs in the company in our ship are of opinion that her distress, and most probably the entire loss of her, was owing to her being manned only by *Lascars*: for she was a very fine ship, and, alas! was full of passengers! Praised be God that he delivered us: for had all my companions and myself been lost, it might have suspended any further attempts of the Methodists to establish Missions in *Asia* for many years.

We have among our passengers a Chinese gentleman, whose name is *Luncheon*, or at least *Luncheon* gives us the exact English sound of his name. He sailed from *China* in an American ship bound to the United States, with about 2,500 pounds worth of tea; but the ship was captured by one of our armed vessels, and carried to *England*. On this, either our Government, or the honourable *East India* Company, I think the latter, as far as I could learn from Mr. *Luncheon*, who speaks very little English, purchased the tea of the captors: sold it and gave the produce to Mr. *Luncheon*, because he was a Chinese. However *political* the step might be, I doubt whether there be another country in the world which would act in so *generous* a manner.

I happened to mention how pleased I was with the singing of some canary birds, on one of my voyages to *America*: on which the steward brought me a canary bird, and hung it up in my study, within about a yard of my elbow chair. The little creature sings so sweetly, and is so entertaining, that I have given him the name of *Dick*, which he seems now to be well acquainted with.

About this time one of our soldiers died, and, after burial service was read, his corpse was consigned in his *hammock*, made heavy with sand, to a watery grave.

One morning, dreadful shrieks were heard from the lower deck. They came from a woman, whose husband, a soldier, was beating her severely. She then fled up stairs, and, as soon as she got upon deck, gave herself a fling over the side of the ship, but a sailor caught her by a part of her clothes, and with great difficulty, drew her back. The husband was brought to trial, before the Captain, but some circumstances appeared so much in dis-favour of the woman, as made the Captain consider the husband as almost justified.

Another accusation was brought before the Captain against a soldier for abusing a Major in the army, one of the passengers. The charge was proved, and the soldier received twenty-four lashes for his fault.

Those who were on the poop of our ship, had the melancholy sight of a sailor, belonging to another vessel, falling from the top gallant-yard into the sea. It does not appear that he could have been saved by any exertions which might have been used: so he was drowned.

On one fine day a fleet of forty ships crossed us. It formed a very grand sight. Our Captain held a long conversation, by the means of trumpets, with the Commodore of the fleet as he was passing; by whom he was informed that they were bound for *Lisbon* and the *Mediterranean*.

One day a signal was made by our Commodore that the only remaining frigate, the *Revolutionaire*, would soon be in want of water; that she had only a month's water on board, and therefore would be obliged to leave the fleet and sail for some port, unless she could receive a supply. Instantly the telegraphs began to work, and she soon found that the fleet would grant her a full supply. Our Captain alone sent her sixteen hundred gallons, and the other ships in proportion.

We have caught two *sharks* and a *boneta-fish*. The former were caught by a hook, the latter by a harpoon. The *sharks* were eaten up by the sailors. The *boneta*,[11] which weighed only 16 pounds, was brought to our table: it is a coarse, well-tasted fish: and variety made it pleasant.

11. 'Bonito' is the name of several tropical species, including the tunny or tuna, which grows to a length of three feet.

Nine of our fleet left us for *Lisbon*. They are store-ships for the Marquis of Wellington's army; and we have reason to hope will arrive safe at their destined port.[12] Both the Commodore and I believe the whole fleet wished to touch at *Madeira*, and to continue there for a few days. I got many letters ready to be sent from thence to *England*. But, alas! we just came within sight of it, and the violent gales obliged us to wear off for the south. On the 25th of January we had a short view of *Palma*,[13] one of the Canary Islands.

Mrs. *Harvard* passed through a long series of violent sea-sickness. But, since we have come between the tropics, she has perfectly recovered, and is, I think, upon the whole even better for all her illness. But alas! this was not the case with Mrs. *Ault*. When she arrived at *Portsmouth* she was very much indisposed, of which I knew nothing before. An eminent physician (Dr. *Waller*) was employed to attend her, who most kindly and gratuitously gave her all the assistance in his power. Her dear husband, as was very natural, apprehended no immediate danger; and Dr. *Waller* was reluctant to give him pain. But the Dr. informed my worthy friends, Mr. and Mrs. *Webb*,[14] at whose house I resided while at *Portsmouth*, that she was in the last stage of a consumption: and that he had not the least hopes of her life, unless the Torrid Zone could restore her. He was sure, he said, that she would soon die on land, and that he expected she would soon die at sea; but that, if she survived to reach the Tropics, there was a possibility, and that but a very bare one, of her recovery. This was the purport of Dr. *Waller's* opinion, which I believe he gave to Mr. and Mrs. *Webb*, that they might deliver it to me. My way then was clear. To part with so very excellent and valuable a man as Mr. *Ault*, when there was no human possibility of Mrs. *Ault's* recovery on land, would have been almost an unpardonable step; and to have left her behind us, when the only possible means of her recovery (*humanly speaking*) was to take her, if possible, to the tropical climate, would have been very inexcusable.

12. The Peninsular War had begun in 1808 as part of the conflict between Britain and Napoleonic France and dragged on until 1814. This was the campaign that established the reputation of the Duke of Wellington.

13. I.e., Las Palmas.

14. Joseph Webb (1735–1819), a Portsmouth gardener, settled in the town in 1767 and became 'a worthy member of the Wesleyan Methodist society more than three-score years.' He was instrumental in buying the society's first chapel, in Oyster Street. He was married three times and entertained Wesley, Coke, and 'other eminent men' on their visits to Portsmouth. The memoir by Jonathan Edmundson in *Wesleyan Methodist Magazine*, 1819, 881-88, speaks of his 'valuable labours as a Local Preacher, Class-Leader, Steward and Trustee.'

The Messrs. *Harvard* and *Clough*, and myself, who sailed in the *Cabalva*, were exceedingly desirous to know the progress of Mrs. A.'s sickness, and therefore agreed with our brethren of the *Lady Melville* that intelligence should be conveyed by means of different coloured handkerchiefs, whenever our ships in the different movements of the fleet, should come near each other. But, alas! all the intelligence thus received was of a melancholy nature. Mrs. *Ault* reached the tropical climate; she held out till we arrived pretty near the Equinoctial line.[15] — On February the 5th, during a calm, Messrs. *Ault* and *Squance* borrowed their Captain's boat, and made us a visit. The interview, as may be supposed, was both pleasing and painful. Mrs. *Ault* was still alive, and Mr. *Ault* was even then indulging some faint hopes that the Torrid Zone, under the divine blessing, would restore her.

Mr. *Squance*, I must observe, gave us a pleasing account of the influence of religion, in the *Lady Melville* among the *cabin passengers*. There were eight officers of the army, of very respectable rank in the ship, who had (as far as I could learn from his modest account) taken a liking to the manners, address and conversation of Mr. *Squance*: so far as to offer him their very large cabin, on the second deck, to preach in on *Sunday evenings*. The cabin at those times, was crowded; and good, I doubt not, was done. As to our *own ship*, I hope to have something good to say of it when we reach *Bombay*.

February the 10th — We were all at breakfast, and an officer of our ship came in and informed us that several ships had hoisted their flag half-mast, as a signal of death. Our signal was immediately hoisted. But our whole company, who had previously known of Mrs. *Ault's* illness, concluded that the signals were raised on account of her death. The signals all continued half-mast-high till about half an hour before sunset, when the *Lady Melville* lifted up her death-signal top-mast-high, which was followed by all the fleet. This was the signal that the officiating minister (who was Mr. *Squance*) had begun to read the 15th chapter of the 1st Epistle of Corinthians. — And when the *Melville* had dropped down her signal, the rest of the fleet followed her example; and thus ended the ceremony.

15. I.e., the Equator.

A few days after this Mr. *Harvard* and Mr. *Clough* took the advantage of a calm and visited our friends in the *Lady Melville*. I am so old, that I dare not venture up and down the sides of ships but as little as possible. I hazarded my life in visiting the ships in the East India Docks, near *London*, to find out ships for myself and my companions. Mr. *Harvard* and Mr. *Clough* found Mr. *Ault* humbly resigned, though feeling exquisitely[16] on the occasion. His dear wife died triumphant in the faith: and her resignation was most entire. When her husband spoke to her relative to having her remains preserved and carried to *Bombay* for interment, she answered in words similar to these: *'O no: let me be buried in the ocean. It matters but little what comes of the MORTAL PART, so that the IMMORTAL, — THE SOUL be secure!'* When she became speechless, she testified her victory over the last enemy, by lifting up her hands in a most triumphant manner; and she continued sensible to the last. When she was at *Portsmouth*, she certainly did not apprehend herself to be in immediate danger, as she observed to Mrs. *Harvard*, when speaking to her on the subject, that she thought Mr. *Ault* would die before her.

On February the 19th, Captain *Burgoyne*, of the *Port Mahon* brig of war, most kindly came on board to inform us that in a few days he should set sail for the *Brazils*, with a fleet of our merchantmen, which are bound for *Rio Janeiro*: and that he would deliver any letters, we should intrust to his care, to the British Consul, to be forwarded to *England* by the first packet. I must therefore now conclude, having indeed, brought down our voyage to the present day, February the 21st, 1814.[17]

16. I.e., 'acutely' or 'keenly.'
17. The editor of the 1816 *Extracts* placed here a note: 'We doubt not that Dr. Coke kept a regular Journal till the day of his death; but no more of it than we have now inserted has come to hand.'

APPENDIX

Coke died at sea during the night of 2-3 May 1814. No further journal has been traced, but the following reports from his missionary colleagues supplement Coke's own account of the voyage to Asia.[1]

Bombay, June 15, 1814

Reverend and Dear Fathers,

We wrote to you, on the 4th instant, by the overland despatch, which we hope you have already received: we therein gave you as full an account of our situation as our limits would permit: we now present to you, not only the substance of what we then transmitted, but also a more full account of our voyage, of our late venerable father Dr. Coke, and also of ourselves.

1813. — Thursday, Dec.30. — We left our very kind friends at Portsmouth, and our little company divided, no more to unite again in this life: each company went aboard our respective ships.[2]

1. The first two accounts were published in Jonathan Crowther, *The Life of the Rev. Thomas Coke L.L.D.* (Leeds: Cumming, 1815), 513-29. A more complete account appeared later in William Harvard's *Narrative of the Establishment and Progress of the Mission to Ceylon and India* (London: for the author, 1823). The third, a letter from James Lynch, was printed in the *Methodist Magazine* (London) 38 (1815).

2. For reasons of economy, Coke's party was divided between two ships: Clough and the Harvards sailed with Coke in the *Cabalva,* while Lynch, Erskine, Squance, and the Aults were in the *Lady Melville* (see pp. 254-55 above). There were only occasional opportunities for visits between the ships, but it was agreed that, whenever the two ships came close enough, a white handkerchief would signify health and a coloured one sickness (Harvard, *Narrative,* 67).

Appendix

Friday 31. — We set sail, in company with 6 Indiamen, 5 ships of war, and about 20 merchantmen, that were going to different parts of Europe, Asia, Africa, and America. We had a fair wind.

1814. — Saturday, Jan.1. — We made a little way down the Channel, the wind being variable. We felt our minds much impressed with our situation: the season was proper for reflection: we entered on the year with very enlarged prospects of future labours in the heathen world. Little did we think that, to some of our little company, this year would prove the last. North Lat. 50 deg. 15 min. West Long. 3 deg. 11 min.

Sunday 2. — The wind being contrary, we were detained in the Channel; and also on the 3rd, till towards the evening, when the wind sprung up fair. About 8 or 9 in the evening, we had the last sight of the Light-house at Lizard Point.

Tuesday 4. — We entered the Bay of Biscay with a strong gale: the rolling of the ships now became very violent, and we expected that a general sickness would ensue.

Wednesday 5. — The sea ran very high: the motion of the ships increased much: most of us were now taken sick: our sickness continued to increase till Sunday 9, when we became more accustomed to the motion; but our sickness continued (though somewhat abated) till we were out of the Bay of Biscay. Indeed, the rough weather continued, with squalls and gales, and a great swell, till Jan.23, when we passed Madeira. North Lat. 46 deg. 44 min. West Long. 8 deg. 5 min.

Sunday 23. — About 10 o'clock this day, Madeira was in sight; but the sea was so high, and the wind so violent, and blowing off from land, that we could not make the shore. The ship *Fort-William* lost her main-top and mizen-mast; she could not proceed with the fleet: the *Briton* frigate took charge of her. We passed Madeira at 2 o'clock in the afternoon. North Lat. 32 deg. 24 min. West Long. 16 deg. 5 min.

Tuesday 25. — We passed the island of Palma: we had now a more pleasant breeze, a smoother sea, and finer weather, than any we had had before, since we embarked. North Lat. 29 deg. 43 min. West Long. 19 deg. 18 min.

Sunday 30. — We had very fine weather and pleasant sailing. North lat. 19 deg. West Long. 25 deg. 26 min. This was the first Sunday that we could have prayers on deck.

On this day, the brethren who sailed on board the Lady Melville,

were very much rejoiced, to see Mrs. Ault rise from her long confinement.[3] From the time that she came on board till this day, she had been violently afflicted with sea-sickness. She was now much reduced. Her sufferings were extreme. She was poorly while at Portsmouth, though brother Ault did not then apprehend danger.

On Monday 31. — She again sat up a little; she was, during the whole of her affliction, quite happy and resigned, always pleasant and cheerful, enjoying sweet union and communication with God.

Monday, Feb. 28. — The American ships parted company for the Brazils. Dr. Coke sent by them some letters to England. South lat. 11 deg. 11 min. West long. 32 deg. 3 min.

Tuesday, March 1. — The Scaleby Castle left us for St. Helena, in which we sent our letters to Europe. South lat. 12 deg. 47 min. West long. 32 deg. 14 min.

Saturday 5. Brother Squance being at this time very unwell, he left the Lady Melville, and went on board the Cabalva, at Dr. Coke's particular request: the Doctor hoped that the change of company would be of service to his health. South lat. 17 deg. 44 min. West long. 33 deg. 52 min.

Wednesday 16. — The commodore left us, and took our letters to the Cape of Good Hope. South lat. 31 deg. 45 min. West long. 27 deg. 20 min.

[Wednesday] 23. — This morning the wind sprung up, and toward the evening was very high, though yesterday the sea was so calm that a shark was caught, which is never the case except in calm weather; we had now a very high sea and large swell, which continued for a considerable time, till we had passed the Cape of Good Hope. South lat. 36 deg. 14 min. West long. 19 deg. 00 min.

Monday 28. — Some time this morning the Cabalva lost sight of the fleet; which was a source of affliction to all our company; we were now separated, and afraid we should never meet again till we arrived in Bombay, but our apprehensions were soon over; we joined company again the next day. South lat. 38 deg. 11 min. West long. 4 deg. 13 min.

Tuesday April 5. — We had a storm. The fleet ran 10 miles an hour, the Cabalva with only 2 top-sails close reefed: the Lady Melville had no other than the foretop-sail reefed: the violence of the

3. Mrs. Ault had been diagnosed as consumptive before they embarked at Portsmouth, but it was hoped that a more tropical climate might prove beneficial. She died on 10 February, as Coke records (p. 261 above).

APPENDIX

wind continued till about 11 o'clock at night, when the wind and sea suddenly fell, and we had a better night than was expected. We were apprehensive of danger from the Telemach shoals, which were supposed to be near South Lat. 38 deg. East Long. 22 deg. 09 min.

Wednesday 20. — We had a fresh gale: a sailor fell down the hatchway of the Lady Melville; his skull was fractured: a man fell overboard from the Neptune and was lost: a man fell from the maintop-mast of the Elphnstone. How awful are these providences! Several sailors have during the voyage, fallen overboard from the different ships; and from the violence of the sea, could not be taken up again. South Lat. 26 deg. 32 min. East Long. 54 deg. 35 min.

Saturday 23. — We passed the island of Bourbon. In the evening, though 12 leagues from shore, we very distinctly saw, with the naked eye, the irruption of the volcano; the streams of fire were seen issuing forth with great velocity; the mountain being high, the flames at first appeared like a comet in the heavens, with a large blaze of fire following in the train; it was seen the whole of the evening, sometimes blazing out very bright indeed, but at other times feeble and dim. South Lat. 21 deg. 58 min. East Long. 55 deg. 50 min.

Sunday 24. — Passed the Isle of France[4] early in the morning. South Lat. 19 deg. 46 min. East Long. 56 deg. 4 min.

Wednesday 27. — At five in the evening we passed the island of Gallega about 5 miles distant: the sounding line was thrown out, but no sounding made at 50 fathoms, though danger was apprehended. Here a Frenchman resides, with his family, and a few slaves.

Tuesday, May 3[5] — This day God has visited us with a most

4. The Ile de France, former name of Mauritius.

5. Harvard's *Narrative*, 78-80, gives details of the last few days of Coke's life. Two days before he died Mrs. Harvard had gone on deck for the first time for several days because she was unwell. 'Upon her return she mentioned to me the visible alteration in the countenance of the Doctor. . . . In the evening the Doctor, as usual, came into our cabin and prayed. He would hardly acknowledge that he was ill, but spoke of taking some tincture of rhubarb, which he did. [He] had complained of cold, from the chilling effects of his own fine linen shirts, when damp from excessive perspiration, and had consulted Mrs. Harvard on having some made of calico, when we should reach Bombay. In the meantime, she begged him to use some of mine; and he took a few with him into his own cabin for that purpose.' Next morning she 'found him in his cabin, sitting pensively in his elbow-chair, with his head on one of his hands.' He made a show of cheerfulness, despite admitting that he 'felt rather poorly, but hoped it would soon go off.' He proposed a walk on deck, but appeared too weak to be able to support himself. On his visit to the Harvards' cabin that evening, 'We perceived the languor of disease, notwithstanding his evident effort to conceal it. . . . Mr Clough accompanied him to his cabin, to see that nothing was wanting for his comfort . . . [and] requested to be allowed to sit up with him; but, thanking him for the offer, he said that was not at all necessary; and that he did not doubt he should be better in the morning.' Coke then took some medicine and a little while later 'a small glass of brandy and water, which he drank in bed.'

awful and afflictive dispensation. Our highly esteemed and venerable leader is taken from us. *Dr. Coke is dead.* This morning he was found dead in his cabin. While we view every circumstance of this most distressing visitation, we are led to wonder and adore. The event would have been less alarming had he been encircled by his friends, who might have heard his latest testimony, received his dying instructions, and obtained directions how to proceed in the work of this great mission; but these advantages were not enjoyed, and we are now left to lament the departure of our Elijah, and to tremble for the cause of God. *He is gone!* and he is gone to receive a crown of righteousness that fadeth not away. His death, though a very great loss to us and to the cause of God, to himself is infinite gain. Though sudden, his death was glorious: he died in the work of God, with his soul fired with an ardent desire and zeal for the enlargement of his church, and the Divine glory. For some time before his death, it appeared that he had no desire to live, but to see the Gospel established in Asia. He frequently observed, that he had given up his life to Asia; and it is astonishing with what assiduity he pursued his object. Though near 67 years of age, in a short time he acquired so competent a knowledge of the Portuguese language, that he had written many sermons in it, and translated many hymns into it: this work he was engaged in but yesterday, and now is enjoying his reward. Thus did he

> His body with his charge lay down,
> And cease at once to work and live.[6]

About 6 o'clock this morning, the captain sent for brother Clough, and communicated to him information of the death of Dr. Coke, which had been first discovered by the servant, upon his entering to call the Doctor, at half past five, which was his usual practice. He found him lying upon the floor in a lifeless state. Brother Clough immediately opened the melancholy subject to brother Harvard in a prudent way. Upon the first mention of the distressing circumstance, brother Harvard could scarcely receive the information; but at length being prevailed upon to believe it, he hastened to the cabin of the late Doctor, when, alas! he found the fact to be mournfully certain. The corpse of the Doctor, which

6. 1780 *Collection of Hymns,* no. 43, st. 3 (Wesley, *Works,* 7:135).

had been moved from the floor, was laid upon the bed: it appeared discomposed but little: a placidity rested upon his countenance: his head appeared turned on one side.[7] The surgeon, after examining the body, gave it as his opinion, from the Doctor's habit of body, that his death might have been produced by an attack of apoplexy. It is supposed, that he rose in the night to reach something that he wanted: and, the stroke coming upon him, he fell in the posture in which he was found by the servant: this must have been about midnight, as, when discovered, the body was quite cold and stiff. It is evident that the Doctor must have had an easy death; since neither Captain Birch nor Mr. Harvard heard any struggle or noise, which they would undoubtedly have done had there been any, as each of their cabins immediately joined with the Doctor's, and were only divided from it by a very thin wainscot partition.

Captain Birch very kindly offered a boat to proceed to the Melville, and brother Harvard wrote a note to the brethren on board that vessel, to prepare their minds for the scene which awaited them. When the note was read, all were as though thunderstruck; the brethren felt as if they were electrified even to stupidity, and could scarcely believe what they read. While thus exercised, sometimes gazing on the note, and then speechless looking at each other, the surgeon of the Lady Melville entered their cabin, with a letter from Captain Birch to Captain Lochner, stating that Dr. Coke was dead. All their fears were now realized, and they hastened to their brethren on board the Cabalva; our meeting on this occasion may be more easily conceived than expressed. After consulting together, it was resolved, to apply to Captain Birch for the preservation of the mortal remains of our *departed father in the Lord.* Brothers Ault and Clough waited upon the captain; he heard them with great attention, but stated difficulties so many and so insuperable, that after maturely weighing the subject, we all concluded that it was most proper to desist. Captain Birch wished us to pursue our own plan, with respect to the interment of our venerable friend, and politely sent a note, desiring to know how we intended to proceed, stating his desire *to shew every respect to the memory of so worthy and excellent a man.*

7. Harvard's *Narrative* (82) says that his body 'appeared but little discomposed; a placid smile rested on his countenance; the head was turned a little on one side; while the stain, from a stream of blood which had flowed from his mouth, remained on his right cheek.'

At five o'clock in the evening the corpse was committed to the deep; this was a very solemn and affecting time, the captain, the passengers, and the whole of the ship's company shewed him every respect; the deck was crowded on the occasion; a large thick deal coffin had been made, and holes left in the bottom. The body was placed therein, and being nailed up, was laid on the leeward gang-way starboardside, respectfully covered with signal flags. The awning was spread, the soldiers drawn up in a rank on deck, the ship's bell called together the passengers and crew, and all seemed struck with silent awe. Four cannon balls had been placed in the coffin, decently tied up in as many bags, and placed two at the head and two at the feet of the corpse. Brother Harvard read the burial service, brother Ault then delivered an address suited to the subject, in which he spoke of the character, respectability, and general usefulness of the Doctor, and of the happiness of the righteous dead; and from the sudden and unexpected dissolution of one who was but yesterday in life, took occasion to shew the necessity that lay on each individual to make a speedy preparation, and stand in constant readiness for death. Brother Lynch then read the 51st hymn, on the 53rd page, *Hark, a voice divides the sky*,[8] &c. and concluded with an appropriate prayer. The whole of the service was interesting and impressive, and the solemnity of the occasion appeared to be felt by all present; some were visibly affected: may the impressions issue in their salvation! The corpse of the Doctor was committed to the deep, South lat. 2 deg. 29 min. east long. 59 deg. 29 min.[9] to wait the resurrection of the just.

As we have no doubt that every information respecting so valuable and worthy a man will be acceptable, we copy brother Clough's account of the Doctor, which embraces chiefly the latter part of his life, from the time of his leaving London. Brother Clough being much with him, had an opportunity of knowing much of the Doctor during his short stay at Portsmouth, and on the voyage. The propagation of the knowledge of Christ in Asia was a subject which had rested on the mind of our late venerable

8. A funeral hymn by Charles Wesley, included as no. 50 in the 1780 *Collection of Hymns* (Wesley, *Works*, 7:142-43).

9. Harvard's *Narrative*, p. 85, gives a different location: 8° S. latitude 39° E. longitude.

father for more than 20 years,[10] but (according to his own account,) he received a stronger and clearer evidence of the will of God on this subject in May 1813, and was then more especially convinced of the absolute necessity of adopting immediate measures to hasten that important period, when the heathen shall be given to our Lord Christ. His zeal, fortitude, and patience (in contending with difficulties which invariably stood in the way of so important an undertaking, from the above period till he left London,) are too well known by many in England to render any further information necessary.

BROTHER CLOUGH'S ACCOUNT OF DR. COKE[11]

1813, *Dec.*10. — We left London and proceeded to Portsmouth, where we were to embark. I have seldom seen the Doctor more lively and happy than he has been this day; he considered this as the commencement of his mission, and the thought that he had so far succeeded in obtaining the consent of Conference, with six missionaries to accompany him, (and that these were all either gone or on their way to Portsmouth,) afforded him unspeakable pleasure. His happy soul would frequently break forth in loud praises to God, who had thus far opened his way to the East. When he had collected his little party at Portsmouth, and they were all assembled round him, he lifted up his heart and hands to God, and broke forth in the following language: *'Here we are, all before God, now embarked in the most* IMPORTANT *and most* GLORIOUS *work in the world. Glory be ascribed to his Blessed Name, that he has given you to be my companions and assistants in carrying the Gospel to the poor Asiatics; and that he has not suffered* PARENTS, BROTHERS, SISTERS, *or the* DEAREST FRIENDS *to stop any of you from accompanying me to India.'* At this time he seemed as though he had not a

10. It was, in fact, just thirty years since Coke had corresponded with Charles Grant of the East India Company about a possible mission to India. In the intervening years he had never entirely lost sight of the possibility, though circumstances and rival commitments had long delayed its realization.

11. Clough, described as 'a young man of cheerful piety,' had been Coke's companion during the previous summer, when they had travelled extensively through the British Isles seeking support for the mission to Asia. So he was already well acquainted with 'the Doctor' by the time they embarked.

dormant faculty about him, every power of his soul was now employed, in forwarding the work in which he had engaged.

We stayed several days in Portsmouth before we went on board, during which period his whole attention was fixed upon his work, and he was unwilling to attend to any that was not connected with it: from morning to night his eye was fixed upon it, as the eye of the racer who continually keeps the prize in view. He would frequently address himself to me, in language like the following: 'Brother Clough, what we are now doing, I am certain, is for God; and therefore what our hands find to do in this cause, let us do it with all our might.' Here I may mention a circumstance which took place between us, a little before we left London. As we were travelling in a coach, upon some business relative to the Asiatic work, in one part of our conversation, I presented a small paper to him to read, which was not altogether connected with the subject in hand; 'Brother,' said the Doctor, 'I beg your pardon, but excuse me, I am dead to all things but Asia.' Though I wished him to read the paper, yet I admired his unremitting zeal in so holy a cause. I confess, it was one of the most powerful and instructive lessons to me, and necessary to be observed in my future life and conduct. I need not add any thing more about him; while at Portsmouth, there were several who had the opportunity of observing his conduct, both in public and private, who are better able to do justice to such a combination of talent, holiness, and zeal.

Early on the morning of *Dec.* 30, 1813, the signal guns were fired from our Commodore, for the fleet to unmoor. I hastened to the Doctor, to inform him of it; upon receiving this intelligence, he exceedingly rejoiced. —The long wished for period was arrived. I collected his remaining scattered articles; meantime a servant of Captain Birch's arrived, leaving a note for the Doctor, containing information that our ship unmoored at 7 o'clock in the morning, and was then under-weigh to St. Helen's. After the Doctor had made the necessary arrangements, he took his leave of his friends at Portsmouth, with that feeling and affection characteristic of his regard for them: yet, with that fortitude of spirit, which pourtrayed a mind convinced of the necessity and importance of his absence from them—whilst they, as a people who had an interest in the court of heaven, offered up their prayers to God, that his aged, and venerable servant might, though in the evening of his

APPENDIX

days, so shine in Asia, as to introduce the glorious morning star of the Gospel in those benighted regions.

When we had arrived safe on board, I was ready to conclude that every anxious thought had taken its flight from the Doctor; I procured the carpenter to fix up his bed; after he had taken proper refreshment he retired to rest, and slept as comfortably as though he had been on land. The next morning he rose, and commenced his usual practice, as one amidst busy multitudes alone; he wrote several letters to send by the pilot to land, when he left the ship. The ship's company began soon to notice him as being a singular character. When we came into the Bay of Biscay, and had to contend with gales of wind, and tempestuous seas, the Doctor seemed alike unmoved, and pursued his labours of prayer, study, reading, and writing, with as much settled composure of mind, as though he had been on land. Now it was that the Doctor, who had been to the present a suspected person, began to gain the good opinion, attention, and even respect of all the passengers. His polite and easy address, his attainments in literature, were conspicuous traits in his character; and these, together with the sacred office which he sustained, attracted the veneration of all.

On *Saturday, Jan.8.* — Dr. Coke proposed to give a short lecture upon some passage of Scripture the next day, after the Captain had read prayers on deck: this offer was not denied, but, the weather being unfavourable, we were prevented from having service in the intended manner. However, this offer of the Doctor's was not afterwards entreated; this was rather a painful subject of reflection to him, but he observed, 'I believe our Captain has his reasons for it.' Since the Doctor's death, Captain Birch informed me that his instructions from his employers were, that 'he should go on just as usual;' the Captain added, that 'it had frequently been a matter of pain to him, to hinder so excellent and valuable a man from doing all the good in his power. I cannot express the regard and respect which I have had for Dr. Coke, since I have had the honour, and very great pleasure of knowing him;' but many of the passengers were disappointed, they frequently expressed their sorrow and regret that Dr. Coke could not fulfil his promise.[12]

12. Harvard's *Narrative* (63-64) relates this incident but adds to Clough's account that the captain heard of Coke's *Commentary*, and by general request it became the custom for Coke to read extracts from it on Sunday evenings. In this way the General Preface and Introduction were read through—one can only hope with general approval and the relief of shipboard tedium.

In the whole of his voyage, he seemed to live with his mind fixed on that passage, Eph. v.16, *Redeeming the time*. He had no idle moment, though in a ship: the work in which he was engaged occupied his attention next to communion with God; every action of the day tended to forward the work of God in Asia. In the beginning of the voyage, he corrected part of the Old and New Testament of the Portuguese Vulgate; this he intended to print immediately on our arrival in Ceylon; but when reflecting on the importance of setting the press for the Old and New Testaments, and the infancy of our work, it was thought proper to defer that at present, and begin with something of less magnitude, such as Tracts, Prayers, Hymns, &c. This being determined upon, the Doctor began to write Hymns, Sermons, Portuguese Prayers, and translate our Hymns; I believe he has translated nearly 50.

Drawing near the line, I began to have serious impressions that the Doctor, by confining himself so much to his studies, would materially injure his health, and I expressed those fears to Mr. Harvard, who was fully of the same opinion. But the difficulty was how to prevail upon him to give up the whole or even any of that employment in which he so much delighted, and which he considered of so much importance. However, I ventured sometimes to say, 'Doctor, you certainly must take a little exercise in the open air upon deck; it will undoubtedly be conducive to your health;' he frequently complied; at other times he would refuse, stating, (no doubt, what in some respects was true,) that the motion of the ship was a great deal of exercise to him. Knowing the delight he took in viewing any thing that was curious or new, I occasionally prevailed with him to accompany me on deck to see shoals of flying fish chased by a dolphin; a shoal of porpoises; the catching of a shark; to see a whale, or view an island; and he always thanked me for giving him the information. He also took great delight in viewing the beautiful appearance of the clouds about sun-set, which in those latitudes are strikingly grand; and on these occasions I could sometimes keep him upon deck for half an hour; yet he laboured very hard, and always rose with the sun; so that when we were under the line, he began to be a little out of order; but soon recovered; and from that period until we got round the Cape, and near the line again, he was as active and lively as I ever knew him to be. Yet, I believe, this kind of labour was too severe for a man of his

advanced age in this hot climate; and I am sorry to add, not only from my own thoughts, but also from the evidence of the medical gentlemen on board, that it was one means of hastening his sudden death. Yet while we view and deplore this conduct, as exemplified in the case of our venerable leader, it is a standard of emulation, at which all young ministers ought to aspire; and even our passengers confessed that Dr. Coke's conduct was a tacit reproof to all. The only way in which I can account for his unremitting labours is this:—that as Asia had so long occupied his serious attention, and to send the Gospel to so great a number of immortal souls, who were in heathenish darkness and superstition, was now the chief concern of his life; as more than once, since we came on board, he had told me that if he had not succeeded in establishing the present Mission, he believed it would have broken his heart; but having so clear a discovery of the will of God on the subject, he cast himself upon his direction, fully persuaded that his way would be opened; and, having so far succeeded, he took it as a proof of the divine approbation of the undertaking, and now determined to spend and be spent in so glorious a cause. And now having made a beginning, by translating and composing in Portuguese, he experienced great joy in his soul; and when he had composed a short sermon or prayer, he always read it to us with joy and gratitude; but that which afforded him the greatest joy was, when, in our prayer-meetings, we sung his translation of our hymns in Portuguese; and which (according to our judgment) were translated astonishingly well. Among all these labours, our *ever dear father* enjoyed deep communion with his Lord and Saviour; this we felt both in our public and private meetings. When he had the soldiers together who desired to flee from the wrath to come, how lovingly and earnestly he would address them! and how fervently would he address the Lord Jesus on their behalf! These little meetings he considered as dawnings of the gospel in the East. One trait in his character while on the voyage, I ought not to omit: when at any time the weather was stormy, or when on any occasion there appeared any fears or alarm, he would encourage the passengers by observing in what small ships he had frequently taken long voyages, what distressing scenes he had witnessed, and how far short this came of what he had witnessed; then he would remind them of our fine large ship; our comfortable

accommodations, &c. &c. and the goodness of God in preserving us from day to day; and that he doubted not that the same God would bring us safe to the end of our voyage, and that all things would be for the best. Thus, while he encouraged their hopes, and dispelled their painful apprehensions, he gained their approbation and esteem.

Those of our company who were on board the Lady Melville, began morning and evening prayers on their entrance into the ship; and also class-meetings every Sabbath. This they always found to be a soul reviving and strengthening means of grace. They had from one to three persons who met with them. Their evening meetings were generally attended by several soldiers: and for a few Sabbath evenings their cabin was very well filled. And on *Sunday, Jan.* 30, several of the military and ship officers sent a note, informing them that if agreeable, they would attend the evening prayers. To this request the brethren cheerfully acceded. Brother Squance, after reading a chapter, spoke about 20 minutes on Heb. ii.3. After the conclusion of the meeting, they expressed thankfulness. On the next Sabbath evening, as the cabin was too small, the military officers requested them to accept of their large cabin, as several more gentlemen and ladies intended to attend the lecture. The captain, with most of the passengers, and several of the ship officers attended. The next Sabbath evening, as one of the military officers was unwell, the brethren were requested to stand in the steerage. This was just what they anxiously desired, as all the soldiers and sailors who had wished to hear, might there have an opportunity. From this time, (*Feb.* 6,) each brother preached in his turn during the voyage. For these opportunities the brethren were truly thankful to God. They also commenced the duty of visiting the sick; and continued this practice till they left the ship: they found this also to be profitable to themselves.

April 8, being Good Friday, and 10, Easter Sunday; being separated from all our religious friends, and from the church of God in Europe, with whom we had spent so many Christian Sabbaths, and days of communion, and who on these occasions were solemnly commemorating the dying and risen Saviour; we considered it our duty and our privilege to partake of the sacred Ordinance, which we blessedly experienced to be owned of God. From the Doctor's death till our arrival at Bombay, we had no

opportunity of an interview with each other. Shortly after we cast anchor on the 21st of *May*, Brother Harvard and Clough visited those of the Melville. It was then realized that no letters or papers among the Doctor's papers, authorized us to become his executors, or to draw money for our support. The brethren stated Captain Birch's friendship; and that a simple, plain statement of our case had been given to him, with which he appeared to be well pleased; and promised to render us every assistance in his power. Immediately on his landing in Bombay, he represented our case to Thomas Money, Esq.[13] and to several of the principal gentlemen of Bombay; so that when Brother Harvard, whom we appointed to act in our name, presented a letter (which Dr. Coke had received for that gentleman) to him, he was treated as a friend by that gentleman, who at once proposed to advance money to us on the respectability of our society. He also kindly assured our brother, that were it not for the delicate state of his health, he would feel pleasure to accompany and introduce him to the governor; to whom the Doctor had recommendatory letters from gentlemen of the highest respectability in England. But this also Captain Birch most generously undertook and performed.

His excellency received Captain Birch and brother Harvard with the utmost politeness; and during breakfast, observed the high opinion of some noblemen in England of the loyalty and usefulness of the late Rev. Mr. Wesley, and talked of Dr. Coke and his death: and in a private way gave orders to his secretary to order a house in the fort for us. But this being previously occupied, he appointed his country-seat at Parell, five miles from town, for our residence. But at this time we received information that the ship Spencer, of 650 tons, Captain Mitchell, would sail for Ceylon very soon; we determined to avail ourselves of so favourable an opportunity. Of this we informed his excellency in our letter of thanks which we sent him; and then removed, May 27, from the inn to Parell. We now expected to sail on the 17 inst. but as several friends and a medical gentleman highly disapprove of sister Harvard, in her present state, going to sea, brother and sister Harvard must remain here for some time. We have already drawn on Mr. Money for 600 rupees, which we hope will nearly clear us out of Bombay.

13. W. Thomas Money, a British merchant in Bombay who declared himself 'a firm friend to the cause of Christianity in Asia' and helped them secure passages to Ceylon.

We have felt considerable pain on account of the vast expences necessary on an unsettled state in such a place as this. These in detail you may expect in our next. Captain Birch has already advanced us £400 which the Doctor lent him in England, as his own property. And though he believes it was designed for the use of the mission, yet he considers it his duty to have a draft from us on you for the amount; which we have given him at three months after sight, and which we hope you will thankfully accept. This we purpose to deposit with Mr. Money, and take a draft on his agent in Ceylon, for the amount; and on this ground we intend to proceed till we receive further instructions from you. We shall leave a considerable quantity of our articles with brother Harvard, in order to dispose of them.

We feel both duty and gratitude constrain us to inform you, that under God, the favourable reception we have met with in Bombay, and escaping the troubles which we dreaded, are principally owing to Captain Birch. During the whole of the time that our late Father and Friend was with him, he evidenced the utmost respect for him; and still more so, if possible, to his memory after his death. He felt as a tender friend for us all; he ever partook of our feelings, and always assured us that we had not so much to fear as he thought we dreaded. His report of us to his Excellency the governor,[14] to Mr. Money, and many other gentlemen, before an unfair statement of our case could circulate, prevented troubles, expenses, and afflictions, which otherwise we must have fallen into. And we are decidedly of opinion, that he justly merits the warmest thanks either of your Committee, or the Conference; as we are certain that his generous mind is above every other kind of acknowledgment.

We also consider it our duty to inform you, that from every information we can obtain of the Isle of France, it would be a very promising place for a missionary. There are several thousand of professing Christians, who have no instructor, and the French language is generally spoken in it. As it is a more cool climate than Ceylon, we have thought that if a Missionary were appointed for it, Brother Squance, who has a little knowledge of the language, and whose health is delicate, might be appointed for it. But we only suggest the business to you. From what we can learn of

14. Sir Evan Nepean.

Ceylon, if Missionaries were acquainted with the Tamul and Cingalese tongues,[15] (which we are told are not difficult to learn) they might expect to be very useful. And we trust that in humility before God, we may say that we were never more firmly determined to labour for God than we are at present. And also that we are deeply sensible of our awful responsibility to God, and our venerable Fathers, and the cause of God at large.

And now Rev. and dear Fathers, being fully sensible that you will not cease to pray for us; and also to recommend us to the public and private prayers of the churches of God: and requesting any information or direction which you may think proper to give us: and trusting that we shall never forget that we are still Methodist Preachers, and ministers of the Lord Jesus Christ—we subscribe ourselves,

Your Sons and Servants in the Gospel of Christ,
James Lynch William Harvard
William Ault Thomas Squance
George Erskine Benjamin Clough.

P.S. In consequence of a variety of incidents and hinderances, we have only finished the above about 15 minutes before the packet closes; so that our Fathers will make allowances for any unimportant mistakes that may be found, as there is no time to revise or correct.

Direct to us at Colombo. From private letters you may receive information on some things which could not be specified here.

Extract of a Letter from Mr. James Lynch, to Dr. Adam Clarke[16]

Rev. and dear Sir, *Bombay,* June 15, 1814
Our overland dispatch renders it unnecessary to say anything

15. The Tamils, originating in southern India, are still mainly found in the north of Sri Lanka; the Sin(g)halese in the centre and south. No instruction in these languages was available in London at that time, so Coke and his missionary band concentrated on learning Portuguese.

16. Published in *Methodist Magazine* (London) 38 (1815): 70.

concerning the death of Dr. Coke, and our present circumstances; I shall therefore chiefly confine myself to the subject of our ship, the Lady Melville. We found on board a colonel, a major, 3 captains, 4 ladies, 6 subaltern officers, 3 cadets, the captain's first and second officers, the doctor of the ship, and the purser. There were five of our party. We saw, that in order to preserve the life of God in our souls, and be useful to the passengers on board, we must worship God in public as well as in private, and so conduct ourselves as not to leave it in their power to accuse us of inconsistency; and I trust that, through grace, we were enabled to do so during the whole of the voyage. We read the Scriptures, and prayed in public, twice a day; and from February 13, we had the liberty of preaching, every Lord's-day evening, in the steerage, when the captain, most of the officers, and many of the soldiers and sailors attended. And though we had not the happiness of seeing much fruit of our labour among them, yet, from what they heard, and the several conversations which were held with them on religious subjects, I am fully persuaded that many of them obtained clearer views on religion, and more favourable ideas of Methodism, and us, and of Missions, than they had before. I doubt not that all the passengers would feel pleasure in rendering us any service in their power.

I bless God for uninterrupted good health. Brother Squance was in a consumptive state before he left England; and there is now little hope of his recovery.[17]

I understand that we must learn the Tamul and Cingalese tongues, in order to be useful at Ceylon; and I doubt not that God will assist us in the study of them. I bless God that we are all fully determined to devote our time, and strength, and talents, to the work in which we are engaged. The ignorance of the inhabitants, their attachment to their respective *casts,* and their prejudice against Europeans, oppose formidable obstacles to the propagation of Christianity in the East. But with God all things are possible.

17. As early as February Ault had reported that Squance was 'very ill indeed' and expressed doubts about his reaching India or being able to stand the climate there. But his, and Coke's, fears proved groundless, and plans to leave him at Mauritius were abandoned. Squance survived, served in Ceylon and India until 1822, remained in the active ministry until 1862, and died in 1868.

APPENDIX

On our arrival at Bombay, we were visited by three Missionaries from America, sent out to India by some religious community; two of them had been at Madras, and the other at Ceylon. I believe they are good men, and that they earnestly desire the conversion of the heathen. Several Europeans assemble with them once a week, to join with them in singing and prayer, and to hear the Scriptures read and explained.

On Sunday morning, the 12th instant, Mr. H. (who had been a member of our society in England,) and his wife, met with us in class. We had a blessed season together: Mr. and Mrs. H. were much affected on the occasion.

We hope to be in Ceylon about the end of this month;[18] and as we are without an experienced superintendent, we feel ourselves in a critical situation; but, at the same time, we have a humble confidence that God will be with us. I doubt not that we shall be remembered by our Fathers and Brethren in the Gospel.

I have lately thought, that God may have permitted so large a portion of the East to fall into the hands of the British, in order to facilitate the spread of the Gospel in it; and I trust that the time of its spreading there is at hand. Requesting, dear sir, a continued interest in your prayers, and any instructions which you may be so obliging as to afford me,

I am, your's, &c.

JAMES LYNCH

18. All the missionaries except Harvard (whose wife was pregnant) left Bombay in the *Earl Spencer* on 20 June and landed at Galle in the south of Ceylon on the 29th and 30th.

BIBLIOGRAPHY

PRIOR EDITIONS OF COKE'S JOURNALS (IN CHRONOLOGICAL ORDER OF APPEARANCE)

An Extract of the Rev. Dr. Coke's Journal, from Gravesend to Antigua, in a Letter to the Rev. J. Wesley. London: J. Paramore / Dublin: B. Dugdale, 1787. 12 mo, 12 pp.

A Continuation of Dr. Coke's Journal: in two Letters to the Rev. J. Wesley. London: J. Paramore, 1787. 12 mo, 12 pp.

A farther Continuation of Dr. Coke's Journal: in a Letter to the Rev. J. Wesley. London: J. Paramore, 1787. 12 mo, 11 pp.

'An Extract of the Rev. Dr. Coke's First Journal to North America'. *The Arminian Magazine* (Philadelphia edition) 1 (1789): 237-44, 286-97, 339-46, 391-98.

Some Account of the late Missionaries to the West Indies; in two Letters from the Rev. Dr. Coke to the Rev. John Wesley. London: n.p., 1789. 12 mo, 12 pp.

A farther Account of the late Missionaries to the West Indies: in a Letter from the Rev. Dr. Coke to the Rev. J. Wesley. London: n.p., 1789. 12 mo, 12 pp.

A Journal of the Rev. Dr. Coke's Visit to Jamaica, and of his Third Tour on the Continent of America. London: n.p., 1789. 12 mo, 16 pp.

Extracts of the Journals of the Rev. Dr. Coke's Three Visits to America. London: New Chapel, 1790. 16 mo, 120 pp. [a collected edition of the *Journals* covering the years 1784–89, including the first British version of the 1784–85 *Journal*].

A Journal of the Rev. Dr. Coke's Third Tour through the West-Indies: in two Letters to the Rev. J. Wesley. London: G. Paramore, 1791. 12 mo, 12 pp.

A Continuation of the Rev. Dr. Coke's Third Tour through the West Indies: in a Letter to the Rev. J. Wesley. London: G. Paramore, 1791. 12 mo, 16 pp.

A Journal of the Rev. Dr. Coke's Fourth Tour on the Continent of America. London: G. Paramore, 1792. 12 mo, 23 pp.

'A Letter from the Rev. Dr. Coke to Mr. Thompson'. *The Arminian Magazine* (London edition) 16 (1793): 218-20, 385-89, 439-42, 543-49; 17 (1794): 47-52 [the Journal of Coke's fifth visit to America and fourth tour of the West Indies].

Extracts of the Journals of the Rev. Dr. Coke's Five Visits to America. London: G. Paramore, 1793. 12 mo, 195 pp. (covering the years 1784–93).

'Dr. Coke's Sixth Tour of the Continent of America [1796–97] and his Last Tour through Ireland'. *Methodist Magazine* (London) 21 (1798): 313-19, 395-401, 447-52, 499-505, 551-57.

'Copy of a Letter from the Rev. Dr. Coke to Mr. J. Pawson'. *Methodist Magazine* (London) 37 (1814): 125-26 (describing his voyage to America, autumn 1797).

Extracts of the Journals of the late Rev. Thomas Coke, L.L.D.; comprising several Visits to North-America and the West-Indies; his Tour through a part of Ireland, and his nearly finished Voyage to Bombay in the East-Indies: to which is prefixed A Life of the Doctor [by Joseph Sutcliffe]. Dublin: R. Napper, 1816. 12 mo, 271 pp.

SELECT LIST OF OTHER SOURCES CITED

Asbury, Francis. *The Journal and Letters of Francis Asbury.* Edited by Elmer T. Clark. 3 vols. Nashville: Abingdon Press/ London: Epworth, 1958.

Baker, G. P. *Those Incredible Methodists.* Baltimore: Commission on Archives and History, Baltimore Conference UMC, 1972.

Bucke, Emory S., editor. *The History of American Methodism.* 3 vols. New York & Nashville: Abingdon Press, 1964.

Candler, Warren A. *Life of Thomas Coke.* Nashville: Cokesbury, 1923.

Coke, Thomas. *An Account of the Rise, Progress, and Present State of the Methodist Missions.* London: Conference Office, 1804.

———. *An Address to the Pious and Benevolent, proposing an Annual Subscription for the Support of Missionaries in the Highlands and adjacent Islands of Scotland, the Isles of Jersey, Guernsey, and Newfoundland, the West Indies, and the Provinces of Nova Scotia and Quebec.* London: J. Paramore, 1786.

———. *A History of the West Indies; containing the natural, civil, and ecclesiastical History of each Island.* 3 vols. Liverpool: Nuttall, Fisher, and Dixon, 1808–11.

Crookshank, C. H. *History of Methodism in Ireland.* 3 vols. Belfast: R. S. Allen, 1885–88.

Findlay, George G., and W. W. Holdsworth. *The History of the Wesleyan Methodist Missionary Society.* 5 vols. London: Epworth, 1921.

Harvard, William. *Narrative of the Establishment and Progress of the Mission to Ceylon and India.* London: for the author, 1823.

Powell, William S. *The North Carolina Gazetteer.* Chapel Hill: University of North Carolina, 1968.

Taggart, Norman. 'The Irish Factor in World Methodism.' Ph.D. diss., Queens University Belfast, 1981.

Vickers, John A. *Thomas Coke, Apostle of Methodism.* London: Epworth / Nashville: Abingdon Press, 1969.

Wesley, John. *The Works of John Wesley.* Edited by Frank Baker. Nashville: Abingdon Press, 1984–.

Williams, William H. *The Garden of American Methodism: The Delmarva Peninsula 1769–1820.* Wilmington, DE: Scholarly Resources, 1984.

Index

Abingdon, MD, 43, 64
Accotenk (Akatinke) Creek, VA, 47-48, 63, 165
Adams, Mrs., of Nixon Town, VA, 51
Addison, Joseph, quoted, 174
Africa, envisaged mission to, 85
Airey, Henry, of Dorset County, MD, 38
Akatinke creek, see Accotenk
Alexandria, VA, 46, 63, 64, 88, 123, 165, 218
Allen, Beverley, 56, 157
 ordination of, 42n
Allen, Dr. Moses D., of Trappe, MD, 38, 39
Almond, Edward, of Charlotte County, VA, 53
America, post-Revolutionary, 9-12
 population of, 224
American Indians, 86, 88, 127, 160-61
American Methodism, see Methodist Episcopal Church

Angel, Mr., of Jamaica, 194
Annadale, Ireland, 243
Annamessex Chapel, Chrisfield, MD, 36
Annapolis, MD, 64, 123, 214-16
 chapel, 214-15
Anson's Court-house, NC, 225
Antigua, 43n, 67, 75-77, 108-9, 115, 116, 137, 186-89
 persecution in, 137
Armagh, 238-40
 Anglican cathedral, 240
 episcopal palace, 239
Armstrong, Robert, of Chesapeake Bay, 212
Asbury, Francis, 31, 63-65, 118, 119, 123, 124, 127, 158, 164, 167, 169, 174, 219, 219-20, 229
 and Coke, 11-12, 13, 34-35, 42, 85
 and Cokesbury College, 41, 89n, 125, 217
 ordination of, 10, 42n

283

INDEX

Asia, mission to, 14-15, 253-56
Atkinson, Dr., of Armagh, 238
Augustine of Hippo, St., 25, 30
Ault, Mr. & Mrs. William, 254, 260-62, 265
Ayr, 234

Bahamas, 229
Baker, Jacob, of Philadelphia, 32
Baker, Mr., of Virginia, 55
Ballymena, Ireland, 236
Baltimore, MD, 42-43, 45-46, 64, 65, 88-89, 123-24, 165, 174-75, 216-18
 'Christmas Conference', 10, 31n, 42-43
 college, 217-18, 229-30
 Light Street Church, 45, 123
Barbados, 93-96, 116, 132-33, 187, 189-91
 persecution in, 132-33
Barratt's Chapel, DE, 34
Basse End (Bassin), Santa Cruz, 114
Basse-Terre, St. Kitts, 82, 109
Bassett, Richard, of Dover, DE, 33, 45
Baxter, John
 in Antigua, 67-68, 75, 137, 187, 189
 in Dominica, 77
 in Grenada, 134-37
 in Nevis, 65n
 ordination of, 65n
 in St. Vincent, 78-79, 91, 96-99, 133-34
Bayside, MD, 39n
Bedford, Col. & Mrs., of Charlotte County, VA, 53
Belfast, 235-36
Bent Chapel, VA, 59
Bertie, Mr., of St. Kitts, 81
Birch, Capt. of the Cabalva, 255, 268, 272, 276-77
Biscay, Bay of, 264, 272
Bishop, Abraham, missionary, 182-84
Black, William, 169, 177, 185, 187
Blackburne, F., see Confessional, The
Blackwell, Ebenezer, of Lewisham, 33
Bladensburg, MD, 46, 165

blindness, cure for, 149-50, 157
Blue Ridge Mountains, 61
Bolingbroke, MD, 38, 39
Bombay, 254, 280
Bond, Mr. & Mrs. John, of New Castle, DE, 167, 173
boneta (bonito), 259
Bouldeston, Capt. of the Halifax packet, 185
Bourbon, Isle of, 266
Bowen, John, Moravian missionary, 195
Bowen, Thomas, itinerant, 59
Boyd, Mrs., of Edenton, VA, 51
Boyer, Caleb, 42n, 65n
Bradford, Joseph, itinerant, 194
Bradshaw, Daniel, of Violet Hill, Co. Fermanagh, 243
Brainerd, David, Life of, 27, 28
Bransford, Mr., of Virginia, 59
Brazier, Mr., of Nevis, 81
Brazier, William, missionary, 112-13, 148
Brazil, 265
Brick Church, VA, 49-50
Bridge Creek Church, Bertie, NC, 52
Bridgetown, Barbados, 132, 189, 190
Briscoe, Mr., of Virginia, 59
Brook(e)borough, Ireland, 242
Brown, Mr., of Barbados, 190-91
Brown, Mr., of Montego Bay, Jamaica, 196
Brownell, John, missionary, 112n
Brown's Chapel, Sussex Co., DE, 36
Bruten, Mr., of Bamberg, SC, 118n
Bull, Mr., of Kingston, Jamaica, 116, 117, 146
Bull, Dr., of St.Kitts, 184-85
Burgess, Col., of Sandy Hook, VA, 50
Burlington, NJ, 44
Burn, Mr., of Dominica, 77
Burn, Mr., of Kingston, Jamaica, 116
Burton, Mr., local preacher, 43
Burton, Capt., of Accomack County, VA, 36

Index

Burton, Col. of Northampton County, VA, 37
Bushby, William, of Alexandria, VA, 63
Busse, Mr. de, of South Carolina, 86
Button, Mr., of Bridgetown, Barbados, 94, 189
Byron, Mr., of North Carolina, 224

Cable, Mr., of St. Kitts, 81
Calliaqua, St. Vincent, 96, 189
Cambridge, MD, 38
Campbel(l), Col., of N. Carolina, 51
Cam(p)den, SC, 226-27
Cape Francois (Cape Haitien), Hispaniola, 192-93
Cape of Good Hope, 265
Carew, Rev. Walter, of Guaave, Grenada, 184
 on predominance of catholicism, 182
Caribs, see St. Vincent
Carver, Jonathan, Travels, 128
Catawba Indians of South Carolina, 160-61
Cavan, Ireland, 241
Ceylon, 254
 passage to, 276
 Tamil and Cingalese missions, 278, 279
Chairs, John, of Centreville, MD, 40
Character of a Christian Bishop (sermon), 42n, 46n
Charlemont, Ireland, 238
Charleston, SC, 56-57, 84-85, 118, 120-21, 156-57, 229-32
 fire at, 230
Charlestown, Nevis, 81, 139, 179
Charleville (Charlottesville?), VA, 61
Charrurier, Mr., of Dominica, 80, 108
Cherokee Indians, 86
Cherrurier, see Charrurier
Chesapeake Bay, 208-12
Chester, PA, 45
Chestertown, MD, see New-Town
Child, Gabriel, of Calvert County, MD, 213

Chizzle, Capt., of St. Mary's, MD, 210-11, 212
christian perfection, 41n
Christianstad, see Basse End
Churchhill, MD, 40n
Clapham, Mr., of St. Vincent, 78
Clarke, John, missionary, 67, 71, 73, 78-80, 96
Claxton, Mr., of St. Vincent, 76n, 78, 79
Clayton, Col., of Hanover County, VA, 163
Clones, 241-42
Clough, Benjamin, 254, 267, 276
 account of Coke's last voyage, 269-78
coconut palm, 76
Coenjock, VA, 50
Coke, Thomas
 Address to the Pious and Benevolent, 67
 and Asbury, 11-12, 13, 35, 85
 baptisms, 38
 birth, 172, 236n
 Commentary, 171
 death and burial, 267-69
 journals, 15-17
 and missions, 7-8, 256
 on national churches, 28
 sciatica, 166
 Wesley and, 4, 5-6, 9-11
Cokesbury College, 35, 41, 43, 64, 89, 124-25, 175, 217-18
Cole, Le Roy, ordination of, 42n
Coleraine, Ireland, 237
Columbia, SC, 227
Confessional, The (F. Blackburne), 28
Cook, Capt. James, 128
Coote, Charles, Earl of Bellamont, 241
Cootehill, Ireland, 241
Corner, The, SC, 228
Cornish Methodists, 257
Council, the, 157n
cowfish, 84n
Cowles, Samuel, itinerant, 161
Cromwell, James O., 44n
 ordination of, 42n
Cuba, the Martyrs (islands), 154

285

INDEX

Cumberland County, KY/TN, 224

Dallam, Richard, of Abingdon, MD, 41, 43, 45, 64, 125, 174
Dameron, (John?), itinerant, 51
Daussey, see Dorsey
Davidson, Dr. George, 96
 on the Caribs, 92, 99-107
Delaware, 126
Dent, Rev. Samuel, of Barbados and Grenada, 135, 136, 182-83
Dicke's Ferry, VA, 162
Dickins, John, itinerant, 31, 42n
Dillard, Capt., of Virginia, 59-60
Dimmey, John, Carib 'prince', 97
Dominica, 77-78, 80, 99, 108, 116, 187
Donaghadee, Ireland, 235
Dorsey, Mr., of Elkridge, MD, 46
Dorsey (Daussey), Elizabeth, of Elkridge, MD, 218
Dover, DE, 33, 45
 Wesley Chapel, 33
Downing, Mr. & Mrs., of Virginia, 53, 58
Downing, Capt. William, of Accomack County, VA, 36
Downpatrick, Ireland, 236, 240
Downs, Henry, of Hillsboro, MD, 39-40, 45
Dromgoole, Edward, 220
Dublin, 90
Duck Creek Cross Roads, DE, 33, 45
Dungannon, Ireland, 237

Edenton ('Edington'), VA, 51
Eding, William, of Edisto Island, 155-56
Edisto Island, 155-56, 157
Elizabeth Parish, Jamaica, 194
Elkridge ('Elcreek'), MD, 46
Elkton see Head of Elk
Ellis, Michael, 65n
Ellis, Reubin, ordination of, 42n
Emery, Col. & Mrs., of Queen Anne's County, MD, 40
English Harbour, Antigua, 188

Enniskillen, Ireland, 242
Errington, Mr., of Barbados, 95
Erskine, George, 254
Everett, Joseph, American itinerant, 125

Falmouth, Cornwall, 200
Falmouth, Jamaica, 143, 197-99
fasting, 27, 30, 132
Finney, John, of Virginia, 59
firefly, 80
Fish, William, 193, 200, 207-8
Fishl(e)y, Mr., of Port Royal, Jamaica, 116, 150
Fletcher, Rev. John, 33
Florida, gulf of, 154-55
Forster, George, Voyage Round the World, 128
Fort Pitt (Pittsburgh), 127
Fort William, Indiaman, 257-58
Forzbrook, (John Fosbrooke?), of Kingston, Jamaica, 192
Fosbrook, Mr., of Castle Donnington, 146n
Foster, James, 65n
France, Isle of (Mauritius), 266, 277
Frazier, Capt. William, 39
Fredericksburg, VA, 48
French language, 72-73
Fry, Henry, of Culpepper County, VA, 62

Gallega, Isle of, 266
Gamble, Robert, missionary, 91, 94, 96
Garrettson, Freeborn, 33-34, 36n, 38n, 42n, 44n, 127
George III, King, 128
George Town, SC, 121
Georgia, 56, 85, 119, 120, 159
 proposed college, 120
Gibbs, Sir, Philip, of Barbados, 190
Gilbert, Nathaniel, of Antigua, 78
Gill, William, ordination of, 42n
Giveham (Givham), Mr., of Dorchester County, SC, 158
Giveham's Ferry, SC, 158
Glasgow, Scotland, 233-34

286

INDEX

Gloucester, William Henry Duke of, 76
Godhead of Christ (sermon), 42, 44, 48
Gough, Henry Dorsey, of Perry Hall, MD, 41-42, 45, 64
Graham, Daniel, missionary, 170, 171, 173
Grand Etang, lake and inn, Grenada, 136
Grange, Mr., of Virginia, 59
Grant, Charles, 253
Gravesend, 69, 170, 205
Green Ponds, Jamaica, 194
Greenock, 233
Grenada, 131, 134-37, 182-84, 187
grew-grew (gru-gru), 133
Grigg, Mrs., of South Carolina, 156
Grimes, Mr., of Virginia, 62
Guaave, Grenada, 137, 183-84
Guirey, Mr., of Kingston, Jamaica, 192, 193, 196
Gunpowder Falls and Chapel, MD, 41, 64

Hagerty, John, of Annapolis, 215
Haggerty, John, ordination of, 42n
Halifax County, VA, 87, 122
Hall, Jacob, of Abingdon, MD, 124
Hall, Dr., of Cokesbury College, 175, 217
Hammet(t), William, 67, 73, 74, 79, 114n
 in Charleston, 153, 154, 230-31
 in Jamaica, 131, 146-47, 150
 in St. Kitts, 81, 109
 in Tortola, 114-15
'Hankey', 93
Harding, Mr., of Barbados, 190
Hare, Richard, of Stepney, 30
Harper, Mr. & Mrs. John, missionaries, 185, 187
Harris, Dr., of Kingston, Jamaica, 147
Harry, black preacher, 82-83, 84, 109-10, 138
 see also Hosier
Harvard, Mr. & Mrs. William, 254, 260, 261, 262, 267-68, 269, 276

Haw, James, itinerant, 87-88
Head of Elk (Elkton), DE, 173
Heath, Mr., of North Carolina(?), local preacher, 220
Heather, George, of Charlemont, Ireland, 237
Henry, Mr., of Barbados, 189-90
Hilditch, Mr., fellow passenger, 73
Hill, Major Green, of Louisburg, NC, 56, 221-22
Hipkins, Mr., of Port-Royal, VA, 164
Hispaniola, 191, 192-93
Hoadly, Benjamin, 29-30
Hodgins (Huggins), Mr., of Salisbury, NC, 86
Holt, Mr., of Williamsburg, 49n
Honduras Bay, 207-8
Hood, Viscount Samuel, 200-01
Hopeton, Mrs., of Charleston, SC, 231
Hopkins, Dr., of Virginia, 61
Hopper, Col. William, of Hall's Cross Roads, MD, 39, 40, 45
Hosier, Harry, black preacher, 35, 37, 39
Hull, Hope, itinerant, 86
Huntingdon, Countess of, 199
Hynson's Chapel, see Kent Chapel

indigenous people, corruption of, 128-29
Ireland, 90, 235-43
Islam, 255
Ivey, Richard, ordination of, 42n

Jackson, Mr., of St. Vincent, 78
Jamaica, 115, 116-18, 131, 140-50, 188, 191-200
 Hammett in, 131, 146-48, 150
 persecution in, 146-49, 150, 196-99
Jamaica, merchant ship, 140
Jarratt, Rev. Devereux, 52-53, 58-59
Jenkins, Major, of Edisto Island, 155, 156
Johnson, Benjamin (?), of Virginia, 59
Johnson, Isaac, of Virginia, 53

287

INDEX

Johnson, John, itinerant, 236
Jolley (Jolliffe?), Mr., of Portsmouth, VA, 49
Jones, Tignel, of Wake County, NC, 57
Jones's Barn, Halifax County, NY, 220
Jordan, Thomas, of Virginia, 53
Joyce, Mr. and Mrs., missionaries, 98, 100n

Kane, Mr., of Nevis, 139
Kelsick, Mrs., of VA, 50
Kempis, Thomas a, 213
Kennon, C.(?), of Virginia, 55
Kent, Mr., of Queen Anne's County, MD, 40
Kent Chapel, MD, 41
Kent Island, MD, 40
Kentucky, 87-88, 89, 121-22, 222
Key, Martin, of Amherst County, VA, 61
Key, Tandy, of Virginia, 61
King Road, R. Severn, 25
Kingston, Jamaica, 25n, 116-18, 145-50, 149, 191-92, 200
 chapel, 146
Kingston, John, missionary, 190
Kingston, St. Vincent, 78, 79-80, 96n, 98, 133, 189
 chapel, 133
Kitchen, Mr., ship's captain, 197-99

Lady Melville, Indiaman, 255, 279
Lambert, Jeremiah, missionary, 43n, 44n
Lambert, Mr., of South Carolina, 227
Land's End, 71
Lane (Line?) Chapel, DE, 37
Las Palmas, Canary Islands, 260, 264
Lascars, 255, 258
Law, William, of Maryland(?), 37
Law, William, on Christian Perfection, 161
Leard, Mr., of Jamaica, 195
Leesburgh, VA, 122
Lenore, Mr., of South Carolina, 227

Leslie, Rev. Dr. Henry, of Tandragee, 240
Life of St. Francis Xavier (Bouhours), 26
Lill(e)y, Mrs., Quaker, of Santa Cruz, 140
Limavady, see Newtown-Limavaddy
Lindsay, Robert(?), of North Carolina, 220
Lindsay/Lindsey, Mr., of St. Eustatius, 109, 111-12, 138
Lion, Capt. Isaac de, of St. Eustatius, 82, 83, 110
Lisburn, Ireland, 236
Lister, Christian, Moravian missionary, 195
Livingston, Mr., of Armagh, 238
locust (false acacia), 165
Londonderry, 237
Louisburg, NC, conference at, 56
Loving, Mr., of Virginia, 60-61
Lower Chapel, (Curtis' Chapel?), MD, 36
Lumb, Matthew, missionary, 91, 94, 99, 134, 137, 169-70, 179, 180-81, 190
'Luncheon', Chinese merchant, 258
Lynch, James, 254, 269
 letter to Adam Clarke, 278-80
Lynch, Mr., of St. George, Grenada, 134
Lyons, James, missionary, 131, 132, 133

M'Cartney, Mr., of Brookeborough, 242
McCornock, William, missionary, 108, 180, 187n
M'Farland, Mr., of Charleston, SC, 231
McKnight, George, of Clemmons, NC, 121, 161
McVean, John, 185
Madeira, 257, 260, 264
Magaw, Dr. Samuel, 32
Malone, Isham, of Mecklenburg County, VA, 53
Mann, Page, of Virginia, 59

INDEX

Martha Brace Point/Martha Bray, Jamaica, see Falmouth, Jamaica
Martin, Mr. & Mrs., of Virginia, 54-55
Martinique, 106-7
Maryland, 123-26
Mason, William, of Brunswick County, VA, 58
Maston, Jeremiah, itinerant, 86
Matthews, Gen., Governor of Grenada, 135, 184
Mauritius, see France, Isle of
May Hill, Jamaica, 193, 194
Ma(y)b(e)ry Chapel, VA, 219
Mecklenburg County, VA, 57, 87
Meredith, Col., of Virginia, 60
Merrit, Mr., of Brunswick County, VA, 58
Methodist Episcopal Church, 89
 'Christmas Conference', 10, 31n, 42-43
 Conferences, general and annual, 175
 Doctrines and Discipline, 176, 232
 itinerant preachers, 174-75
 marriage of, 226
Middle-Mouse Rock, Irish Channel, 130
Milton, John, quoted, 145
Mobjack ('Mojock'), VA, 50
Money, W. Thomas, Bombay merchant, 276
Montego Bay, Jamaica, 140-42, 196
Montpellier plantation, Jamaica, 196
Montserrat, 109, 138, 188
Moore, Anthony, of Northampton County, NC, 52
Moore, Mark, of South Carolina, 227
Moore's Chapel, Sussex County, DE, 36
Moravian missions, 77
 in Antigua, 108
 in Jamaica, 194, 195
Morgan, Mr., of St. Vincent, 78-79
Morris, James(?), itinerant, 50
Mother-Bank, Isle of Wight, 70
Mount Diablo, Jamaica, 143-44, 200

Mount Holly, Burlington County, NJ, 44-45
Mount Vernon, VA, 63n
Mountague, Mr., of Montego Bay, Jamaica, 197
Moxat Bay, 65
Mundingo, prince of, 150
Myrick, Owen or Matthew, of Brunswick County, VA, 220
Myrick's Chapel, 220

Nesbitt, Richard and Walter, of Nevis, 139, 186
Nevis, 81, 112, 115, 138-39, 184-85, 187-88
New Castle, DE, 167, 173
New Chapel, VA, 62
New England, 127
New Jersey, 126
New Mills (Pemberton), NJ, 45
New-Town (Chestertown), MD, 41, 125
New York, 31, 44, 90, 126-27, 167, 176-77
 fire at, 230
 John Street church, 31n, 126n
 select society, 176-77
New York State, 127
Newark, NJ, 176
Newcome, William, archbishop of Armagh, 239
Newry, Ireland, 240
Newton, John, quoted, 255
Newtown-Limavaddy, Ireland, 237
Newtown-Stewart, Ireland, 237
Ninety-Six Town, SC, 159
Nixon Town, VA, 51
North Carolina, 86, 121, 161-62
 rural diet, 57
Norton, Mr., of Virginia, 55
Nova Scotia, mission to, 43

'Offer them Christ' (painting), 25n
Ogden, Rev. Uzal, of Elizabeth Town, NJ, 90, 176
Ogee, Mr., of Virginia, 59

Index

O'Kelly, James, 42n, 157, 169, 174n, 223, 232
Old Carmel Moravian mission, Jamaica, 195n
Old Harbour, Jamaica, 193
Orde, Sir John, Governor of Dominica, 108, 132
ordinations, 87
Ostervald, J. F., Bible, 205
Otley, Mr., of St. Vincent, 79
Otterbein, Rev. Philip, 42n, 43n
Outlaw, Mr. L.(?), of North Carolina, 51
Owen, William, of Mecklenburg County, VA, 220
Owens, Thomas, missionary, 112, 182, 184, 185

Paine, Thomas, 211
Painter, Sam, of Grenada, 135, 136
Palma, see Las Palmas
Paramore, Col. William, of Accomack County, VA, 37
Parell, near Bombay, 276
Parrott, Mr. and Mrs., of Richmond, VA, 219
Parry, Major David, Governor of Barbados, 94, 133
Pasquotank, VA, 50-51
Patillo, Rev. Henry, of Grassy Creek, NC, 56
Patten, William, of Tandragee, 240
Pattison, Richard, missionary, 179, 185
Pawson, John, 246
Pearce, Benjamin, missionary, 91, 94-96, 132, 189(2), 190
Pee-Dee Circuit, SC, 85-86
Pelham, Thomas, Irish secretary, 235
Pemberton, NJ, see New Mills, 45
Pennsylvania, 126
persecution
 in America, 38, 55, 193-94
 in West Indies, see under individual islands
Petersburg(h), VA, 122, 163, 219

Pettigrew, Rev. Charles, of Edenton, NC, 51
Philadelphia, 32, 43-44, 45, 90, 126, 166-67, 175-76
Philps, Capt., (or Phelps), of Newtown, VA, 54
Pigman, Ignatius, itinerant, 42n, 65n, 215-16
Pill, Somerset, 25n
Pittsburgh, see Fort Pitt
plantain, 145-46
Plante, Mr., of North Carolina, 225-26
Pleasant Gardens, McDowell County, NC, 225
Pontavice, Pierre de, 205, 209, 231-32, 235
Pope, Henry(?), of Virginia, 163
Port Patrick, 234-35
Port Royal, Jamaica, 116, 118, 150
Port Royal, VA, 164
Porto (Puerto) Rico, 248-49
Portsmouth, Hants, 70, 270-71
Portsmouth, VA, 49
Portuguese, Coke studies, 255, 273
Preacher's mark, the, 162-63
Price, Mr., of Jamaica, 196
Princeton, NJ, 44n
Providence Island, Bahamas, 229
publishing, 127
Puerto Rico, see Porto Rico
pufferfish, 81n
Purnell, John (or Purnall), of Pokomoke City, MD, 37

Quantico Chapel, MD, 36
quarterly meetings, 54

Racine, Louis, Poem de la Religion, 220
Rae, John, of Grenada, 136-37
Ragland, Mr., of Virginia, 55
Rainey, William, see Reyney
Raleigh, NC, 222
Randle, William, of North Carolina, 225

INDEX

Randle (Randall), John, of Stanley County(?), NC, 225
Raynal, Abbe, Philosophical and Political History, 113
Rechabites, 32
Reed, Nelson, 42n, 68
Rees, Henry, of Dinwiddie County, VA, 59
Reid, Mr., of Philadelphia, 32
Rennolds, Mr., Governor of St. Eustatius, 178-79
Republican Methodist Church, 223n
Reyney, Mr., (William Rainey?), of Orange County, NC, 223, 224
Richmond, VA, 88, 122, 163, 218-19
Ringold, William, 65n
Road Town, Tortola, 114, 140
Roanoak Chapel, VA(?), 52
Roberdeau, Gen. Daniel, of Alexandria, VA, 46n, 63n, 218
Roberts, Capt. of the Dashwood packet, 185
Robinson, Dr., of Maryland, 36
Robinson, Richard, archbishop of Armagh, 239
Roe, Samuel, of Burlington, NJ, 44
Rogers, Mr., of Brunswick County, NC, 58
Rogers, Philip, of Baltimore, 174, 216
Roman Catholicism in West Indies, 134, 137, 182n, 188n
Roseau, Dominica, 78, 80, 108, 180
Rose's (Creek) Chapel, VA, 220
Royster's Church, Virginia, 54
Rudder, Samuel, of Virginia, 163
Russel(l), Mr., of North Carolina, 225
Ryley, Mr., of St. Eustatius, 138

Saba, 112-14
Sadler's-Cross-Roads, DE, 45
St. Anne's parish, Jamaica, 143
St. Ann's Bay, Jamaica, 199-200
St. Christopher, see St. Kitts
St. Croix, see Santa Cruz, 114
St. Eustatius, 76, 82-84, 109-11, 115-16, 131, 138, 177-79
 persecution in, 109-12, 169, 178-79
St. Helens, Isle of Wight, 70, 271
St. John's, Antigua, 108, 188
St. John's Chapel, NC, 51-52
St. Kitts, 76, 81-82, 109, 112, 116, 138, 139, 147, 179, 184-85, 185, 187-88
 earthquake, 109
St. Mary's Bay, Potomac River, 210
St. Vincent, 76, 78-80, 96-99, 115-16, 133-34, 137, 140, 146, 180-82, 187, 189, 191
 Caribs, 91-92, 96-98, 99-107, 131, 134
 persecution in, 150-51, 169-70, 180-82, 189
Salem, NJ, 193-94
Sampson's Chapel, NC, 221
Samuel, St. Eustatius black, 84
Sands, Stephen, of New York, 31
Sandy Hook Church, VA, 50
Sandy-Point, St. Kitts, 82
Sandys, William, 253
Santa Cruz, 114, 140
Savannah, GA, fire at, 230
Scotland, religion in, 234-35
Seabury, Bishop Samuel, 153
Seaton, Mrs., of St. Kitts, 81
Seaward, Mr., of Virginia, 53
'select society', 176-77
sensitive plant, 139
Seven Rivers plantation, Jamaica, 196
sharks, 259, 265
Shaw, John, of Alexandria, 46n
Sheridan, Thomas, on elocution, 125
Sherry, Mr., captain of the Jamaica, 140
Shine, Daniel, of North Carolina, 221
Shore, Dr., of Virginia, 163
Shoreland, Mrs., of Barbados, 191
Sidare, Ireland, 242-43
Skeate, Col., of Barbados, 190
Skelton, Mr., of Virginia, 60
skyscapes, 31, 71, 129, 172, 273
 'calm-clouds', 129, 206
Slacke family, of Annadale, 243
slavery, witness against, 53-62, 65, 88
Smith, Isaac, of Camden, SC, 226

Index

Smith, John Addison, Captain of the President, 248, 251
Smith, Hon. Mr., of Guaave, Grenada, 183-84
Smith, Dr., Presbyterian minister, 44n
Smithfield, VA, 49
Smyrna, DE, see Duck Creek Cross Roads
Snow Hill, Worcester County, MD, 37
Sommersal, Mr., of St. Kitts, 82
soreness in the breast, cure for, 222-23
South Carolina, 56-57, 85, 119, 155-58
Sowell, Col., of Raleigh, NC., 222
Spain, Mr., of Virginia, 59
Spanish Town, Jamaica, 144-45, 148-49, 149, 200
Spenser, Edmund, 73
Spithead, 70
Spraggs (Sprague), Samuel, 45
Squance, Thomas Hall, 254, 261, 265, 275, 277, 279
Staples, John, of New York, 177
Steward, Mr., of St. Vincent, 79
Strawbridge, Robert, 33n, 41n
Suckley, Mr. & Mrs., fellow passengers, 251
Sunday Schools, 243
Sunday Service of the Methodists, 48n
Sundius, Christian/Christopher, 93, 248
Susquehanna river, 43
Swedenborg, Emanuel, 196, 217
sweet potato, 121

Tand(e)ragee, Ireland, 240
Tauler, Dr. John, 134
Taylor, Edmund, of NC, 56
Taylor, Col., of Virginia, 55
Telemach shoals, 266
Thomas, Sir George, of Antigua, 188
Thompson, Mr., of Pennsylvania, 43
Thomson, James, quoted, 221
Threadgill, Mr., of North Carolina, local preacher, 225
ticks, 158, 161

Tittford, Dr., of Spanish Town, Jamaica, 144
Tortola, 114-15, 140, 185, 187-88
 Hammett in, 147-48
Toy, Joseph, of Abingdon, MD, 43n
Treble, Mr., of Kingston, Jamaica, 116
Trent-Town (Trenton), NJ, 44, 126
Trotman, Henry, of Barbados, 95
Tuckaho
 Ebenezer Chapel, 39
Tuckaho, MD, 45
Tucker, (Benjamin, of Stoney Hill, VA?), 218
Tunnel(l), John, itinerant, 35n, 42n, 65n, 82
Turner, Mr., of Raleigh, NC(?), 222

Valley, de, Carib chief, 97
Vasey, Thomas, 28, 29, 31
Vermont, 127
Vickers Col., of Dorset County, MD, 38
Violet Hill, Ireland, 243
Virgil, 73, 200
 quoted, 28, 30, 256
Virginia, 86-88, 122, 162-64
 King William County, 48-49

Waller, Dr., of Portsmouth, 260
Walters, Mrs., of Quantico Chapel, MD, 36
Walters, Richard, (of Abingdon, MD?), 41
Ward, Mr., of Charleston, Nevis, 179, 184, 186
Ward, Mr., of Virginia, 54
Ward, Mr., ship's captain, 198
Warrener, William, 67, 70, 71, 76, 108, 179, 185
Warren's Point (Warrenpoint, Armagh), 240
Warwick, Thomas, itinerant, 234
Washington, George, 63-64
 loyal address to, 92
Washington DC, site of, 218
Watson, Mr., of Virginia, 62
Watts, Isaac, quoted, 159

INDEX

Webb, Mr. & Mrs. Joseph, of Portsmouth, 260
Webley, Mrs., of Dominica, 78, 108
Weems, David, of Maryland, 214
Wells, Mr., of Charleston, SC, 56-57
Werrill, see Worrell
Wesley, as Christian name, 159
Wesley, Charles, quoted, 69, 238
Wesley, John, 89n
 at Charleston, SC, 231
 Coke and, 4, 5-6, 9-10
 death of, 164-65
 at Enniskillen, 242
 Primitive Physick, 150n
 reinstated in the Minutes, 120
 Thoughts on Slavery, 60
West Indies, 75-84, 91-118, 132-50, 177-200
 stations and statistics, 8, 115-16, 187-88
 see also under individual islands
Whatcoat, Richard, 27, 29, 31, 34n
White, Judge Thomas, of Whitleysburg, DE, 35, 45
White, Bishop William, 32, 153
White, William, of Charlotte County, VA, 87n
White Oak Chapel, Dinwiddie County, VA, 58
Whitefield, George, 199, 234
White's Chapel, Kent Co., DE, 35
Whitfield, George, 246
Wight, Isle of, 69-71
Wilkes, John, Essay on Woman, 143
Williams, Col. Holliwell, of Mobjack, VA, 50
Williams, Mr., of St. George's, Grenada, 136
Williamsburg, VA, 49
Williamson, Thomas, itinerant, 88
Willis, Henry, itinerant, 42n, 223n
Willis, Mr. and Mrs., of North Carolina, 223-24
Wilmington, DE, 45, 166, 167
Withey, Mrs. Mary, of Chester, PA, 33n, 45
Witness of the Spirit (sermon), 169, 176
Worrell (Werrill), Thomas, 131, 132-34, 137, 140, 142, 148, 149, 151
Worton Chapel, MD, 41

Yarmouth, Isle of Wight, 71
Young, Sir William, of Antigua, 79-80

Printed in the United States
36989LVS00005B/82-297